Maya Blue

MAYA BLUE

Unlocking the Mysteries of an Ancient Pigment

DEAN E. ARNOLD

UNIVERSITY PRESS OF COLORADO
Denver

© 2024 by University Press of Colorado

Published by University Press of Colorado
1580 North Logan Street, Suite 660
PMB 39883
Denver, Colorado 80203-1942

 The University Press of Colorado is a proud member of the Association of University Presses.

The University Press of Colorado is a cooperative publishing enterprise supported, in part, by Adams State University, Colorado State University, Fort Lewis College, Metropolitan State University of Denver, University of Alaska Fairbanks, University of Colorado, University of Denver, University of Northern Colorado, University of Wyoming, Utah State University, and Western Colorado University.

∞ This paper meets the requirements of the ANSI/NISO Z39.48-1992 (Permanence of Paper).

ISBN: 978-1-64642-667-6 (hardcover)
ISBN: 978-1-64642-668-3 (ebook)
https://doi.org/10.5876/9781646426683

Library of Congress Cataloging-in-Publication Data

Cataloging-in-Publication data for this title is available online at the Library of Congress

Cover photograph by Dean E. Arnold, © The Field Museum, image no. CL0000_48158_WithoutScale_XMP2, cat. no. 48158.

This book will be made open access within three years of publication thanks to Path to Open, a program developed to bring about equitable access and impact for the entire scholarly community, including authors, researchers, libraries, and university presses around the world. Learn more at https://about.jstor.org/path-to-open/.

Contents

How are scientific discoveries made? Are they the result of careful scientific work and repeated testing of hypotheses? Are they the result of seemingly random, unpredictable events? Is the process like solving a mystery with a problem (the "crime"), data ("evidence"), and persistence ("drive") to put all the pieces together? Is it the slow progression of accumulating data? Is it the excitement of a eureka moment in which everything falls into place? Scientific discoveries can involve all these scenarios, but they are undergirded by an indefatigable curiosity to know, understand, and explain.

Curiosity cannot be taught, and someone who is not naturally curious may not be well-suited to a career in scientific research. Unfortunately, undergraduate education does not usually identify or encourage curiosity, or other personal qualities, such as creativity, which are necessary for those who want to go into science. Nevertheless, curiosity and creativity can be modeled and encouraged.

For my final semester of teaching before retiring, my department chair asked me to teach a course on any topic I wanted, but one that chronicled my personal scholarly pilgrimage. He convinced me to offer a course to help students understand the process of discovery by exposing them to the history of my own research. So I offered a course called "The Foundations of Discovery." Students were required to read three of my books and many of my articles and come to class prepared to discuss the process of engaging the research question/

https://doi.org/10.5876/9781646426683.c000

problem, collecting, and analyzing the data, and writing up the results that were evident from my publications.

The point was not to summarize the content of my published material, but rather to analyze and reflect upon the process of doing the research: What kind of personal qualities, experiences, and skills were necessary for making discoveries and creating knowledge? One-third of each class period was devoted to discussing the research and discovery process illustrated in my publications. During the second third, the class watched sequential segments of one of Dorothy L. Sayers's Lord Peter Wimsey mysteries. In the last third, I required students to synthesize the similarities and differences between the visual narrative of solving a mystery and the process of doing research as illustrated in their readings. Students were graded on their participation in class, four summary/reflection papers about the discovery process as illustrated in the course, and a final project. It was a small class of six, and we had a rewarding time together teaching and learning about the process of discovery.

The class learned about the seemingly uncanny similarity between the research and discovery process, and the unfolding of the mystery that they saw on the screen. They became aware that there were worthless asides, false leads, failures, discouragement, and the often boring and unexciting process of collecting data, but they realized that discovery required a lot of hard work, drive, persistence, and perseverance.

Probably for the first time in my career, the course caused me to reflect on my curiosity and my drive to know and understand, rather than thinking that I have something significant to contribute to a research problem. I asked myself, "How did I get there?" and "What were the events and the processes that led me to make my contributions to this problem?"

Teaching this class prompted me to reflect on my research on Maya Blue and the scenarios that unfolded during the history of that research. From its original discovery in 1931, the composition of Maya Blue was a mystery. When that was solved in the 1960s, research shifted to explaining those characteristics responsible for its unusual properties, which are unlike either of its constituents and why. Along with this quest, scientists have tried to understand how the ancient Maya made the pigment.

Much of the cultural context of the creation and distribution of Maya Blue, however, remains a mystery with many unsolved problems and unanswered questions. This work aims to help answer some of these questions, challenges some of the previous work about the pigment and its constituents, and distills some of the chemical and material science literature most useful to anthropologists, archaeologists, and art historians. First, however, this work attempts

to provide a holistic anthropological perspective about Maya Blue, but it only scratches the surface for finding answers to deeper questions about it.

This work does not just summarize the research about Maya Blue, but it is written as my own scientific journey over many decades to understand this pigment, its composition, and its cultural and environmental context. This journey, however, did not begin with studying the pigment itself. Rather, it started with my study of contemporary pottery firing in Ticul, Yucatán, in 1965, using the Maya language learned by eliciting parts of the firing process that introduced me to potters' Indigenous knowledge. During that research, I discovered that to avoid damage to their vessels, potters must mix their clay with a culturally constituted marl that includes a critical substance called *sak lu'um* ("white earth"). I eventually discovered that this "white earth" was the unusual clay mineral palygorskite, one of the critical components of Maya Blue. At that time, palygorskite was known by the name "attapulgite," and there was no evidence of the mineral in Yucatán. I not only discovered the link of how palygorskite related to modern Maya culture but suggested that the massive removal of palygorskite from the mine in the cenote in Sacalum (Hispanicized *sak lu'um*) indicated that the Maya began using palygorskite from there in the pre-Hispanic past for the production of Maya Blue—a hypothesis that my subsequent research, in collaboration with my colleagues, has shown to be correct.[1] As a consequence, I dropped my study of pottery firing and began an intermittent pilgrimage to learn about the pigment, trying to solve some of the mysteries about its constituents and its cultural and environmental context. During my research over the many decades since then, I have verified that palygorskite (*sak lu'um*) is a critical part of Indigenous knowledge of Maya potters and others in and around Ticul and is part of their cultural heritage.

This book thus documents a personal journey of discovery to understand more about Maya Blue. It is also an anthropological journey, not just because I am an anthropologist, but because the holism of anthropology sees technology as socially embedded, a part of culture, and related to its people, society, and religion. Chemists, material scientists, and geologists do not have the background and the academic training to understand these relationships in the human past in quite the same way and to relate the technical information to Maya culture. Conversely, anthropologists cannot relate the behavior and meaning of Maya Blue to its scientific analyses without the help of physical scientists. Engaging in this task thus requires teamwork between anthropologists, archaeologists, and physical scientists and is an essential component of this journey. With its unique perspective, anthropology provides the holistic

perspective that not only ties these threads together but provides a broad perspective that is part of the training of many anthropologists.

I have continued to write about Maya Blue and its components since 1965, and under my direction, various teams of archaeologists, archaeometrists, and physical scientists have worked with me to help unravel the mystery of this unique pigment and the cultural context of its constituents. This investigation first involved my participant-observation among the contemporary Maya, and then used hypothesis-testing to verify information in the field and in the laboratory by analyzing ethnographic and museum samples using techniques in the physical sciences (XRD, SEM, INAA, XRF, and LA-ICP-MS, among others) conducted by my colleagues. Some of the research presented here has appeared in other publications, but this book summarizes it with abundant bibliographic and explanatory endnotes providing the interested reader with sources for deeper study and exploration.

There are other summaries of Maya Blue,[2] but those are written from the perspective of chemistry and material science, focus on the laboratory research on the pigment, and occur in highly specialized books and journals. They do a better job of summarizing the details of the chemical composition and laboratory experimentation of the pigment than the distillation of that research described here. This work, however, is different, and although it summarizes some of the physical science research about Maya Blue, it focuses on its cultural dimension from my own fieldwork among the contemporary Maya over a period of more than forty years, and it summarizes the archaeological, ethnohistoric, historical, and physical science research about its use, composition, constituents, and sources. Nevertheless, in many ways, the story of Maya Blue is far from over, and while there are many questions yet to be answered, this work chronicles one view about where the knowledge of the pigment stands now and how it got there.

I thought about titling this work "Maya Blue: A New Perspective" because it does not just summarize previous research, but challenges some of the ideas about the pigment and presents new ones about how the ancient Maya created it. That title, however, was that of my master's thesis of 1967.[3] It was published in the same year with a different title,[4] one of six of the earliest papers about Maya Blue since its discovery in 1931. Rather, for this work, I opted for a broader title and format that incorporated much of the research about the pigment in a more holistic, anthropological perspective. Nevertheless, even after fifty-five years, this work is still a "New Perspective," but for different reasons.

Acknowledgments

This book is the culmination of a long stream of research that began in 1965, and I am grateful for the many individuals and institutions that funded and facilitated this work. Given so much funding invested in my research by granting agencies and my former college and universities, I have a great responsibility to provide a tangible outcome of its results.

I am grateful for the inspiration and encouragement of the late D. W. Lathrap, who first alerted me to the relationship of my field research to Maya Blue when Bruce F. Bohor of the Illinois Geological Survey identified palygorskite in my samples of *sak lu'um* from Ticul, Yucatán. Luis Torres Montes (formerly of the now defunct Centro de Estudios para la Conservación de Bienes Cuturales 'Paul Coremans' of INAH, and more recently from Universidad Nacional Autónoma de Mexico) and Alejandro Huerta Carrillo (also of the Paul Coremans Center) both encouraged and corrected me in the early years of this research and shared much information with me about the research on Maya Blue done by Mexican and Spanish chemists.

Many of the results reported here "piggy-backed" on other research projects that I have done. Several individuals and organizations have helped make the fieldwork and the publication of its results possible. The Social Psychology Laboratory of the University of Chicago (via a Midwest Universities Consortium grant originally from the Ford Foundation), the Department of Anthropology of the University of Illinois, the

xvii

University of Illinois Research Board (with B. F. Bohor), the Department of Anthropology at the Pennsylvania State University, the Research Office of the College of Liberal Arts of the Pennsylvania State University, an American Republics Research Grant under the Fulbright program, and the Wheaton College Human Needs and Global Resources Program provided funds for field research between 1965 and 1994. A National Endowment for the Humanities grant (Grant Number RK 20191-95), a grant from the Wenner-Gren Foundation for Anthropological Research (Grant Number 6163), and the Wheaton College Alumni Association supported research in Yucatán in 1997. These three grants provided a reduced teaching load for the analysis and write-up of some of my data, along with support for fieldwork in 1997. The National Geographic Society (Grant Number 8433-08) provided a grant for research in Yucatán in 2008.

The now defunct Inter-University Project for Behavioral Science Training in Yucatán and its former directors, the late Asael T. Hanson and the late Herman Konrad, provided housing and field support facilities in Yucatán between 1965 and 1968. The late Fred Strodtbeck and Asael T. Hansen asked my informants to collect a few samples for me in December of 1965. The late William Sanders cooperated in the collection of samples in the Petén in 1970.

Over the many years of compiling the data, analyzing the samples, and preparing material for publications, funds came from various entities of Wheaton College: the Department of Sociology and Anthropology (with thanks to department chairs Zondra Lindblade, Ivan Fahs, Alvaro Nieves, and Hank Allen), Wheaton College Faculty Development Funds, and the Norris and G. W. Aldeen Memorial Funds of Wheaton College (with thanks to academic deans Patricia Ward, William Henning, and Dorothy Chappel; to Vice Presidents for Academic Affairs Don Mitchell and Ward Kriegbaum; and to Provost Stanley Jones). The Wheaton College Alumni Association also provided generous funding for writing up parts of this project. Hank Allen, former chair of sociology and anthropology at Wheaton College, encouraged me to teach the class that led directly to the writing of this book.

My research and teaching assistants over the fifty-seven years of this project also provided help transcribing audio tapes, preparing samples, doing bibliographic research, and preparing maps, diagrams, and images. These included Warren Deutsch, Ralph Houck, Prudence Rice, Richard Kirsh, Carla Tiling, Randy Turner, Heidi Biddle, Helen Wooley, Greg Dolezal, Dan Gross, Matt Wistrand, Charles Shrack, Christa Thorpe, Sara Swulka, Masako Kawate, Delores Ralph Pacino, Christy Reed, Becky Seifried, Susan Crickmore, Hilary

Mulhern, Wendy Jennings, and Hayley Schumacher. There were others, as well, that unfortunately I do not remember.

I am grateful for the help of the late clay mineralogist B. F. Bohor, who provided much collaboration and technical help with the identification of palygorskite throughout the many years of this project. William Betterton of the USGS provided the X-ray diffraction patterns of the samples collected in 2008 with Bohor. Hector Neff, Ronald Bishop, Michael Glascock, and Robert J. Speakman analyzed many of the samples of palygorskite that I collected in Yucatán using INAA. The IIRMES Archaeometry Lab at the California State University at Long Beach (under the leadership of Hector Neff) conducted some of the LA-ICP-MS analyses of my samples that were supported by NSF grants BCS-0917702 and BCS-0604712. My colleagues at the Field Museum, Patrick Ryan Williams, Laure Dussubieux, Jason R. Branden, and J. P. Brown, did the analyses of Maya Blue from the Field Museum described here (LA-ICP-MS and others) and along with Gary Feinman were coauthors of two of the articles summarized here. Gary Feinman was a constant source of encouragement for many aspects of the latter stages of this project. Charlie Kolb provided continuing bibliographic suggestions. I am also grateful to Katherine Moore, who provided the reference of the use of deer antler for mining flint in southern England.

All of the photographic images were originally made by me unless noted otherwise (Linda Nicholas). Bill Koechling converted slides into electronic formats and with modifications for publication. Michael Anderson enhanced the drawings from my originals, which had been inked by Carla Tiling. Chelsea M. Feeney (cmcfeeney.com) made the maps. Linda S. Roundhill, Jeff Greenberg, Miguel Sánchez del Río, Charlie Kolb, Gary Feinman, Lisa Niziolek, Jennifer Meanwell, Elizabeth H. Paris, and Charles Weber provided bibliographic help or called attention to relevant data. Chris Phillip, Julia Kennedy, and Nicole Roth assisted with finding the appropriate objects with Maya Blue in the Field Museum's collection, and Robert Salm facilitated my access to the museum as an adjunct curator. Jerry Sabloff encouraged this research at the beginning of this journey and kindly gave me a copy of Tozzer's translation of Bishop Landa's classic work. Megan Kassabaum Crandal provided links to some of the objects with Maya Blue in the Penn Museum collection, and Megan and Tom Tartaron facilitated permission to use the image with Egyptian Blue from that collection. During the last several years of this project, Joe Ball provided encouragement, articles, images, data, and ideas that enabled me to think in new directions about Maya Blue and its context. His insight and critique inspired and encouraged me and pointed me

in new directions. Luis May Ku, who recently produced Maya Blue in Yucatán for artists and his own creative work, generously shared descriptions, analyses of his own replication of the pigment, and a blue and green sample of it.

Laura Osorio Sunnucks and Joanne Dyer of the British Museum invited me to make a presentation to an online symposium on Maya Blue sponsored by the museum in September of 2021 that provided much stimulation for this work.

This book would not have been possible without the help of my informants in Ticul. I have known my principal informant, Alfredo Tzum Camaal, since the fall of 1964 before I went to Ticul. I could not have done my research in Ticul without his help and gracious demeanor or the help and cooperation of his extended family, Eusebio Tzum Camaal, Francisco Keh Chan, Elio Uc Tzum, Ademar Uc Tzum, Jose Uc Tzum, Crecencio Cima, Eusevio Tzum Huicab, Jose Tzum Huicab, and many others. It was my contact with Alfredo that provided me with instant rapport with his extended family and most other potters in the community, and I paid Alfredo and others for their time when it took them away from making pottery.

Finally, I dedicate this volume to the memory of the late Bruce F. Bohor, whose association and persistent contact over more than fifty years led to much cooperation and many coauthored articles about Maya Blue and related topics.

Maya Blue

1

Maya Blue is a beautiful blue pigment used by the ancient Maya from the Late Preclassic period (300 BC–AD 300) up into the colonial period.[1] It mimics the color of the azure blue sky and the deep blue of the Caribbean that one sees from the Maya Riviera—that incomparable strip of coastline that stretches along the east side of the Yucatán Peninsula.

Introduction

Maya Blue was the color of sacrifice for the ancient Maya, and they painted human sacrifices, sculpture, pottery, murals, and codices with it. Symbolizing the rain god Chaak, among other meanings, the Maya employed it largely during the Late Classic, Terminal Classic, and Postclassic. After the Spanish Conquest, it occurred on murals in churches and convents, and there is some evidence that it was used up into the nineteenth century.[2]

Apart from its incredible blue color, Maya Blue does not fall into a class of just any blue pigment. Rather, it is unique in the ancient world both physically and chemically. Unlike other ancient pigments, Maya Blue is not organic or inorganic. Most pigments usually consist of an organic material derived from a plant, tree, or insect (like cochineal), or are made up of an inorganic mineral (or minerals) such as azurite or lapis lazuli, or are glazes with metallic ions, such as copper, that color them blue or green.

Rather, Maya Blue consists of both an organic component and an inorganic component combined into a single hybrid material. It is a unique human-created combination of an unusual clay mineral called

https://doi.org/10.5876/9781646426683.c001

palygorskite (and/or with sepiolite) and indigo, an ancient dye used through-out Middle and South America before the Spanish Conquest.[3] It resists the attack of caustic acids and bases, and its rich blue color does not fade over time, even after exposure for many hundreds of years in one of the world's harshest climates—the tropical forests of southern Mexico and Guatemala.[4]

During the last sixty years, the uniqueness of Maya Blue has simulated great interest among chemists and material scientists who have written many hundreds, if not thousands, of pages to explain its unusual properties trying to discover how the Maya created it. One thing is certain; however, Maya Blue is quite different from either indigo or the clay mineral to which it binds. Now considered the first ever nanostructured artificial organic-inorganic hybrid material, its exceptional stability has inspired much research for designing new such materials. It is one of the world's most unusual pigments.

This stability was dramatically demonstrated by a team from Mexico's Instituto Nacional de Antropología y Historia in 1985. Using a fragment of a blue pigment removed from page 10b of the pre-Hispanic *Códice Maya de México* (formerly the Grolier Codex), the researchers found that it

> . . . resisted the solubility test of six acids, two bleaches, and eight organic solvents, which included hydrochloric acid, nitric acid, aqua regia, sulphuric acid, perchloric acid, acetic acid, acetic hydroxide, sodium dithionite, acetone, methanol, ethanol, xylene, chloroform, carbon tetrachloride, carbon disulfide and benzene, a resistance only observed in the Maya blue pigment.[5]

This unusual characteristic helps drive the continuing study of Maya Blue by chemists and material scientists.

Before the modern rush of tourism forced the closure of many parts of archaeological sites, one could see Maya Blue on the sculpture and murals that still retained its rich blue color, unchanged from the time of its creation. One archaeological site that evinces its persistent color is Chichén Itzá, an ancient Maya city on the northern Yucatán Peninsula. As visitors walk north-ward from the great Pyramid of Kukulkan to a sinkhole called the "Sacred Well," they encounter a low pyramidal structure known as the Venus Platform. Careful observers will note that the low-relief sculpture on it still retains some of its ancient paint. Looking closely, they can see the remains of a blue pig-ment clinging to the crumbling limestone, yet with a richness of color unfaded after a millennium of exposure to the harsh tropical sun, torrential downpours, and hurricanes that have plagued Yucatán for centuries. Although much of the pigment has disappeared because of the erosion of the limestone under-neath it, that which remains still retains its bright blue color (figure 1.1).

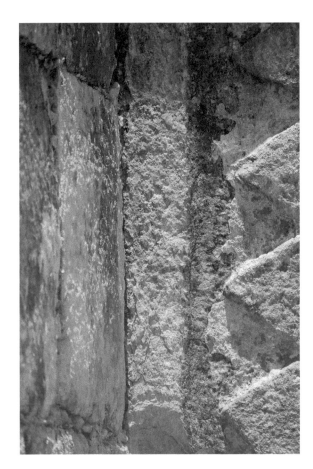

FIGURE I.I. *Close-up view of Maya Blue on a low-relief sculpture on the Venus Platform at Chichén Itzá, May 2008. Exposed to the weather for at least 900 years, the blue shown here has not lost its color, although the limestone underneath and around it has deteriorated.*

Blue was the color of sacrifice of the Maya, and the most prominent uses of Maya Blue at Chichén Itzá lie hidden within the restricted areas of the site. In the 1960s visitors still had access to some of these areas. One such area was the Temple of the Warriors, where the unique characteristics of the pigment were originally first discovered (figure 1.2). As I strolled among the columns outside of this structure, I could see tiny remnants of Maya Blue on the low-relief figures. In 1970 I was able to enter the chamber under the temple and saw the blue on the headdresses of the figures on the columns (figure 1.3) and the murals on the wall. It was here that chemist H. E. Merwin first noted the unique characteristics of Maya Blue.[6] Similarly, after the short but steep climb to the Upper Temple of the Jaguar, located on top of the east wall of the ball court, a mural inside the temple also shows the pigment.[7] All of these areas

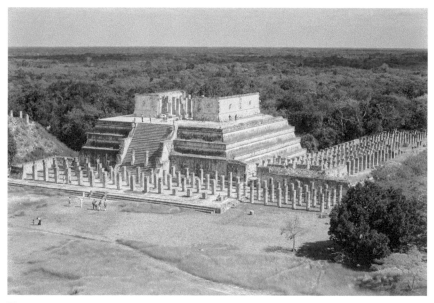

FIGURE I.2. *The Temple of the Warriors at Chichén Itzá. The story of Maya Blue began here when the pigment was first identified on murals and columns in the chamber underneath it.*

are now closed to visitors, but one can still see Maya Blue on the low-relief sculpture in the interior of the Lower Temple of the Jaguar.

It is ironic that although the ancient Maya used Maya Blue widely for more than seventeen centuries, modern scientists still have much to learn about it. Archaeologists, for example, have devoted little attention to the pigment. This book aims to help fill this gap. It documents the story of Maya Blue from its original discovery and summarizes some of the research about its composition, meaning, and creation in a cultural and environmental context. Many others have studied various aspects of the pigment, but this work brings together what I have learned about the pigment: how it was made, how it was used, and how it was spread throughout Mesoamerica from an anthropological and archaeological perspective.

NARRATIVE AND SCIENCE

Like much of science, descriptions of Maya Blue research employ a literary fiction that invokes the passive voice as if the data flowed from the analyses

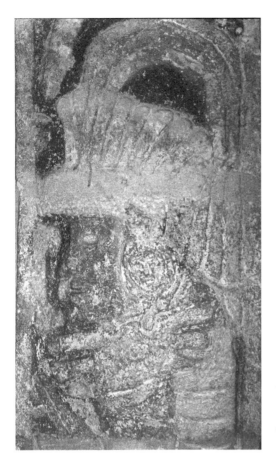

FIGURE 1.3. *Maya Blue on the headdress of a warrior on a column under the Temple of the Warriors.*

of the pigment through the methodology directly to the written presentation. Such descriptions encourage the illusion that the investigator was merely a passive participant and that the real source of the data was the methodology. Methodology protects the scientific process from methodological biases so that the results measure what they purport to measure and assures that the data can be replicated by another investigator. These procedures thus ensure results that are both valid and reliable.[8] Nevertheless, the investigator is just as much an instrument of scientific inquiry as physical instruments because personal factors, such as experience and academic training, affect the development of a research design and its execution. Furthermore, inexplicit cultural biases of the investigator can influence the interpretation of the data. As this study will show, these biases also occur in studies of Maya Blue and its constituents.

Consequently, a narrative description of the research design, its development, and its execution provides considerable insight into the scientific process, and thus illuminates a more complete and holistic perspective of Maya Blue than a more impersonal presentation. Why is this? Compared to abstractions derived from scientific observations, "story" is a literary genre that reflects the context of the real world most closely. Since science is concerned with this real world, narratives provide one more way to understand how scientists personally encounter that world. Rather than acquiring knowledge through impersonal methodology, narrative reveals the personal dimension of discovery and adds a more holistic perspective and greater descriptive integrity of the knowing process. When combined with other approaches, narrative provides a powerful way to communicate methodology, data, and the results of one's research.

Ironically, narrative conforms closely to the manner by which research is reported informally. It is often the way in which scientists interact at professional meetings to exchange ideas, report results, and negotiate books and articles. In fact, it is a common belief, among archaeologists at least, that what happens at parties, book exhibits, bars, and restaurants at professional conferences is just as important as what occurs during the formal presentations in the meeting rooms, if not more so.

Narrative in reporting research thus can restore personal engagement in the scientific process, and it is becoming more appropriate to use "I" and "we" in describing research. Such a change recognizes the agency of human beings in the discovery process rather than the apparent fictional primacy of an impersonal methodology that seems to perform itself. Rather, narrative puts scientific investigation in a larger situated context that shows not just "how" the research was conducted and "what" was accomplished, but also "who" did it, "why," and under what conditions. It is just as important to focus on the "who," the "why," and the context of the research as on just the "what" and the "how."

Research is thus always situated within a personal, historical, theoretical, cultural, and social context. Understanding this context not only provides a different perspective of the data but helps to clarify why an investigator focused on the topics that he/she did. It provides a larger epistemological context for the methodology and the results. While never substituting for actual data, a narrative approach challenges the sufficiency of the empiricist and logical positivist approaches that dominated science up until the 1960s and complements them. Relating this approach to Maya Blue, the cultural interpretation of the pigment does not follow directly from physical science analyses without knowledge of the cultural context of the investigator as well

as the cultural context in which the data are collected and that of the Maya, both ancient and modern.

So to completely understand the scientific process, one must understand the historical and personal context of the research. This same perspective was laid out by philosopher of science Michael Polanyi,[9] who recognized that the scientific process of knowing was personally embedded and had a significant personal dimension. Polanyi demonstrated that the discovery of so-called "objective" knowledge in the history of science had ignored the personal dimension of knowing that plays a significant role in scientific discoveries. The investigator and his/her biases (whether explicit or implicit) thus are a significant part of the knowing process that cannot be ignored or neglected but should be made explicit.

Presenting the "knowing process" as a narrative thus reveals a perspective of research consistent with the holistic goals of anthropology itself. Since the anthropologist's data come from his/her personal experience and is recorded as a narrative in the field, its use in a scholarly presentation provides a holistic perspective of the discovery process. This work thus does not just summarize research about Maya Blue but recounts some of it as "story," presenting it through a personal perspective of discovery and meaning within the context of Maya culture and the scientific process.

STRUCTURE OF THE BOOK

This book is organized around several themes that correspond to the history, composition, creation, use, and diffusion of the pigment throughout Mesoamerica. The next chapter (chapter 2) documents the history of the discovery of the composition of the pigment. It details what we know about Maya Blue mentioned in the compilation attributed to the sixteenth-century Spanish priest Diego de Landa and summarizes some of the uses and various contexts of what we now know as Maya Blue. Scientists who have studied Maya Blue have emphasized its uniqueness as a hybrid organic-inorganic composite, and chapter 3 surveys the use of some other blue and green pigments throughout the world and compares them with Maya Blue. Chapter 4 describes the chronological journey of my discovery of one of its key components in Yucatán, palygorskite, and its cultural context as a part of Maya Indigenous knowledge. Chapter 5 details the culturally significant sources of palygorskite in modern Yucatán based upon its use for pottery temper and medicinal purposes. It also summarizes data about the antiquity of those sources and why they are part of Maya cultural heritage useful for locating

ancient sources. The following chapter (chapter 6) surveys other sources of palygorskite in the Maya area and evaluates whether the ancient Maya tapped them to produce Maya Blue. Chapter 7 briefly discusses the plant sources of indigo, their distribution, their history in Mesoamerica, and their role in Maya culture. Chapter 8 recounts the process by which the ancient sources of palygorskite used to make Maya Blue were identified by comparing the trace-element analyses of palygorskite from modern sources with those of samples of Maya Blue. These analyses reveal that both Sacalum and a source near Ticul were the actual sources of the mineral used in the Maya Blue on a sample of artifacts from Chichén Itzá and Palenque.

One of the ways in which the ancient Maya created the pigment is explored in chapter 9, showing the role of ritual and how mixing indigo, palygorskite, and copal incense and heating it as an offering to the rain god Chaak gives Maya Blue its sacred status. As convincing as burning copal appears to be in creating the pigment, chapter 10 explores some of the details of the chemistry of making Maya Blue by several other ways in which the ancient Maya might have created it, including grinding a mixture of leaves of the indigo plant (or an aqueous extract from them) and wet palygorskite and then heating it by burning copal or charcoal under it. This chapter also details the evidence of making the pigment in bowls excavated from El Osario (the Grave of the High Priest) by E. H. Thompson in 1896.

The Maya first created Maya Blue in the Late Preclassic period, and chapter 11 explores the ways in which the pigment diffused throughout Mesoamerica. These are grouped into commodity movement (Maya Blue or its constituent, palygorskite) and technology transfer, but in the final analysis both processes were involved in its dissemination. Finally, chapter 12 concludes the book by laying out a few areas of research in anthropology and archaeology that need to be explored in the future.

2

The story of the discovery and meaning of Maya Blue begins at the ancient Maya site of Chichén Itzá, one of the great wonders of the ancient world. Known for its mammoth ball court, its iconic pyramid, its observatory, and other spectacular monumental buildings, its structures and layout parallel those of the ancient Toltec site of Tula, located 60 kilometers north of Mexico City and some 1,100 kilometers west of Chichén Itzá (figure 2.1).

Background

In the 1920s and 1930s the Carnegie Institution of Washington financed a large project of recording, excavating, and restoring ancient Maya monuments that began at Chichén Itzá.[1] Among the many scholars who participated in the project was a chemist named H. E. Merwin, who noted the bright blue on the murals and sculpture under the Temple of the Warriors (figure 1.3). Still vibrant after more than eight centuries, this blue, Merwin observed, resisted the attack of various reagents, including solutions of weak acids, alkalines, and low heat.[2] After detailed examination of the pigment eleven years later, Gettens and Stout called this unusual pigment "Maya Blue."[3]

Now, more than ninety years after its discovery, we know much more about this unusual pigment and recognize that it is indeed a technological marvel. It was ". . . one of the great technological and artistic achievements in Mesoamerica."[4] Used on sculpture, murals, and pottery, blue was associated with the rain god Chaak. Found throughout the Maya area, it is more common in the Maya lowlands, used from the Late

https://doi.org/10.5876/9781646426683.c002

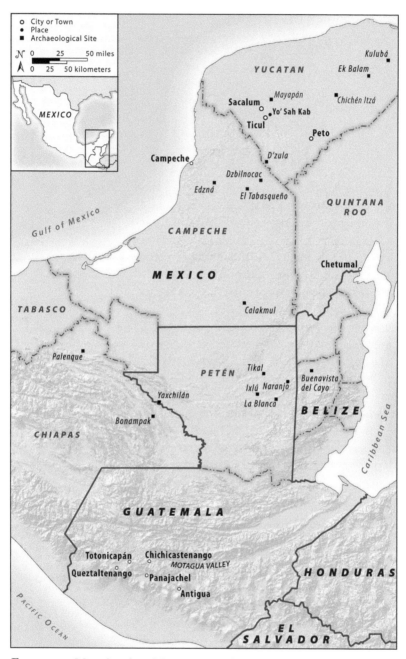

Figure 2.1. *Map of southern Mesoamerica with some of the cities, towns, and archaeological sites mentioned in the text. (Map by Chelsea M. Feeney, www.cmcfeeney.com)*

Preclassic period into the colonial period and perhaps into the nineteenth century.[5] As this work will show, this pigment was not just a blue pigment used by the Maya, a Maya *blue*, but rather it possessed unique and special qualities. It was uniquely *Maya Blue*.

Maya Blue, however, is not just the color "blue"; it may also be green with variants grading from blue to green, but all consist of a hybrid of indigo and palygorskite (and/or sepiolite).[6] Although analytical chemists have proposed chemical reasons for this color variability that will be discussed later (chapter 10), this variability also needs to be understood from two other perspectives.

One perspective relates to the natural variability of the color of palygorskite, which, when mixed with indigo, can alter the color of the resulting pigment. The light yellow color of some of the palygorskite deposits, for example, could produce a Maya Blue pigment that is greener. Since 1965 I have visited many deposits of palygorskite in Yucatán and collected about 180 samples of it over a period of forty-three years.[7] Most of the samples from these deposits are white, whereas others, especially those collected in 2008 from the mine in Sacalum (chapter 5), are pale yellow, stained with the iron mineral limonite with flecks of the red iron mineral hematite.[8] This variation could produce a blue-green or greenish Maya Blue when prepared with indigo.

Second, although interesting to the chemist and art historian, the blue/green variability of Maya Blue may not be as significant to the ancient Maya as one might think. Rather, their perception of "blue" differs from that of English speakers because of the way that the Maya languages encode color. For those languages and Yucatec Maya, in particular, color terminology does not distinguish between the color "blue" from the color "green," labeling both as *ya'ash*.[9] They recognize the difference between the colors blue and green, but when they describe an object by color, they use the same color term for both, *ya'ash*.

The color term *ya'ash* is one of the five different color terms that the Maya use to describe their world—white (*sak*), yellow (*k'an*), red (*chak*), black (*ek'* or *boosh*), and blue/green (*ya'ash*). This classification is verified by the authoritative Cordemex dictionary of Yucatec Maya, a massive volume that incorporates many previous dictionaries of the language as well as modern Yucatec Maya as it was spoken up until the mid-1970s.[10]

I first encountered this fivefold color classification in 1964 as a first-year graduate student at the University of Illinois. I was learning to use a monolingual eliciting technique in a language that I did not know (see chapter 4).[11] I was assigned to an informant who spoke a Maya language called Tzeltal, used in the State of Chiapas in southern Mexico. While learning the technique

(and in the process, a bit of Spanish), I discovered that the Tzeltal used only five color categories to describe their world. When I asked about color and pointed to the blue sky, my informant responded with *yaash*[12], the Tzeltal word for blue-green, and when I pointed to the grass, he responded with the same word, *yaash*. At some point I asked if the colors of the sky and the grass were the same, and he replied that they were not but that they were both *yaash*. From this interaction, it was clear to me that perception may not be the same as cognition. Although informants recognize differences in color, their color categories are different from ours.

Just like the color categories of Tzeltal, this five-category color classification parallels that of many other languages investigated by linguists Brent Berlin and Paul Kay. In their study of the basic color terminology of ninety-eight of the world's languages,[13] they used both the literature and speakers of the languages to group squares of color into categories and then grouped the different societies with identical classifications together. After arranging groupings into a sequence of simple (two color categories) to more complex (eleven color categories), Berlin and Kay argued that this sequence represented the universal stages of evolution of color categories in the world's languages. Yucatec Maya, and indeed all Maya languages, fall into what they called "Stage Four Languages," which include terms for the same five colors (black, white, red, yellow, and blue/green).[14]

For the modern Maya of Yucatán, however, this fivefold color classification is changing, and at least some speakers have separated blue terminologically from green. In a recent dictionary of Yucatec Maya based upon the dialect spoken in the town of Hocabá, Yucatán, the color blue is separated from the color green.[15] The color green is called *ya'ash* (the Maya word for blue/green), but the color blue is *ch'ooh*, the Yucatec Maya word for the indigo plant (*Indigofera suffruticosa*),[16] the source of one of the raw materials used to create Maya Blue.

By empirically comparing languages of the fivefold color classification with those languages with sixfold color classifications, Berlin and Kay accurately predicted that the change from five to six terms evolves through time by separating the terms of "blue" and "green" from "blue/green,"[17] just as it occurred recently in Yucatán.

The Maya potters of Ticul apply all five of these color terms to their raw materials, but they only use *ya'ash* (blue/green) occasionally to describe them. The only earthen material of this color is clay and occurs only rarely in the area around Ticul. During the more than forty years of my research in Yucatán, I have found only a few clays that informants described using the color term *ya'ash*.

As interesting as this color classification is for describing geological materials, the fundamental questions for its use for Maya Blue are these: Did the ancient Maya know how to manipulate the color of the pigment deliberately during its creation to produce different varieties of blue and green on their pottery, sculpture, and murals? Or were the colors of Maya Blue employed for these media the result of using different varieties of the pigment that resulted from the natural variability of the color of the palygorskite? Some aspects of these questions will be discussed later, but for the moment one must place these questions in the semantic context of the Maya languages that lump blue and green into the same color category and in the geological context that iron minerals in the raw palygorskite may affect the variability of the color of Maya Blue.

THE MEANING OF BLUE TO THE MAYA

In contrast to the perception of color and its encoding into language, the meaning of color varies far more than Berlin and Kay's straightforward classification of its terminology. Indeed, the color "blue" (ya'ash) has a special meaning to the ancient Maya that can be inferred from its use on pottery, murals, and sculpture and in the ancient Maya books called "codices." Maya Blue was not just an unusual pigment; it was also a critical part of ancient Maya religion and ritual. Blue was the color of offerings, applied to pottery, murals, and sculpture, and was used in ritual contexts.[18] Among other meanings, it symbolized the rain god Chaak.[19]

Just as the discovery of the uniqueness of Maya Blue began at Chichén Itzá, its meaning and link to ancient Maya culture comes from the descriptions of the rituals there described in a compilation of documents attributed to Friar Diego de Landa, a sixteenth-century Spanish priest who lived in Yucatán right after the Spanish Conquest. Landa's tenure in Yucatán occurred from 1549 to 1563, a stint that began seven years after Francisco de Montejo y León conquered the region in 1542. Landa eventually became the bishop of Yucatán, and when he returned to Spain, he wrote *Relación de las Cosas de Yucatán* ("Relation of the Things of Yucatan") in 1566. Using Maya informants who had experienced life in Yucatán before the Spanish Conquest, oral history, and historical documents consulted in Spain, Landa's compilation remains one of the essential sources about Maya culture before the arrival of the Spanish, although there is skepticism about the amount of the document that Landa actually authored.[20] It also played a key role in deciphering Maya hieroglyphics, the script that the ancient Maya used for writing their books (codices), for

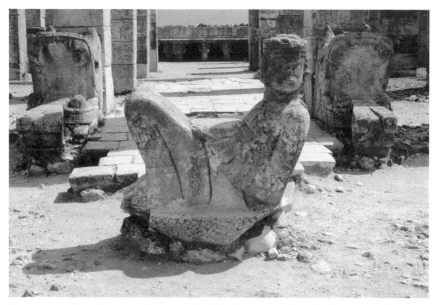

FIGURE 2.2. *The altar at the Temple of the Warriors upon which the Maya probably offered human sacrifices. (Photo by the author; reprinted from Dean E. Arnold et al., "The First Direct Evidence for the Production of Maya Blue: Rediscovery of a Technology," Antiquity 82 [2008]: 158, fig. 5. © Antiquity Publications Ltd., 2008, published by Cambridge University Press, used with permission.)*

painting inscriptions on their pottery and murals, and for sculpting texts on their monuments, wooden lintels, and stela.[21]

Bishop Landa's compilation documents the exceptional ceremonial significance of blue at Chichén Itzá.[22] It was associated with sacrifice, priests, and Maya deities, especially the rain god Chaak.[23] These associations imply that it was highly valued and religiously important. Although there are other colonial documents about the Maya and four codices that survived the Spanish Conquest, Landa's work provides a description that informs us most about the role of blue in ancient Maya life.

The Landa account reported that human sacrificial victims and the stone altars upon which they were laid were painted blue before their beating heart was cut out and sacrificed to Chaak (figure 2.2).[24]

> When the day of the ceremony arrived, they [the sacrificial victims] assembled in the court of the temple; if they were to be pierced with arrows, their bodies were stripped and anointed with blue, with a miter on the head. . . .

If his heart was to be taken out, they conducted him with great display and concourse of people, painted blue and wearing his miter, and placed him on the rounded sacrificial stone after the priest and his officers had anointed the stone with blue and purified the temple to drive away the evil spirit. The *chacs* then seized the poor victim and swiftly laid him on his back across the stone, and the four took hold of his arms and legs, spreading them out. Then the *nacon* executioner came, with a flint knife in his hand, [and] with great skill made an incision between the ribs on the left side, below the nipple; then he plunged in his hand and like a ravenous tiger tore out the living heart, which he laid on a plate and gave to the priest; then quickly went and anointed the faces of the idols with that fresh blood.[25]

The ancient Maya also sculpted an image of human sacrifice in low relief on a panel in the interior of the ball court at Chichén Itzá. If the panel was painted, the colors have eroded away. Nevertheless, blue, according to Landa's description, was a critical part of ancient Maya religion.

MAYA BLUE AND THE SACRED CENOTE

Maya sacrifices did not exist in isolation from their cultural and environmental context, and one part of that context was the Maya concern about water. Yucatán generally lacks surface lakes and streams but has natural sinkholes that were critical sources for water for household consumption.[26] Found in many parts of the world with karst landscapes, sinkholes form when slightly acidic rainwater dissolves the subsurface limestone. Over millennia, the surface rock collapses into the empty cavity, creating a roughly circular depression that, in some cases, reaches the level of groundwater. The Maya refer to this kind of feature as *ts'onot* in their language (Yucatec Maya), which is transliterated into Spanish as *cenote*.

At Chichén Itzá one sinkhole is located south of the center of the site and was the principal source of water for domestic purposes because it was easily accessible from the surface. Eight hundred meters to the north lies another large sinkhole (figure 2.3). Between this sinkhole and the one to the south, the Maya constructed most of Chichén's ritual center, including the ball court, the Temple of the Warriors (figure 1.2), and a massive pyramid, the iconic Temple of Kukulkan.

Although the sinkhole to the north also contained water at its base, it was relatively inaccessible from the surface and was limited as a source for water because of its vertical sides.[27] Nevertheless, archaeologists have inferred that

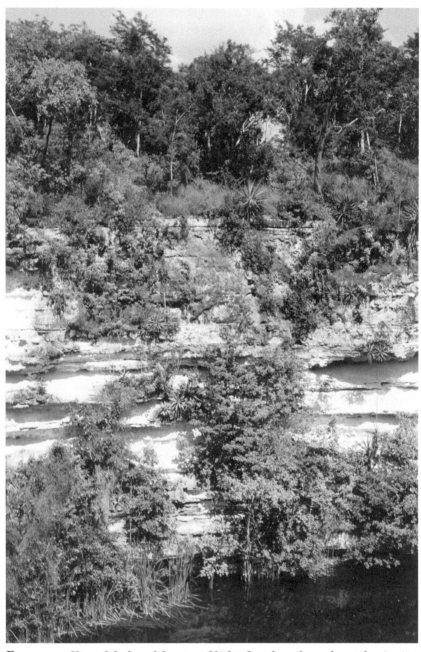

FIGURE 2.3. *View of the Sacred Cenote at Chichén Itzá from the southwest showing its size and vertical walls.*

the ancient Maya also used it as a water source up through at least part of the Terminal Classic period (AD 800–1100) because of the broken water jars found in it.[28] Bishop Landa said that the ancient Maya deemed this sinkhole as sacred and threw offerings for Chaak into its depths,[29] including human sacrifices and "a great many other things, like precious stones and things which they prized."[30] It became known as the Sacred Cenote.

The artifacts recovered from the Sacred Cenote in the early twentieth century corroborate Landa's description of the offerings of objects and human sacrificial victims thrown into it as well as the importance of blue paint. In 1893 the U.S. consul in Yucatán, Edward H. Thompson, bought Chichén Itzá and the property around it.[31] During the next twenty years, he excavated the Grave of the High Priest (El Osario, "The Ossuary") there,[32] and from 1896 to 1910 he dredged the depths of the Sacred Cenote.[33] In 1904 a student named Alfred E. Tozzer witnessed part of the dredging operation.[34] He eventually became the director of Harvard's Peabody Museum, and fifty years after the dredging operation, he published a massive summary of the project.[35] Even then, the description of most of the materials recovered remained unpublished. More than seventy years later, however, some were selected for a museum exhibit and were published in its catalogue.[36] Finally, almost ninety years after Thompson's dredging operation, a more complete analysis and description of these artifacts finally appeared in print.[37]

These publications revealed that Thompson had recovered a massive number of objects that included pottery, copal incense, wood, gold, rubber, jade, and leather as well as much human skeletal material. The analyses of the skeletal material from E. H. Thompson's dredging of the cenote and that recovered during the pumping operations in the cenote in the 1960s revealed that more than 200 individuals were dispatched into the cenote, many with traumatic injuries consistent with human sacrifice. About half were children.[38] Using the analyses of oxygen and strontium isotopes present in the bones to determine their geographic origin, investigators discovered that some of these individuals came from distant areas, such as the Gulf Coast farther west, the central Maya lowlands, and perhaps even the central Mexican highlands.[39]

Blue was the most common color found on the objects recovered. Indeed, blue was painted over most, if not all, of the copal offerings removed from the cenote between 1904 and 1910.[40] Its use on offerings was so frequent that some of it washed off, sank to the bottom of the cenote, and created a layer of blue silt below a layer of mud.[41] Tozzer's profile of the cenote shows that the layer of blue silt is roughly between 4.5 and 5.0 meters (14–15 feet) thick.[42]

Why was there a thick layer of blue silt at the bottom of the cenote? Maya Blue is a post-fire fugitive paint (see chapter 3), and without a binder holding it together, it is easily removed from pottery and any other material on which it is painted. Even though the water level in the sinkhole fluctuated seasonally between 19.4 and 25.8 meters (60–80 feet) below ground level, according to Tozzer,[43] the velocity at which the offerings hit the water and sank the remaining 9.7–19.4 meters (30–60 feet) to the bottom created enough friction to remove at least some of the pigment.

Why is the blue layer below the layer of mud? The mud layer consisted of decayed organic material from decomposed human flesh, offerings of organic material, and plant detritus that fell into it. Even though no more than 3% of Maya Blue consists of indigo, the pigment principally consists of palygorskite (97%), which is made up of silicon, magnesium, and aluminum; these elements are heavier than the decomposed organic material consisting of carbon, nitrogen, and oxygen in the mud above it. Once free of the objects thrown into the water, the pigment was denser and heavier than the organic material in the mud and sank to the bottom of the cenote.

Tozzer, among others, believed that the blue paint on the artifacts was indigo.[44] Unlike Maya Blue, however, indigo is an organic dye that fades over time.[45] If any indigo remained uncombined chemically with the palygorskite on the objects thrown into the cenote, the indigo would be lighter in weight than the Maya Blue; in time (more than five centuries in this case), it would fade, decompose into compounds of its constituent elements of carbon, hydrogen, nitrogen, and oxygen, and become part of the organic mud that lay above the blue layer. The persistence of the blue layer under the layer of mud after many centuries thus further verifies that the blue layer was indeed Maya Blue because it was heavier than the organic remains of the indigo, did not decompose, and did not fade over time.

The importance of blue on objects thrown into the Sacred Cenote is further corroborated by the meaning of blue in the Madrid Codex, one of the four ancient Maya codices that survived the Conquest. In it, blue is associated with themes of offering, rain, agriculture, the Maya rain god Chaak, and the sky god Itzamná and was used in ceremonies dedicated to Chaak.[46]

Rain, of course, was necessary for the growth of the Maya staple, corn (maize), which needs rain at critical times during its growth cycle such as the filling of the cob. If the amount and frequency of rainfall diminishes, the returns from the maize harvest would be insufficient to sustain the population through the following year.

The role of Maya ritual to propitiate Chaak to provide rain is now more important than previously thought. Up until recently, it was thought that the appeal to Chaak to bring rain was related to the seasonal cycle of rainfall. The rainy season begins in late May or early June and tapers off from September through December except for the occasional hurricane.[47] By way of contrast, the dry season occurs from January through May with little or no rain. The ground becomes dry and baked during this time and the vegetation thins.

Although this seasonal pattern usually occurs consistently in northern Yucatán, long-term patterns of climate reveal a much more complicated picture. Based upon carbon-14 dates and the hieroglyphic dates on ancient Maya monuments, the period between AD 850 and AD 925 experienced several multi-decadal droughts. These dates corresponded to end of political activity and the cessation of the construction of monuments in many of the centers in the Yucatecan hill country (in Yucatec Maya, *puuc* is "hill").[48] During this period, the rainfall was insufficient for the maize crop, and the rainwater stored in cisterns (*chultuns*) for domestic use probably did not sustain the Maya through the dry season. Consequently, many of these *puuc* populations abandoned their settlements,[49] moving north and clustering around natural sources of water found in sinkholes. Although this change in settlement pattern provided access to water for domestic use, it did not provide the much-needed water to grow the staple of their diet—maize.

Chichén Itzá and some centers in the *puuc*, however, survived these droughts until AD 1000 when, according to regional climate records, the longest and most severe drought in 2,000 years plagued the area. It affected the mobilization of labor for monumental construction, and political activity was reduced. Eventually the social and political institutions of Chichén Itzá collapsed, and the city was abandoned.[50]

Reading about the rituals that involved the use of blue in Landa's work, one gets the impression that he was reporting accounts of eyewitnesses who had lived just before the Conquest and had seen the sacrifices at Chichén Itzá. The city, however, had been abandoned centuries before, and the human sacrifices involving the ritual use of blue first occurred during the period from AD 850 to AD 1000 when Chichén Itzá was still occupied and northern Yucatán experienced great droughts. One response to those droughts appeared to be an appeal to the rain god with human sacrifices and the heavy use of the deity's symbol—Maya Blue. This use intensified that appeal and reinforced the ancient Maya's plea for rain. Most of the pottery with Maya Blue that was thrown into the cenote during these rituals, however, dates to

the Postclassic period more than a hundred years later and will be discussed in a later chapter.

Landa thus probably did not just compile records of the memories of those who lived immediately before the Conquest; rather, his book probably consisted of a synthesis of the oral tradition of the socially embedded memory that the Maya had passed down for generations. Some of these rituals might have been recorded in the ancient codices and then recounted to Landa before he burned them in the town of Maní during the early colonial period. Indeed, Landa's work reveals that he knew some Yucatec Maya and had learned enough of Maya hieroglyphic writing (or knew those who did) that he provided the keys that eventually led to its decipherment in the last decades of the twentieth century.[51]

A HISTORICAL PERSPECTIVE

Several key breakthroughs have occurred in the history of Maya Blue research. After its discovery by Merwin in 1931, the composition of Maya Blue remained a mystery up until the 1960s. In an article in *Painting Materials: A Short Encyclopaedia* in 1942, Gettens and Stout confirmed its resistance to alkalis and hot concentrated acids and briefly described a microscopic study of its color and refracting index in a report for Harvard's Fogg Museum. A spectrogram showed elements of calcium, magnesium, silicon, aluminum, and iron—some of which (magnesium, silicon, and aluminum) were later found to be the constituent elements of palygorskite. They believed that the paint was inorganic and appeared to correspond to the rare mineral aerinite from Spain.[52]

Then Elizabeth West, a scientist at the Smithsonian Institution, found that one of the constituents of Maya Blue was palygorskite (then called attapulgite), using X-ray diffraction.[53] Reported by Rutherford Gettens in an article in *American Antiquity* in 1962, this discovery was the first breakthrough in solving the mystery of its composition. Gettens also recounted the history of the research of the pigment up until he submitted his article, and in an addendum he said that by using X-ray diffraction, Anna O. Shepard had identified peaks of the clay sepiolite in Maya Blue on an Aztec spindle whorl from central Mexico.[54] Sepiolite is a clay mineral similar to attapulgite (palygorskite).

Perhaps most remarkable about Gettens's work was his discovery that the color of Maya Blue was not "discharged by boiling nitric acid and was not affected by heat much below redness."[55] Further work with the pigment revealed that the color was unaffected by concentrated hydrochloric acid, aqua regia, concentrated sulphuric acid, and 5% sodium hydroxide after eighteen

hours at room temperature. Later the samples were lowered into a concentrated sulphuric acid bath that was raised to 100°C and allowed to stand for thirty minutes. Still there was no change in the blue color.[56] Exposure to all these caustic chemicals revealed that Maya Blue exhibited remarkable stability consistent with Merwin's original test results. Only high heat (330°C–350°C) caused the blue color to disappear.

Because of these unusual properties, Anna O. Shepard, writing a short piece in the same issue of *American Antiquity* in which Gettens published his article, suggested that Maya Blue was a clay-organic complex.[57] Shepard had been a part of the Carnegie Institution of Washington for many years and had published many short reports on her work on ceramics in Yucatán in the institution's yearbook. Shepard's article, along with another small monograph that she published with Hans Gottlieb in 1962, further elaborated her hypothesis that Maya Blue was a clay-organic complex.[58]

The next breakthrough in the discovery of the composition of Maya Blue came in 1966 with the publication of a paper in the journal *Science* by H. Van Olphen, then of the National Academy of Sciences. Van Olphen showed that a Maya Blue–like pigment could be synthetically produced in the laboratory from a mixture of palygorskite, a small amount of indigo (<2%), and low heat at a temperature between 100°C and 150°C. By showing that heat was necessary for the synthesis of a pigment, Van Olphen verified his interpretation by experimentally replicating this preparation using another technique, thereby indicating that the ancient Maya may have used more than one method for preparing it.[59]

The mystery of the composition of Maya Blue was finally solved in 1967 when chemists working in Spain, Belgium, Mexico, and the United States identified the pigment as a combination of indigo and palygorskite (then called attapulgite) using infrared absorption spectrometry and X-ray diffraction.[60] In 1969 Cabrera Garrido verified this result using the same techniques. Combining the effectiveness of both the techniques and the lessons learned from his own research, Cabrera Garrido proposed a sequence of steps to analyze the pigment.[61] His research paralleled the unpublished research of two Mexican scientists, Luis Torres with the National Autonomous University of Mexico and Alejandro Huerta of the Centro de Estudios para la Conservación de Bienes Cuturales 'Paul Coremans.' They had analyzed many samples of Maya Blue and identified palygorskite in all of them, but sepiolite (both with and without palygorskite) tended to occur in Postclassic blue pigments from central Mexico.[62] Sepiolite is a clay mineral similar in structure to palygorskite, and subsequently some research has focused on whether it

can form a chemically stable, acid-resistant pigment with indigo like palygorskite. Experimental attempts to synthesize Maya Blue using sepiolite, however, indicated that it is not as stable in acids and its color is not as persistent as that of palygorskite-based Maya Blue.[63]

Equally important, the pigment that Cabrera Garrido analyzed came from the ancient market site of Tlatelolco in the Aztec capital of Tenochtitlán under modern Mexico City. His work demonstrated that the Aztecs, not just the Maya, also knew how to create the pigment and suggested several alternatives that the ancients may have used to made it.[64]

A BLUE MONTMORILLONITE?

Scientific breakthroughs occur when multiple and often opposing hypotheses are tested and either accepted or rejected. The study of Maya Blue is no exception. One failed hypothesis postulated that Maya Blue was a blue variety of the clay mineral montmorillonite (now called smectite).

This hypothesis was originally proposed by chemist Edwin R. Littmann.[65] Littmann had published several articles about mortars and plasters in the leading journal of American archaeology, *American Antiquity*, in the 1950s and 1960s.[66] About 1973 he submitted an article to *American Antiquity* challenging previous research about Maya Blue and argued that the pigment from the site of Palenque was a blue montmorillonite.

The editor of the journal sent the article to me for peer review. I had published an article in the same journal in 1971 showing that the potters of Ticul, Yucatán, knew the physical properties of a material they called *sak lu'um*, which was palygorskite/attapulgite and one of the materials used to make Maya Blue.[67] My article did not mention the Maya Blue link but focused on potters' ethnomineralogical knowledge. It was, however, a version of my master's thesis, "Maya Blue: A New Perspective," published in the same year (1967) as my research report by the University of Illinois Department of Anthropology with a different title. In that report I linked the potters' knowledge of palygorskite with its use for making Maya Blue.[68]

I found two major problems with Littmann's article. First, he did not know about the articles by Kleber, Masschelein-Kleiner and Thissen, Van Olphen, and Cabrera Garrido, who had conclusively shown that Maya Blue was a combination of indigo and palygorskite more than four years earlier.[69]

A second problem with Littmann's analysis was his sample preparation and analytical methodology—a problem that remained when his paper was finally published. Littmann's samples were not prepared in a way that could identify

the clay minerals unambiguously using X-ray diffraction. He appeared to use the bulk powder method in which a ground sample is packed into the diffractometer's sample holder. This type of preparation was widely used at the time for non-clay minerals, but because of the very small particle size of the clay minerals, their orientation is randomized, and when mixed with non-clay minerals, their crystal layers may not be thick enough to diffract the X-ray beam to produce a peak sufficiently high for detection. If a non-clay mineral, for example, shares a refractive peak with a clay mineral, the non-clay mineral may mask the peaks of the clay mineral completely unless it is separated from the non-clay minerals.[70]

The way to avoid these problems is to (1) physically separate the clay from the non-clay mineral component of the sample; (2) orient the minerals in the clay portion to provide enough thickness to obtain an X-ray pattern; and (3) use a wide range of angles for X-ray diffraction to resolve any ambiguities with peaks co-occurring at the same angle. The first two procedures can be accomplished by dispersing (and deflocculating) samples in water using ultrasound. With this procedure, the non-clay minerals will sink to the bottom of the container while the clay minerals remain in suspension. This suspension is then drawn off using a pipette and carefully deposited on at least three glass slides so that the surface tension does not allow the suspension to run off the slide. This procedure creates a thin layer of oriented clay particles unencumbered by the non-clay minerals; with successive applications on the slides, the clay suspension is thick enough to produce an X-ray peak without the interference of the peaks of the non-clay minerals.

The slides are then carefully dried. One is heated. Ethylene glycol is added to a second, and a third is left untreated. Heating drives off any interlayer water in the sample. As a result, the clay layers may collapse in some clay minerals (such as smectite/montmorillonite) and will be evident in the shift in intensity and location of the X-ray peaks from the peaks of the unheated samples. For the glycolated samples, the glycol is taken up between the clay layers in some clay minerals (such as smectite/montmorillonite), a change that also produces a shift in the position of the X-ray peaks.

The untreated, heated, and glycolated slides for each sample are then analyzed using X-ray diffraction, and the peaks at the various angles of incidence are compared. Smectite (montmorillonite) and palygorskite (attapulgite), for example, share some of the same X-ray peaks. Montmorillonite has a diagnostic peak at an angle of 6.2 degrees, and palygorskite has a diagnostic peak at an angle of 8.5 degrees.[71] Neither peak occurred in Littmann's X-ray data because the diffraction angles in his analyses were greater (11.3 degrees).[72] According to

clay mineralogist B. F. Bohor, formerly of the Illinois State Geological Survey and the United States Geological Survey, montmorillonite/smectite should be easily distinguished from palygorskite when peaks at these angles are used as criteria. These procedures thus enable an analyst to differentiate a sample containing montmorillonite from that containing palygorskite or some other clay mineral.[73]

Littmann said that the definitive peaks separating montmorillonite and palygorskite were not there, but he did not separate and orient the clay minerals in the manner described above. Littmann removed the calcite and dolomite in his samples with hydrochloric acid, but he did not remove other non-clay minerals or utilize the above procedures to definitively identify palygorskite and montmorillonite in the sample.

Consequently, Littmann's sample preparation and his failure to use the full range of diffraction angles significantly affected his interpretation of his analyses, and he did not demonstrate that Maya Blue was a blue montmorillonite. The use of X-ray diffraction with properly prepared samples and lower diffraction angles could have validated or invalidated his hypothesis. I did not recommend publication, telling the editor that Littmann should read the articles by Kleber et al. (in French), Van Olphen (in English), and Cabrera Garrido (in Spanish).[74]

Some months after I had submitted my review to the journal office, the editor wrote to me saying that Littmann did not have access to a library to obtain these articles. So the editor asked his assistant to find them. Unfortunately, he could not track them down, and editor asked me to send them directly to Littmann by mail so that he could see for himself.

Except for obtaining Van Olphen's article in *Science* magazine years before, I also experienced some difficulty in getting hold of copies of the articles by Cabrera Garrido and Kleber et al., having to write to the authors to obtain copies using the addresses I obtained from colleagues that I met at the annual meeting of the Society for American Anthropology in Mexico City in April of 1970. In the paper that I presented there ("Ethnomineralogical Studies in Yucatan: Archaeological Implications"), I reported my discovery that Maya potters in Ticul knew about the properties of palygorskite, that they used it in pottery temper, and that the ancient Maya used it in the production of Maya Blue.[75] In that presentation I said that the composition of Maya Blue was still unknown except for the presence of palygorskite (attapulgite). After the session was over, the two Mexican scientists mentioned above, Luis Torres and Alejandro Huerta, told me that the composition of Maya Blue *was* known because of the analysis by three chemists, Kleber, Masschelein-Kleiner, and

Thissen, and verification by Spanish chemist Jose Maria Cabrera Garrido.[76] After reading these works, I realized that from 1967 forward, the mystery of the composition of Maya Blue had been solved.

After having sent copies of these articles to Littmann, I was shocked when the January 1980 issue of *American Antiquity* arrived with Littmann's revised article, which stated that Maya Blue could either be a combination of indigo and palygorskite or, at Palenque, a blue montmorillonite. He discussed the articles that I had sent him, but the methodological problems with preparing his samples and interpretations of the X-ray patterns remained. Further, he said that indigo did not show up in the X-ray peaks of Maya Blue. Because indigo is less than 3% of the pigment, however, X-ray diffraction was not the best way to identify it.

Unfortunately, Littmann did not follow Cabrera Garrido's procedure using both X-ray diffraction and infrared absorption spectrometry to analyze the pigment even though I had sent him the article.[77] Nevertheless, Littmann claimed: "*Yet in no case has the presence of indigo in Maya Blue been confirmed by any acceptable technical procedures*"[78] (emphasis in the original). For me, the weight of the analytical evidence from more than ten years prior to Littmann's published article had already demonstrated that Maya Blue consisted of palygorskite and indigo using X-ray diffraction and infrared absorption spectrometry, but he was unconvinced. The analyses by Kleber, Masschelein-Kleiner and Thissen, and Jose Maria Cabrera Garrido were clear and overwhelming: Maya Blue consisted of palygorskite and indigo.[79] Further, Van Olphen had shown experimentally that it was possible to create a Maya Blue–like pigment in the laboratory using palygorskite and indigo.[80]

The Littmann preoccupation with the "blue montmorillonite hypothesis" was unfortunate and distracted research away from previously published analyses that had already established that Maya Blue was a combination of indigo and palygorskite (sometimes with sepiolite). It was true, however, that blue and blue/green clays did occur in Yucatán. Gettens noted that well-diggers in Yucatán had found a blue clay 20 meters below the surface about 1957, but it lost its color after drying.[81] Clay mineralogist B. F. Bohor and I also found a green clay in Yucatán in 1968 when we were looking for sources of palygorskite and other clays there. Doing a reconnaissance around the clay mine at Hacienda Yo' K'at near Ticul, we came upon a pile of back dirt from a recently excavated well that was covered with a substantial amount of green clay. Even though the clay did not have the color of what we thought at the time was Maya Blue, we now know that some Maya Blue is greenish. We collected a sample of the clay, but like the blue clay that Gettens described, its

color lightened considerably when it dried. Bohor's X-ray diffraction analysis revealed that it was montmorillonite (smectite). It was not palygorskite and was not Maya Blue.

I suppose that I could have written a critique challenging Littmann's methodology, adding the data and observations that Bohor and I made in Yucatán and submitting a short article for the comments section of *American Antiquity*. But the editor of *American Antiquity* had already discounted my review of Littmann's article, and it seemed unlikely that he would publish my comment even with peer-review. Further, I was teaching three courses per quarter and had a three-year-old and a wife pregnant with our second child. I was also invested in working on a manuscript that eventually became *Ceramic Theory and Cultural Process*. I recognized that my book project merited more effort and would provide a more positive contribution to archaeology than a critique of Littmann's paper that would be destined for rejection or eventual obscurity.

I also thought about authoring subsequent articles about attapulgite/palygorskite in *American Antiquity*. I was, however, also engaged in drafting a paper for the 1980 Society for American Archaeology meetings on the relationship between the social organization of a Peruvian community and the structure and symmetry of the design on the pottery made there.[82] My instinct proved to be prescient. Both *Ceramic Theory and Cultural Process* and my design paper proved to be far more important with greater longevity than I ever dreamed possible than my comments about Maya Blue would have been at the time.

Unfortunately, Littmann's 1980 article was the "last word" on Maya Blue research for years. Because his work had appeared in a respected archaeological journal, the blue montmorillonite hypothesis was perpetuated as an alternative to the palygorskite-indigo hypothesis for many years in the leading and most authoritative book on ceramic technology for archaeologists.[83]

Nevertheless, Littmann published another article in *American Antiquity* in 1982 about alternate syntheses of indigo and palygorskite providing important options for how the Maya might have produced the pigment, a topic followed up six years later by Luis Torres and later by Reyes-Valerio. More recently, chemists have proposed a variety of preparation techniques as well as one discovered from the analysis of an incense-filled bowl found in the collection of the Field Museum in Chicago (see chapter 9).[84]

Sometimes failed hypotheses can contribute to understanding a problem heretofore unknown. Littmann's original failed hypothesis is a case in point. Subsequent research has revealed that montmorillonite (smectite) occurs in some Maya Blue samples and that palygorskite alters to smectite and thus can

occur naturally with palygorskite.[85] When palygorskite with naturally occurring smectite was used make Maya Blue, the smectite probably served as a binder for the pigment, a critical characteristic necessary for its coherence and its adherence to objects painted with it (see chapter 3).

Littmann's hypothesis that Maya Blue was a blue montmorillonite proved to be erroneous, but it did show that montmorillonite could be one of the minerals found in Maya Blue. It was not responsible, however, for its color. Since that time, continuing technical work on Maya Blue has affirmed the crucial role of palygorskite in the unique qualities of this unusual pigment, indicating that they were a consequence of the unique chemical bonding between palygorskite and indigo, its precursors, and other indigo-like molecules (indigoids).[86] In actuality, however, this conclusion is much more nuanced and will be discussed in a later chapter (see chapter 10).

More recently, research on Maya Blue has focused on several interrelated themes, and several authors have provided lengthy summaries of the Maya Blue research from a chemical and molecular perspective.[87] One of these themes focused on the structure of palygorskite itself.[88] Palygorskite is a fibrous mineral with long parallel channels—rather than sheets like most clay minerals—and this characteristic, along with that of sepiolite, is critical for its chemical bonding to the indigo to create Maya Blue's striking color, its unusual chemical stability, and it persistence through time without fading.[89]

Consequently, some chemists have focused on the nature of the bonding between the palygorskite and indigo using synthetic mixtures to ascertain the nature of the chemical bonding that gives the pigment its great stability in acids and alkalines, the persistence of its color over time, and the conditions that create this bond. Most recently, surveys of the literature indicate that different bonding scenarios exist depending on the preparation technique used, the precursors of indigo found in the various species of *Indigofera*, and perhaps their regional and seasonal variation (chapter 10).[90]

Critical to the appeal and allure of Maya Blue is its uniqueness. The next chapter explores those characteristics in more depth and detail.

3

Why Is Maya Blue Unique? In March of 2008, I returned to my office from a trip to London where I had presented a paper at a conference at the British Museum. I had just published an article about Maya Blue with my colleagues at the Field Museum in the British archaeological journal *Antiquity*, and it had received a great deal of attention from the press. The day before, a full-page article about our work appeared in the *Chicago Tribune*, in which I (and Gary Feinman) explained our collaborative research in an interview with the *Tribune* reporter (see chapter 9).[1]

When I picked up my phone, the staccato of the dial tone told me that I had a voice mail message. I pushed the appropriate button to listen to the message, and an unidentified older male voice proceeded to criticize our work, saying that our discovery of a technique of making Maya Blue was unimportant. It was unremarkable, he said, because the Egyptians had developed a blue pigment ("Egyptian Blue") many millennia previously and the process of its creation was already known. Maya Blue was not unique or unusual, he claimed.

The message was abusive and derogatory, and fortunately I did not have to deal with the caller directly. He did not leave a name or a number; he just wanted to abuse me and disparage my work and the collaborative work with my colleagues.

https://doi.org/10.5876/9781646426683.c003

IS MAYA BLUE REALLY UNIQUE?

Ironically, it was clear that the caller had not read the article in the *Chicago Tribune*, nor did he know anything about Egyptian Blue or about how it was different from Maya Blue. Nevertheless, the call prompted me to consider the other blue pigments in antiquity, how they differed from Maya Blue, and it raised a significant question in my mind. Is Maya Blue unique among ancient pigments? If so, why?

Unlike most pigments, Maya Blue is a clay-organic complex in which indigo is chemically bound to the clay mineral palygorskite. Maya Blue is not really a dye, and indigo does not really dye the palygorskite. Rather, the link between indigo and palygorskite is more complicated (see chapter 10). Unlike indigo, Maya Blue does not impart its color to cloth, but in Maya Blue the indigo combines chemically with the palygorskite at the molecular level to form a unique stable pigment.[2] Unlike Maya Blue, indigo (and the color of the cloth dyed with it) fades over time and is destroyed by a variety of chemicals (e.g., acid). As noted in chapter 2, Maya Blue, on the other hand, is resistant to the effect of weak acids, alkalis, and other reagents, retains the richness of its color for centuries in the harsh tropical climate of southern Mesoamerica, and only loses its color with heat above 325°C–350°C.[3] Because the preparation of Maya Blue produces structural modifications when the indigo molecule combines with the palygorskite structure, ultraviolet-visible (UV-vis) spectroscopy, Raman spectroscopy, and Fourier transform infrared spectroscopy (FT-IR) can distinguish it from indigo.[4]

Besides combining with indigo, its precursors, and its derivatives to create Maya Blue, palygorskite, like sepiolite, combines uniquely with certain kinds of other molecules (see chapter 10). This uniqueness is related to the channel-like structures of these minerals in which various kinds of colorants (e.g., methyl violet) bind to the channels to create stable materials.[5] That the ancient Maya discovered this quality by using palygorskite (and sepiolite) and indigo (and similar molecules called indigoids) has led some chemists and materials scientists to refer to the practice of creating Maya Blue as "Maya nanotechnology."[6]

A second unique aspect of Maya Blue that separates it from many other pigments is its physical lack of self-coherence. It does not stick together or adhere well to an object without a binder. The principal explanation for this characteristic is its unusual structure. During the creation of Maya Blue, indigo and its precursors bind to the channels (and/or the exterior grooves of the broken channels) of palygorskite (see chapter 10), and the resulting pigment still retains its needlelike structure. Unlike other clay minerals, this structure results

in a friable material that archaeologists call a "fugitive pigment": it is easily washed off an object. Therefore, Maya Blue, in its purest form, needs some binder to hold it together and adhere to the material to which it is applied.

To understand the fugitive character of Maya Blue, it is necessary to emphasize that the needlelike structure of palygorskite still persists after the pigment is created. If one sees its shape as a blade of grass, its fugitive character becomes clearer. When wet, grass clippings might stick together for a while, but to coat a wall or object, they need a binder like clay to hold the blades together to stick to the surfaces to which it is applied. Similarly, without a binder, Maya Blue does not cohere well or adhere to objects of pottery, stone, or plaster.

This characteristic helps explain why there is a thick layer of blue silt at the bottom of the Sacred Cenote at Chichén Itzá. Without some kind of binder to make Maya Blue adhere to an object, the friction of hitting the water from a position 20–26 meters above and then sinking to the bottom of the cenote removes at least some of the pigment from it. Even though some of the Maya Blue washed off the objects thrown into the cenote, some still retained the pigment. Why? This adherence suggests that at least some of the Maya Blue painted on the objects thrown into the cenote included a binder.

The most likely binder for Maya Blue is smectite, a clay mineral with a different crystal structure than palygorskite. Smectite forms in layers with water between the clay sheets that swell or shrink depending on temperature and humidity. When dry, this characteristic results in a hard surface.

Smectite is often found mixed with palygorskite in the geological deposits in Yucatán. In the samples that Bohor and I collected in Yucatán, for example, Bohor found that smectite occurs naturally with palygorskite in some contexts (e.g., at Yo' Sah Kab near Ticul).[7] Other investigators also found that smectite occurs with palygorskite elsewhere on the Yucatán Peninsula and suggested that palygorskite alters to smectite naturally in post-depositional weathering.[8]

The smectite that naturally occurs with the palygorskite thus would function as a binder for Maya Blue and causes it to cohere. So when Maya Blue was made with palygorskite that included smectite, the pigment would adhere to the object being painted much better than Maya Blue without the smectite. Smectite thus helps the pigment to cohere and adhere to pottery, murals, floors, and the surface of other materials such as sculpture. Indeed, samples of Maya Blue from the island of Jaina off the coast of Campeche included some smectite.[9]

That at least some Maya Blue contained smectite is affirmed by Littmann's failed hypothesis that Maya Blue was a blue montmorillonite (smectite). Even though angles of X-ray diffraction analyses failed to distinguish the

FIGURE 3.1. *Two successive floors with different shades of Maya Blue in one of the two temple structures at Mayapán, 2008. (Reprinted from Dean E. Arnold, "Maya Blue,"* in Encyclopaedia of the History of Science, Technology, and Medicine in Non-Western Cultures, *ed. Helaine Selin, 2866–2870 [Dordrecht: Springer, 2015]; courtesy of Springer Nature.)*

palygorskite peaks from those of smectite, in retrospect, his research indicated that smectite occurred naturally in the palygorskite used to make Maya Blue.

A second feasible option for a binder is copal. Burning copal was one way of creating Maya Blue (see chapter 9); then any copal remaining could serve as a binder for the pigment to cohere and allow the pigment to adhere to pottery and other media to which it was applied. Copal was used as a binder elsewhere in ancient Mexico to secure turquoise and other minerals in mosaics. It is not likely to be an effective binder for Maya Blue, however, because copal must be heated to mix with the pigment to apply it to pottery, sculptures, or murals, although this issue is a question for future research. Consequently, one might expect to find naturally occurring smectite as a binder in Maya Blue but would not expect to find copal used in this way.

The ancient Maya also probably used lime as a binder for the pigment. In Yucatán in the late 1960s traditional Maya masons used quicklime (CaO) as a binder to make mortar and plaster by mixing it with natural marl. Natural marl also contains some smectite. So with its case-hardening properties,

smectite also contributed to being a binder for mortars, plasters, and for surfacing floors.[10]

Quicklime and marl probably also served as binders for the Maya Blue present on the floors in two of the temple structures at Mayapán (figure 3.1). These floors each have hardened surfaces of Maya Blue, consisting perhaps of a mixture of Maya Blue and slaked lime and marl as binders, placed over a layer of plaster without the pigment.

Because the natural occurrence of smectite with palygorskite does explain why *some* Maya Blue has adhesive and cohesive qualities, discovering whether the binder was natural or added to the pigment is another question, and each Maya Blue sample must be analyzed uniquely to ascertain if there is a binder and, if so, what kind of binder it is.

The inability of Maya Blue to adhere to objects without a binder creates practical challenges for its modern use in painting. Several years ago an artist in Oregon contacted me with a question about Maya Blue. He had read about the pigment and created it using indigo and palygorskite that he had purchased from commercial sources. Unfortunately, he could not get the pigment to stick to anything, and he asked me about the problem. I replied that even the ancient Maya needed a binder for the pigment and that they probably used copal and/or smectite. Since then, however, I have doubted that copal was used in this way for reasons cited above.

To seek a solution to this problem, I contacted my daughter, who is an artist, and asked her about the problem. It turned out that artists may also need binders for their pigments. Would she allow me to send her email address to the artist in Oregon? She agreed, they corresponded and copied me, and she suggested an appropriate binder for the pigment. Shortly thereafter, the Oregon artist emailed me a picture of a piece of posterboard that he had painted with Maya Blue. Then, some months later, he sent another image of how he used the pigment; he created a large amount of it, added the binder that my daughter suggested, and used it to paint his bathroom.

Among its other unusual characteristics, Maya Blue is a post-firing pigment for pottery; it must be applied to pottery after firing because its color disappears at temperatures exceeding 300°C–350°C. Early in the search for its composition, this characteristic provided the first clue that Maya Blue was not a mineral pigment but had an organic, non-mineral component.[11] Being a post-firing paint for pottery, however, does not limit its use on other media such as sculpture, murals, or codices.

Maya Blue is not a slip. A slip is usually applied to change the color of the pot, and it covers the entire vessel. A slip may also serve to limit permeability

of the vessel walls so that liquids cannot seep through the pores in the clay fabric, even though the potter, or the consumer, may not recognize the importance of this feature.[12] By way of contrast, Maya Blue is fugitive and easily washed off a vessel because of the crystal structure of the palygorskite. A vessel covered with Maya Blue thus is not a barrier to prevent the seeping of liquids through a vessel wall. This physical property is one reason Maya Blue does not occur as a slip on ancient vessels used for utilitarian purposes such as carrying and storing water, but rather adorned ritual and religious vessels as a paint. Further, Maya Blue may be placed over the slip. On the tripod grater bowls excavated from the Osario at Chichén Itzá (figures 9.1, 9.3–9.5), for example, Maya Blue appears over a red slip on some of their interior walls and on some of the exterior walls. It also appears on basal flanges and lips on Cabrito Cream–Polychrome pottery at Buenavista de Cayo, Belize.[13] For this usage, Maya Blue would not function as a slip to limit permeability but rather as a paint for decoration and perhaps as a symbol of deity or elites. The postfiring characteristic of Maya Blue and its use on sculpture, murals, and codices indicate that those who created and used the pigment did not need to be potters but could be another kind of specialist. Indeed, my ethnographic research among potters in Ticul who paint classic Maya designs on tourist pottery indicates that the skills of making a pot and painting a design on it are vastly different. Painters are not potters, and larger workshops in Ticul include both potters and painters.[14] Smaller workshops contract with household potters to provide them with "blank" vessels for painting.

OTHER BLUE/GREEN PIGMENTS

In addition to the unique characteristics just described, Maya Blue is also unique among ancient blue pigments used on paintings, pottery, and artifacts from Europe, Asia, and the Americas. In ancient Greece, for example, craftsmen created blue and green pigments from minerals such as azurite, lapis lazuli, and malachite from the Bronze Age through the Archaic and Classical periods.[15] By way of contrast, Maya Blue is not derived from any of those naturally blue (or green) minerals or from synthetic, human-created blue colors such as Egyptian Blue, Han Blue, and Seri Blue. Rather than a naturally occurring substance, Maya Blue is a human-created clay-organic complex in which indigo is chemically bound to the clay mineral palygorskite.[16]

A worldwide survey of blue and blue-like pigments is beyond the scope of this chapter, but a brief review of some of them from Mesoamerica and from other parts of the world reveals their differences from the properties

and composition of Maya Blue. Some green pigments are included because some varieties of Maya Blue grade into green because of limonite (yellow) or hematite (red) in the raw palygorskite, or because they contain a different indigo-like component that is not blue, such as the yellow dehydroindigo (see chapter 10). Further, the ancient Maya, like the modern Maya, made no distinction between blue and green in their language, as explained in chapter 2. But it is unclear whether they deliberately manipulated and then selected the different shades in creating Maya Blue or whether the variation was natural and unintended because of the raw material or the techniques used to create it (see chapter 10).

Natural blue colors are rare in the natural world. The accidental synthesis of a new blue color called "YInMn Blue" stimulated science writer Kai Kupferschmidt to ponder the incidence of the color "blue" in nature.[17] Blue colors are rare in nature because their complex chemical compositions are difficult to synthesize. Most synthetic pigments, he says, are the result of accidental discoveries or synthetic versions of natural blues. Their use among cultures of the world date back millennia.[18] Kupferschmidt, however, did not mention Maya Blue, Han Blue, Seri Blue, or the verdigris group of pigments, but he did show the unusual nature and rarity of blue pigments (in minerals, plants, and food dyes) in nature.

To understand the unusual nature of Maya Blue, it is useful to review some of the blue/green pigments both found in nature and those that are artificial and made by humans.

NATURAL BLUE/GREEN MINERALS

Some blue/green minerals were used as pigments; others (e.g., jade and turquoise) were not. But all overlapped with the colors of Maya Blue.

Chrysocolla

Chrysocolla is a hydrated copper phyllosilicate mineral with variable composition ranging from blue, blue-green, or green and is often found in association with malachite and azurite in nature (see below). Chrysocolla has been found with azurite and malachite in some pigments used on polychrome vessels from Teotihuacán in central Mexico (figure 3.2).[19]

Malachite

Malachite is a hydrated copper carbonate that varies in color from light to dark green.[20] Often used as a gemstone, it can also be a pigment. A combination

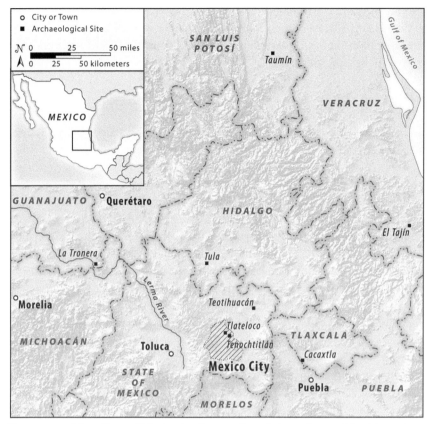

Figure 3.2. *Map of central Mexico showing state boundaries and some of the cities and archaeological sites mentioned in the text. (Map by Chelsea M. Feeney, www.cmcfeeney.com.)*

of malachite and chrysocolla was used as a pigment in Mesoamerica, and it accounts for the green color on Teotihuacán stucco vessels and on the murals at Xalla in Teotihuacán during the Classic period (AD 150–750) in central Mexico.[21]

Azurite

Azurite, like malachite, is also a copper carbonate that is a deep blue and is often found with malachite in oxidized zones of copper deposits. Like malachite, it can be a semiprecious stone and was also employed as a pigment for paintings in China and western Europe during the Middle Ages and the Renaissance. Azurite and a glass that is colored blue with cobalt oxide were

used on the ceiling paintings (AD 1707) in the Sant Joan del Mercat church in Valencia, Spain. Azurite and some chrysocolla were also used as the blue-green pigment on Teotihuacán stucco vessels from the Classic period (AD 150–750) in central Mexico.[22]

Lazurite

Lazurite, better known as the gem lapis lazuli, is a sodium calcium aluminum silicate with sulfur. Its most prized forms are crystals that come from Afghanistan and from deposits in nearby Tajikistan and Pakistan. Still other deposits, usually in a massive (rather than crystal) form, occur in Russia, Canada, Argentina, and Chile, with some in the United States.[23]

The earliest use of lapis lazuli occurred in western Pakistan about 7000 BC with its use extending to Egypt by at least 1600 BC. As a pigment, however, ground lapis was not used until much later in the fourth century AD when it was combined with a binder to decorate walls in the central Asian caves devoted to Buddhist rituals. Later used in glazes, paints, enamels, and ink, ground lapis continued to be used up into the medieval period. One variety of ground lapis is ultramarine blue, a pigment created by crushing and grinding lapis lazuli, but successively enriched with lazurite via a flotation process.[24]

Turquoise

Turquoise is hydrous basic copper aluminum phosphate and is found principally in the states of Nevada, Arizona, Utah, and New Mexico in the United States.[25] Traded into Mesoamerica, this mineral was used in Aztec mosaics,[26] such as ear coverings in a burial in the Templo Mayor in the Aztec capital Tenochtitlán in central Mexico. Many pieces of turquoise are also embedded in the mosaic "The Disk of Chichén Itzá" from the throne seat of the Chac Mool at Chichén Itzá, currently in the collection of the Quai Branly Museum, Paris.[27]

Jade

Jade was not used as a pigment, but it is a common name for two green minerals, jadeite and nephrite. Of these, only jadeite was used in Mesoamerica and was an important object for the ancient Maya. A pyroxene mineral, its only definitive source in Mesoamerica lies in the mountains on the north side of the Motagua Valley of Guatemala along the Motagua Fault, which forms the junction between the North American and Caribbean tectonic plates.[28]

The ancient Maya threw many items of jadeite into the Sacred Cenote at Chichén Itzá, including beads, ear flares, effigy ornaments, a globe, masks, nose buttons, pendants, a pebble head, plaques, rosettes, and spangle disks.[29]

Beads or fragments of jade were also embedded in some of the copal offerings in the bowls recovered from the cenote.[30]

OTHER BLUE/GREEN MINERALS

Besides the minerals above, other minerals were used for blue, blue green, and green pigments in Mesoamerica as well. In Guatemala paintings using blue and green minerals occur on the 500 meters of paintings along the rear wall of a shallow rock shelter called La Casa de Las Golondrinas ("The House of the Sparrows") at the southern end of the Antigua Valley (figure 2.1). Consisting of 225 painted figures, the site is the "single largest painted rock art site registered in highland Guatemala."[31] Iconographic analysis of the paintings indicate a Late Postclassic date. The blues and greens in the paintings include the following minerals:

1. Spangolite contains a copper ion and may be blue, blue-green, green, or dark green. One source of the mineral is the Sapper Fumerole, Santiaguito Dome in Guatemala.
2. Languite also is a copper mineral that occurs in blue, greenish-blue, sky blue and bluish-green shades. This mineral is found in the Pacific Coastal waters in Guatemala.
3. Volkonskoite is a brilliant green mineral that contains a chromium ion, but no copper. The Tajumulco Volcano in western Guatemala is one source of the mineral.[32]

There are other possible blue/green minerals that could be used as a blue/green pigment, such as sodalite, but they do not appear to have been used in Mesoamerica. Nevertheless, of all the natural blue and green pigments potentially available to make Maya Blue, only azurite and malachite appear to be the most available to the ancient Maya but were only employed as pigments on Teotihuacán pottery during the Classic period. Other minerals, such as jade, turquoise, green obsidian, and other blue/green minerals, were used as beads and/or in mosaics rather than pigments.[33]

ARTIFICIAL AND SYNTHETIC PIGMENTS

A second group of blue/green pigments are diverse, artificial, and, like Maya Blue, were created by artisans. These include Egyptian Blue, Han Blue, Seri Blue, and the verdigis group of pigments, among others. Berke has written an extensive review of these and other blue pigments.[34]

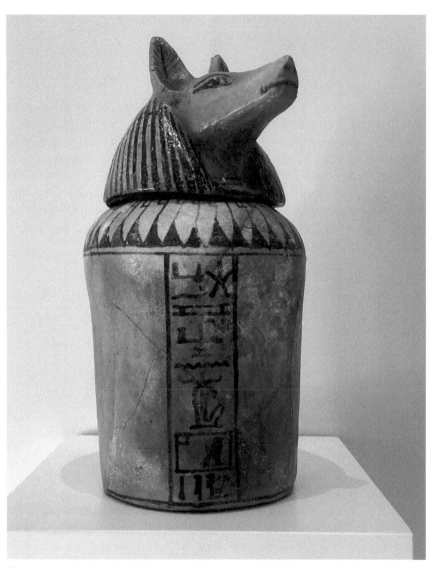

FIGURE 3.3. *Jar glazed with Egyptian Blue, ca. 1275 BCE, Nineteenth Dynasty of Egypt. As shown here, the texture and luster of Egyptian Blue differs greatly from that of Maya Blue. (Canopic Jar, no. E14227A, https://www.penn.museum/collections/object/251158, courtesy of the Penn Museum.)*

Egyptian Blue

Egyptian Blue is a blue variety of a material called faience, a ceramic glaze originally created in Mesopotamia; it then spread east to the Indus Valley and west across the Middle East to Egypt, where it took on a blue color because of the presence of copper ions in the glaze (figure 3.3).

Consisting of calcium copper tetrasilicate, Egyptian Blue is an inorganic glaze formed at high temperatures; it appears to have been made by heating a mixture of quartz, lime, a copper compound (such as copper oxide or malachite), and an alkali flux in the range of 850°C–1000°C. Some regional variability in composition exists, indicating that Egyptian Blue was produced in a variety of locations. Although artificial and not natural, Egyptian Blue was found to correspond to the copper mineral cuprorivaite.[35]

Egyptian Blue was the first artificial pigment developed in antiquity and one of the first to be examined by modern scientific methods. It was used first on grave goods and then in the decoration of tombs, wall paintings, furnishings, sculptures, cylinder seals, and beads during the third millennium BC.[36]

As a pigment, blue was the most prestigious color in ancient Egypt and was believed to represent water, fertility, and good luck. Since no deposits of lapis lazuli have been found or recorded in Egypt, it is believed that the production of Egyptian Blue was an attempt to imitate the color of the highly valued lapis lazuli because Egyptian Blue was more available.[37]

After its initial use in Egypt, Egyptian Blue spread throughout the Near East and eastern Mediterranean and occurs on wall paintings and small objects. Its use continued for centuries: at Hasanlu in Iran from 1200 to 900 BC, later at the Persian sites of Persepolis and Ziwiyh, and still later in Turkmenistan during the fourth century BC. During the time of the Romans, it occurred in the city of Pompeii, on the murals at the site of Caulk in Spain, and in eastern Anatolia, among other locations, to the limits of the Roman Empire. Its use continued up into the seventeenth century.[38]

In comparison with Maya Blue, Egyptian Blue was created only from inorganic materials whereas Maya Blue consists of both organic and inorganic components. Egyptian Blue is, of course, much older than Maya Blue, but its composition and antiquity are irrelevant to Maya Blue. All that they share is that they are artificial blue pigments created in antiquity and were highly valued, but they consist of vastly dissimilar materials and are made differently, applied differently, and differ in their composition.

Nevertheless, the widespread adoption of Maya Blue in Mesoamerica may parallel that of Egyptian Blue in the ancient Middle East where Egyptian Blue was likely an attempt to imitate the color of the scarce mineral lapis lazuli,

which was unavailable and difficult to import.[39] Similarly, Maya Blue may be an attempt to imitate the blue color of azurite and malachite in Mesoamerica because of the association of the color with water, rain, and fertility and because it could be created from substances (palygorskite and indigo) that were more abundant than azurite and malachite.

Han Blue (and Han Purple)

Han Blue, along with a related color, Han Purple, was produced in ancient China and used extensively for decorating pottery, metallic objects, and wall paintings, particularly during the Han Dynasty (208 BC–AD 220).[40] Han Blue and Han Purple, like Egyptian Blue, are human-created inorganic pigments, but they also occur in nature. Han Blue ($BaCuSi_4O_{10}$) has a chemical formula like Egyptian Blue except that barium in Han Blue substitutes for calcium in Egyptian Blue. Han Purple, on the other hand, is less rich in silica than Han Blue and has a different crystal structure.

Seri Blue

Seri Blue, another indigenous blue color from Mexico, consists of both an organic and inorganic component just like Maya Blue. Named for the Seri Indians that live along the coast of the Gulf of California in the State of Sonora in northern Mexico, the Seri created the pigment by grinding a clay together with the resin of the plant *Guaiacum coulteri* in the presence of water.[41]

The clay that the Seri used to make their pigment was an expandable, random mixed-layer clay such as montmorillonite (smectite). X-ray diffraction analyses show that the basal spacing of the raw clay differed from that of the synthesized pigment, indicating that the plant resin is chemically bound to it. Drying does not affect its color, but unlike Maya Blue, its color is destroyed by concentrated nitric acid. Experimental work with the technique of making the pigment has shown that it is possible to create varying shades of blue from a variety of clay minerals, including palygorskite (attapulgite),[42] but like Seri Blue itself, these shades are different from the colors of Maya Blue.

The Verdigris Group of Pigments

Pigments in the verdigris group are pale blue or turquoise and were used during the late medieval and Renaissance periods. They are based on copper acetate made by exposing copper sheets to stale wine or sour vinegar. A variety of recipes can create both blue and green colors, but most recipes produce salts such as copper acetates that are light blue in color. These acetates can also be recrystallized from vinegar solutions to form copper acetate dihydrate, which

is green. This latter method was preferred for oil painting because it was less susceptible to undesirable reactions and color changes that occur by using other copper salts.[43]

Applying These Pigments

Many of these pigments, particularly mineral pigments such as malachite, azurite, and lazurite, require grinding and a binder to hold the particles together and adhere to the painted surface. Seri Blue must also be ground, but since it appears to contain smectite, it would appear to adhere to objects without a binder. Egg has been used for a binder for verdigris green on ancient paper.[44] Similarly, other pigments, such as Egyptian Blue, Han Blue, and Han Purple, must be ground and may be applied with a binder, but they are also glazes, a kind of glass that is a highly viscous, non-crystalline coating fused to the surface of an object at high temperatures (about 900°C–1000°C). Glazes are placed on vessels after the first firing (called the bisque firing), and then the vessels are fired again.[45] Unlike Maya Blue, which may be added at any time after a vessel is fired, glazes must be applied by the potter before a second firing.

Other blue and green pigments are colored glazes formed by the addition of metal ions to their raw materials, such as copper (blue or green), cobalt (blue), or chromium (green), but their intended color also depends upon the firing atmosphere because glazes are glass and require high heat to adhere to a vessel. The amount of heat, however, to melt the glaze and allow it to adhere to a vessel destroys Maya Blue. Although Maya Blue is added to pottery after firing, it is not a glaze but is fugitive because of its structure. Its texture and luster are not like glazes such as Egyptian Blue.

In summary, Maya Blue is unique among the pigments of the world because it consists of both organic and inorganic components that result from the binding of indigo, its precursors, and derivatives to the molecular structure of palygorskite. Its composition, structure, and physical properties differ from other blue and green pigments.

The next strand in the mystery of Maya Blue involves the discovery that the contemporary Maya are aware of the properties of one its constituents, palygorskite, and use it for pottery temper and as a medicine.

4

Palygorskite and Maya Indigenous Knowledge

Solving the mystery of Maya Blue involves following several different strands of research. The discovery of the actual composition of the pigment as an indigo-palygorskite chemically bound complex, discussed in chapter 2, was one of these strands. Another strand was the discovery that palygorskite was part of the Indigenous knowledge of the contemporary Maya.

WHAT IS THAT STRANGE ROCK?

As I stated in the introduction to this work, curiosity is one of the fundamental attributes that drive scientific discovery. If one does not possess curiosity, then there are no discoveries, no frontiers to cross, and no scientific understanding. Curiosity cannot be contrived, and getting to the point of being curious cannot be scripted. It is a character trait fueling the challenging work of study and observation that results in discoveries arising out of ordinary circumstances or out of behaviors that seem strange. Curiosity drives the search for answers to the question "Why does this happen?"

My interest in Maya Blue was predicated upon my discovery that one of its fundamental components, palygorskite, was part of the Indigenous knowledge of the contemporary Maya. This discovery goes back to one improbable, serendipitous event in 1965: my curiosity about a simple set of strange behaviors of my Maya informant. This curiosity, however, did not come out of nowhere but was a consequence of learning a

44

https://doi.org/10.5876/9781646426683.c004

monolingual eliciting technique in graduate school that, in turn, provided the foundation of my learning basic Yucatec Maya in the field.

I entered the University of Illinois as a graduate student in the Department of Linguistics in 1964, but I really wanted to study anthropology. My advisor, Dr. Robert B. Lees, suggested that I enroll in a course called Ethnographic Methods taught by Dr. Duane Metzger, one of the early practitioners of cognitive anthropology. Metzger had brought two Mexican informants to Urbana to work with graduate students. One of them, Alfredo Tzum, was a Maya potter from Ticul, Yucatán. Because Metzger wanted him to make pottery and produce a movie about the process,[1] he also brought clay, temper, and pottery-making equipment from Alfredo's household workshop so that he could make pottery at the university. Two other professors participated in the project. One, Dr. Donald W. Lathrap, a South American archaeologist, required his seminar class to observe the potter, learn about the pottery-making process, and then compare their observations with the sherds that Metzger had brought from Alfredo's kiln in Ticul. Another faculty member, Dr. Arthur H. Rohn, was engaged to curate the raw materials, the production equipment, and the potter's finished products and then to develop a teaching museum.

Later in the fall semester, the amount of clay that Metzger brought from Ticul was running out. So Metzger and Lathrap asked the Illinois Geological Survey to find a clay that had properties like the soon-to-be-exhausted Yucatán clay. Based on their knowledge of the geology of Illinois, they found such a deposit and were able to replenish the potter's supply.

Metzger also brought the Mexican informants to Urbana so that graduate students could master his monolingual eliciting technique (called "ethnoscience" at that time) and use it to learn about a culture without using a common language (Spanish in this case).[2] During the first session of Metzger's course, he promised that those who received an A in the course would go with him to Mexico and do research.

Metzger's claim that someone could use his monolingual eliciting technique to learn about the cultures of these informants without a knowledge of Spanish seemed naive and outrageous to me. Nevertheless, I knew that I could manage the transcription and analysis of an unwritten language because I had studied linguistics and had some experience in two other independent studies that required me to transcribe and analyze a spoken language unknown to me. One involved working with a Malayalam informant from India that was concurrent with Metzger's independent study, and the other was an independent study with a Japanese informant at the University of North Dakota more than a year earlier. The other informant that Metzger brought from Mexico

was a Tzeltal-speaking man from Chiapas named Alonzo Mendez. Metzger assigned me to work with him.

I applied Metzger's technique in working with Alonzo with remarkable success, and I elicited a folk taxonomy of Tzeltal pottery. Consequently, I discovered the stylistic differences that Alonzo recognized between vessel shapes made in different communities of potters (now called "communities of practice") in Chiapas, even though he knew no English, and I knew no Spanish. I received an A in Metzger's course, and as promised, he took me (and another graduate student) to Ticul to do fieldwork. I proposed to do thesis research there like my work with Alonzo in Tzeltal.

We arrived in Ticul in February of 1965 in the middle of the dry season. Metzger suggested that I work on pottery firing with Alfredo Tzum, whom Metzger brought with us from Urbana. I followed his suggestion, but Metzger's guidance ended there. He left my student colleagues and me on our own, returning only to pay our informants and our rent. Nevertheless, I began using the ethnoscience technique that I had learned in Urbana with a little knowledge of Spanish, and I eventually learned enough Yucatec Maya to understand much about how the Maya potter understood and organized his craft in his own language.[3]

As time progressed, the lack of rain created increased dust that became increasingly annoying. The wind whipped up swirls of it from the streets that drifted into my eyes and mouth and through the cracks in the windows and doors of our house. When our footprints became visible in the dust on the floor, we hired a man with a horse-drawn water tank to wash it down with buckets of water. We were looking forward to the rainy season to quell the incessant coating of dust in our house and possessions. The rain, however, would not begin for several more months. In retrospect, it was not hard to imagine the frustration of the ancient Maya and their appeals to Chaak, the rain god, for relief from persistent drought, even though the lack of rainfall in this case was seasonal.

So for much of the dry season, I worked with Alfredo, eliciting the Maya vocabulary and semantic structure of the firing process. I eagerly anticipated the beginning of the rainy season to quell the daily renewal of dust—all to no avail. The weeks passed, but one day in late May the sky clouded up in the afternoon and brought rain. As the first drops hit the thatched roof of Alfredo's house, he rushed outside and covered a pile of white rocks—at least, that is what I thought they were (figure 4.1).

This behavior seemed very strange. Why protect a pile of white rocks from rain? These rocks were very unusual because even though they were extremely hard, they were exceptionally light in weight.

FIGURE 4.1. *Pieces of rocklike* sak lu'um *collected from the temper mines near Ticul. The miner, Elio Uc (*right*) will soak them, then crush and dry the result to sell to potters to supplement inferior temper. These chunks were removed from bottom of the palygorskite stratum at Yo' Sah Kab. (From Dean E. Arnold,* Maya Potters' Indigenous Knowledge: Cognition, Engagement, and Practice *[Boulder: University Press of Colorado, 2018], 89; used with permission.)*

Several days later the daily rains of the wet season began with a full-blown tropical downpour. Being distracted because of his work with me, Alfredo forgot to cover the white rocks outside. When we went outside after the rain, only an amorphous mass of white mud remained where the white rocks had been before (figure 4.2).

I was astonished, and wondered: What was this strange rock-like material that was white, hard, and became mud when it was wet?

Alfredo called this material *sak lu'um*, literally "white earth" in Yucatec Maya. By that time, I had already discovered that *sak lu'um* was a critical ingredient of the temper that potters used to mix with clay to make, dry, and fire their pottery successfully. If they prepared their temper with an insufficient amount of it, their vessels would crack and break. Consequently, potters always kept some on hand to add to their clay if they perceived that their temper lacked it (figure 4.3).[4] So I collected a large sample of the white "rocks" of *sak lu'um*

FIGURE 4.2. *The effect of rainfall on* sak lu'um, *removed from the temper mines at the beginning of the rainy season in May 2008. When miners removed these pieces, they were too large and too hard to be broken up. So they were left in the tailings to be weathered, as shown here. Sometime in the future, when the pieces are smaller, they will be used to prepare temper. With continued rainfall, these rocklike chunks will become white mud.*

and other pottery raw materials and brought them back to the University of Illinois for analysis.

After returning to Urbana in the fall, I learned that Metzger had left the university for a new position at the University of California at Irvine, and archaeologist Dr. Donald W. Lathrap became my advisor. I had collected a mass of data about the Indigenous knowledge of pottery firing in Ticul and was going write my master's thesis on the subject. I met with Professor Lathrap as I began analyzing my data and drafting my thesis about the potter's Indigenous knowledge of pottery firing. When I told him about my experiences, and my samples of the white rocklike material, he sent me to the Illinois Geological Survey to talk with clay mineralogist Dr. W. A. White.

White was preoccupied with other projects at the time and took me to see Dr. B. F. Bohor, another clay mineralogist at the Geological Survey. I turned the samples of clays, temper, and white rocks over to Bohor, and one of his graduate students analyzed them using X-ray diffraction.

FIGURE 4.3. *Pieces of* sak lu'um *stored in a potter's house. They will be ground and added to inferior pottery temper.*

While I waited for the analyses, I continued to work on my thesis, translating my texts from Yucatec Maya in order to describe the Maya Indigenous knowledge of pottery firing.[5] I was about one-third done with my translation and synthesis of the data when I received the results of the X-ray diffraction analyses of my samples. Bohor found that the "rocks" of *sak lu'um* were an unusual and unique clay mineral called attapulgite.

Named after the town of Attapulgus in the State of Georgia, attapulgite is mined nearby for a variety of uses, such as medicines, drilling muds for oil prospecting, and for making carbonless copy paper, among many others. Its large surface area, ability to absorb a range of petroleum-based liquids, and decolorizing power make it an important resource for a variety of chemical processes and consumer products.[6] Attapulgite and a similar clay mineral, sepiolite, have also been proposed as a liner for landfills because of their ability to absorb leachate with toxins such as those with heavy metals.[7] Because attapulgite was first found in the Palygorsk Range in the Ural Mountains in what was then the Soviet Union, it was also called "palygorskite." As a

consequence, in 1971 the Clay Mineral Society decided that the term "palygorskite" should have priority as the preferred name for the mineral and the term "attapulgite" should be a synonym.[8]

The unusual characteristics of palygorskite result from its unique structure. Most clay minerals crystallize in thin sheets in which water is chemically bound in their structure. In some such minerals, physically held water also occurs between these sheets. These characteristics give these clays their plastic qualities, allowing them to be formed into a variety of shapes that can be fixed by driving off all the water—first through drying and then through firing.

Whereas palygorskite is classed as a clay mineral and is plastic, it does not have a sheetlike, platy morphology like other clay minerals. Rather, like a similar clay mineral called sepiolite, palygorskite crystallizes in fibrous or needle-like structures with long parallel channels that contain water molecules that are not bound to its chemical structure.[9] In cross-section this structure looks like a brick wall with every other brick missing. The long channels of the missing "bricks" are the spaces that contain the physically held water.

TOWARD THE STUDY OF MAYA BLUE

I took the analyses of my samples to Professor Lathrap, and he informed me that attapulgite (palygorskite) was one of the constituents of Maya Blue. Since its discovery at the Maya site of Chichén Itzá in 1931, its composition had been a mystery. Highlighting this mystery in two articles published in 1962 in *American Antiquity*, Anna O. Shepard of the Carnegie Institution of Washington and Rutherford Gettens of the Smithsonian Institution reported that attapulgite had been identified in the pigment using X-ray diffraction. At that time, however, attapulgite was the only known component of the pigment, but Shepard suggested in her article that the pigment might be a clay/organic complex, a point that she and coauthor Hans Gottlieb elaborated in a short monograph published that same year.[10]

Up until 1965, there were no published reports showing that palygorskite occurred in the Maya area. Extensive deposits of the mineral were mined in southwestern Georgia and in some of the adjacent parts of Florida,[11] but there was no evidence that it occurred in Yucatán. Although a well-digger had found a blue clay in a deep well in Yucatán, it was not palygorskite. Was the presence of palygorskite in Maya Blue coincidental and unrelated to its blue color? Or was it a critical component of the pigment?

If, indeed, palygorskite *was* a critical part of Maya Blue (it was uncertain at that time), it seemed unbelievable that the contemporary Maya were still using

one of the constituents of this ancient pigment in the mid-twentieth century. Ticul potters believed that "white earth" (*sak lu'um*) was a critical ingredient for preparing their clay to make pottery. But were the potters *aware* of its unique properties and deliberately selecting it for preparing their temper? Was *sak lu'um* simply an earthen material that was "white," or was it uniquely palygorskite? Was the potters' inclusion of "white earth" in pottery temper simply coincidental?

TESTING HYPOTHESES

Unfortunately, I could not establish a link between *sak lu'um* and palygorskite without collecting more data, and I needed to test several hypotheses relating palygorskite and Ticul potters' Indigenous knowledge. I wanted to see if the Maya "white earth" category was indeed palygorskite. If so, did it have a unique cultural significance to Ticul potters? Were they aware of its properties and were they consciously choosing it to include in their temper? Did those properties match the unique properties of palygorskite?

These questions were reformulated into three testable hypotheses: (1) Is the occurrence of *sak lu'um* merely coincidental in the temper, or do the potters and miners know its properties and deliberately include it? (2) Do all the materials that potters say contain *sak lu'um* contain palygorskite? (3) Conversely, do the materials that potters say do not contain *sak lu'um* lack palygorskite? The crucial issue was not merely the presence of palygorskite in materials from Ticul but whether the Maya potters recognized its properties and deliberately selected it to prepare their pottery temper.

To test these hypotheses, I returned to Ticul in January of 1966, funded by a small research grant from the university's anthropology department. Operationalizing them involved two issues. The first consisted of formulating a research design that would test the link between the Maya Indigenous knowledge about *sak lu'um* by assessing whether the presence of palygorskite in pottery temper was just behaviorally and geologically coincidental, or whether potters recognized its unique properties and deliberately included it in their temper. Second, I needed to ascertain whether my proposed relationship between *sak lu'um* and palygorskite was idiosyncratic or was widespread among the potters in Ticul.

These two issues correspond to the two critical dimensions of social science research called validity and reliability. Validity involves measuring what one purports to measure (that *sak lu'um* was palygorskite), and reliability concerns the consistency of a pattern across a population such that another investigator

could repeat the study and obtain the same results.[12] Applying these criteria to my research topic, I wanted to know if all Ticul potters knew about *sak lu'um*, whether they would say that it is an important ingredient in the temper, and whether another investigator could verify that fact by reproducing the same results using the same methodology that I would use.

To test the relationship between *sak lu'um* and palygorskite, I carefully designed a research methodology to collect diverse types of ethnographic data to compare with the mineralogical analyses of the potters' materials that would prove or disprove that relationship. First, my research design focused on collecting raw material samples of those semantic and behavioral categories that Ticul potters recognized. I did not select my samples using geological criteria but rather collected examples of raw material categories that the potters themselves chose to prepare their temper to make pottery. I also collected examples of raw materials that potters recognized but did not use to make pottery and did not contain *sak lu'um*.

My research methodology produced five results. First, the analyses of the samples of the Maya category of *sak lu'um* revealed that it was indeed the clay mineral palygorskite. Mineralogically, *sak lu'um* was entirely different from Maya categories of rocks (*tunich*) and clay (*k'at*) of the area. Rocks consisted of the limestone minerals of calcite and/or dolomite, and the clays were either smectite or a random mixed layering of smectite/kaolinite and smectite. Rather, *sak lu'um* was a kind of earth (*lu'um*) to the potters, even though they sometimes called it *sak lu'um tunich* ("white earth rock") because it was so hard. So even though *sak lu'um* was a clay mineral, potters did not classify it as clay (*k'at*) but rather put it in a different category, *lu'um* ("earth"), or sometimes in the category *tunich* ("rock").[13]

Second, the potters recognized the unique properties of *sak lu'um* that corresponded to the properties of palygorskite and included it in their pottery temper. *Sak lu'um* is a critical raw material for making pottery because even though it is a clay mineral, it acts as a non-plastic in the paste (along with the calcite and dolomite) because its plastic limit is higher than the body clay; it adsorbs a greater amount of water than the body clay without becoming plastic, thereby reducing the plasticity in the paste mixture so that a newly formed pot will retain its shape during drying and not sag.[14]

Ticul potters explain this characteristic by saying that *sak lu'um* gives strength (*muuk'*) to vessels for carrying and storing water, and this quality made their vessels unique. Other pottery-making villages in Yucatán (Tepakán and Mama) produced some of the same shapes as Ticul, but consumers believed that Ticul water jars were technologically superior because they kept the water

cooler and gave it a better taste. These characteristics, according to potters, resulted from the *sak lu'um* in the pottery, which functioned as cement binding it together.

Third, because potters believed that *sak lu'um* was a critical ingredient of pottery temper, I discovered that all potters and those non-potters who mined temper affirmed that the temper for non-cooking pottery should contain *sak lu'um*. I further verified this link from the analyses of the temper samples from 97% (N = 28/29) of the potters' households in Ticul; all of them contained palygorskite.

Fourth, the constituents of temper that potters and miners prepared at the temper mines, and reported to contain *sak lu'um*, contained palygorskite.[15]

Fifth, although pottery temper had the same Maya name (*sah kab*) as a naturally occurring marl that was used for construction purposes, it was different from the temper for making pottery. Potters said that *sah kab* for construction purposes did not contain *sak lu'um*, and none of the samples of this material contained palygorskite.[16]

My research thus definitively tied *sak lu'um* to palygorskite and demonstrated that Ticul potters were aware of its properties and used it for a variety of purposes. Excited about what I had found, I wrote to Anna O. Shepard, who had authored two publications about Maya Blue three years earlier,[17] and I told her that I had found palygorskite in Yucatán.

She responded that long before Bohor's analyses of my Yucatán samples, she and her colleagues at the US Geological Survey had found palygorskite in pottery raw materials that archaeologist Raymond Thompson collected from potters in the towns of Ticul, Becal, and Mama during his ethnographic research there in 1951.[18] So even though there were no *published* reports of the existence of palygorskite in Yucatán, I was not the first to discover its presence there. I argued, however, that potters' awareness of its properties and its cultural significance were more important than its existence in Yucatán. Indeed, the cultural link between *sak lu'um* and palygorskite was crucial for understanding the significance of palygorskite in the production of Maya Blue. Shepard, however, believed that I had overstated its role in pottery:

> In the study of pottery making we have to go beyond what the Indian calls his materials to what they are in our terms, i.e., mineralogically. The potter classifies his materials from his own experience with them; how they mine [them], their color and hardness, their effects on vessel forming, drying, firing, and use. His judgments of effects on the pottery may be influenced partly by custom, and sometimes he may misinterpret his experience. We cannot judge these factor[s] or his understanding without reliable definition of his materials.[19]

What Shepard said was, of course, true, but she did not realize that the Ticul potter did indeed have a practical mineralogical knowledge of palygorskite compared with the physical properties of other pottery-making materials available.[20] I had spent six months studying pottery making in Ticul, using participant-observation and learning Yucatec Maya. I understood the potters' terminology used for describing and selecting raw materials and observed how they used them. Eventually, I also learned to select the appropriate raw materials myself under the watchful eye of my informants.

In the spring of 1966, I had planned a trip to Denver to visit a friend's family. So I arranged to visit Shepard in nearby Boulder. During our subsequent correspondence, I asked her if I could cite her discovery of palygorskite in Thompson's samples in my thesis (with full citation as a personal communication), but she asked me not even to mention her unpublished analyses.[21] So I did not mention her work. I thus was confined to my own data and emphasized my own unique contribution to the Maya Blue mystery: the validity and reliability of the cultural relationships of Ticul potters' "white earth" category and palygorskite as well as its significance for Maya Blue. I was not the first to discover palygorskite in Yucatán (Shepard and her colleagues were the first). Rather, I demonstrated that its cultural significance was a part of the Indigenous knowledge of Ticul potters using a triangulation of methodologies. As it turned out, however, the cultural significance of palygorskite was much more important than simply its geological occurrence in Yucatán. Ticul potters knew the unique properties of palygorskite as "white earth," and used it in making pottery.

In early 1967 I wrote my master's thesis showing the relationship between *sak lu'um* and palygorskite.[22] After completing it, I was off to Peru on another project.[23] During my absence, the Anthropology Department at the university published my thesis as *Sak Lu'um in Maya Culture and Its Possible Relationship to Maya Blue* as the second work in their new mimeographed series called Department of Anthropology Research Reports.[24]

Before I departed Urbana, however, I decided to send a copy of my thesis to Shepard. After reading it, she wrote to Bohor saying that she disagreed with me that potters recognized the properties of palygorskite. Again, she believed that I had overstated the role of palygorskite in pottery because it was only one component of the temper:

> Not only is the importance of calcareous attapulgite temper exaggerated in
> Dean's discussion, his idea of the importance of attapulgite [palygorskite] in
> prehistoric pottery is unfounded.

[Postscript] Just a word about temper materials: In all villages visited by Ray [Thompson] either *hi'*, or *sascab* [Hispanicized *sah kab*] was used. In a number of villages, these are used for vessels with different functions. This in itself is an interesting problem. The *sascab* is a marl, and the argillaceous constituent is the local type of clay—in only three villages attapulgite [palygorskite]. It seems to me misleading to disregard the calcareous component of the tempering material when this may constitute a third or more of the temper.[25]

It is, of course, true that palygorskite is only one component of the temper, and I did not really disagree because I had already determined the amount of the calcareous materials in the temper. I used acetic acid to dissolve the carbonate minerals in the temper and found that the percentage of clay in the temper had a mean value of 37.14% (N = 3),[26] but I did not report these tests in my thesis. To me, the issue was not the percentage of palygorskite in the temper, as Shepard believed, or whether palygorskite occurs in temper from some communities and not in others, but whether the Ticul potter recognized its unique properties—that is, its cultural significance. Whereas the *sascab* (*sah kab*) used for mortars and plasters in Ticul is indeed a natural marl, the *sascab* temper used by potters was *not* a natural marl but rather consisted of a complex cultural mixture of argillaceous marl and the crushed tailings of previous temper preparations, both of which must include *sak lu'um*. Sometimes potters deliberately must add *sak lu'um* to their temper if the amount present is insufficient to make high-quality pottery (figure 4.3). Although the temper is generally called by the same Yucatec Maya term as the marl (*sah kab*, "white powder") and looks similar to the temper, potters know the difference between them.[27] Shepard, however, did not understand that potters made this distinction. Her viewpoint and challenges to my conclusion thus graphically illustrate the point that Sillar and Tite made many years later: that material scientists often fail to understand the social embeddedness of technology.[28] One cannot read cultural patterns from the technical analyses without linking concepts that relate cultural behavior to scientific data. Often, however, such linking concepts are inexplicit and involve untested assumptions about that relationship.

Although she was an excellent ceramic technologist, I realized that Shepard was not an anthropologist, and I was not surprised that she disagreed with me. I argued that the cultural link between *sak lu'um* and palygorskite was important for understanding the relationship of palygorskite and Maya Blue in antiquity. Shepard, however, believed that I was attributing mineralogical knowledge to the potters.[29] In a sense, I was, but that knowledge was *practical* mineralogical knowledge that had a scientific basis and was not *scientific*

mineralogical knowledge. She was looking at ceramic materials from a mineralogical and materials science perspective, but my concern was trying to understand how the Maya perceived their raw materials in their cultural, behavioral, and environmental context. My ethnographic data revealed that the potters recognized the unique properties of *sak lu'um* and obtained it from a unique source. Furthermore, analyses of it revealed that it was pure palygorskite; the physical properties that potters recognized corresponded to the actual properties of the mineral. Finally, potters and miners deliberately selected palygorskite (as *sak lu'um*) during the process of mining and preparing temper.

PALYGORSKITE AND COMMUNITIES OF PRACTICE

Because raw materials for making pottery in Yucatán come from an area with a common geology with common minerals, Shepard, in the statements quoted above, seemed to imply that the perception and use of raw materials for making pottery should be consistent across the northern peninsula. It would be a mistake, however, to think that the Maya perceptions of their environment and the raw materials extracted from it are uniform across northern Yucatán or, for that matter, throughout any other subregion of the Maya area. Rather, as I have shown elsewhere, environmental knowledge and perceptions of pottery materials are local, as demonstrated by Raymond Thompson's research on pottery making in Yucatán in 1951. The variability in the naming of those raw materials and their sources that Thompson described, and that I subsequently verified, is, in reality, a rather reliable indicator of potters' different perceptions of the local environment around each community and of the raw materials extracted from them. Although raw materials for pottery making from other communities contained some common minerals such as calcite and dolomite, different communities used different names for their raw materials that came from different socially perceived sources.[30] Further, these intracommunity perceptions of raw materials are reinforced by social interaction and by the socially perceived landscapes around each pottery-making community. Even though the gross geological and mineralogical picture across Yucatán is similar, the pottery-making communities perceive the landscape around their community as being different from that around other communities. Each community, its named raw materials, the environment from which they come, and the community's practices of making pottery thus represent a local community of practice that engages local materials from a unique socially perceived landscape.[31] Michelaki and colleagues have referred to this kind of pattern as a "ceramic taskscape" after Tim Ingold's "taskscape."[32]

THE MEDICINAL USE OF *SAK LU'UM*

While learning about *sak lu'um* for making pottery, informants told me that they used it for other purposes as well. They said that "white earth" possessed excellent qualities for treating certain kinds of medical conditions.[33] For infections, it is moistened and spread over the affected area to draw out the infection. For throat infections, it is eaten or sucked. It is also used to treat bad burns and *papera* (goiter or mumps) and is moistened and spread topically on the affected area. It may also be taken internally for such maladies.

Sak lu'um is also consumed by pregnant women and given to children who have the vice (*vicio*) of eating dirt, which can lead to stomach problems.[34] Even without eating dirt, consuming *sak lu'um* can alleviate stomach trouble like diarrhea. When it is the ground into a powder, it also served as a lubricant for rolling henequen fibers.[35]

Upon my return to Ticul in 1966, I also learned that *sak lu'um* was mined in the village of Sacalum 12 kilometers northwest of Ticul. The word *Sacalum* is a Hispanicized form of the Yucatec Maya expression *sak lu'um* ("white earth"), which comes from a large mine within the sinkhole in the town's plaza. White earth from Sacalum, however, was mined exclusively for medicinal purposes and not for making pottery. Informants reported that the Maya had extracted *sak lu'um* from the mine there for many years and peddled it widely in Yucatán.[36]

I visited Sacalum in 1967, found the mine at the base of the cenote, and collected some samples from the working face of the *sak lu'um* deposit (see chapter 5). Clay mineralogist B. F. Bohor of the Illinois Geological Survey analyzed the samples and verified that they were indeed palygorskite (attapulgite).

Does palygorskite have medical efficacy? It does, indeed. Travelers to remote parts of the world know that they often face intestinal problems and that the antidiarrheal medicine Kaopectate alleviates the symptom of watery stools. Usually combined with some other product to sooth the lining of the intestines, its main active ingredient is a clay mineral that absorbs the excess water that is normally absorbed by the intestine. Although kaolinite is one clay mineral used for this purpose (in Kaopectate), palygorskite is also used in this way and possesses excellent properties to alleviate diarrhea.[37] Indeed, clinical studies have shown the effectiveness of palygorskite for this purpose. In a double-blind placebo-controlled study in Bangladesh, subjects were given 600 milligrams of attapulgite (palygorskite) or a placebo in a random order and then were evaluated daily for seventy-two hours. Palygorskite fared significantly better than the placebo in reducing the severity and duration of diarrhea, as indicated by the frequency of the motion and consistency of stools, the severity of dehydration, and the amount of oral rehydration solution consumed.[38]

The value of palygorskite as an antidiarrheal medication results from its crystal structure. Unlike other clay minerals that crystallize in horizontal layers with water occurring in and between the layers, palygorskite contains long parallel channels in which the water molecules are not bound to the chemical structure.[39] When palygorskite is "activated" with low heat, the water in the channels is driven off, providing more surface area for the adsorption of liquids and other materials. Even without heating, however, these channels have an affinity for water and can capture the causative agent (e.g., bacteria) of diarrhea. Because palygorskite can adsorb as much as 200% of its own weight in water,[40] it adsorbs much of the water that the intestine normally rejects during diarrhea. After its movement through the intestines, the body then excretes the water- and pathogen-laden palygorskite.[41] As a consequence, palygorskite is an effective antidiarrheal, and palygorskite-containing medications are marketed in the United States under a variety of trade names, such as Diarrest, Kao-Tin Advanced Formula, and Diasorb.[42]

Palygorskite's affinity for adsorbing a great amount of water and other liquids is a consequence of its higher plastic and liquid limits than most other clay minerals. The plastic limit is the lowest percentage of water that the dry clay will absorb before it becomes plastic,[43] and the liquid limit is the lowest percentage of water that the dry clay will absorb before it begins to flow when it is jarred slightly.[44] These unique properties contribute to the widespread application of palygorskite for both medical and industrial uses and correspond to those that the Maya recognize, especially its function as a non-plastic when mixed with clay to make pottery. For Ticul pottery, this characteristic means that the pottery clay (montmorillonite and kaolinite) becomes plastic with far less water than the palygorskite in the temper, and the palygorskite in the temper functions as a non-plastic just like the calcite and dolomite in it, even though it is a clay mineral.[45]

CONCLUSION

As I stated earlier in this chapter, two of the interconnected dimensions of scientific methodology are validity and reliability. First, if a technique measures what it purports to measure, then the results are *valid*. Second, if a methodology used to study a particular phenomenon is repeated and produces the same results, then the results are *reliable*. Such was the case with the techniques used to determine whether *sak lu'um* and its properties correspond to the clay mineral palygorskite among with Maya potters of Ticul.

My repeated ethnographic research in Ticul over forty-three years further validated the link between *sak lu'um* and palygorskite. Since my original ethnographic work in Yucatán in 1965 and 1966, I have returned to do research in Ticul for ten more visits. My fieldwork in 1967, 1968, 1970 (twice), 1984, 1988, 1994, 1997, 2001, and 2008 further validated and reliably reinforced the fact that Ticul potters' perception of *sak lu'um* was, in fact, palygorskite.[46]

My research later in the twentieth century reinforced this link in another way. After 1988 full-time temper mining specialists emerged who were not potters. As a consequence, these specialists paid less attention to the addition of *sak lu'um* to the temper, and its quality became more variable. To deal with the inevitability of buying poor-quality temper from specialist miners that were careless or not knowledgeable about *sak lu'um*, some potters accumulated piles of *sak lu'um* in their production units to crush and mix with their temper to improve its quality (figure 4.3).[47]

More recently, others have written about the mining and mixing of *sak lu'um* to make pottery temper in the area between Ticul and Chapab. These descriptions further corroborate my earlier work during the previous fifty years about the mining areas, the operational sequence of creating temper, and the importance of palygorskite in the temper.[48]

As of this writing, *sak lu'um* is still important in Ticul as an additive for pottery temper. After reading my book *Maya Potters' Indigenous Knowledge: Cognition, Engagement, and Practice*, a British colleague visited Ticul in May of 2018 and told me that one of the potters he visited showed him some *sak lu'um* that was used to add to the clay for making pottery.[49]

As the next chapter will show, the Maya Indigenous knowledge of *sak lu'um* includes its sources near Ticul and in Sacalum that are also part of Maya cultural heritage. Relating this discovery to the mystery of Maya Blue, the question is: Did the ancient Maya use these sources to mine palygorskite to make Maya Blue? The next chapter will answer one dimension of this question, and another will be the subject of chapter 6.

5

As is often the case in science, one discovery leads to more questions with new leads to follow. With the discovery that the Maya recognized the properties of palygorskite as *sak lu'um* and used it for medicinal purposes and pottery temper, where was its source (or sources) for making Maya Blue?

Just as the discovery that the modern Maya understood the unique properties of *sak lu'um*, finding its ancient source also came from Maya Indigenous knowledge. As anthropologist Tim Ingold argued, one must consider the perception of the ancient landscape in understanding the past.[1] In this case, the ancient Maya's perception of the sources of *sak lu'um* is more important than its geological occurrence or its mineralogical presence. Although this perception is unavailable, the Indigenous knowledge of their descendants can provide great insight into the ancient sources of the palygorskite used to make Maya Blue.

For me, understanding these perceptions was not possible without immersion in the culture, learning some of the Maya language, studying pottery making, and participating in the craft by acquiring the potters' knowledge of how they select their raw materials. Potters' Indigenous knowledge about palygorskite, its properties, and its sources are socially embedded and are not universal among the Maya of Yucatán. Rather, this knowledge is local and limited to specific communities of practice.[2]

Over the period from 1965 to 2008, I have made twelve visits to Yucatán, and with clay mineralogist

https://doi.org/10.5876/9781646426683.c005

B. F. Bohor we found palygorskite in many locations (see chapter 6). The only places where the sources of palygorskite (*sak lu'um*) were part of Maya Indigenous knowledge, however, were thick beds (1 meter) of palygorskite near Ticul (Yo' Sah Kab) and in the sinkhole (cenote) located in the central plaza of the village of Sacalum.[3] These two locations were the only places where the Maya knowledge of a semantic category matched the unique properties of palygorskite, and they were the only places where local populations used the linguistic label *sak lu'um* to signify this category. These facts strongly implied a historic and prehistoric association between palygorskite and the two towns, indicating that they were likely pre-Columbian sources of the mineral used to create Maya Blue.

THE MINES NEAR TICUL

Driving northeast of Ticul toward the village of Chapab, travelers might notice piles of a white material along the road and see excavations into the hillocks along its edges. As they pass, they might catch a glimpse of more such activities deeper in the forest.

If one were to explore those excavations on either side of the road, beginning about 3.3 kilometers from the Plaza of Guadalupe, one could see that the forest is pockmarked with mines burrowed horizontally into a marl layer between about 1.0 and 2.5 meters below surface. For those familiar with Yucatán, these mines look like the small quarries (*sah kabo'ob* in Maya, or *sascaberas* in Spanish) where workers extract the calcareous marl (*sah kab* in Maya) that the Maya have used for centuries to construct their houses, roads, patios, and monuments. This marl occurs universally below the cap rock in Yucatán and is mined extensively in quarries that are frequently visible along roads and on the edges of cities and villages. It was used as a filler in mortars and plasters and for surfacing streets, roads, and patios before asphalt and cement became widely available.[4]

Potters refer to this mining area northeast of Ticul as Yo' Sah Kab, literally "over marl" (*sah kab*). But if marl and its sources are so ubiquitous in Yucatán, why is there a special place called "over marl" near Ticul? Isn't every area of Yucatán literally "over" marl? Yes, most of them are. Yo' Sah Kab, however, is unique because it implies a special sense of place in the Indigenous knowledge of Ticul potters. Unlike the marl used for mortars, plasters, and surfacing that is abundant everywhere, the marl from Yo' Sah Kab contains *sak lu'um*.[5]

Potters' oral history and descriptions by others reveal that Yo' Sah Kab served as the singular source of temper for Ticul potters at least for most of

the twentieth century and into the early twenty-first century. Potters imbue Yo' Sah Kab with a unique sense of place and associate it with unique religious and mythological connotations. These beliefs appear to be related, at least partially, to the uniqueness of Yo' Sah Kab as a source of *sak lu'um*, a critical ingredient of pottery temper (also called *sah kab*). This uniqueness, in turn, is related to the distinction between *sah kab* for construction purposes, which is ubiquitous in Yucatán, and the linguistically homophonous *sah kab* temper that was mined *only* at Yo' Sah Kab and nearby. Both types are called *sascab* in Spanish, but they are semantically different depending on the context. Both types are mixtures of calcite and dolomite and a clay mineral. *Sah kab* for construction purposes is a natural marl consisting of calcite and dolomite and smectite, whereas *sah kab* temper is a carefully prepared cultural mixture consisting of calcite and dolomite and palygorskite, which occasionally may include some smectite. The presence of *sak lu'um* (palygorskite) in temper is not natural but cultural, in that potters and miners deliberately select it to include in their temper; it is clearly a semantic and behavioral choice of a material that potters mix with their clay for all of the non-cooking pottery made in Ticul (see chapter 4).[6]

Sak lu'um at Yo' Sah Kab occurs in two basic strata whose thickness and depth below the surface varies with a rolling contact between them. Between a depth of about 1.0 and 2.5 meters, large chunks of *sak lu'um* occur in a marl layer mined for temper (figure 5.1).[7] Miners usually discarded these chunks in the tailings for future temper preparation after they have weathered and become more friable (figure 4.2). Below the marl layer, a bed of solid palygorskite (*sak lu'um*) extends downward from about 2.5 meters to about 4.0 meters with a minimum thickness of about 1 meter.[8] Because some mines may have marl that does not contain *sak lu'um*, miners must identify its presence before they extract any material to prepare their temper.

I first visited Yo' Sah Kab in April of 1965. At that time, the road to Chapab was little more than a vehicle track upon which vehicles lumbered along slowly because of the protruding rocks and potholes. The low places filled with water during the rainy season. Consequently, few vehicles made the trip to Chapab, and the quality of the road limited the transport of temper to human carriers, pack animals, and horse carts.

So to make the trip, two potters and I rode bicycles to Yo' Sah Kab. It was an extremely sweltering day at the end of the dry season, and I remember how exhausted I was riding the 4–5 kilometers from the potters' houses to the mining area. Made for smooth surfaces, regular bicycles do not do well on roads with rocks and potholes.

FIGURE 5.1. *Mining cut showing palygorskite-containing marl above and a solid layer of palygorskite below it. The miner, Elio Uc, is digging out the* sak lu'um *from the bottom of the layer of the deposit at Yo' Sah Kab. The solid layer of palygorskite begins at the rocklike protrusion (*upper center*) and extends to the right, dipping slightly and extending to the bottom of the excavation shown here. Above this boundary lies palygorskite-containing marl mined for pottery temper. Two rocklike chunks of* sak lu'um *extracted from the hole lie on the ground to the right of the miner. The pile of material on the left consists of rocks and marl discarded by the miner because they do not contain* sak lu'um.

Since that original trip, I have explored the extent of this mining area during all my twelve trips to Ticul between 1965 and 2008. I have tracked the changes in mining location many times on the ground and on Google Earth. Originally, the mining area was confined to the Ticul *ejido*, communally owned land that could be worked by anyone. In the 1960s, however, mining also took place on privately owned land that belonged to the Maya Cement Company adjacent to the *ejido* to the south and west.[9] In 1966 I made a sketch map of the mining area on the cement company property, but it was largely useless because the configuration and extent of the mining area changed greatly over time and moved from area to area—often tens of meters away. Furthermore, the forest reclaims former mining and preparation areas, making them difficult to find. By 1984 the cement company land was abandoned, reclaimed by

the forest, and mining had moved back into the *ejido* and to the north side of the Ticul-Chapab road.

In the 1980s Yo' Sah Kab was heavily exploited, and mining temper there became more difficult and time consuming. Nevertheless, the mining area expanded, moving from one location to another. These changes were difficult to track because once mining areas were abandoned, the forest quickly reclaimed them. Consequently, potters' Indigenous knowledge provided the best way to locate the extent of the mining areas. Without the help of a machete-carrying local potter or miner as a guide, finding abandoned mining areas would be difficult if not impossible.

About 1983 one of the men who transported temper to Ticul discovered *sak lu'um* on his land 5 kilometers closer to Chapab. After one of the miners at Yo' Sah Kab verified its presence, he mined and prepared temper there and sold it to potters. By 1988 most temper mining and preparation had moved to the new location.[10]

Although temper mining continued at Yo' Sah Kab after 1988, its importance declined relative to the Chapab source so that by 1997 most of the temper came from the source nearer to Chapab. Visits to this new source in 1994, 1997, and 2008 revealed that the raw material for temper was mined from a thick (1–2 meters) layer of *sak lu'um*-containing marl. The miners prepared their temper there in the same way as it was done at Yo' Sah Kab.

An Ancient Source

The temper mining and preparation area at Yo' Sah Kab probably was an ancient source of palygorskite. During my visit there in July of 1967, informants told me about an archaeological site just north of the Ticul-Chapab road across from the active temper mines.[11] At the time, the site was situated within a fenced pasture within 100 meters of the mining areas. I had no permit for a formal survey, but I did walk over the site, made some notes, and collected some surface pottery. My field notes from July 18, 1967, describe my initial impressions, to which I've added some clarifying details:

> We went to Yo' Sah Kab today to look for a location which [potters said] was
> "like" a ruin and where *sak kab* [temper] was mined before it was mined in
> the two major places now [the Ticul *ejido* and the cement company land]. . . .
> Someone told us that across the road [on its north side] there was a hill which
> had *piedras labradas* [shaped stones], most of which were used [removed] when
> the road was built, so we went to investigate and see if it was a ruin. Within 50

ft. of the road was a small artificial hill which may have been a pyramid. From the top, you could see other such hills in several directions. There were no cut [shaped] stones, and although the walls or the foundation[s] were standing in many places, there was nothing which gave me any clue as to the relative date of [the] architecture. Later, we found one rock cut [shaped] like those of [the archaeological site of] San Francisco nearer Ticul, which is contemporary with Uxmal, but that was the only cut stone we found. Everything else seemed to be very crude. In one place we did see some plaster, but it was only a little and appeared to be done [placed] over rough stones. Corners, walls—everything was done with rough stones rather than nice cut trimmed [shaped] stones.

This archaeological site contributed to the sense of place for potters because oral history and the religious beliefs associated with it inhibited mining activity there until the last quarter of the twentieth century. In the late 1960s informants said that the older generation of potters were afraid of mining temper near the site. It was the place of many snakes, they said, and one informant's father had been bitten twice there.

Local folklore reinforced this fear. In the early 1900s some people from Chapab came to an area near the archaeological site to obtain *sak lu'um* for medicinal purposes. When they encountered a large snake with a beard and hair on both sides of its head that blew air, they were afraid to return. One miner believed that the ancient Maya had once inhabited the site and worked the mines. Potters thus feared the location, and only one returned to mine temper there but reportedly provided offerings of the maize drink *posole* every Friday to placate the serpent.[12]

The structures on the site consisted mostly of low mounds less than 0.5 meter in height, with one having a height of 2–3 meters. Several subterranean cisterns or storage chambers (*chultuns*) occurred within the site, and informants reported that there were two more along the south edge of the Ticul-Chapab road. Finely worked stone was rare, but some occurred near one mound and on the top of the larger mound. Informants reported, however, that most of the worked stone had been removed when the road from Ticul to Chapab was built. The small amount remaining was like that used in Terminal Classic (AD 800–1100) sites such as Uxmal and the archaeological site of San Francisco de Ticul north of modern Ticul.

Sherds from the Terminal Classic period littered the surface. All were fragmentary and weathered with no traces of a slip or painted decoration on any of them. Rim sherds indicated the presence of bolster rim basins, basal break bowls, and some undefined bowl and jar forms. The bolster rim basins

could be identified as Puuc Slate Ware because they were characteristic of this ware.[13] The only sherds with decoration consisted of parallel incised lines on a fabric with crystalline inclusions. Potters recognized this fabric as similar to that of the contemporary cooking pottery made in Ticul at the time.[14] This fabric and the incised lines on the surface of the sherds also characterized the Puuc Unslipped Ware of the Terminal Classic period.[15]

Although the site was close to the active temper mines in 1967, potters did not mine temper near the mounds or anywhere north of the road. There was, however, a large hole approximately 4 meters in diameter within a few meters of the ruined structures of the site. Approximately 2 meters deep, it was filled with brush. Other than this feature, no obvious evidence of any mining or temper preparation occurred in or near the archaeological site on the north side of the road, although no systematic survey of the site was made.

My repeated observations at Yo' Sah Kab over a period of forty-three years as well as geological profiles of the pits and mines drawn and measured there in 1968 and measured in 2008 indicated that the archaeological site was situated directly over a layer of palygorskite-containing marl that eventually was mined for pottery temper. A layer of solid palygorskite, approximately 1.0 meter thick, lay below it. Between 1967 and 1984, the fear of snakes and the religious associations no longer restrained miners from digging within the site because miners were no longer potters and did not know about this folklore. Consequently, by 1984 the area north of the road was pockmarked with the mines and preparation areas like those across the road to the south, and the archaeological site was destroyed. Construction workers took all the remaining dressed stone to Ticul. Asked about the site at that time, my informant said that he did not know where the site was. When I asked whether we could search for it, he said that the forest was too thick and we had no machete to cut through the vegetation. Furthermore, I did not have permission to do an archaeological survey. During a visit to Yo' Sah Kab in 1994, I asked about the site again, but my informant reiterated that nothing remained and that it had been completely obliterated.

The co-occurrence of a Terminal Classic site directly over a palygorskite deposit indicates that a small population had deliberately placed their settlement there for mining the *sak lu'um* and preparing *sak lu'um*-containing pottery temper. Although the large hole in the site was not cleared or investigated, the mining activity that eventually destroyed the site revealed that it was excavated into the palygorskite-containing marl and into the solid palygorskite layer below the site. The fragments of bolster rim basins found on the surface indicated that its inhabitants may have used these vessels for transporting

palygorskite and pottery temper in the same way that Andrews suggested that the ancient Maya used these shapes to transport clay and temper out of Balankanche Cave near Chichén Itzá to make pottery.[16]

On the south side of the road an informant-directed reconnaissance in 1967 revealed other archaeological remains that also dated to the Terminal Classic period. In one isolated location deep in the forest an oval outline of unworked stones indicated the remains of the foundations of a Maya house. Sherds of Puuc Unslipped Ware covered the surface around the stones, and these sherds were identical to some of the pottery found in the archaeological site across the road.[17]

A temper mining and preparation area was situated near the structure. Like the current mining and temper preparation areas, this area consisted of both open and collapsed mines that extended 5–6 meters horizontally underground. A small area covered with discarded screenings from temper preparation lay adjacent to it. Small fragments of Puuc Unslipped Ware from the Terminal Classic period were scattered on the surface. Miners had crushed these sherds with the marl screenings to prepare their temper.[18] Informants also reported that miners had discovered ancient vessels buried within these screenings. North of the mining area away from the structure, we found a large rectangular stone receptacle that informants identified as a water basin (*pila*); more likely it was a greatly worn grinding stone (*metate*, a mortar) used to grind maize or perhaps to grind marl and/or palygorskite for preparing temper.[19]

Grinding stones like these were abundant nearby in the Terminal Classic site of San Francisco de Ticul, described by the nineteenth-century traveler John L. Stephens. Located north of the modern city of Ticul along the road to Sacalum, the site is 3 kilometers directly west of the Yo' Sah Kab site. Stephens, who visited the San Francisco site during his trip of 1841–1842, said that he could see these grinding stones (*metates*) "in all directions" from the top of one of the mounds, along with many of the other portions of the grinding apparatus called *manos* (the functional equivalent of a pestle).[20]

Temper mining and preparation activities also uncovered ancient pottery at Yo' Sah Kab. During the first half of the twentieth century, a potter found a jar (*apaste*) and red pitcher (*jarra*) in the screenings of one preparation area. More recently (1994), a miner found ancient pottery on the surface when he was clearing a new preparation area north of the Chapab road in what had been the archaeological site; one sherd, he said, was the red rim of an ancient vessel. Although the details of this pottery are not known, its presence corroborates the observation that at least some temper mining areas at the time were located within the archaeological site and that the site was positioned

directly over the palygorskite deposit that probably also served as a source of palygorskite to make Maya Blue.

The remains of the house foundations at Yo' Sah Kab, the Terminal Classic cooking pottery surrounding it, a temper preparation area, and the *metate* nearby provide the basis for two alternative interpretations. It could mean that the house and the nearby preparation area were the residence and activity area of a potter or temper miner from the Terminal Classic period, or it could indicate that modern miners were reusing an ancient mining and temper preparation area around a house that dated to the Terminal Classic.

Although the antiquity of palygorskite mining at Yo' Sah Kab is not as direct and definite as one would like, a second line of indirect evidence of its antiquity comes from its cultural uniqueness, its sense of place, and its cultural heritage. Potters said that temper with *sak lu'um* comes only from Yo' Sah Kab. Indeed, from 1965 up until a new source opened in the late 1980s nearer Chapab,[21] Yo' Sah Kab served as the singular source of *sah kab* temper and *sak lu'um* in the immediate area of Ticul. This uniqueness is borne out by geological reconnaissance. In 1968 Bohor and I surveyed many marl (*sah kab*) mines and former clay sources around Ticul and found no palygorskite (*sak lu'um*) in them. Since the Yo' Sah Kab site dates to the Terminal Classic and there is no other apparent explanation for locating the site there, or for the large hole in it, the exploitation of palygorskite there probably also dates to this time.

Besides the singular presence of *sak lu'um* there, Yo' Sah Kab is also unique because its name, *sah kab* ("over marl") in Yucatec Maya, parallels the place-names for other sources of pottery raw materials near Ticul. The place-name for the source of potters' clay (*k'at*) is Yo' K'at ("over clay"), and Hacienda Yo' K'at (4 kilometers from Ticul) served as the traditional clay source up until late 1991.[22] In 1968, when Bohor and I investigated the interior of the mine there, we discovered a sherd from a Terminal Classic bolster rim basin sealed in a collapsed tunnel deep inside the mine.[23] Its shape indicated that ancient clay miners used it as a scraper to gather clay eight hundred to a thousand years ago. A third place-name comes from the Maya word *hi'* ("crystal"), which potters used as a temper for cooking pottery. This material came from a cave called Aktun Hi' ("crystal cave") in the hills south of the city. Excavations in the cave in the early twentieth century found sherds of the Terminal Classic period there.[24] Because the place-names for sources of clay and temper in Ticul use the Maya words for the materials that come from them, and because Terminal Classic pottery is associated with each of these sources, it is likely that Yo' Sah Kab was an ancient mining site for pottery temper as well, and probably for the *sak lu'um* (palygorskite) used in the creation of Maya Blue.

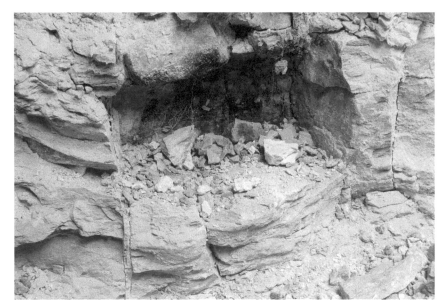

FIGURE 5.2. *The rocklike character of* sak lu'um *in situ at the base of a solid palygorskite deposit at Yo' Sah Kab.*

Finally, like their ancient forebears, contemporary Maya potters that work with their raw materials daily are not geologists or clay mineralogists, but they classify, engage, and select their raw materials using their Indigenous knowledge of the sources and the physical properties of the materials from them. Because of its uniqueness as a source of *sak lu'um*, Yo' Sah Kab is part of Ticul potters' cultural heritage.[25] It is only one of two locations in Yucatán where Bohor and I found a massive, thick deposit of a material with the distinctive physical properties that potters recognize as *sak lu'um*: white, hard, rocklike, and yet light in weight. Geologists call this material "palygorskite mudstone" (figure 4.1; figure 5.2).[26]

SOURCES IN SACALUM

Using Maya Indigenous knowledge as a base, the second major source of palygorskite lies within the sinkhole that served as a water source for the town of Sacalum.[27] The name Sacalum is the Hispanicized form of the Maya term *sak lu'um*, and the sinkhole there lies in the street at the northeast corner of the plaza (figure 5.3). A low wall (about 1 meter high) surrounds its opening, and

Figure 5.3. *The entrance to the cenote in Sacalum in 2008 looking south-southwest. The circular wall (left center) encloses the natural opening to the cenote with a gate to the stairway down into it on the far side of the wall. The low, covered structure (right foreground) is the opening formerly used to draw water from the pool below. The entrance as it appeared in 1968 can be seen in Dean E. Arnold and Bruce F. Bohor, "Attapulgite and Maya Blue: An Ancient Mine Comes to Light," Archaeology 28 (January 1975): 24.*

a gate on its west side opens onto a stone stairway that leads down to a small pool of water (figure 5.4). Up until piped water was installed in the community in the 1970s, local inhabitants obtained their water through a rectangular opening in the surface rock directly above the pool using buckets that could be lowered directly down into the water.

The Large Mine

The principal source of *sak lu'um* in the cenote consists of a large horizontal cavity created by removing a massive portion of a solid, meter-thick layer of palygorskite.[28] The only access to this cavity is a very low (35–50 centimeters high), narrow passageway leading from the north wall of the cenote interior (figure 5.5). Inside, the cavity covers an area of approximately 307 square meters and has an average height of 1 meter (figure 5.6). A 1.3-meter layer of palygorskite forms the north, west, and east walls of the cavity.

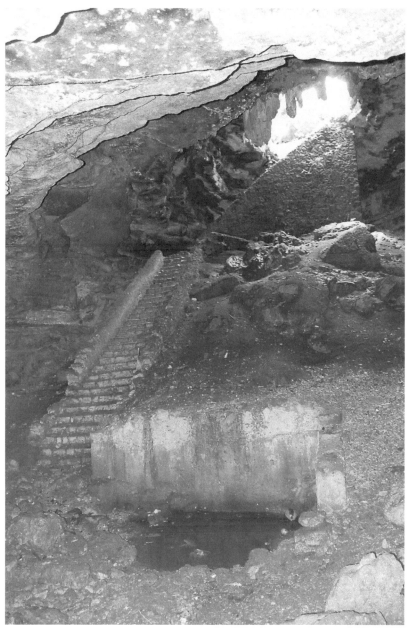

FIGURE 5.4. *The interior of the Sacalum cenote in 2008 showing its opening on the surface and the stairs down to the pool of water. The pool is directly below the structure where water was formerly drawn. The entrance to the mine lies directly behind the photographer.*

FIGURE 5.5. *The north wall of the interior of the Sacalum cenote showing the entrance to the mine—the small, dark area just above the individual in the white shirt. The image also shows the talus of the collapsed overburden of the mine that once extended further into the cenote interior.*

Mining takes place along these walls but was concentrated on the north wall (figure 5.7).

I first learned that *sak lu'um* was mined in Sacalum during my research in Ticul in 1966, and my first exploration of the mine began during July of the following year (1967) when I made a stopover in Yucatán from a trip from Peru. My field notes from this visit describe my initial (and somewhat erroneous) impressions:

> I visited the cenote at Sacalum. There were potsherds all over the bottom of the cenote with rocks, dirt, etc. There may be a deep, or at least some, cultural deposit on the floor of the cenote. I collected a few sherds from it.
>
> On the west side of the cenote, slightly above (about one hundred feet below the surface) the floor was the entrance to the mine where *sak lu'um* was mined.[29] The entrance was downward over a series of fallen rock and low—sometimes less than 2' high. At the bottom of this entrance was a large room which appeared to me to be formed by the miners of attapulgite (palygorskite). The edges of the entire area (inside the room) were subjected to mining activity and

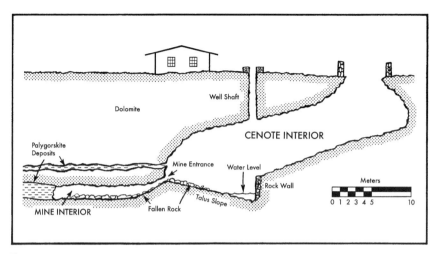

FIGURE 5.6. *Profile of the Sacalum cenote showing a cross-section of the mine and the layer of* sak lu'um *above it. (Drawing by Michael Anderson, modified from Dean E. Arnold and Bruce F. Bohor, "Attapulgite and Maya Blue: An Ancient Mine Comes to Light,"* Archaeology *28 [January 1975]: 26; and Arnold and Bohor, "An Ancient Attapulgite Mine in Yucatán."* Katunob *8, no. 4 [1976]: 28; reprinted with permission of* Archaeology.*)*

in some areas, there was fallen rock from the ceiling. The mining had been done across a layer of attapulgite (palygorskite) and was in a rough "L" shape: 2.5' to 4' in height and 75'–100' long and about 40' wide in its greatest width.

It looked as though the attapulgite had been mined there recently and we found two machetes inside which were used for mining. We took several samples of the *sak lu'um* and the overburden. The guide said every week someone enters the mine to mine the *sak lu'um*. He said it was sold and was given to pregnant women, and used as a substitute for people who had the vice of eating earth or dirt.

After I returned to Urbana, Bohor analyzed my samples of *sak lu'um* from the mine using X-ray diffraction and found them to be palygorskite. Later that year, he visited the cenote himself, but could not enter the mine because it was underwater. The water from the rainy season had raised the level of water in the cenote and covered most of the interior of the mine.

In 1968, when Bohor and I visited the cenote together and measured the inside of the mine, I revised my original estimates the size of the cenote, the mine within it, and its orientation. During these visits, we talked to local informants, examined the interior of the cenote and mining area, and

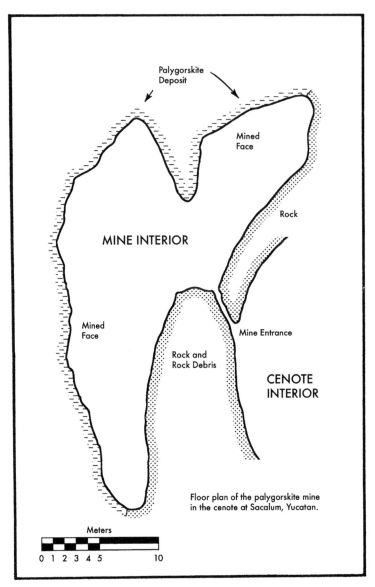

Palygorskite
Deposit

Mined
Face

Rock

MINE INTERIOR

Mined
Face

Mine Entrance

Rock and
Rock Debris

CENOTE
INTERIOR

Floor plan of the palygorskite mine
in the cenote at Sacalum, Yucatan.

Meters

0 1 2 3 4 5 10

FIGURE 5.7. *Plan view of the palygorskite mine in the Sacalum cenote as it appeared in 1968 showing the extent of the cavity north of the cenote interior. (Drawing by Michael Anderson, modified from Dean E. Arnold and Bruce F. Bohor, "Attapulgite and Maya Blue: An Ancient Mine Comes to Light,"* Archaeology *28 [January 1975]: 26; and Arnold and Bohor, "An Ancient Attapulgite Mine in Yucatán."* Katunob *8, no. 4 [1976]: 29; reprinted with permission of* Archaeology.)

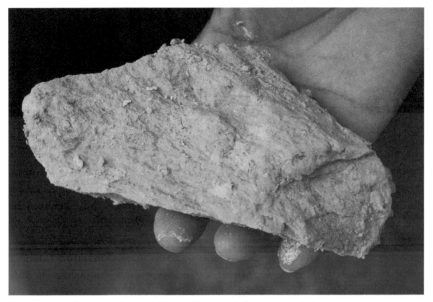

Figure 5.8. *Piece of yellow* sak lu'um *(k'an sak lu'um) from the large mine in the cenote of Sacalum. Using this kind of palygorskite to create Maya Blue would produce a pigment with a more greenish color.*

collected samples of *sak lu'um*. Bohor's mineralogical analysis of the samples by X-ray diffraction again revealed that *sak lu'um* from the mine interior was pure palygorskite.

Two children accompanied us into the mine, and while we were taking measurements and selecting samples of *sak lu'um*, they ate pieces of it. As a result of our inquiries, we learned that *sak lu'um* existed in three colors: white (*sak sak lu'um*), yellow (*k'an sak lu'um*, figure 5.8) and red (*chak sak lu'um*) and that it was given to children who had something wrong with their stomachs. They also said that it was given to people who have the habit of eating dirt and to pregnant women who have the desire to eat "things."

On the trip back to Ticul, one of our informants told us that the Virgin Mary had appeared to the people of Sacalum and that they considered her to be the owner of the cenote. He also reported that if nine children of the same age went into the cenote together, the Virgin would leave and the children would die.[30]

Our reconnaissance and measurements indicated the Maya had removed a massive amount of the palygorskite from the deposit. Using the height of the mined-out cavity (about 1 meter) as the thickness of expended palygorskite

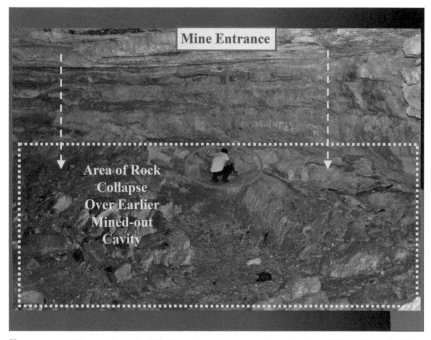

FIGURE 5.9. *The north wall of the Sacalum cenote showing the talus of the collapsed ceiling of the former mine and the small entrance of the current mine. The interior of the mine extends roughly the width of this image. This rock fall suggests that the area under it was at one time part of the palygorskite mine into which the rocks collapsed.*

deposit along with the measurements of its interior, we calculated that the Maya had removed approximately 307 cubic meters of palygorskite from the mine.

Originally, the palygorskite layer formed the north wall of the cenote and extended into what is now its interior, but as the working face of the deposit receded from the cenote wall, a massive horizontal cavity remained. Eventually, the rock above it collapsed into it, leaving the talus along its north side obscuring the width of the mine (figure 5.9). When this collapse occurred is unknown, but it is likely that when the rectangular hole was cut into the rock above to provide direct access to the pool of water from the surface, explosives were used, and part of the overburden above collapsed into the mine, sealing off the back of the mined-out cavity. The talus of this col- lapsed rock covered the evidence of earlier mining in what is now the cenote interior. The local inhabitants then removed part of the rubble that separated

the mined-out cavity from the cenote interior, opening a passage into what is now the current mine.

This collapsed area extends 5 meters into the cenote interior. Using the height of the current mine as the thickness of the former palygorskite layer under the talus and the area of the footprint of the talus, we calculated that the Maya had removed approximately 589 cubic meters of palygorskite from both the current mine and the collapsed cavity under the talus.[31]

During the last third of the twentieth century, the cenote continued as a source of *sak lu'um* that was distributed widely for medicinal purposes. In 1997 a friend from Ticul, who was a schoolteacher in Sacalum, said that he had dug some *sak lu'um* in the mine two years earlier. The people in Sacalum at that time, he said, mined and sold it for fifteen pesos a bag in Peto, 80 kilometers to the southeast.

I returned to Sacalum again in 2008 with Bruce Bohor to investigate the mine and collect more samples. I knew that the mine would fill with water during the rainy season, as Bohor had witnessed during his visit in 1967. So I scheduled our visit in late May before the rainy season was expected to begin. Unfortunately, tropical low-pressure systems still brought late-afternoon rains, even though it was early for the beginning of the rainy season. So we went to Sacalum first.

We rolled into Sacalum on a sunny afternoon. The town center had changed so much in the previous forty years that I had to ask directions to find the cenote because the plaza was exceptionally large. We thought it best to check in with the police before we began our investigation, so we stopped at the police station, and two police officers accompanied us into the cenote.

I asked one of the police officers if anyone was still mining the *sak lu'um*, but he said that the last miner had died a year and a half earlier (mid-2006). I had already queried others nearby about *sak lu'um* and its use, and they had reported that it was used to treat diarrhea—a purpose identical to its use in contemporary pharmaceuticals (see chapter 4).[32]

Sometimes investigating the sources of ancient materials brings unintended consequences. Because crawling into mines is usually hard on my clothing, I take old shoes, jeans, and shirts to use when I go into the field so that I can leave them behind to make space in my luggage for samples to be analyzed when I return. On this trip I had taken a worn pair of gym shoes and planned to give them away when I left the field. My wife had cautioned me that they were smooth on the bottom and might be hazardous, but I brought them anyway and wore them on the day we visited the cenote.

We eventually found the cenote, with a wall surrounding its opening. I opened the gate to the stairway and proceeded down the stairs (figure 5.4). As

I descended to the third step, I slipped and fell, rolling down four of the stone steps. Embarrassed but uninjured. I picked myself up and proceeded down the stairway with Bruce and the two police officers. As I did, my wife's words about not bringing my worn gym shoes echoed through my brain.

We got to the bottom and went over to the entrance to the mine. I crawled into it and investigated the excavated cavity. My flashlight was too weak to use. So one of the police officers went back and got another one so that I could peer into its depths with more light.

The mine was damp from the early rains of the wet season, and its floor was cluttered with rock falls from the ceiling that seemed to warn that it could collapse at any moment (figure 5.9). The interior looked very dangerous, but it appeared to be similar, if not identical, to the way it was forty years previously, having the same shape and size as it did in 1968 based upon my memory and our drawing of its interior.[33] It appeared that little additional palygorskite had been mined since then (figure 5.0).

Forty years earlier (and being forty years younger), I did not think about the cramped quarters of the mine or the rock falls, and both Bruce and I had crawled into the mine to collect samples and measure its size and extent. During that same trip, we had squeezed into the active clay mine at Hacienda Yo' K'at, crawling through an entrance tunnel that was barely 50 centimeters wide and little more than 20 centimeters high. It was so small that I had to move through it on my stomach with arms stretched out in front of me, propelling myself forward by the action of elbows and toes. As the toes of my boots dug into the bottom of the tunnel, my heels simultaneously scraped its ceiling. (I was a much smaller man then!) Although the tunnel opened inside the mine into a large, excavated room, I was profoundly aware of the challenges and dangers of clay mining. The air was bad, and the recording I made there revealed its quality by my rapid breathing. Reflecting on this experience afterward proved to be psychologically traumatic. When I showed slides of the interior of the mine to my classes and played the audiotape made there, it had devastating effects on my mental state. Nightmares about claustrophobia in the mine plagued me for years afterward as I reflected on my experience there.[34]

Now, in the Sacalum cenote again forty years later, the thought of crawling into the interior of the mine took on a heightened sense of danger for me. So, as I looked into the damp mine with its rock falls and cramped crawl space, I turned to Bohor and said, "I'm not going in there!"

"I'm not either!" he replied.

Would one of the police officers go into the mine to collect samples for us? They refused.

FIGURE 5.10. *The interior of the palygorskite mine in the cenote of Sacalum in 2008 showing the rock fall from the ceiling. The cavity seen here is the space remaining after the palygorskite was removed. The crouched figure (*upper right*) is an informant collecting samples of* sak lu'um *along the working face of the deposit, which extends horizontally to the left and right.*

In a moment of sober reflection about my dilemma, I turned toward Bruce with frustration, and reminded him that we had received a research grant and simply must get some samples of *sak lu'um* from inside the mine. I had received a grant from the National Geographic Society to investigate the sources of palygorskite to identify those that may have been used in the production of Maya Blue. We simply *had* to collect samples from the mined face of the palygorskite deposit deep in the mine. So we asked the police officers if they could find someone else to do the collecting for us. We told them that we would pay one hundred pesos (about US $5.00) for the task, which would require about ten minutes of work. One of the police officers climbed up the steps out of the cenote and found a young man who was willing to collect the samples that we needed. I watched with interest, instructing him where to get the samples as I photographed his shadowy figure, silhouetted by his flashlight, as he crawled into the depths of the mine (figure 5.10). He collected about twenty samples along the worked face of the deposit, pulling up the front of

his T-shirt to hold them, and then crawled back to the entrance through the cramped quarters of the mine.

In retrospect, my fears about going into the mine were conscious, but they were based upon real experiences tucked away in my unconscious memory. When I was writing up my field notes for my books about pottery making in Ticul, I came across accounts of potters and miners who had been killed in cave-ins in the mines at Yo' K'at and at Yo' Sah Kab, one as recently as 1978. More recently, other accounts described the collapse of walls of open pit mines and overburden in underground mines that temporarily trapped miners but who were rescued by their colleagues.[35]

So it was only after writing about crawling inside of clay and temper mines over a period of forty-three years and talking with miners about their work that I remembered their stories of the dangers of overburden collapse, injuries, and death. I even regretted my own cavalier visit to the interior of the clay mine at Hacienda Yo' K'at in 1968. At the time of our Sacalum visit in 2008, however, I had unconsciously repressed all these accounts.

Our visit corroborated our 1968 observations that the deposit of palygorskite once extended about another 5 meters into the cenote interior. Images of the cenote interior verified that as the layer of palygorskite was excavated northward from the cenote interior, it left a cavity that was the ancient mine. Subsequently, the rock above it had partially collapsed and left a talus along the north side of the cenote interior and a large cavity above it. In fact, all the rocks up to about 5 meters south of the mine cavity appeared to have fallen from the cenote ceiling (figure 5.9). The original mine excavation and subsequent collapse of the rock above the palygorskite deposit thus appeared to account for the cavelike feature of the cenote interior along its north side.

The Layer in the Cenote Wall

A second source of *sak lu'um* in the cenote is a thin layer of palygorskite exposed above the entrance to the mine. The first information about this source was not published until 1969.[36] Because my visits to the cenote in 1967 and with Bohor in 1968 occurred before its publication, I naturally did not know about it.

I first became aware of this source because one of my graduate school colleagues at the University of Illinois had done research in Yucatán with Dr. William Folan, then of Simon Fraser University, and my colleague had sent Folan a copy of my published thesis (1967). Folan subsequently wrote to me and reported that a colleague had identified palygorskite in a sample that he collected from the thin bands on the cenote wall in 1962.[37]

Folan did not know about the large mine at the time, and my report prompted him to publish his data about Sacalum. By the time his report was published in 1969, however, Bohor and I had already visited the cenote in 1968 and done a reconnaissance of the cenote interior, measured the size of the mine, and collected samples from the working faces of the palygorskite deposit in its interior. We did not investigate the bands of palygorskite on the walls of the cenote because we did not know about them and they were not pointed out to us at the time. To us, the discovery of the large mine was evidence enough that the people of Sacalum had removed massive amounts of palygorskite over a lengthy period.

When Bohor and I returned to the cenote in 2008, I wanted to investigate and sample the layers that Folan had described in 1969. I looked for them on the cenote walls, and about 1.5 meters above the entrance to the mine, a 6-centimeter layer of whitish clay was exposed. It appeared to be one of the thin bands of *sak lu'um* that Folan observed being mined in 1962. I collected samples from this layer over a linear distance of 10 meters. Using X-ray diffraction, Bohor identified these samples as palygorskite.[38]

Moving along the interior walls of the cenote on the top of the talus, I examined the entire perimeter of the cenote interior, but I found no other obvious layers of *sak lu'um* in the wall. Nevertheless, the talus around the cenote interior may have resulted from the detritus of mining activity from dissipated layers of palygorskite.

Why would miners use the thin layer on the cenote wall as a source of *sak lu'um* when an abundant, meter-thick layer of it lay inside the large mine just below it? There are three possible answers to this question. First, when Bohor visited the cenote in 1967, the mine was underwater from the rains of the wet season because it was so close to the level of ground water. So the seasonal flooding of the mine would make the palygorskite deposit there inaccessible for at least three to four months each year. Consequently, the only access to *sak lu'um* was the thin layer of palygorskite on the walls above the mine. Second, although it is unclear when the overburden in the front part of the mine collapsed, the talus could have blocked access to the mine; this may be the reason that Folan did not mention its existence during his 1962 visit. Third, ancient miners simply may have found it easier and safer to remove the *sak lu'um* from the thin layer above the mine on the cenote wall than from the cavity below. Perhaps they were just as intimidated by the perceived danger of entering the large mine below as Bohor and I were in 2008.

AN ANCIENT SOURCE

According to oral tradition reported by informants in Sacalum, the ancient Maya came from great distances to obtain *sak lu'um* for curing illness, and for this reason the village was named Sacalum. Most recently, the people of Sacalum also use *sak lu'um* for medicinal purposes. Therefore, the use of the cenote as a source of *sak lu'um* probably predates the name Sacalum for the town.

The removal of 589 cubic meters of palygorskite from the extended mine could not have occurred in the recent past. First, water in the mine made access to the palygorskite seasonally impossible since the floor of the mine lies so close to the local water table. If the mine was under water regularly at the end of the rainy season, it must have impeded the extraction of palygorskite in the past. Second, extraction of the palygorskite from the mine appears to occur slowly. Judging by the amount of palygorskite removed in the forty years between November of 1968 and May of 2008, little change occurred in digging areas within the mine. Third, palygorskite is extremely hard and is difficult to mine, even with a pick or machete. With the tools of wood, stone, antler, or bone that miners used to extract it before the Conquest, mining would inhibit the deposit's rapid depletion. Fourth, ancient miners would find their tools difficult to wield effectively in the restricted height of the mine, and the small size of the mine entrance limited the amount of *sak lu'um* removed. Consequently, the height of the cavity and the size of the entrance constrained the mining of the palygorskite, and it probably occurred over a lengthy period.

On the contrary, the great paucity of rainfall during the droughts of the Late Classic, Terminal Classic, and Postclassic periods may not have raised the water level enough to impede the extraction of the *sak lu'um* in the mine. This allowed more frequent access to the palygorskite layer and increased the amount extracted precisely when it was needed to create Maya Blue for more frequent appeals to the rain god, Chaak.

Since the name of the town of Sacalum is the Hispanicized form of the Maya term *sak lu'um* ("white earth") and the *sak lu'um* from its cenote has been identified as palygorskite, mentions of the town in historical and ethnohistorical sources provide some evidence of the time-depth of palygorskite mining there. Its earliest mention appears in the 1549 tax list made seven years after the Spanish Conquest.[39] In the 1557 map of Yucatán the name of the town appeared again, but with a spelling (*şac luum*) that more closely matches the pronunciation of the actual Maya name, *sak lu'um*, than its Hispanicized form, Sacalum.[40] Both of these mentions indicate that the mining of palygorskite dated at least to the Spanish Conquest of Yucatán in 1542.

Ethnohistoric evidence also reveals that the ancient Maya mined palygorskite in the cenote before the Conquest. Indeed, the Book of Chilam Balam of Chumayel, a pre-Conquest narrative that came to light after the Conquest, mentions Zacluum-cheen (literally, "*sak lu'um* cenote" or "*sak lu'um* well") as a stopover during the migration of the Itzá Maya from the east coast of the peninsula to Chichén Itzá, and Folan links two of the towns mentioned in the narrative (Ticul and Sacalum) to the use of *sak lu'um*. At Ppoole (Polé or Xcaret), it says, the Itzá married, took the local women "as their mothers," and increased their numbers. At Kikil they contracted dysentery, and at Ticul, Zacluum-cheen (Sacalum), and Tixtohilcheen (Xtohil), the Itzá "recovered their health."[41]

Although Folan says that the narrative tends to force association between the actions of the Itzá and the meaning of the names of the Maya settlements through which they passed, he argues that the Itzá obtained *sak lu'um* at Zacluum-cheen and Ticul, enabling them to recover from the dysentery contracted in Kikil and to satisfy their pregnant wives' craving to eat chalky substances. These uses are consonant with ethnographic data from the inhabitants of Sacalum who said that *sak lu'um* was distributed widely, that it provided relief from stomach trouble and diarrhea, was eaten by pregnant women, and given to children who had the *vicio* (vice) of eating dirt. These practices are also similar to its medicinal uses in modern Ticul. Folan suggested that Tixtohilcheen (Xtohil) was another source of *sak lu'um* or something else of medicinal value.[42] If the knowledge recorded in the Book of Chilam Balam was part of a widely known Maya cultural heritage, then Sacalum was a widely known source of the curative *sak lu'um* in antiquity.

A more recent translation of the Book of Chilam Balam of Chumayel by Munro Edmonson provides a scenario different from the translation by Ralph L. Roys that Folan used.[43] Edmonson ties the portion of the narrative mentioning Sacalum to the Maya calendar and says that the movement of the Itzá was a ceremonial circuit that took place in 1539, three years before the Conquest.[44] If this journey was a historical event, however, this date seems too late.

> Then they came to Tz'am,
> And soaked for three days.
> Then they went to Ticul,
> To Zac Luum Ch'een,
> And Ix Tohil Ch'een
> Which straightened then their hearts.[45]

In this passage of the document, the narrative says that the Itzá traveled from Maní (east of Ticul) to Ts'am (modern Dzan), located between Ticul and Maní, and then to Ticul before they went to Sacalum (figure 5.11).[46] The "Ticul" of which the narrative speaks, however, was not the modern city of Ticul but rather the ancient site of Ticul, called San Francisco de Ticul, which lies directly north of modern city.[47] That site was an important political center in the Terminal Classic period.[48] It was moved south to its present location in the early colonial period.[49]

The journey of the Itzá from Dzan to San Francisco de Ticul and then to Sacalum would have taken them right through, or near, the archaeological site of Yo' Sah Kab, where potters mined sak lu'um and pottery temper. It is now difficult to fix the exact location of this site, but my reconnaissance of Yo' Sah Kab in 1967 placed the site on the north side of the Ticul-Chapab road approximately 3.3 kilometers from Ticul.[50] If the Itzá actually obtained sak lu'um in Ticul, as Folan suggested, that source likely was Yo' Sah Kab. The Terminal Classic occupation located on top of the sak lu'um deposit there lies close (0.38 kilometers southwest of it) to a straight line from the center of Dzan to the Sacalum cenote and passes through mining areas of Yo' Sah Kab utilized during the period 1965–2008. If, on the other hand, the Itzá went from Dzan to ancient Ticul (San Francisco de Ticul), they may have passed through the mining areas of Yo' Sah Kab, but no more than 1.17 kilometers northeast of it. Both locations were calculated from the point where the straight line crossed the road from Ticul to Chapab (figure 5.11).

If the Itzá obtained palygorskite in Sacalum and Ticul, as Folan suggested from his reading of the Book of Chilam Balam of Chumayel, those sources likely precede the late prehistoric date attributed to them by Edmonson. Like the archaeological site at Yo' Sah Kab and San Francisco de Ticul, Dzan also has ancient occupation that dates to the Terminal Classic period.[51] Just as the Terminal Classic site at Yo' Sah Kab lies over a palygorskite deposit, mining sak lu'um in the Sacalum mine dates at least to that period. Folan found Terminal Classic pottery at the bottom of the cenote and suggested that the Maya might have used the layer in the walls of the cenote as a source for sak lu'um at that time.[52] As a part of Maya Indigenous knowledge, the medical uses of sak lu'um thus probably extends at least to the Terminal Classic period as well.

In 1967 I suggested that Sacalum might also have been a production center for Maya Blue or a center for mining the palygorskite used to make it. This suggestion was consonant with Shepard's and Shepard and Gottlieb's belief that Maya Blue was widely traded from a source on the Yucatán Peninsula

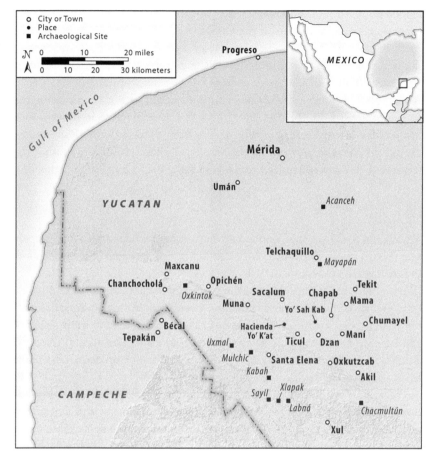

FIGURE 5.11. *Map of the northwestern portion of the Yucatán Peninsula showing some of the places mentioned in the text. (Map by Chelsea M. Feeney, www.cmcfeeney.com.)*

because its copious use on pottery intended for household ritual at Mayapán indicated a local source. Since Sacalum is only 20 kilometers from Mayapán, Sacalum could easily be the source of palygorskite for the Maya Blue used there. Indeed, 20 kilometers lies at the lower end of worldwide distances that potters go to acquire to slip and paint resources.[53]

In addition to the ethnohistorical and archaeological evidence of mining *sak lu'um* at Sacalum and Yo' Sah Kab, the size of these deposits indicates their potential as ancient sources of palygorskite for Maya Blue. Both sources have an extensive palygorskite layer with a thickness of at least a meter. If one

includes the marl layer above the solid palygorskite layer at Yo' Sah Kab, the palygorskite-containing deposit there reaches a thickness of 3–4 meters. Even though the amount of the mineral extracted from Yo' Sah Kab in antiquity is unknown, the massive extraction of as little as 307 cubic meters to as much as 589 cubic meters of palygorskite from the Sacalum mine indicates that it was a significant source of *sak lu'um* in antiquity, even without considering the amount removed from the thin layer in the cenote wall above it. Indeed, comparison of the trace elements in palygorskite from Sacalum with those in some examples of Maya Blue from the Osario at Chichén Itzá indicates that the palygorskite in them did indeed come from the mine in Sacalum (chapter 8).[54]

SUMMARY

According to Maya Indigenous knowledge revealed through ethnographic research, two major sources of palygorskite occur in Yucatán: Sacalum and Yo' Sah Kab near Ticul.

The community of Sacalum and the potters of Ticul recognize the physical characteristics of *sak lu'um*, and the sources in or near these communities have massive deposits of it in layers of at least 1 meter (Sacalum) or more (Yo' Sah Kab). Mining activity at both sites also has a long time-depth and thus contributes a significant part of the Maya cultural heritage as modern and ancient sources of palygorskite.

Verification, corroboration, and the reproduction of results by other scholars are cornerstones of scientific research. This process is no less true for anthropology and archaeology than it is for the more experimental approaches in the biological and physical sciences. Not only have my twelve research visits to Yucatán between 1965 and 2008 repeatedly verified that Sacalum and Yo' Sah Kab (and nearby) were important sources of palygorskite, but many geologists, material scientists, and chemists have traveled to Sacalum and the Yo' Sah Kab sources, obtained samples of *sak lu'um* for their own research, implicitly verifying my original hypothesis in 1967 that *sak lu'um* from these resources is indeed palygorskite. The presence of a massive bed of palygorskite and the mine within it at Sacalum was confirmed by Isphording and Wilson in 1974 and Isphording in 1984, and by Cisneros de Leon and colleagues in 2019. Further, Littmann, José-Yacamán et al., and Polette-Niewold et al. obtained samples of palygorskite from Sacalum that they reported in 1980, 1996, and 2007 respectively. Cisneros de León et al. also confirmed the existence of the thin band of palygorskite above the mine in 2019 that was originally identified by Folan in 1969 and observed later by me and Bohor in 2008.[55]

Unfortunately, the Indigenous knowledge concerning *sak lu'um* is disappearing, largely because of the disappearance of the Maya language. When Sánchez del Río and colleagues visited the Sacalum cenote during the early 2000s, they referred to the palygorskite there by the Hispanicized name (*sacalum*) rather than its Maya name (*sak lu'um*). A decade earlier, Reyes-Valerio also called the clay *sacalum*.[56] Although using this terminology may have resulted from questioning informants in Spanish rather than Yucatec Maya, I had already noted that Maya Indigenous knowledge and its context within the Maya language was already being lost in the latter part of the twentieth century. Indeed, when Bohor and I visited the Sacalum cenote in 2008, informants also referred to palygorskite from the mine as *sacalum* rather than *sak lu'um*. It is, of course, possible to regain knowledge of Yucatec Maya, but not the Indigenous knowledge tied to it such as that described in *Maya Potters' Indigenous Knowledge*.[57] Similarly, one can learn Latin but not regain the unwritten knowledge of Roman times associated with it.

The amount and extent of palygorskite at Yo' Sah Kab and in the Sacalum cenote raises another question with a potential avenue of research. Were there other ancient sources of *sak lu'um* that were used to make Maya Blue? This question will be answered in the next chapter, but as we shall see, no other community has such massive deposits that were accessible to the ancient Maya, and no other community appears to recognize the term *sak lu'um* or a linguistic category with a meaning that corresponds to the properties of palygorskite. Furthermore, the amount and extent of palygorskite from Yo' Sah Kab and Sacalum are much greater than elsewhere, and the existence of palygorskite in these locations could not be consistently verified over time.

6

Scientific research does not always move in a straight line toward an answer to a question or to a solution of a problem. As scientists discover new data, new leads develop with new hypotheses. Just as a lead in a mystery may result in a dead end, a lead in the search for answers to questions about Maya Blue may lead nowhere. Or it may produce interesting and important hypotheses but not really produce significant answers to the original question. One such lead was the discovery that palygorskite occurred in many areas of Yucatán.

HISTORY

By early 1966 it was clear to me that the temper mines at Yo' Sah Kab near Ticul were likely an important location for palygorskite used for Maya Blue because of the cultural link between potters' category of *sak lu'um* and palygorskite and the association of *sak lu'um* with the temper mines there. The cenote in Sacalum was likely an ancient source for the palygorskite to create the pigment as well. Later that year I had visited with Anna Shepard and learned that she and her colleagues had found palygorskite in potters' materials in Ticul, Becal, and Mama. It was thus clear that palygorskite occurred elsewhere in Yucatán besides Ticul and Sacalum.

Did the ancient Maya use these other sources of palygorskite to make Maya Blue? More important, how widespread was the Maya Indigenous knowledge about the properties of *sak lu'um*, and did the term *sak lu'um*

https://doi.org/10.5876/9781646426683.c006

exist among Maya speakers elsewhere in Yucatán? Further, how might the geological occurrence of palygorskite elsewhere relate to the Maya perception of the sources of *sak lu'um*? These questions led me to search for other sources of palygorskite that the ancient Maya might have used to create Maya Blue.

Unfortunately, changes in my PhD program distracted me from the Maya Blue mystery and from searching for more sources of palygorskite in Yucatán. When I returned from Yucatán in 1965, I was assigned a new advisor, Dr. Donald W. Lathrap, a South American archaeologist, and consonant with his expertise he moved me away from research in Yucatán toward dissertation research in South America. So I finished my master's thesis about *sak lu'um* and Maya Blue, but my interest in Maya Blue, palygorskite, and Yucatán remained strong.

By mid-1966, I had received a three-year fellowship that involved a trip to Peru to do my dissertation research during the first half of 1967.[1] Although that trip temporarily distracted me from research on Maya potters and pottery materials, I planned to stop in Yucatán upon my return from South America.

During that stopover I visited the Sacalum cenote and worked with my Ticul informants again. That interaction led to the discovery of the archaeological site at Yo' Sah Kab (see chapter 5). In addition, I traveled to the pottery-making communities of Becal, Maxcanú and Tepakán. I found no potters in Becal (figure 5.11). In Maxcanú and Tepakán, I talked to potters, collected samples, and briefly searched for other deposits of *sak lu'um* elsewhere. I also visited one source that my informants identified near Uxmal.

Meanwhile, clay mineralogist B. F. Bohor of the Illinois Geological Survey became interested in the palygorskite occurrences in Yucatán. He and his graduate assistant had analyzed my original samples from Yucatán using X-ray diffraction, and he applied for a grant from the University of Illinois Research Board for both of us to travel to Yucatán during November of 1968 to search for additional sources of palygorskite. We visited Ticul, Sacalum, Mama, Maxcanú, and Tepakán (figure 5.11). When we learned that there were potters in Akil and Peto, we went there as well. The few potters in Akil worked seasonally, making food bowls and incense burners for the Day of the Dead rituals in late October and early November. We found potters in Peto, but they had quit making pots six years earlier. Since Shepard had identified palygorskite in materials from Becal, I wanted to return there and see if I had missed finding potters during my visit the previous year, but we found none. In all the pottery-making communities we visited, we talked to potters and obtained samples of their raw materials; where possible, we visited their sources and collected samples from them.

Bohor and I looked for potential sources of palygorskite elsewhere as well but were limited to places where the subsurface geology was exposed or accessible. The most obvious such locations were the quarries used to mine the ubiquitous marl (called *sah kab*) that the Maya had used for many centuries to prepare mortars, plasters, and surfacing materials.[2] So we investigated every quarry that we encountered and collected samples from each, especially those that looked like *sak lu'um*. None, however, contained palygorskite. Other source locations were road and railroad cuts through hillocks that exposed the subsurface geology, and we collected samples from those as well as those that appeared to be *sak lu'um*.

OTHER DEPOSITS

Outside of the culturally recognized sources of palygorskite that were part of Maya cultural heritage and described in the previous chapter, Bohor and I found several other palygorskite deposits.

MAMA

One location that was shown to have palygorskite repeatedly is the sinkhole that Mama potters used to obtain their raw materials. Raymond Thompson visited the village in 1951 and collected samples from the potters there, but he did not mention a visit to the source of those samples. Anna O. Shepard and her colleagues analyzed them and identified palygorskite in them, recounting this result in a letter to me in 1966 (see chapter 4).

Knowing that palygorskite was found in pottery materials from Mama, Bohor and I wanted to visit the source of these materials during our trip to Yucatán in 1968. This source was a large sinkhole that Thompson said was located along the trail to Chumayel.[3] We went to Mama and asked two local men to take us to the sinkhole.

I remember the trek well because it was a sweltering day, even though it was early November. It was an exhausting hike in the middle of the day, and I was not feeling well because of a headache. Consequesntly, the trek seemed to take a long time, but we eventually arrived at the edge of the sinkhole and followed the path down into its large, shallow interior. We collected samples from each area that our informants indicated were the sources of pottery-making materials. When we arrived back in Urbana, Bohor analyzed the samples using X-ray diffraction and found palygorskite in one of the materials (*xlu'um hi'*) used for making pottery.

In 1971 Anna O. Shepard and H. E. Pollock published the results of their analyses of the pottery-making materials collected by Raymond Thompson twenty years earlier. They reported that palygorskite (attapulgite) was found in temper from Ticul (*sascab*) and Becal (*cu'ut*) and in potters' clay and two types of pottery temper (*chi'ich'hi'* and *xlu'um hi'*) from Mama that presumably came from the same sinkhole that Bohor and I visited in 1968.[4]

Bohor's identification of palygorskite in only one of the materials that we collected in contrast to its presence in two of the samples collected by Thompson indicates that the presence of palygorskite in the Mama materials appears to vary over time and that the sinkhole was not a consistent source of palygorskite through the years. Furthermore, we found that Mama potters were not aware of the presence of *sak lu'um* or any other category that matched the characteristics of palygorskite, and there were no deposits in the cenote that looked like the *sak lu'um* at Yo' Sah Kab or that from the Sacalum mine.

I returned to Mama in 1994 and visited the sinkhole again. By this time, there was a road to Chumayel, and the sinkhole was located just southwest of the junction of the highway from Tekit to Chumayel.[5] Again, I wanted to find out whether potters in Mama recognized the term *sak lu'um* and/or whether they knew the properties of a unique material that corresponded to palygorskite. On the contrary, they did not know the linguistic and semantic category *sak lu'um* and did not know the physical characteristics of any material that corresponded to the properties of palygorskite. Even though some of the raw materials from the Mama sinkhole contained palygorskite, there was no deposit with the characteristics of *sak lu'um* that was large enough or distinctive enough to equal the massive deposits of *sak lu'um* at Yo' Sah Kab and in Sacalum that informants identified as corresponding to the properties of palygorskite. None of the samples from Mama with palygorskite were like the *sak lu'um* collected in Sacalum or at Yo' Sah Kab, and none were called *sak lu'um*.

The Source near Uxmal

Another source of *sak lu'um* was discovered by potters who worked at the Hacienda Uxmal, a tourist hotel located across the highway from the entrance to the archaeological site. Between late 1956 and 1982 the hotel employed a small group of Ticul potters to make decorative items for the rooms, hallways, and souvenir shop of the hotel.[6] Rather than import all their materials from Ticul, potters tried to find a more local source of temper that contained *sak lu'um*. Their search turned up a small deposit in a roadcut through a knoll about 1 kilometer east of Uxmal along the highway to Santa Elena. An informant

took me to the deposit in 1967, and I collected a sample from it. Using X-ray diffraction, Bohor found that it was indeed palygorskite. Bohor and I sampled it again in 1968, collecting samples from both sides of the road, and verified that the material from there was indeed palygorskite, but the amount of *sak lu'um* present in the deposit was small. The Uxmal potters did not use this source for long and subsequently brought all their temper from Ticul.

MAXCANÚ

When Bohor and I visited potters in Maxcanú in 1968, informants took us to a raw material source near the railroad track that linked Mérida and the city of Campeche to the south, and we noticed that the rail line cut through the western edge of the *puuc* ridge, exposing its profile. We explored the cut, photographed and drew it, and collected samples from it. We took a sample of what looked like *sak lu'um* from the east side of the cut, and using X-ray diffraction, Bohor identified it as palygorskite.[7] In the early 2000s Sánchez del Río and colleagues also found palygorskite in two samples from that same railroad cut.[8] Returning to this cut in 2008, however, Bohor and I discovered that much of the profile had sloughed away, and although some of the material looked like *sak lu'um*, X-ray diffraction analyses of our samples revealed that they were not palygorskite.[9]

MANÍ

Although I had visited the cenote in Maní in 1967, Bohor visited it later that year and collected a sample from its wall. Using X-ray diffraction, he identified it as palygorskite.[10]

THE PETÉN

During my first year of teaching at Penn State, I received a university research grant to study contemporary pottery making in communities in the Valley of Guatemala during the summer of 1970 to test the assumptions used to interpret the data from the neutron activation analysis of pottery. Penn State's anthropology department had already begun a project of excavation and survey of the site of Kaminaljuyu in the Valley of Guatemala, and my ethnographic study presumably would complement their archaeological research.[11]

Maya Blue was still very much on my mind at the time, and I was interested in looking for sources of palygorskite in Guatemala. Potters in Chinautla and

Sacojito near Guatemala City used a white clay, and these potters and those in the neighboring hamlet of Durazno obtained another clay for a white slip from a location called Lo de Reyes approximately 6 kilometers east northeast of Sacojito.[12] All of these clays looked like palygorskite, but analyses of them indicated that they were not.

My association with the Kaminaljuyu project provided other opportunities to discover sources of palygorskite in Guatemala. As part of the learning experience for graduate students and his colleagues, the director of the project, Dr. William Sanders, took project participants on trips throughout Guatemala to visit archaeological sites. On one of these trips we traveled overland to the site of Tikal, deep in the Petén region in the northern part of the country. From my research with Bohor two years previously, I had learned that palygorskite had formed from volcanic ash falling into highly saline magnesium-enriched water behind reef structures and that these structures sometimes were exposed in road and railroad cuts through hillocks. So during the trip to Tikal I noticed that roadcuts along the way exposed the same geomorphology that I saw in the roadcut near Uxmal and in the railroad cut near Maxcanú. So, I collected samples from four roadcuts in the Petén between Lake Izabal and Tikal. Two samples came from northwest of Lake Izabal, and the other two samples came from roadcuts in or near Tikal National Park.[13] Bohor analyzed these samples using X-ray diffraction and identified palygorskite (with much dolomite and some quartz) in only one sample, which came from a cut in the road that climbed into the Sierra of Santa Cruz northwest of the ferry at San Felipe.

In the late 1970s and beyond, our discovery of these and other deposits of palygorskite were verified and corroborated by others. Isphording as well as Isphording and Wilson believed that palygorskite was common in Yucatán, but they said that the mineral occurs in "isolated, relatively thin lenses that are rarely traceable for more than a few tens of meters, laterally."[14] These statements, however, do not fit my experience during my repeated visits to Yucatán over forty-three years: extensive deposits of palygorskite exist in Sacalum, Yo' Sah Kab, and near Chapab that measure a meter or more in thickness (see chapters 4 and 5).[15]

Other deposits of palygorskite were reported by Liberto de Pablo-Galán in 1996, and he refers them as palygorskite mudstone. This description fits the Maya potters' perception of *sak lu'um* as rocklike and its occasional classification by Ticul potters as "white earth-rock" (*sak lu'um tunich*). In addition, Pablo-Galán reported a deposit that seems to be the same as the one that we had visited twenty-eight years earlier near Maxcanú and reported

by Bohor in 1968, but Pablo-Galán found other deposits of palygorskite-rich mudstone less than 3 meters high and 15 meters in diameter around Umán, Muna, Chapab, Uxmal, and Ticul.[16] The Ticul and Chapab deposits were likely those described in the previous chapter, but the exact locations of these and other deposits were not explicit in his article. Isphording also reported that "palygorskite (attapulgite) is . . . locally common at several sites north of the Sierra de Ticul and was identified in several half-meter lenses along the Xul-Oxkutzcab road, not too far from Loltun cave, at two sites near Peto, and as a 10 cm lens of paper-thin layers within 2 kilometers of Edzná."[17]

Another deposit of palygorskite was reported in 2009 by Krekeler and Kerns in a roadcut in the State of Quintana Roo about 50 kilometers northwest of Chetumal. Sánchez del Río and colleagues also reported other sources of palygorskite in addition to those described above in southern part of the state of Yucatán near Chanchocholá.[18]

Could the ancient Maya have used any of these sources of palygorskite to create Maya Blue? Probably not. Geological occurrences of palygorskite do not necessarily indicate that the mineral was accessible and available to the ancient Maya. Rather, the ancient sources of palygorskite need to be understood in relationship to the ancient landscape and the Maya's perception of it. This ancient landscape is different from the contemporary landscape, which has been altered by modern technology.

If palygorskite was so common in Yucatán, why are massive deposits of palygorskite associated with only two Maya place-names: Sacalum (palygorskite) and Yo' Sah Kab (palygorskite and palygorskite-containing marl for pottery temper)? Why, if the mineral was so widespread in Yucatán, did the Maya come from great distances to obtain the *sak lu'um* from the Sacalum cenote, and why do oral history and ethnographic data indicate that it was transported and sold elsewhere in Yucatán for decades, perhaps for centuries?

Consequently, all these other locations were unlikely candidates for sources of palygorskite used in the production of Maya Blue. All were small, and almost all are in road and railroad cuts.[19] The exposure of palygorskite deposits in a topography altered by roads and railroads indicate that the ancient Maya could not access them because they lacked metal tools, heavy earth-moving equipment, and explosives. Most important, these other sources were overshadowed by the massive amounts of pure palygorskite found in Sacalum and Yo' Sah Kab that they *could* access easily. No other known deposits of palygorskite would have been accessible enough, large enough, or comparable to the estimated 589 cubic meters of palygorskite removed from the mine in the Sacalum cenote or the extensive deposit at Yo' Sah Kab.

The single possible exception to the ancient Maya's inaccessibility to other palygorskite deposits besides Yo' Sah Kab and Sacalum is the sinkhole from which Mama potters obtained their raw materials. This sinkhole was an ancient source of pottery materials for Mama potters and was not exposed by metal tools and explosives. It was certainly part of the ancient Maya landscape, but Mama potters did not recognize a material called *sak lu'um* or any other material that corresponded to the properties of palygorskite. In this case, the presence of palygorskite in these raw materials was coincidental. The potters did not select these materials because of the presence of palygorskite in them, but rather because the sinkhole was simply the traditional source of their raw materials based on their cultural heritage.

The palygorskite in the pottery raw materials from Mama sinkhole, however, probably did convey some technological advantage to the pottery made from it, and it probably produced better-quality pottery than other materials obtained nearby.[20] Mama potters, however, could not control the presence of palygorskite in their raw materials in the way that Ticul potters did when their temper proved to be inferior and their vessels broke during drying and firing. But the Mama potters could vary their paste preparation recipe, as they did between 1951 and 1994.[21] Nevertheless, paste recipes failed as a solution to declining quality of raw materials, and losses of pottery from inferior-quality raw materials increased from 1968 to 1994. During my 1968 visit, pottery making was still viable, but an informant reported losses of 16%–25%, which included 20% of the food bowls and 12%–25% of a kiln load of twenty-four water-carrying pots. During my visit to Mama in 1994, one man who fired his wife's pottery complained that 40% of it broke during firing and that production could not be sustained with such a high loss. By that time, however, pottery making in Mama had declined greatly and was practiced only by two women who only made food bowls seasonally for the Day of the Dead ceremonies.

The ancient Maya could not perceive the presence of palygorskite mineralogically in soils and clays of Yucatán and did not select their raw materials using that criterion. Like the modern Maya of Sacalum and the potters in Ticul, the ancient Maya were not clay mineralogists; rather, they made choices based upon the cultural heritage of known sources provided by oral history, tradition, and narratives like that recorded in the Book of Chilam Balam of Chumayel. This cultural heritage also made them aware of the unique physical properties of *sak lu'um* that contrasted with those of other mineral categories: it was white, hard, and lightweight, and it became soft and pliable when enough water was added to it.[22] These properties corresponded to palygorskite mudstone.

These dramatic physical characteristics of *sak lu'um* from Sacalum and Yo' Sah Kab made these locations distinctive and unique, even though palygorskite was found elsewhere in smaller quantities. The Maya category "white earth" (*sak lu'um*), however, was not recognized as occurring in other communities, and the presence of palygorskite in the ceramic raw materials from them (such as the sinkhole near the village of Mama) could best be described as coincidental and simply a consequence of the sources used. Ticul potters and the inhabitants of Sacalum thus appeared to be the only populations of Yucatán that recognized the properties of *sak lu'um* and its unique presence in or near these communities and used it for medicinal uses or for pottery temper. Further, being peddled throughout the area by traders from Sacalum, and to a lesser extent from Ticul, indicates that palygorskite, although widely known in Yucatán as *sak lu'um*, was not widely available among the contemporary Maya. Consequently, the mere presence of palygorskite in the clays and soils of Yucatán is insufficient evidence that the ancient Maya used these other sources to make Maya Blue.

PROBLEMS OF SELECTING *SAK LU'UM*

As I have said repeatedly, even though *sak lu'um* is palygorskite, the Maya who use it do not perceive the presence of palygorskite mineralogically. Rather, they recognize the unique physical properties of *sak lu'um* that are found in sources that are part of their cultural heritage. This point can be illustrated by some examples of my own engagement with potters' raw materials.

During our 2008 trip to Yucatán, Bruce Bohor and I visited many locations with palygorskite. In some, the presence of *sak lu'um* was obvious, but in others it was not. In Sacalum we knew that the large mine of *sak lu'um* was indeed palygorskite because of oral history and from the X-ray diffraction patterns of mine samples collected four decades previously.

The thin layer of *sak lu'um* in the Sacalum cenote that Folan had reported, however, was more ambiguous. When Bohor and I visited the cenote in 2008, it was not clear whether the thin layer of white clay we found above the mine was the layer of palygorskite described by Folan. First, Folan's description of the location of the palygorskite layer in the wall of the cenote was very general, noting that "thin, horizontal veins of *sac lu'um* in the cenote had been worked recently by the local residents."[23] Second, the material in this layer did not have the same physical properties as the material from the mine below. It was wetter and less solid. Nevertheless, Folan found that the clay from a thin layer in the cenote wall, such as this one, was called *sak lu'um* and was associated

with the name of the town (Sacalum). So it was likely that the layer that we encountered in 2008 was indeed the same as Folan's because of the cultural heritage of Sacalum. Bohor's analyses of this clay confirmed that it was indeed palygorskite. Years later, Cisneros de León and colleagues also verified that the clay in this layer was palygorskite.[24] Consequently, even though this clay did not conform explicitly to the Maya definition of the properties of *sak lu'um*, the cultural heritage of the cenote as a source of *sak lu'um* became the critical factor in initially identifying that layer as a source of palygorskite.

Similarly, the cultural heritage of Yo' Sah Kab and the physical properties of *sak lu'um* were critical in the opening of the new source of *sak lu'um*-containing temper nearer Chapab. When, in the mid-1980s, a hauler delivering temper from Yo' Sah Kab thought he had found *sak lu'um* on his land nearer Chapab, he brought a temper miner to the site to corroborate his identification. The material did indeed turn out to be *sak lu'um*, and since that time this new mining area has become an important source of *sak lu'um* and pottery temper for Ticul potters.[25]

When Bohor and I visited the Chapab mines in 2008, the cultural heritage of nearby Yo' Sah Kab and the properties of *sak lu'um* provided the context for identifying *sak lu'um* in the new mining area, just as the similarity of its physical properties of *sak lu'um* to those of Yo' Sah Kab led to the original development of temper mining there more than twenty years earlier.[26] So I used the potter's criteria to select samples of *sak lu'um* for analysis at the Chapab source. Some of these samples came from the interior of the mines, and others were chunks from the mine tailings.

Many times, after taking a sample in hand, Bohor would ask me if it was *sak lu'um*. I found it ironic that an experienced clay mineralogist would ask me to identify a clay mineral that the contemporary Maya potters knew as *sak lu'um*. My answers were sometimes "yes" and sometimes "no." Some samples were *sak lu'um*, and others were not. My experience of working with *sak lu'um* over a period of more than forty-three years, and seeing Ticul potters select and use it, enabled me to know its properties: white, hard, rocklike, but lightweight. At Yo' Sah Kab and Chapab mines I checked the accuracy of my selections with my informant, and he agreed that I had indeed selected *sak lu'um*. All my selections of *sak lu'um* from these locations turned out to be palygorskite. Like the potters' perception of the physical properties of *sak lu'um*, my knowledge of *sak lu'um* was first anchored in its physical properties and then in the Maya heritage of the sense of place associated with Yo' Sah Kab. Since the mid-1980s, however, potters and miners had applied that knowledge to the new source nearer Chapab.

Were it not for the massive demand for tourist pottery and large plant pots from stores and hotels in Cancún, temper mining probably would have remained at Yo' Sah Kab rather than changing to the Chapab source.[27] Using the Maya criteria for *sak lu'um* to identify and confirm its presence there made the movement to the Chapab source possible.

Selecting samples from other sources of *sak lu'um* that were not part of the Maya cultural heritage produced vastly different results. During my 2008 research visit to Ticul with Bohor, I tried to use the same selection criteria that I used at Yo' Sah Kab and Chapab at what I thought were other deposits of palygorskite, but analyses by Bohor indicated that they were not. For example, I collected samples of a white clay from a bed in a roadcut along the highway from Opichén to Maxcanú at the turn-off to the ruins of Oxkintok (figure 5.11). I thought that it might be *sak lu'um*, but subsequent analyses of it indicated that it was not palygorskite.[28] In retrospect, I realized that it did not match the physical properties of *sak lu'um*. Here again, the clay collected in the sample must not only match the physical properties of *sak lu'um* but must also reflect the cultural heritage of its sources.

A similar problem existed with collecting samples in the railroad cut near Maxcanú that Bohor and I visited in 2008. We had explored this cut in 1968, had drawn a profile of it, and had found palygorskite back of a reef structure.[29] By 2008, however, the sides of the cut had collapsed and eroded. The samples of white clay that we collected appeared to be *sak lu'um* but were not palygorskite. Again, all white clays are not palygorskite. Consequently, both the cultural heritage of a source and the match of the properties of a material to the Maya definition of *sak lu'um* are critical in finding possible ancient sources of palygorskite used in the production of Maya Blue.

In other cases, palygorskite discovered from the nontraditional sources outside of Maya cultural heritage did not reveal its consistent presence over time. They were so variable that locations discovered with palygorskite previously had none in subsequent visits. Sánchez del Río and colleagues experienced this problem in research reported in 2009.[30] They could not find the source along the Uxmal–Santa Elena highway that I had sampled in 1967 and 1968. Bohor and I also looked for this source again in 2008 but could not find it, either because of weathering and the amount of undergrowth or because it was so small that it had become exhausted. Further, Sánchez del Río and colleagues could not find the layer of palygorskite in the Maní cenote or locate the sinkhole near the village of Mama that was the source of the materials for the potters there. In the latter case, it was likely that practicing potters no longer existed in Mama who could help them locate the sinkhole. On the

other hand, they found palygorskite in the Maxcanú railroad cut where we found none in 2008, in a roadcut along the new Uxmal-Mérida highway,[31] and in a marl quarry near Chanchochoclá (figure 5.11).[32] The selection criteria of sampling of these locations is not clear from their article, but the intent seemed geological rather than cultural. Nevertheless, their analyses showed that some locations contained palygorskite and some did not. It appears, however, that they did not use the Maya potters' criteria for *sak lu'um* to collect their samples.

As noted above, these newly discovered sources were not part of the ancient Maya landscape as sources of *sak lu'um*. Rather, they emerged because of the modification of that landscape by roads and railroads using metal tools, explosives, and large mechanical equipment. Further, the variation of the identification of palygorskite in some places and not in others as well as the variation in its presence/absence in the same locations on separate occasions indicate the critical significance of Maya cultural heritage for consistently procuring *sak lu'um* to make Maya Blue. Sacalum and Yo' Sah Kab meet the criteria of cultural heritage, whereas the other occurrences of palygorskite do not. Only in Sacalum and at Yo' Sah Kab do massive deposits of palygorskite exist that consistently match the Maya's perception of the physical properties of *sak lu'um* and remained so over time.

The takeaway from trying to find new sources of palygorskite in the Maya area demonstrates that the ancient Maya faced the same challenges of identifying sources of palygorskite outside of Sacalum and Yo' Sah Kab, just as modern scientists do. Without the cultural heritage associated with the source of *sak lu'um* and the clear similarity of the physical properties that the Maya recognize, searching for new sources that were used by the ancient Maya will be unproductive. On the other hand, those who want to make Maya Blue (whether contemporary anthropologists, geologists, or artists) may be able to discover other sources of *sak lu'um*. Just as modern Ticul potters changed their source of *sak lu'um* to a location nearer Chapab in the 1980s, once the criteria for selecting *sak lu'um* is applied to a search for it in new areas, it is possible that new sources will be discovered. These sources, however, will not likely be those that the ancient Maya used consistently to make Maya Blue.

Another problem in discovering other ancient sources of palygorskite for Maya Blue rests upon the Maya's threshold of perception for the properties of *sak lu'um*. How much palygorskite needs to be present in a deposit before the Maya recognized it as *sak lu'um* and suitable for making Maya Blue? The answer to this question is difficult, if not unknowable, but the Maya likely found it simpler to use known sources of *sak lu'um* from their cultural heritage

rather than use unknown ones. The Aztec use of sepiolite to make Maya Blue during the Postclassic period (see chapters 11 and 12) complicates this problem.

In retrospect, looking for other sources of palygorskite in Yucatán may seem to be a distraction, unproductive, and a dead end. On the contrary, the search for these other sources of palygorskite and evaluating them reinforced the importance of the traditional sources of palygorskite at Sacalum and Yo' Sah Kab as part of Maya cultural heritage. From this evaluation alone, these sources were likely ancient sources of the clay used in the production of Maya Blue. As I will demonstrate in chapter 9, my work and that of my colleagues in comparing trace element analyses of Maya Blue and the palygorskite from these two sources indicates that they were indeed those that the ancient Maya used to obtain palygorskite to make their unusual blue pigment.

Besides palygorskite, there is another constituent of Maya Blue, indigo. This narrative now turns to describing the details of this other important ingredient.

7

By 1966 it looked like Maya Blue was a combination of indigo and palygorskite. This hypothesis was based upon Shepard's 1962 paper that proposed that Maya Blue was a clay-organic complex as well as Gettens's belief that the blue component might be indigo. In November of 1966, Van Olphen reported his synthesis of a blue pigment combining palygorskite and indigo that emulated all the characteristics of Maya Blue.[1]

After reading Van Olphen's report, I convinced a graduate student colleague in chemistry at the University of Illinois, Stanley Anderson, to try to create Maya Blue using Van Olphen's method of mixing indigo powder and palygorskite and then heating it. I had already collected a sizable amount of palygorskite from Yucatán, and my colleague could obtain synthetic indigo from the stockroom of the chemistry department.

We went to his lab and began the experiment. He ground the palygorskite and then added the indigo powder. He was unconvinced that only a small percentage of indigo was sufficient to make the pigment. So he added more and then heated the mixture. The color of the resulting mixture seemed too dark to be Maya Blue. Realizing this, and with my urging that the experiment should work, he retreated from his error by trying to extract the excess, and presumably uncombined, indigo with repeated washes with acetone—a technique that Van Olphen had used, although he added far less indigo than we did.[2] Throughout the extraction process, however, the acetone failed to lighten the color of the

pigment, even though each batch of fresh solvent was tinted slightly blue. After repeatedly discarding the acetone from each wash, my colleague decided that the cost of repeated use of acetone was too expensive to continue the process.

After decades of reflection about our failed experiment, I concluded that most of the indigo that we added to the mixture combined chemically with the palygorskite because the acetone failed to remove more of the color than it did. The beautiful Maya Blue–like color could have been created with far less indigo, but it appeared that most of the indigo we used had bound to the palygorskite, forming a stable pigment that was darker than Maya Blue. Consequently, it looked like palygorskite could adsorb a large amount of indigo and still form a stable compound.[3] In retrospect, I realized that this outcome illustrated one of the unique characteristics of palygorskite: its large surface area allows it to adsorb a large amount of water, dye, toxic chemicals, and leachate. When heated, the surface area of palygorskite increases with the loss of the water in the channels, allowing the clay to bind with more of the indigo.

This failed experiment indirectly verified the two salient points of Van Olphen's work. First, very little indigo is necessary to make Maya Blue; experiments have synthesized the pigment using as little as 0.5% indigo.[4] Second, sustained low heat (75°C–150°C) was critical to create the pigment, fix its color, and acquire its unique chemical and physical stability.[5] If the indigo had not combined with the palygorskite, we could have extracted more of it from the pigment with the acetone, and the acetone solution would have been a darker blue color than it was. Subsequently, others have replicated Van Olphen's results and suggested that his experiments emulated two of the techniques of how the pigment was made.

For the Maya, however, indigo is not a blue powder purchased commercially or conveniently found in the stockrooms of university chemistry departments. Rather, it is a blue dye that comes from the leaves and stems of several species of plants of the genus of *Indigofera* (from the Latin "indigo-bearing"). The most important of these species, *Indigofera suffruticosa* and *I. tinctoria*, were grown to extract the dye for commercial use. *Indigofera suffruticosa* was widely cultivated in the Americas during the Spanish colonial period for export to Europe. Because such widespread production began shortly after the Spanish Conquest in Mexico and Guatemala, *I. suffruticosa* has a long time-depth in the Americas long before the Conquest. At some point during the colonial period, *I. tinctoria* was introduced into the Americas from India to supplement this cultivation.[6]

THE ANTIQUITY OF PLANTS PRODUCING INDIGO

When my interest in Maya Blue began in the mid-1960s and I learned that the pigment was a combination of palygorskite and indigo, I wondered whether indigo, and the plant from which it came, existed in the Americas before the Spanish Conquest. Margaret A. Towle had described the use of indigo in the pre-Columbian Andes in a book published four years earlier,[7] but I wanted to find out whether there was pre-Columbian evidence for the plants and the dye in Mexico. Without direct evidence of datable dyed cloth and plant remains at the time, I wanted to know if there was another way to assess the relative antiquity of indigo in Mexico before the early sixteenth century. Critical to this quest was learning where the species of *Indigofera* grew and how widely they were distributed.

In the fall of 1966 I signed up for a course in South American archaeology taught by my advisor, Professor Donald W. Lathrap, who wanted me to have competence congruent with his expertise even though the course did not appear to be related to my interest in Maya Blue. I wanted to use the course requirements as an opportunity to learn more about the pigment. Lathrap had been heavily influenced by geographer Carl Sauer and his work on the diffusion of domesticated plants in the Americas. At the time, I learned that the great diversity of the potato varieties in the Andes indicated their Andean origin. Further, the botanical and archaeological work on maize, its varieties, and its relatives in Mesoamerica indicated its origin in Mexico. Consequently, I learned that the diversity of the distinct species and subspecies in an area indicates their deep evolutionary history in that location. Specifically, the greatest hybridization and diversification of plants within a genus occur in the geographical area of its longest development.[8] Without direct pre-Columbian evidence of indigo or the cloth dyed with it, could a distributional approach to the species of *Indigofera* reveal that it existed before the Spanish Conquest?

Lathrap's South American archaeology course required a research paper. So I asked Lathrap whether I could pursue a survey of the species of *Indigofera* in the Americas in general, and in Mexico in particular, and ascertain whether that evidence could reveal a pre-Columbian origin. He gave his consent, and I spent a considerable amount of time in the botanical literature in the biology library at the university where I had regular contact with a woman who became my wife. I consulted a variety of botanical descriptions in the publication series from the Field Museum, among many others. My paper, published twenty years later in the Mexican journal *Antropología y Técnica*, is summarized below, but juxtaposed with recent updates.[9]

First, botanists did not question whether indigo and plants in the genus of *Indigofera* existed in the Americas before the Spanish Conquest. Several botanists cited archaeologists who had discovered cloth dyed with indigo in Peru, particularly on its dry coast, but provided no evidence, except its color, that the dye was indigo as opposed to some other colorant.

Now, however, convincing evidence exists that the earliest use of indigo for dyeing occurred about 6,200 years ago at the site of Huaca Prieta on the northern coast of Peru. Although indigo-like dyes may be prepared from several genera and species of plants in South America, the source of the Huaca Prieta dye was believed to be a species in the genus *Indigofera*.[10]

Second, according to the botanical literature, historical sources from the sixteenth century indicated that indigo-producing plants in the Americas were not introduced species but rather were cultivated by Indigenous populations and were used for dyeing. The Spanish subsequently scaled up indigo cultivation for export.[11]

Consequently, indigo quickly became a significant export from Mexico.[12] By 1565, twenty years after the conquest of Yucatán (1542), the Spanish had established indigo production on the northern Yucatán Peninsula on a grand scale and were exporting it to Spain. It was also grown and exported from other areas of New Spain, such as Guatemala, El Salvador, the Mexican state of Campeche on the Gulf of Mexico, and Oaxaca, Michoacán, and Chiapas on the Pacific Coast.[13] Production continued through the eighteenth century and into the nineteenth century.

Third, although the Spanish introduced a species of indigo called *I. tinctoria* into the Americas, it was only one of the indigo species cultivated in New Spain during the colonial period. A native of India, it supplemented the cultivation of local species.[14]

Fourth, I discovered that there were many species of *Indigofera*. The distribution of these species extended from the southeastern United States to northwest Argentina. Seven were widely distributed. The greatest number of species, twenty-three, occurred in Mexico, with the highest frequency in the states of Puebla (six); Morelos, Mexico, and Veracruz (seven); Michoacán (eight); Oaxaca (nine); and Guerrero (ten). The most common and most widespread species was *Indigofera suffruticosa*, which was used for dyeing, among other uses.[15]

Some of the species documented in this literature, however, could be duplicates of the same plant with different botanical names in different areas or different plants having the same names—problems pointed out by Lathrap in his evaluation of my paper. Another problem could be sampling bias, with

some areas being more intensively collected, analyzed, and named than others. Nevertheless, even with these problems, there does appear to be great diversity of species in certain areas of Mexico, indicating that indigo antedates the Spanish Conquest. The number of species and their widespread distribution showed that plants in the genus *Indigofera* were old in the Americas, particularly in Mexico.

Now, however, with computerized databases and botanists checking the classifications of all plants—not just those in the genus of *Indigofera*—my paper is still a useful survey of the botanical, historical, and cultural data, even with its dated evidence. The plants in the genus of *Indigofera*, formerly placed in the Leguminosae family, are now in the Fabaceae family—a terminological replacement parallel to the reason for the change of the name attapulgite to palygorskite.[16] More important, the paper points the way as a series of hypotheses to be further tested and verified more thoroughly with a more in-depth and up-to-date survey of the botanical literature and other *Indigofera* species possibly used to make indigo in antiquity. Equally important, by documenting the wide variety of *Indigofera* species in the New World and their wide distribution, the paper indirectly demonstrated the great time-depth of the genus in the Americas, probably antedating the Conquest, and briefly surveyed some of the medical uses of the plant, which are expanded in more detail below using more recent literature.

The massive number of *Indigofera* species reveals that the genus has a long time-depth going back deep into antiquity. According to the *Tropicos* database of the Missouri Botanical Garden, botanists place 1,821 named species within the genus *Indigofera*,[17] and 1,828 species are named in the World Flora Online database.[18] Of those in the *Tropicos* database, 128 species names are invalid or illegitimate, and 136 names are valid. The status of the validity of the remaining 1,557 named species is unclear.

These species are distributed in the tropical areas across the world, and many of them are found only in the Americas. Of those in the Americas, *I. suffruticosa* is the best known, appears to be the most widespread, and was used to produce indigo in the colonial period. It does not occur outside the Americas and was not introduced in the colonial period like *I. tinctoria*. The ancient Maya probably used *I. suffruticosa* to create Maya Blue.

Besides a constituent of Maya Blue in the prehistoric and colonial periods, the Indigenous cultures of Mesoamerica used indigo for dying cloth such as wool, silk, linen, and cotton. Silk and linen (made from flax) were, of course, introduced to the New World after the Conquest, but dyeing cotton, a crop native to the New World, has a long history and extends back into the

pre-Hispanic period.[19] Sheep were also introduced into the New World after the Conquest, and their wool was also dyed, but in the Andes the wool from llamas, alpacas, and probably vicuñas was also a candidate for dyeing in antiquity, just as the wool from llamas and alpacas is today.

Between 1880 and 1882, Bayer synthesized the indigo molecule in Germany, and by the end of the nineteenth century artificial indigo was mass-produced, supplanting the demand for plant-based indigo.[20] Later, the development of aniline dyes further rendered the use of natural dyes like indigo unnecessary.

Nevertheless, synthetic indigo is still important as a dye for fabrics such as blue jeans, but like other cloth dyed with indigo, they fade over time.[21] By way of contrast, Maya Blue exhibits remarkable stability without fading over many hundreds of years in one of the world's harshest of climates. This characteristic, among others, indicates that Maya Blue is not simply the result of dyeing a clay, as described in chapter 3, but something else—a phenomenon that will be explored more deeply in chapter 10.

Finally, my research on indigo revealed a variety of names that Indigenous cultures used for the plant. Although the use of the Spanish word *añil* is common, the Indigenous languages of Mesoamerica have their own words for the plant, indicating that it was a part of their cultural heritage and not derived from a post-Conquest Spanish introduction. For example, the Yucatec Maya use the word *ch'oh* (*choh* in some orthographies) for the plant *I. suffruticosa*. Similarly, the most common word for the plant in central Mexico is *jiquilite* or sometimes *quilitl* and appears to be derived from the Aztec (Nahuatl) word *xiuhtic* (*xiuhquílitl*).[22] The use of this word for the indigo plant and its dye occurs almost exclusively in Mexico and Central America.[23] There are a variety of other indigenous names for the plant in Peru and for other species of indigo in south-central South America, although some names are obviously Spanish or derived from Spanish.[24]

MEDICINAL USES OF *INDIGOFERA SUFFRUTICOSA*

Besides dyeing, *Indigofera suffruticosa* and other species of *Indigofera* were used for medical purposes in many parts of the Americas. In Mexico it is used as a febrifuge and for purposes that exploit its vulnerary, antispasmodic, diuretic, and stomachic properties. Among the Yucatec Maya, *ch'oh* was a treatment for convulsions. The modern Maya also used it for "curing the wind of epilepsy" and for *x-tatac-moo-ik* (meaning unknown).[25] The Aztecs administered the plant as a treatment for urinary diseases and ulcers, as a remedy for syphilis, and as a poultice applied to the head to reduce fever.[26]

Given these medical uses by Indigenous peoples in the Americas, does *Indigofera suffruticosa* have genuine medicinal value verified by scientific research? Indeed it does, just as palygorskite does. Although not necessarily confirming the precise curative properties mentioned above, pharmacological research has demonstrated that an aqueous extract of its leaves provides action against twenty-two different bacterial and fungal organisms.[27]

In a summary of the botanical, ethnopharmacological, phytochemical, and pharmacological literature of *Indigofera suffruticosa* and its distribution, a Brazilian team found that the plant is used in popular medicine as a febrifuge and has antispasmodic, diuretic, abortive, and analgesic properties. Administered as a purgative or soothing agent for stomach and urinary problems and for jaundice and ulcers, it is also used (surprisingly) as an insecticide.[28]

The Brazilian team also identified more than forty chemical compounds from the indigo plant and isolated a few that came from its essential oils and its aqueous extracts. They found that the plant and its active compounds possess wide pharmacological actions, such as anti-inflammatory, antibacterial, antifungal, antitumoral, antioxidative, antimutagenic, anticonvulsant, gastroprotective, and hepatoprotective properties. Their review also documented many of these effects in experiments with laboratory animals (mice) using extracts from the plant in the hope that such research would eventually lead to the development of new drugs.[29]

HOW IS INDIGO DERIVED FROM THE *INDIGOFERA* PLANTS?

The process of producing indigo from the *Indigofera* plants is both a physical and chemical process. Knowledge of the process comes from the ethnographic and historical records of its extraction for commercial export and from reconstructing the process from experimental chemistry.

First, the young, tender stems and leaves of the plants are cut. The best time to do this is during the rainy season so that the plants can recover.[30] After cutting, there are two options for processing the stems and leaves.

For the first option, the cuttings are crushed and placed in a container of water and allowed to ferment. Sometimes warm water is used, and the mixture is repeatedly stirred. This process oxidizes the indigo precursors (such as indoxyl) in the plant to produce indigo. After many hours, the stems and leaves are removed, and the remaining liquid is stirred. Eventually, the insoluble indigo precipitates out of the solution and is collected from the bottom of the vessel and dried.[31]

This process was scaled up during the colonial period, and vats were used for crushing and soaking the sprigs of the *Indigofera* plants. The mixture in the first vat was stirred, and then the liquid was drained into another vat to filter out the remaining portions of the indigo plant. The liquid was stirred until it turned blue, with the insoluble indigo precipitating out of the solution, and then the precipitate was removed, filtered, and dried.[32]

For the second option, the leaves and stems are crushed in a suspension of quicklime in water.[33] This process reduces the indigo molecule to a water-soluble compound called leucoindigo. The coarse leaves and stems are removed, and the resulting mixture is stirred intensively over several days, oxidizing the leucoindigo to indigo and leaving it in suspension, which is then filtered. A variation of this method involves the boiling and cooling of the mixture before it is stirred and filtered.[34]

A QUALIFICATION

With the antiquity of the *Indigofera* species established and with our knowledge of the physical and chemical processes that produce a blue dye from the plant, it would seem that the mystery of how the Maya created the pigment is solved. Nevertheless, despite the ethnographic, historical, and experimental evidence for preparing Maya Blue by extracting indigo from the *Indigofera* species, and adding palygorskite to the solution, an anthropological and archaeological approach to the process reveals a different technique for making the pigment. That technique and its variations will be covered in subsequent chapters.

8

As illustrated earlier, one of the methodologies of scientific research (or of solving a mystery, for that matter) is hypothesis testing. Formulating a hypothesis is usually informed by data and experience as well as by one's creativity and imagination, but the hypothesis should be tested against a new, independent set of data to determine if it is true or false. In chapter 4, for example, I described how I tested the hypothesis that established the relationship of palygorskite and *sak lu'um* among the Maya potters of Ticul in 1966.

In chapter 5, I suggested that the traditional sources of *sak lu'um* at Yo' Sah Kab near Ticul and in Sacalum were probable ancient mining sites for palygorskite used in the production of Maya Blue based upon the amount of palygorskite present, the archaeological evidence, and their role in Maya cultural heritage. In the chapter that followed I identified several other deposits of palygorskite that were unlikely sources for the palygorskite in Maya Blue. So how can one verify that Yo' Sah Kab and Sacalum were the actual sources of palygorskite used in Maya Blue?

One way to answer this question is to use trace element analysis to compare the composition of modern palygorskite with that of Maya Blue. Trace element analysis involves analyzing a material for elements with extremely low concentrations. A clay deposit, for example, may have a unique trace element composition. So testing a hypothesis to find the source of the palygorskite used in Maya Blue involves discovering

*Identifying Ancient
Sources of Palygorskite
Used in Maya Blue*

https://doi.org/10.5876/9781646426683.c008

whether each source of palygorskite in Yucatán has a unique composition and, if so, then comparing it with the analyses of Maya Blue. Since palygorskite has been found in many locations, is the trace element composition of these clays different from those found at Sacalum and Yo' Sah Kab? Or are the palygorskite clays in Yucatán so similar in trace element composition that they cannot be differentiated? If the trace elements from each source are at least somewhat different, then it should be possible to discover the source of the palygorskite used to make Maya Blue.

CHARACTERIZING SOURCES OF PALYGORSKITE

My long history of using trace element analysis of ethnographic pottery and raw materials prepared me to search and identify the ancient sources of palygorskite used to make Maya Blue. This history involved the collaboration of many colleagues who did the actual analyses of the raw materials that I collected over more than forty years with the purpose of linking the trace element composition of pottery to social and cultural patterns. Since 1988, I have concentrated this research in Yucatán, setting the stage for using trace element analysis to analyze Maya Blue.[1]

Of the techniques available to determine the trace element composition of pottery and its constituent raw materials, archaeologists have widely used three: instrumental neutron activation analysis (INAA), laser ablation-inductively coupled plasma-mass spectroscopy (LA-ICP-MS), and X-ray fluorescence (XRF). All these techniques have been applied successfully to characterize both ancient and modern pottery and clays.[2]

Initially, I chose INAA to identify the sources of the palygorskite because of my long association with those who used the technique. This association began when I was an assistant professor at Penn State University between 1969 and 1972. During my first year there, I became acquainted with Dr. William A. Jester, who was an associate professor in nuclear engineering at Penn State's nuclear reactor. At the time, neutron activation analysis was a new technique, and a seminal paper about it had just been published (1969) in the British journal *Archaeometry* proposing that INAA could link ancient pottery to the source of the clay used to make it.[3]

I doubted this claim because, having studied pottery making in Peru and Yucatán, I knew that the variables affecting the trace element composition of pottery involved more than just the clay. Rather, pottery consists of a complex mixture of materials that include water, clay, temper, and naturally occurring non-plastics. Firing may also alter its composition, even though now we

know it does not affect those elements used in routine trace element analyses. Further, potters may use multiple sources of raw materials for their pottery that may greatly complicate social inferences made from its trace element composition. Temper used by potters may also contain clay minerals, as it does in Ticul, Yucatán, Mexico, and Quinua, Peru.[4] These realities of pottery production indicated that the relationship of the trace element analysis of pottery and the source of its clay was far from clear and created a unique problem of interpretation. Consequently, the chemical composition of the pottery could not be linked to the potter's behavior without making several assumptions.

Since I had studied pottery making in Peru and Mexico, Jester suggested that I develop a project using INAA to analyze the samples of contemporary pottery and raw materials that I had collected. So I involved a graduate student as a research assistant to work on the project and prepare the samples. My sample sizes, however, were small, and I had sieved the raw materials from Peru at the University of Illinois for another paper.[5] Further, the number of samples was too small for statistical analysis. So the INAA results turned out to be useless. Nevertheless, the technique still had promise for my research.

Concurrently, Penn State's anthropology department had just begun a project to excavate the ancient site of Kaminaljuyu within urban Guatemala City and do an archaeological survey of the surrounding Valley of Guatemala. With the encouragement of my colleague, Dr. Joseph Michels, I conceived of a project testing the proposition that pottery could be unequivocally related to its clay source.[6] Since pottery was being made at several sites in the valley, I planned to collect firing wasters (broken pieces of pottery from firing), clays, and tempers from potters in these communities, use INAA to analyze them, and then compare the results from community to community. The goal was to discover the kind of cultural and social information that the trace element analysis of pottery revealed.

I applied for a small grant from the College of Liberal Arts at Penn State, and in the summer of 1970 I traveled to Guatemala as a part of the Penn State project and studied pottery making in four communities in the valley. Where possible, I collected samples from as many sources of clays and temper as I could and samples of clay, temper, and wasters from many of the potters I visited. Dr. Jester and his colleagues analyzed the pottery and raw materials at Penn State's Breazeale Nuclear Reactor assisted by my graduate assistants.[7]

The first analysis of these data resulted in many problems with the data that were difficult to interpret and are recounted elsewhere.[8] Like the problems with my previous analyses, the data again proved useless, but for quite varied reasons. When I presented my results at the annual meeting of the Society for

American Archaeology in Tucson in 1978, Dr. Ronald Bishop of Brookhaven National Laboratory in New York chided me because of these problems. I replied that I knew that there were problems with the analysis, but I told him that if he could do a better job, I would give him the samples for a more rigorous analysis. Although the statistical analyses of the original data were inadequate because we did not use multivariate analyses, the size of the collection of the original clays, tempers, and sherds was large and had been selected with carefully controlled ethnographic provenience. So a reanalysis of them would provide significant insight into discovering if (and how) the social, geographic, and cultural patterns might be reflected in the trace elements in them.

Bishop was already involved with the analysis of pottery using INAA, and he agreed to reanalyze the samples using this method. This task, however, was not done until the late 1980s when Hector Neff completed the analyses. The results revealed that the pottery from each community showed a unique trace element signature that was a consequence of the spatially limited resource area around it from which the potters obtained their raw materials. The trace element signature for each community came from the clays rather than the temper. The composition of the white wares from a community was different from that of its red wares because they were made with clay from a different source. We also discovered that temper did not significantly affect the relationship between the white wares and communities of practice where communities used volcanic ash as temper from the same geological strata.[9]

Since I had also studied pottery making in Yucatán, Bishop suggested that I might want to see whether INAA could differentiate the communities of potters there as we did in Guatemala. Could the results of our Guatemala work be replicated in an area with a more homogeneous geology than Guatemala? First, however, I wanted to determine if individual household workshops could be related to their clay sources, as Perlman and Asaro had originally proposed.[10] So in 1988 I made a research visit to Ticul in order to collect sherds and discover whether significant trace element variability existed between individual potters' households within the same community. Approximately fifty sherds from the waster piles of each of six households were collected and analyzed by INAA by Hector Neff. Unfortunately, the results revealed no significant differences in the chemical composition of wasters among potters' households because they used the same clay source.[11]

At about the same time, I remembered that my former professor at the University of Illinois, Duane Metzger, had collected sherds from the kiln of one of these same households in 1964. As a result of Metzger's project with graduate students in 1964–1965 at the university (chapters 4 and 5), the

Department of Anthropology had stored them. So I thought that it would be useful to discover if there was any variability in the trace element composition of Ticul pottery through time. I traveled to the university in 1990, sampled the collection, and then submitted the sherds to Neff. INAA analyses of these sherds and of the sherds collected in 1988 provided a picture of the compositional variability of one of the households sampled across twenty-four years of ceramic production. No significant differences in trace element composition existed, however, among the sherds from each of the six households or between those sherds and the sherds of the one household collected in 1964 because all households used clay and temper from the same traditional sources between 1964 and 1988.[12]

In July of 1994 I returned to Ticul again for two weeks to gather data for collaborative work with Neff to continue to test the assumptions of INAA with two goals in mind. First, I wanted to test the results of our Guatemala research that demonstrated that INAA provides a trace element pattern congruent with a community of potters within a particular resource area.[13] Three other communities of potters besides Ticul were visited (Tepakán, Akil, and Mama), and wasters were collected from each of them. A second goal was to ascertain whether any changes in trace element patterning had occurred in Ticul pottery since 1964 and 1988. So I collected thirty wasters from each of the kilns of four of the six households sampled in 1988. Finally, I wanted to assess the changes in production that had occurred since 1988 and since the beginning of my research in Ticul in 1965, a period of almost thirty years (i.e., between February 1965 and July 1994).

The samples collected during the 1994 field session (N = 393) confirmed the results of our Guatemala work that trace element analysis can identify distinct ceramic production communities. The data showed that each pottery-making community in the relatively homogeneous geology of Yucatán (compared to that of Guatemala) produced pottery with a unique chemical pattern.[14] Most important, these analyses revealed that each community reflected a unique community of practice that utilized resources from their own unique resource area based largely on the composition of the clays that the potters used, but also on the composition of the clay in the temper.[15]

By 1994 the traditional clay source in Ticul had been abandoned, and potters were getting their clay 80 kilometers away in the State of Campeche. When I received the report of the analyses of the 1994 sherds from Ticul, I was surprised to discover that the analytical data showed the effects of the clays from these new sources. The analyses of the 1994 sherds revealed differences from those collected in 1964 and 1988 and from the Tepakán sherds, although the

Tepakán potters also used the same Campeche clay source as the Ticul potters used. Meanwhile, the 1994 ethnographic data had revealed that two Ticul potters had their own unique clay source in Campeche. Was their pottery different from that of the potters who used the other Campeche clay sources? If the pottery of each production unit was significantly different from each another, then it might be possible to identify an individual potter's production unit in antiquity using this same technique and assess the patterns of distribution of the wares of individual potters.

The analyses of the sherds collected in 1994 further indicated that the radical geographical shift in the Ticul clay source after 1988 did not obscure a unique trace element pattern of Ticul pottery. This unique pattern persisted because clay minerals are primarily responsible for most elements present in the pottery. Since approximately one-third of the Ticul temper consists of the clay mineral palygorskite and temper makes up two-thirds of the mixed paste, 22% of the Ticul paste is the clay mineral palygorskite and consistently came from Yo' Sah Kab over that period. Consequently, the constant chemical signal of the Ticul palygorskite persisted over time in the pottery, despite the radical change in the location of its clay source, which made up 33% of the finished paste.[16]

In 1995 I received a National Endowment for the Humanities grant to assemble my Ticul data into a book.[17] In addition, I had secured funding from the Wenner Gren Foundation for Anthropological Research and from the Wheaton College Alumni Association to return to Yucatán to see how pottery production had changed.

For the fieldwork component of the project, I added the goal of collecting data to test the hypothesis that the chemical composition of pottery from an individual production unit could be identified when it used a unique clay source. Clay sources had diversified since 1988, and I wanted to see if these changes were evident in the pottery of individual households. So in 1997 I visited thirty-five production units in Ticul as well as all clay and temper sources. I collected a total of 111 sherd wasters from the kilns of three production units that used their own unique clay sources. Comparing the INAA results of these samples with those of the sherds collected in 1964, 1988, and 1994 indicated that it was not possible to identify individual workshops, even if they did use different clay sources.

All my experience with my colleagues in interpreting trace element analyses of pottery and its constituent raw materials in Yucatán and Guatemala led me to want to apply that analysis to identify the sources of palygorskite used in Maya Blue. By the early 2000s, Hector Neff had moved from the University of Missouri Research Reactor with its INAA facility to California State

University at Long Beach, where he had established a lab using laser ablation-inductively coupled plasma-mass spectroscopy. LA-ICP-MS can analyze many trace elements with high precision and sensitivity, is faster than INAA, and is cheaper. So in many respects it was a better technique for determining the trace element composition of palygorskite and Maya Blue than INAA.[18]

Neff and I had worked well together, and he was consistently my "go-to" analyst in trace element analysis. So if I wanted to continue collaborating with him to identify the sources of palygorskite and their relationship with Maya Blue, I would need to change course and involve Neff's use of LA-ICP-MS rather than INAA. To continue our collaboration, Neff suggested that we compare the INAA and LA-ICP-MS analyses of palygorskite from several diverse sources of palygorskite to assess the feasibility of LA-ICP-MS (as opposed to INAA) to characterize those sources. If the results were like those of INAA, either technique could be used to compare the analyses of palygorskite and Maya Blue for discovering the source (or sources) of the palygorskite used to make the pigment.

TRACE ELEMENTS IN PALYGORSKITE

From my research in Yucatán between 1965 and 1997, I had already accumulated a sizable number of samples of palygorskite from various sources. These samples were originally selected using one or more of three criteria: (1) samples of sak lu'um collected from potters; (2) samples identified by informants as sak lu'um at the sources, and (3) samples with the properties of sak lu'um that I had collected. The samples thus were collected in a way that corresponded to how the ancient Maya would have selected them by using contemporary Maya informants (at Yo' Sah Kab, Sacalum, Uxmal) or by using the same Maya criteria (samples from the Petén). Samples from three other locations (Maní, Maxcanú, and Mama) were included in this data set because Bohor had found palygorskite in them using X-ray diffraction.

Selection criteria are critical because, like the modern Maya who mine and sell sak lu'um, the ancient Maya probably used similar criteria: (1) sak lu'um came from sources that had a strong "sense of place" that were part of Maya cultural heritage, and (2) sak lu'um was white, hard, rocklike, and lightweight but became plastic with water. The ancient Maya were not selecting soils and clays that contained the clay mineral palygorskite because they did not use mineralogical criteria to make those choices. Rather, they made choices based upon their Indigenous knowledge of the sources of sak lu'um and its physical properties, which contrasted with those of other mineral categories, just as they do today in Ticul.[19]

To determine if trace element analysis could differentiate these sources, I submitted thirty-three of them for INAA at the University of Missouri Research Reactor and for LA-ICP-MS by Hector Neff at the California State University at Long Beach. Twenty-nine of the samples were analyzed by both techniques for nineteen elements.[20]

Comparison of the analyses of the two techniques revealed that each yielded a similar result. One comparison used statistical correlation of the trace element concentrations. Fourteen of the nineteen elements analyzed had correlation coefficients above 0.5, and twelve had correlation coefficients above 0.6. That two completely independent analytical techniques yielded such high correlations demonstrated that either technique could be used to analyze palygorskite. Since the sample preparation for LA-ICP-MS is far easier than that for INAA and requires a far smaller analytical investment, it would be the technique of choice for future analyses.[21]

Besides the strong correlation of the concentration of many elements between the two techniques, statistical patterning of the data was evaluated by first controlling for the sources of palygorskite and then ascertaining which chemical elements differentiated those sources. This approach clearly distinguished the sources of Yo' Sah Kab, Sacalum, and Chapab and that near Uxmal (figure 8.1). The two samples from the southern Petén, the two samples from Maxcanú, and the single sample from Mama diverged from these patterns. These results indicated that trace element analyses could identify discrete sources of palygorskite. Consequently, it was possible to determine whether the palygorskite used to make Maya Blue came from widespread sources or whether it came from a single or small number of sources.[22]

Unfortunately, the number of samples used for this study was small (N = 33). To create a larger database to characterize the sources, it was necessary to collect more samples. By sampling more sources and those that were used by the ancient Maya, one could characterize their variability more completely and accurately, corroborate the results of our earlier study, and then compare the unique composition of each source with Maya Blue.

I wrote a grant proposal for the National Geographic Society so that Bruce Bohor, Hector Neff, and I could return to Yucatán and collect more samples. I wanted to expand the earlier pilot study and corroborate whether each of the major sources could be chemically differentiated.

My grant application was successful, and in May of 2008 Bohor and I traveled to Yucatán to collect samples from palygorskite sources. With the goal of discovering the sources of the palygorskite used in Maya Blue, I wanted to sample source locations more intensively, collecting as many samples from

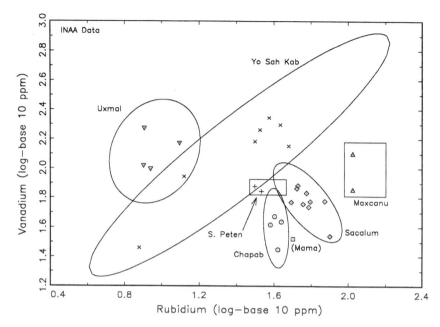

FIGURE 8.1. *Biplot of vanadium and rubidium log concentrations in palygorskite samples from various locations in Yucatán, as determined by INAA. Ellipses represent 90% probability of membership in the groups. (Fig. 2 from Dean E. Arnold, Hector Neff, Michael D. Glascock, and Robert J. Speakman, "Sourcing the Palygorskite Used in Maya Blue: A Pilot Study Comparing the Results of INAA and LA-ICP-MS,"* Latin American Antiquity *18, no. 1 [2007]: 44–58. © Society for American Archaeology 2007, published by Cambridge University Press, reproduced with permission.)*

each location as possible, but principally to focus on those that were used by the ancient Maya. Because of my forty-three years of experience working with Ticul potters, I knew the physical characteristics of *sak lu'um* and, like knowledgeable Ticul potters, could easily recognize the deposits that the potters know as *sak lu'um* and that clay mineralogists would identify as palygorskite.[23]

The first of these deposits was the cenote at Sacalum (see chapter 5), and we were able to corroborate many of the observations that Bohor and I had made forty years earlier. We collected approximately forty-three samples of *sak lu'um* from the cenote interior. Most samples came from the mine itself, with some from the thin layer exposed in the cenote wall above it. The second source was the temper mines (Yo' Sah Kab) near Ticul, beginning 3.3 kilometers northeast of Ticul, and the mining area beyond it closer to Chapab.[24]

Revisiting the temper mines near Ticul was disorienting for me. The straightening and widening of the Ticul-Chapab road into a level two-lane asphalt highway created a new landscape that was different from the narrow, bumpy road that I had traveled many, many times between 1965 and 1997. Several mining areas were in the wide right-of-way of the new highway where it cut through small hillocks. I recognized nothing from my previous experiences over the previous forty-three years.

From those experiences, however, I knew that there were many more mines abandoned and obscured in the forest. So it was obvious that the mining area had expanded far beyond what I had observed between 1965 and 1997. Some mining remained on public *ejido* land, but the activity nearer Chapab had expanded and in 2008 was the source of most of the pottery temper consumed in Ticul.[25]

To characterize the trace element composition of any source, it is necessary to assess its variability across geographical space and at different stratigraphic levels. The Yo' Sah Kab and Chapab sources revealed great challenges in this regard because the mines were located along a linear distance of several kilometers and dispersed in the forest on both sides of the road. We visited seven distinct mines 3 to 4 kilometers from Ticul and four more nearer Chapab, about 2 kilometers beyond. In total, we collected samples of *sak lu'um* from eleven of the mining areas between Ticul and Chapab. This selection clearly met the criterion of sampling across the geographic space of temper mining.

Sampling the stratigraphy inside the temper mines was more complicated. *Sak lu'um* occurred in two distinct stratigraphic levels (figure 4.1). The top layer, about 1.5 meters below ground level, was about 1.5 meters thick, was mined for pottery temper, and consisted of a mixed layer of marl and chunks of *sak lu'um* that miners had discarded on piles of the screenings from temper preparation. After years of weathering, future miners would crush these discarded chunks and use them again to prepare temper (figure 4.2).[26]

Below that layer, we had repeatedly noted a solid bed of palygorskite exposed on the floor of the mines but did not pay much attention to it. Belatedly, we realized that Bohor had identified this layer in his stratigraphic profile of the 2 × 2 meter pits dug by the Maya Cement Company during our 1968 visit. After consulting that profile, Bohor noted that below the palygorskite-containing marl layer was indeed a solid layer of palygorskite that was about 1 meter thick and was present in two of the three Maya Cement Company pits.[27]

To adequately characterize the composition of the Yo' Sah Kab/Chapab source, we realized that we needed to sample this solid layer of the palygorskite. Further, Bohor believed that palygorskite was formed from volcanic ash falling into a saline lagoon with a high magnesium concentration, and he

wanted to verify this hypothesis. If it was valid, then the heavy minerals in the ash—beta-quartz-form crystals, euhedral zircons, apatite, and sanidine (high-temperature feldspar)—would settle to the bottom of the water in the lagoon before palygorskite was formed and would occur in samples taken from the base of the layer. Most important, the trace elements in these minerals would affect the composition of the palygorskite in the deposit.

To characterize the Yo' Sah Kab source, we had to sample the entire range of variability in the stratigraphic profile—from the chunks of palygorskite in the marl layer to that at the bottom of the solid palygorskite layer. To operational-ize this goal, it was necessary to dig down to the bottom of the palygorskite layer and remove samples from the deposit directly above the contact with the layer below it. Because the palygorskite layer was not mined for temper, digging through it would require at least several hours. Unfortunately, our remaining research time in Yucatán was limited to two more days, so we had to do it as soon as possible. Who could we hire to do the digging, and where should it be done?

I decided that we should hire Elio Uc for the task. I had known Elio for more than forty years; and he was the cousin of Alfredo, our principal infor-mant. Elio was a temper miner, but recently he had turned to mining pure *sak lu'um* at Yo' Sah Kab to sell to potters for improving the quality of their temper.[28] I asked Alfredo if he could help us hire Elio for the task. Elio agreed, and the four of us drove to Yo' Sah Kab.

Along the way, Alfredo suggested that we should examine Elio's mine first before we dug elsewhere because the task would require a lot of work to dig through the meter-thick layer of *sak lu'um* to its base. I was not excited about this proposition but nevertheless acquiesced to his suggestion.

Elio directed us to his mine, located no more than 10 meters from the south side of the road to Chapab and about 3 kilometers from the southwest corner of the Plaza of Guadalupe (Calle 13 and 26). As it turned out, the mine was well within the area of the traditional temper mines (Yo' Sah Kab) and was within the limits of the communal *ejido* land. Fortunately, Elio was already mining pure *sak lu'um* there, exposing approximately 4.5 meters of a vertical profile that extended from the ground surface to the rock layer at the base of the solid palygorskite deposit (figure 4.1). The palygorskite-containing marl layer began about 2 meters below ground level and was 175 centimeters thick. Below it lay a solid rocklike layer of pure palygorskite that was 70 centime-ters thick. Mining this layer produced the rocklike chunks of palygorskite that potters recognized as one of the critical characteristics of *sak lu'um*. These chunks were what geologists call "palygorskite mudstone."[29]

After Elio had cleaned off the base of the profile of the *sak lu'um* layer, I dropped down into the mine and removed about a cubic foot of palygorskite in large, flat chunks from the base of the palygorskite deposit that lay up against the rock below it (figures 4.1 and 4.2). Then I sampled the middle of the deposit near the top of the pure palygorskite layer and, finally, sampled the chunks of the palygorskite mixed with the marl further up in the stratigraphic profile.

Besides collecting many samples from Sacalum, Yo' Sah Kab, and the Chapab sources, we also wanted to obtain samples from other palygorskite sources, some of which we had identified in 1968. Working with potters over a period of more than forty years and being familiar with the properties of *sak lu'um*, I collected samples that I thought were *sak lu'um* from the railroad cut in the hill just east of the town of Maxcanú as well as from a cut on the road from Muna to Maxcanú that skirts the north edge of the *puuc* ridge just west of the turnoff to the archaeological site of Oxkintok. My identifications of *sak lu'um* in these locations, however, were spurious, based upon the X-ray diffraction patterns. The clays were not palygorskite,[30] and in retrospect were not mudstone, and would not be identified as *sak lu'um* by potters. The deposits were much smaller than those at Sacalum, Yo' Sah Kab, and Chapab, and their exposure was a product of modern alteration of the landscape.

We also examined the new road that had been cut through the *puuc* ridge between Muna and the archaeological site of Uxmal, a roadcut along the road between Ticul and the village of Sacalum, and a quarry for cutting stone blocks on the north side of the *puuc* ridge as well. We found no material with the obvious physical properties of *sak lu'um* in any of these locations.

From visiting all these sources, I collected a total of 154 samples of palygorskite, and Bohor collected another set of samples that he used to answer his own research questions. As a result, in addition to samples from forty-three years of research in Yucatán, we had enough samples to characterize the source areas of palygorskite chemically and compare those analyses with the analyses of Maya Blue. Matching palygorskite sources to Maya Blue, however, can be problematic because analyses must consider the variability in each deposit to match the palygorskite in the pigments to that found in its ancient sources. Rather than simple comparisons of the elemental composition, multivariate analyses are necessary to determine if the palygorskite in the Maya Blue samples occurs within the range of compositional variability of the palygorskite from the sources we investigated.

Hector Neff analyzed our palygorskite samples by LA-ICP-MS and X-ray fluorescence. In addition, Bohor and Neff analyzed forty of these samples by X-ray diffraction and confirmed that samples of *sak lu'um* collected from

Sacalum, Yo' Sah Kab, and the Chapab source were palygorskite. Bohor also collected and analyzed another thirteen samples of *sak lu'um* that were in situ in the deposits. Both sets of samples contained other minerals such as smectite (montmorillonite) that were also found in temper samples from Yo' Sah Kab collected in the late 1960s.[31] In a few samples palygorskite was a secondary component.

Bivariate plots of the concentrations of several elements were generated, but only a few elements distinguished the sources of palygorskite. Nevertheless, the elemental analyses confirmed the same pattern that emerged from our earlier pilot study that showed that Sacalum and Yo' Sah Kab could be differentiated from one another and from other sources (figure 8.2, 8.3). The composition of the Sacalum samples was distinct from most of the Yo' Sah Kab samples and from all of those from the mines nearer to Chapab. The composition of the Yo' Sah Kab samples, however, was quite variable compared with that of Chapab and Sacalum, and those from the Sacalum cenote varied more than those collected there in 1967 and 1968. Most of the new samples from Sacalum fell within the high-yttrium main Sacalum group, and this element reliably discriminated the samples from Sacalum from those collected at other sources (figure 8.2, 8.3). A smaller group of samples came from the thin band on the cenote wall and displayed yttrium values consistent with those of Yo' Sah Kab, but with higher vanadium and chromium.[32] With the sources of palygorskite characterized, the stage was set for comparing their composition with that of Maya Blue.

RELATING THE TRACE ELEMENTS OF PALYGORSKITE TO MAYA BLUE

Before one can use the trace element composition of palygorskite sources as a proxy for identifying the sources of the mineral in Maya Blue, however, it is important to remember that Maya Blue is a clay-organic complex of palygorskite and indigo. Indigo is an organic compound consisting of carbon, hydrogen, nitrogen, and oxygen, and these elements are not used in routine trace element analyses. Further, experimental data have revealed that indigo makes up only 0.5–3.0% of the pigment.[33] As a consequence, it appears that even if there were inorganic trace elements in indigo, they would contribute little to the overall trace element composition of Maya Blue.

Palygorskite, on the other hand, is a hydrated magnesium aluminum silicate that includes many trace elements. As I have already shown earlier in this chapter, trace element analyses can indeed uniquely identify palygorskite

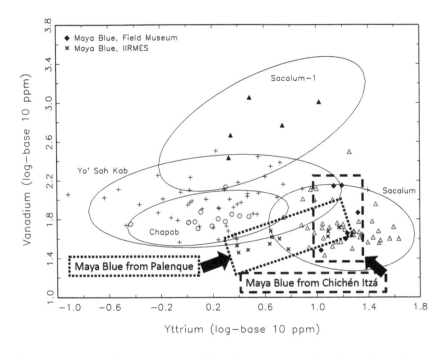

FIGURE 8.2. *Biplot of yttrium and vanadium log concentrations in palygorskite and Maya Blue pigment samples, as determined by LA-ICP-MS. Palygorskite samples: Yo' Sah Kab, Chapab, "Sacalum-1" (thin layer in wall of Sacalum cenote), mine in Sacalum cenote. Maya Blue pigment samples: Chichén Itzá artifact, Field Museum collection, Palenque artifact, IIRMES collection. Ellipses represent 90% probability of membership in the groups. Rectangles clarify the relationship of the composition of the Maya Blue samples relative to those of the palygorskite. (Modified from fig. 3 in Dean E. Arnold, Bruce F. Bohor, Hector Neff, Gary M. Feinman, Patrick Ryan Williams, Laure Dussubieux, and Ronald Bishop, "The First Direct Evidence of Pre-Columbian Sources of Palygorskite for Maya Blue," Journal of Archaeological Science 39 [2012]: 2256; used with permission.)*

sources,[34] and thus can qualify as a proxy for identifying the source/s of that mineral in Maya Blue because the trace elements in the pigment are inorganic and largely, if not exclusively, come from the palygorskite, not from the indigo.

The process of combining palygorskite and indigo to make Maya Blue could also add some elements to the pigment. These elements, however, are few and are water soluble and thus could be dropped from the analytical results. By way of contrast, the thirty-three elements used in routine trace element analysis do not exist as water soluble compounds and are found

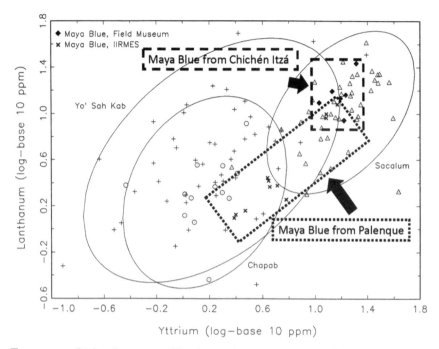

FIGURE 8.3. *Biplot of yttrium and lanthanum log concentrations in the palygorskite samples and Maya Blue pigment samples as determined by LA-ICP-MS. Palygorskite samples: Yo' Sah Kab; Chapab; mine in the Sacalum cenote. Maya Blue pigment samples: Chichén Itzá artifact, Field Museum collection; Palenque artifact, IIRMES collection. Ellipses represent 90% probability of group membership. Rectangles clarify the relationship of the composition of the Maya Blue samples relative to those of the palygorskite. (Modified from fig. 5 in Dean E. Arnold, Bruce F. Bohor, Hector Neff, Gary M. Feinman, Patrick Ryan Williams, Laure Dussubieux, and Ronald Bishop, "The First Direct Evidence of Pre-Columbian Sources of Palygorskite for Maya Blue," Journal of Archaeological Science 39 [2012]: 2256; used with permission.)*

exclusively in the clay. Consequently, it is likely that those trace elements from the indigo and those from the preparation of Maya Blue would not significantly compromise the ability to characterize the pigment chemically and relate it to palygorskite sources.

The next step of the project was to analyze the samples of Maya Blue. These samples came from two sources: the Field Museum (N = 6) and the Institute for Integrated Research in Materials, Environments, and Society (IIRMES) at California State University at Long Beach (N = 3). The Field Museum

samples originally came from Edward H. Thompson's 1896 excavation of the Osario (the Grave of the High Priest) at Chichén Itzá and from a bowl recovered from Thompson's dredging of the Sacred Cenote there. The IIRMES samples came from the Maya site of Palenque and have no other provenience information. The Palenque samples were analyzed at IIRMES by Neff; those from the Field Museum were analyzed by Dr. Laure Dussubieux and Dr. Ryan Williams using the Field Museum's on-site LA-ICP-MS equipment like that in the IIRMES lab.[35]

The analyses of Maya Blue samples fell within the same range of variation as most of the analyses of the palygorskite sources analyzed (figure 8.2, 8.3). Seven of the nine analyses of Maya Blue show a high-yttrium composition consistent with the Sacalum source. Six of these samples came from Chichén Itzá, and one came from Palenque. The samples from Palenque were replicated, and three of the four replicates were high in chromium, consistent with the composition of the palygorskite sampled from the thin layer in the wall of the Sacalum cenote. Two of the replicated samples from Palenque showed lower yttrium composition, characteristic of Yo' Sah Kab.[36]

In summary, all of the Maya Blue samples from Chichén Itzá that were analyzed were made with palygorskite from Sacalum, whereas the palygorskite in the samples found at Palenque came from Sacalum, Yo' Sah Kab, or perhaps another source.[37] This result successfully tests the hypothesis that Sacalum and Yo' Sah Kab were ancient sources of the palygorskite used in the production of the samples of Maya Blue analyzed, and it corroborates that evidence from Maya cultural heritage (described in chapter 4).

9

Linking disparate strands of knowledge also provides the foundation for discovery. Such strands may often come from one's experiences accumulated over decades. For Maya Blue, one such strand consists of ethnographic information about the Indigenous practices that I observed in various parts of the Maya area. Initially, these observations seemed irrelevant to the mysteries of Maya Blue, but with the accumulation of information and much reflection after many years, such observations have contributed insight for discovering one way of how and why the ancient Maya created the pigment.

How Was Maya Blue Made?

THE FOOD OF THE GODS

This ethnographic strand considers Maya religious practices at sacred sites near the towns of Panajachel, Chichicastenango, Totonicapán, and Quetzaltenango (among others) in highland Guatemala (figure 2.1). One of these sites, called Pascual Abaj, is located about a ten-minute walk from the church of Santo Tomás in the town of Chichicastenango. Occupying a clearing in a pine forest on a hill south of the town, the site consists of several altars. The most prominent is an ancient sculpture on which local shamans sprinkle marigold petals, place flowers, and pour out libations of cane alcohol. Because of the crosses at other altars nearby, one might think that this site is a Christian holy place. On the contrary, it is a location where Maya shamans feed, placate, and worship their principal deity,

FIGURE 9.1. *Shaman burning copal incense at Pascual Abaj near Chichicastenango, Guatemala, 1970.*

the earth god (Dios Munt), who inhabits the earth, makes the corn grow, and causes earthquakes and volcanic eruptions. In traditional Maya religion the earth god is symbolized by the cross.[1] If a shaman is present (figure 9.1), as occurred during my 1970 and 1971 visits, he or she will burn copal incense there, and the aroma of burning incense fills the clearing. Called *pom* in Yucatec Maya, copal is a resin that comes from the sap of a tropical tree found throughout central and southern Mexico, Belize, Guatemala, and Honduras.[2]

The contemporary Maya of Yucatán use this same incense during their Day of the Dead rituals at the end of October and early November. As the family offers food to the spirits of their departed relatives who have returned to their houses to be fed during the ceremony, a family member burns incense in an earthenware vessel (*incensario*) on and/or in front of the household altar. Its distinctive aroma fills the house.[3]

The Maya have burned this same incense for centuries, long before the Spanish Conquest. Because it comes from the sap of a tree, some Maya groups regard it as the blood of the tree. Just as blood is the symbol of human life, so the sap of a tree is its blood and symbolizes its life. Similarly, just as maize was the traditional staple in the Maya diet, the smoke and aroma from burning

copal was the staple food of gods because it symbolizes life, and they imbibe it in the form of smoke along with the requests of the petitioners who offered it.[4]

The relationship between copal incense and maize is not simply analogical for the ancient Maya but materially linked in the ritual of preparing copal offerings and then throwing them into the depths of the Sacred Cenote at Chichén Itzá (chapter 3). In their account of the copal offerings dredged from it, Coggins and Ladd describe impressions of maize husks, leaves, and the cob on them. Although they note that half of the copal offerings from the cenote were made in vessels of pottery, wood, or basketry, some were worked on maize leaves and husks while the copal was still soft before they were cast into the cenote. Blue occurred on "most, if not all, of these offerings."[5]

COPAL AND MAYA BLUE

Besides copal offerings to the mountain god among the modern Maya as well as the offerings thrown into the Sacred Cenote at Chichén Itzá, archaeologists sometimes find copal incense in their excavations of ancient Maya sites. In July of 1970 I visited the ancient Maya site of Tikal, Guatemala, and visited its museum. In one of its exhibits the museum designers had reconstructed the interior of the burial chamber in one of the great pyramids of the site (Temple I). It contained all the accoutrements normally associated with high-status individuals such as jade and finely painted pottery, but it also included three balls of copal incense that were mixed with Maya Blue.[6] This association of copal and Maya Blue further affirms the possibility that the Maya could have created the pigment by burning incense.

AN INCENSE BURNER: A EUREKA MOMENT

All this information moved into the recesses of my brain until almost forty years later. In 2005 I had just published an article about a source of palygorskite near Ticul that the ancient Maya might have used to make Maya Blue (see chapter 5).[7] I summarized some of the data about the pigment and decided to prepare another article documenting the trace element variability of palygorskite from different areas using samples that I had collected in Guatemala and Yucatán from 1965 to 1970, those that B. F. Bohor had collected in 1967 and 1968, those that Bohor and I collected in Yucatán in 1968, and those that I had collected in 1984, 1988, 1994, and 1997 (chapter 7).[8] I wanted to know if the different sources of palygorskite could be identified based upon their trace

element composition by comparing two analytical techniques to see if either could be used to identify the sources of palygorskite (chapter 8). Both techniques did indeed identify the distinct sources of palygorskite.

After the completion of that analysis, I wanted to see if the chemical composition of Maya Blue could be matched to the composition of any of the palygorskite sources sampled over the decades of my research (chapter 8). At the time, I was a research associate at the Field Museum, and I asked my colleagues there if the museum had any objects with Maya Blue in its collection. I talked with Gary Feinman and Ryan Williams about my interest in comparing analyses of my palygorskite samples to analyses of Maya Blue on objects in the museum's collection. Gary was curator of Mesoamerican Anthropology, and Ryan was associate curator of South American Anthropology and oversaw the newly acquired LA-ICP-MS facility. Both agreed to collaborate with me on this project. They enlisted a graduate student from the University of Illinois in Chicago, Nicole Roth, who, with the Field Museum's collection manager, Christopher Philip, searched the museum catalogue and the collection to provide a list of artifacts with Maya Blue.

Subsequently, Gary took me into the storerooms of the museum to look at the objects on the list and evaluate whether there was enough of the pigment available for analysis. Gary and Ryan consulted with Laure Dussubieux of the museum and determined that the amount of Maya Blue available for analysis was indeed sufficient to make the comparison.

Several months later I returned to the museum, and Ryan again showed me the list of objects with Maya Blue that the graduate student had found. Most of the list was identical to a previous list that I had seen, but it also included an additional object that I had not seen previously; it was simply described as "blue on copal in a bowl."

When I saw this entry, I got very excited, and it prompted memories of my ethnographic experiences among the Maya and my earlier research about Maya Blue. I recalled that the contemporary Maya burned copal for their indigenous religious ceremonies and that Van Olphen showed that heat could be used to create a Maya Blue–like pigment from palygorskite and indigo. I also remembered that Cabrera Garrido had found tiny fragments of charcoal with the Maya Blue in a charred substance in an incense burner excavated at the former Aztec market of Tlatelolco in the Valley of Mexico; he had suggested that the ritual burning of incense might have provided the heat necessary to combine indigo and palygorskite to make the pigment. Recognizing that the association of Maya Blue and copal in the Field Museum bowl was precisely that which

Cabrera Garrido believed to be one of the possible scenarios for creating Maya Blue,[9] I asked Ryan if I could examine the bowl and its contents.

We went to the museum's artifact catalogue to find the location of the bowl. It had been added to the list because it had been recently returned to storage from a disassembled Mesoamerican exhibit. These materials and those from other culture areas in the Americas were temporarily housed in a remote part of the museum in anticipation of the construction of the new "Ancient Americas" exhibit that would open in 2006.

I followed Ryan as we walked downstairs to the far northwest corner of the museum. At a temporary plywood door, we paused, Ryan unlocked the door, opened it, and then disappeared into a dark room. After fumbling for the light switch, he turned it on, and we entered an enormous dimly illuminated room half full of metal shelves covered with all kinds of artifacts. If there was a system of organization that would make finding the bowl easy, it was not initially evident.

"How do we find the bowl in this mess?" Ryan asked. I assured him I could find it, as I knew what I was looking for. He reminded me to put on latex gloves. Because objects in the museum were previously treated with an arsenic compound (and other toxic compounds) to kill any pests on the organic materials, one must wear gloves when examining the artifacts, not only to prevent absorption of arsenic through the skin but also to keep oils on the hands from being deposited on objects and discoloring them.

I started walking down the aisles of the storage area and quickly noticed that the objects and the shelves, although unlabeled, were organized by culture area, then by culture, and finally by the type of artifact such as pottery, basketry, cloth, or metal. I found the section with Maya pottery and searched the shelves in vain for the bowl. I could not see the pottery on top of the shelves, but I did find a movable stairway that I pushed over to a spot where I could catch a glimpse of as much of the pottery on the top shelf as I could.

After climbing up the steps, I saw the bowl perched near the rear of the top shelf. "I found it!" I shouted as I descended the stairs with the bowl and carried it over to a table where the light was better. The bowl was obviously an incense burner filled with copal incense that had melted to fill the bowl. Ryan pointed out a large magnifying glass on the table that would allow me to examine the bowl more closely. Looking at the top of the copal in the bowl through the lens, I saw nothing but the partially melted incense and patches of blue.[10] Then Ryan gave me permission to remove the copal from the bowl, and with his help, I turned the bowl over, and the copal fell into my hand as one solid piece.

FIGURE 9.2. *Underside of copal from a Maya tripod bowl recovered from the Sacred Cenote at Chichén Itzá. Patches of palygorskite (white), Maya Blue, and indigo can be seen. (Photo by Linda Nicholas; courtesy of the Field Museum, cat. no. 189262.)*

Carefully laying it on the table, I pulled over the large magnifying glass with its light to illuminate the underside of the copal.

I noticed that there were patches of white and blue on the underside, and with the light, the magnifying glass revealed the detail of the patches (figure 9.2). Remembering that Cabrera Garrido believed that Maya Blue might have been made by burning incense that heated the indigo-palygorskite mixture, I wondered if the white material was palygorskite.

Having seen palygorskite in Yucatán and worked with it repeatedly over the previous forty years, I carefully examined the white material on the underside of the copal. It showed tiny specks of red with yellow patches that were hematite and limonite, respectively. I had seen material like this before, and it looked like some of the palygorskite that I had seen in Yucatán. Some palygorskite was pure white. Other deposits, like the palygorskite from the cenote of Sacalum, were pale yellow with specks of red and yellow, just like the specimen before me. Later I discovered that the similarity of this palygorskite to that obtained from the Sacalum cenote was not just a superficial observation. Based on the comparison of the trace element analyses of samples of palygorskite from Yucatán and the Maya Blue in the bowl, we now know that the palygorskite in pigment did indeed come from Sacalum (see chapter 8).[11]

I could not believe my eyes that I was holding ancient incense that might have contained the remains of the palygorskite component of Maya Blue that was uncombined with the indigo.

As I looked at the bottom of the copal, I realized that Cabrera Garrido might be correct in his hypothesis that Maya Blue was created by burning incense with palygorskite and indigo and that this technique was used more widely than just central Mexico. Now, we had an object to test that hypothesis, but I had to be sure. The evidence was in front of me, but I realized that the white and blue areas on the incense burner needed further investigation.

Ryan was teaching a class about the technical analyses of archaeological materials at Northwestern University and agreed to put a student on the problem. One type of analysis should seek to discover the structure of the white material (palygorskite), and a second type of analysis was needed to identify blue material present (hopefully indigo and/or Maya Blue). The blue and white patches on the copal indicated that the bowl and its copal offering probably was an incomplete attempt to produce Maya Blue from heating the indigo and palygorskite and then throwing the bowl and its offering into the cenote.

Physical science analyses of the white and blue portions of the bowl's contents were conducted by J. P. Brown, of the Field Museum's conservation department, and Jason Branden, an undergraduate in materials science at Northwestern University. Scanning electron microscopy and secondary electron and backscattered electron images of the white component showed fibrous or needlelike features like the structure of palygorskite. Energy dispersive X-ray analysis of both components showed compositions that were analogous to previous analyses of Maya Blue, with one spectrum dominated by a carbon peak, indicating an organic material, likely indigo. These analyses revealed the presence of indigo and palygorskite, the two main components

of Maya Blue, and that this copal offering represented an attempt to produce Maya Blue that was interrupted by being thrown into the Sacred Cenote.[12]

THE BACKGROUND OF THE BOWL

The background of this bowl provides critical information about the cultural context of the creation and use of Maya Blue. It begins with Edward H. Thompson, a Massachusetts resident who had an interest in ancient civilizations. In 1879 he authored a popular article about Atlantis for *Popular Science Monthly* that caught the attention of Stephen S. Salisbury, who was an officer of the American Antiquarian Society in Worcester, Massachusetts. Salisbury was sponsoring archaeological explorations in Mexico, and when he ended their funding in 1885, he proposed that Thompson go to Yucatán to do similar research for the society while serving as US consul. Thompson agreed, was appointed to that post, and that same year he and his family arrived in Mérida to assume his duties.[13]

Three years later, a friend of Salisbury in the American Antiquarian Society, Charles P. Bowditch, made a trip to Yucatán and proposed that Thompson work jointly for the society and for Harvard's Peabody Museum, of which Bowditch was a benefactor. Thompson then conducted archaeological work at the site of Labná in the hill country in the southern part of the state and made molds of the mosaic facades at Labná and Uxmal that were featured in the 1893 Columbian Exposition in Chicago. These caught the attention of Allison V. Armour of Chicago, who subsequently sponsored Thompson's work at the Maya site Xkichmook, Yucatán.[14]

Meanwhile, the office of the US Consulate in Yucatán moved from Mérida to Progresso in 1892, a port town on the Gulf of Mexico, and Thompson's interest turned to the ancient site of Chichén Itzá, located 130 kilometers east-southeast of Progreso. Using funds from Armour and Salisbury, Thompson bought the property around it in 1893 and used the old hacienda buildings there as his home. During the next twenty years, he excavated the Grave of the High Priest (now called El Osario) and from 1896 to 1910 dredged the depths of the Sacred Cenote.[15]

In 1920 the artifacts recovered from the cenote went to the Peabody Museum at Harvard University. The artifacts from the Grave of the High Priest were eventually purchased by the Field Museum, together with E. H. Thompson's report of his excavations.[16]

About this time, the Carnegie Institution of Washington began clearing and excavating Chichén Itzá. One of the members of this team, Maya archaeologist J. Eric Thompson, eventually became curator of Central and

South American Archaeology at the Field Museum. During his tenure there (1926–1935) he prepared E. H. Thompson's notes from the excavations of the Grave of the High Priest for publication, and his report subsequently appeared as an issue in the Field Museum's anthropology series.[17]

In 1932 the Field Museum traded some of its collection to the Peabody Museum.[18] Among the objects that the Field Museum acquired in exchange was a tripod pottery bowl containing copal incense that E. H. Thompson had dredged from the Sacred Cenote in 1904.[19] It was a part of a larger collection of 160 copal offerings recovered from the cenote.[20] About half of these offerings were in their original containers, and some of the copal in these containers showed leaf imprints on their base. Other offerings not in containers also revealed leaf impressions.

Except for fragments of pottery, copal incense was the most frequent item recovered from the cenote, and its quantity bespeaks the significance that copal played in the ritual offerings thrown into it. Most of these copal offerings had blue paint on them. Tozzer believed that this paint was indigo. Later, in describing the copal and rubber objects from the cenote, Coggins and Ladd also believed that the blue was indigo. We now know that some of this paint was not just indigo but was Maya Blue as well.[21]

In a letter to Bowditch about dredging the cenote, E. H. Thompson wrote: "Both vessels and incense [were] evidently painted blue before being thrown into the ts'onot."[22] Were they painted blue, or was the blue created by burning incense with palygorskite and indigo before the offering was made? The data presented here indicate that the creation of Maya Blue took place before the offerings were thrown into the watery depths. Creating the pigment from indigo and palygorskite by burning copal was a deliberate ritual activity at the edge of the cenote.

All the copal offerings looked like they had been heated to the melting point because the copal took the shape of each bowl. Tozzer, who wrote about the artifacts recovered from the cenote, noted that other artifacts had been heated as well.[23] Beads melted like glass, and the rubber was burned. Metal objects also showed the effects of heat, distorting many pieces and melting parts of others. According to Tozzer, ". . . the effect of intense heat, from the copal, is shown on many of the specimens taken from the Cenote. . . . The temperature of burning copal must have been very high as the heat melted obsidian, often reduced jade to a powder, and melted some of the metal objects."[24] Tozzer also noted, "The black smoke of the incense often covered the metal and jades with a deep patina."[25] To account for the heat and the melting of the copal, E. H. Thompson believed that the structure on the rim of the cenote was a large incense burner with air holes that heated the offerings before they were

FIGURE 9.3. *The structure on the edge of the Sacred Cenote at Chichén Itzá. Whether the structure was used as a large incense burner, a steam bath, or some other purpose is unclear.*

thrown into the depths below (figure 9.3).[26] Tozzer believed that this heat came from burning copal incense. Given the large mass of unburned incense that remained in the offerings, the Maya undoubtedly made extensive use of burning copal at the time when they used it for offerings.

The structure at the edge of the cenote, excavated in the 1960s by Mexico's Instituto Nacional de Antropología y Historia (INAH) during its dredging of the cenote, was believed to be a steam bath and not a large incense burner.[27] Steam baths occur among Maya language groups in parts of highland Mexico and highland Guatemala, but not among the contemporary Yucatec Maya. Whether the structure was an incense burner or a steam bath, it still could have provided the heat necessary to melt the copal, but it may not have produced the high level of heat evidenced by the metal and jade described by Tozzer.

WHEN WERE THE OFFERINGS THROWN INTO THE CENOTE?

From what is known about the pottery with copal recovered from the cenote, it appears that these offerings were not made during the apogee of Chichén Itzá during the Terminal Classic period, but much later during the Postclassic period when Mayapán became the dominant center in the northern lowlands.[28] Surprisingly, these data indicate that the use of the cenote as a

place for copal offerings occurred at a time when Chichén Itzá was abandoned and the center of power had shifted 93 kilometers west to Mayapán. This scenario is evident from the analysis of the ceramics recovered by Thompson that concluded that the pottery recovered from the cenote came from two major periods, the Terminal Classic and the Postclassic. Postclassic pottery consisted of vessels that were used in offerings and came from Mayapán whereas the Terminal Classic pottery recovered was not from offerings but rather from trash dumped into the cenote.[29]

This interpretation was corroborated when the cenote was dredged again between 1959 and 1962 by INAH. Funded by the National Geographic Society, the operation used a suction technique that vacuumed up the remaining artifacts from the bottom of the cenote.

To clarify the water, the excavators pumped out as much of it as they could. It lowered the water table and exposed a small peninsula on its west side. Digging there, excavators encountered three stratigraphic levels, the second of which included "copal balls, small tripod dishes painted blue with copal in the inside and several complete vessels typical of the Mayapán era in Chichén Itzá."[30]

Unlike the pottery dredged from the cenote by E. H. Thompson, which was restricted to the Terminal Classic and Postclassic periods, the ceramics that emerged from the INAH project dated back to the Middle Preclassic (800–350 BC) and continued up through the modern era. The number of early ceramics was very small, but throughout the early part of the cultural sequence the evidence suggested that the cenote was a trash dump. Even though another cenote lay some 800 meters away to the south, sherds from water jars indicated that the Sacred Cenote was also a water source that continued up through the Terminal Classic period, but it was also a trash dump during this period.[31]

The ceramics with Maya Blue recovered from Thompson's dredging of the cenote and from the INAH project revealed that they were restricted to the Postclassic period during the dominance of Mayapán.[32] The pigment occurred on copal, on vessels that contained it, and as a paint on other vessels as well, particularly on small bowls and tripod vessels.

The bowl with copal in the Field Museum's collection is one of these Postclassic vessels. It is an example of Mayapán Red Ware that is almost identical in shape to a bowl that archaeologist Robert E. Smith illustrated in his classic work *The Pottery of Mayapán* (1971). The bowl illustrated by Smith also comes from Chichén Itzá, but he says it was "painted blue all over." Blue paint, Smith says, was almost exclusively associated with ceremonial pottery.[33]

This bowl, as well as 90% of the one hundred whole or nearly whole vessels dredged from the cenote, dated to the Middle to Late Postclassic period (AD 1300 to 1460).[34] Smith found the same kind of Late Postclassic pottery on the

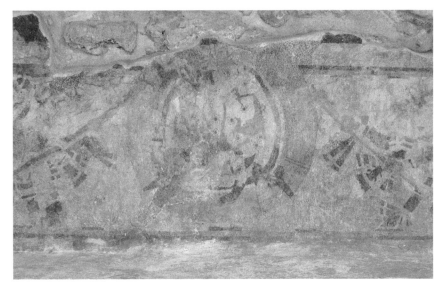

FIGURE 9.4. *Murals at the base of the pyramid at Mayapán (the Castillo). Here the Maya Blue pigment has a greenish tint.*

surface at Chichén Itzá, particularly on fallen structures, an indication that the site was already abandoned by this time.[35]

Most of the complete, or nearly complete, offering bowls recovered from the cenote thus were offered during a time when Chichén Itzá was abandoned. Nevertheless, Chichén Itzá was still an important pilgrimage site. According to a document attributed to the sixteenth-century Spanish priest Diego de Landa, the inhabitants of Mayapán traveled there and threw offerings for Chaak into its Sacred Cenote, a practice continuing into the early colonial period.[36]

After the demise of Chichén Itzá, Mayapán became the principal Maya capital, and Maya Blue became even more important there than it was at Chichén Itzá. In his description of the pottery of Mayapán, Smith observed that blue or blue-green paint occurred most often on its pottery.[37] In the ceremonial center of the site, Maya Blue covers the floors of two small temples. In one structure, the floors were exposed to the elements, and although the blue color had not faded, the plaster below had crumbled, revealing several successive floors covered with Maya Blue over plaster (figure 3.1). The inhabitants of Mayapán also employed a blue-green pigment, also shown to be Maya Blue, in the murals at the base of the central pyramid of the site (figure 9.4).[38] Maya Blue is also found on murals and stucco elsewhere at the site.

WHY THROW BLUE OFFERINGS INTO THE CENOTE?

The first use of Maya Blue occurred during the Late Preclassic period (300 BC–AD 300) on a polychrome facade of Substructure II C at the Maya site of Calakmul in the tropical forest in southern Mexico. An extended drought occurred at end of this period, and the symbolic use of Maya Blue at this time may be associated with the Maya's appeal to Chaak to provide relief. This drought followed stable climatic conditions during the Middle Preclassic (~900–300 BC), and it may have contributed to the decline of some major polities in the central Petén. Calakmul may have been a survivor of this decline because the use of Maya Blue on wall painting there continued into the Early Classic (AD 300–600) and the Late Classic (AD 600–900) with a concomitant evolution of the preparation of the pigment (see chapter 10).[39]

Although the use of Maya Blue began in the Late Preclassic and continued thereafter into the Classic, Terminal Classic, and Postclassic periods, why were the Maya more concerned with using it in the Postclassic period? Why were they preoccupied with blue at this time? Why did the Maya use more of it during the Postclassic period than the periods before it?

If one pauses for a moment and thinks about the religious significance of Maya Blue as a symbol of the rain god, maize, and agriculture, one can get closer to understanding its meaning during these periods. To put this observation in the form of a question: Why were the inhabitants of Mayapán making pilgrimages at Chichén Itzá to throw offerings into its Sacred Cenote for Chaak?

The journey to the Sacred Cenote at Chichén Itzá was not just a pilgrimage to a sacred site. The concern about rain did not involve the lack of domestic water at Mayapán or the paucity of water sources nearby because a cenote occurred within its ceremonial center. Furthermore, this center was located 4 kilometers north of the "cenote zone," in which sinkholes are distributed along a portion of a ring that follows the outline of the Chicxulub Crater, which was formed when a meteor struck the earth sixty-five million years ago. The ring continues to the west and east, and it is likely that the outskirts of the site were very close to the cenote zone. Further, many cenotes lie along the straight-line distance between Mayapán and Chichén Itzá.[40] So why did some inhabitants of Mayapán travel 93 kilometers to the Sacred Cenote at Chichén Itzá to make an offering when a cenote existed in the ceremonial center of Mayapán? With so many cenotes nearby and along the route, why did they think that they needed to make that pilgrimage? The Sacred Cenote obviously had a unique sense of place to the Maya, but might there be an additional explanation?

To answer this question, at least partially, pilgrimages to Chichén Itzá must be placed in the context of the regional patterns of weather and climate. First,

Yucatán experiences distinct rainy and dry seasons. The rainy season begins abruptly in late May or early June when rain falls almost daily with a heavy downpour almost every afternoon. The rains continue until October except for a brief break (*canícula*) during July or August. Besides this seasonal pattern of rainfall, the Yucatán Peninsula lies in the path of frequent tropical storms that sometimes develop into devastating hurricanes with intense, heavy, prolonged rainfall.[41]

Although rainfall may be more intense, heavy, and prolonged during the hurricane season, the rains from November through January are less frequent but more erratic and unpredictable than the rains from May through October. By January, the rains have usually ended, except for an occasional storm (*norte*) from the Gulf of Mexico. Between February and May, little if any precipitation falls.

This annual dry season is so intense that it genuinely may inspire doubt that the rains will come and nourish the newly planted maize, the staple of the Maya diet. Near the end of the dry season particularly, life can be difficult and unpleasant. The midday sun is oppressive, and the wind whips up dust from roads and house lots. As I discovered myself, working at midday during the heat of the dry season is almost unbearable.

Because of these challenges, archaeologists formerly thought that the intensity of the dry season raised doubts among the Maya about whether the life-giving rains would return each year. The sacrifices to the rain god, it was argued, ensured that the rains would come again.

More recently, however, climatological information has revealed that the Maya experienced several droughts during the Terminal Classic and Postclassic periods. In fact, research indicates that the Terminal Classic was among the driest period of the last several thousand years in northern Yucatán. Indeed, data from these studies indicate that the annual rainfall must have diminished by an average of 50%, and up to 70% during peak drought conditions, during this period. It was during the latter part of the Terminal Classic that the Maya abandoned their cities and smaller settlements south of the *puuc* ridge, such as Uxmal, Sayil, Kabah, and Labná, and moved northward.[42]

These droughts were critical for two principal reasons. First, this decline in rainfall was devastating for growing maize. Maize is dependent upon substantial amounts of rainfall, particularly during critical portions of the growth cycle, and many of the soils of the peninsula do not retain moisture well enough to sustain growth during a dry period. Some of the soils south of the *puuc* ridge, however, are excellent, with at least some moisture-retaining organic matter in them.[43] These high-quality soils probably were

the reason some populations did not immediately abandon their cities in the *puuc* region and move north.

Besides devastating the maize crop, drought affected rainwater for domestic consumption. Almost no surface lakes and streams exist in this area, and the water table is deep. In some places sinkholes, caves, and catchment areas on the surface (called *aguadas*) could sustain populations during a dry spell, but generally these were infrequent south of the *puuc* ridge. To provide water for domestic uses during the dry season, the Maya built underground cisterns (*chultuns*) that were plastered on the inside to store rainwater and positioned to catch runoff from a plaza or house lot.[44]

If, however, the rain that flowed into the cisterns during the rainy season was insufficient to sustain a population until the beginning of the next rainy season, the populations would have to move. Move they did, leaving the area south of the *puuc* ridge and relocating to towns further north that had permanent sources of water, such as cenotes, found in the towns of Maní, Telchaquillo, Sacalum, and at the site of Mayapán.

This change in settlement pattern placed the populations closer to sources of water for domestic use, but it did not solve the problem of insufficient rain for their maize crop. If drought had a devastating effect on the Terminal Classic populations, then making an offering of incense to the rain god was one response to that crisis. Indeed, the great frequency of mosaic images of Chaak on the buildings of *puuc* sites, such as Uxmal, Kabah, Sayil, and Xlapak, suggests that these populations were already in need of more rainfall.

At Kabah, the Temple of the Masks lies on a high platform with the entire west side of the building covered with mosaics of Chaak. To face those masks and make offerings to the deity, one faces east, the direction from which the rains come during the rainy season. At Uxmal, the Maya placed similar mosaics of Chaak on the Palace of the Governors, the Temple of the Magician, and around the interior and exterior of the Nunnery quadrangle.

Another extended drought took place between AD 1020 and 1120 and was associated with a population collapse at Chichén Itzá. It was at this time that the center of power in the northern lowlands shifted to the city of Mayapán.[45]

Droughts occurred again in the early historic period between AD 1535 and 1575, with the interval from 1535 to 1542 being particularly dry.[46] This latter period corresponds with the Spanish struggle to subdue the Maya and their ultimate conquest of Yucatán in 1542. Since this period corresponds archaeologically to the Late Postclassic period, it was the pottery from this period that was covered with Maya Blue and recovered from the cenote at Chichén Itzá. Indeed, some of the accounts of sacrifice at the cenote in the document attributed to

Fray Diego de Landa may have come from eyewitnesses; although Landa's account was a compilation of documents at least partially from the sixteenth century, compilers may have used accounts of informants who lived during the first half of the dry period between 1535 to 1575.[47]

NOT JUST A TECHNICAL PROCESS

Besides simply an offering to Chaak, the ritual performance of making Maya Blue using *sak lu'um*, *ch'ooh* and *pom* represented a deeper meaning to the Maya because of the physical healing associated with these components. *Sak lu'um* (palygorskite) had a variety of healing properties, such as alleviating diarrhea and stomach trouble among other uses. The Maya used the indigo plant (*ch'ooh*) for a variety of medicinal purposes (chapter 6), as they did with copal resin (*pom*).[48] Finally, burning copal as incense provided the smoke and aroma that was food for the gods and a vehicle for their petitions.

Creating Maya Blue by burning incense thus would imbue this pigment with thrice its symbolic power: (1) its unique color symbolized the rain deity;[49] (2) it provided food for the deity and a vehicle for their requests in the form of the aroma from burning copal incense; and (3) it combined the healing properties of its components, *ch'oh*, *sak lu'um*, and *pom*. The creation of the pigment by burning incense thus might symbolize, if not ritually enact, the transubstantiation (and even the incarnation) of Chaak in the blue color of the resulting pigment, much like the bread and wine in the Roman Catholic Mass are believed to become the actual body and blood of Christ. As the Maya priest feeds Chaak with the aroma from the burning copal, he appears as the unique color of Maya Blue within the heated mixture.[50]

Just as rain brings healing and relief to the parched land of Yucatán after the rainless dry season, so the ritual feeding of Chaak using a combination of three healing constituents (indigo, palygorskite, and copal incense) materialized the presence of Chaak at the end of the ritual by the creation of a pigment that symbolized the most valued commodity required to sustain human life—water.

Performing this ritual more frequently during drought certainly must have further intensified this request. Therefore, it is not likely that the link between the medicinal value of palygorskite, indigo, and incense and their use in the creation of Maya Blue went unnoticed by the ancient Maya during the droughts of the Terminal Classic and Postclassic periods. Whereas the symbolism of the blue color for the god of rain is undoubtedly critical, the actual ritual performance combining these three components probably led to the perception that the act itself of creating Maya Blue brought physical healing

to the Maya landscape in the form of rain, just as the medicinal uses of its components brought healing to the human body. Consequently, the combination of the materials used for healing and their role in the performance of creating Maya Blue probably elicited social memory beyond simply the symbol of the rain god.[51]

In their analyses of the pottery from the cenote at Chichén Itzá, Maya ceramicists Joe Ball and John Ladd believed that these vessels, as well as other materials, were ritually "killed" by heating and burning the copal before being thrown into the cenote. Similarly, the report of the more recent dredging of the cenote argues that Father Diego de Landa held a great termination ritual at the cenote in the sixteenth century and that this event accounts for the masses of pottery, figurines, copal, and other artifacts recovered from there.[52]

These explanations are certainly possible, and the late date of the pottery that E. H. Thompson recovered makes a termination event at the cenote reasonable. But a single termination event does not explain the remains of more than 200 individuals found in the cenote and the massive amount of Maya Blue in the blue silt under the layer of mud at its base.[53] This blue layer was hydrated Maya Blue (see chapter 2).

By calculating the volume of this blue silt in the bottom of the cenote, it is possible to estimate the massive amount of the pigment that wore off the persons and objects thrown into its depths. Although the cenote is not completely circular, the volume of the hydrated pigment can be roughly determined by using Thompson's measurements of the cenote and its profile.[54] Calculating the area of the cenote (πr^2) from its radius (84 feet or 25.6 meters) and then multiplying the area (2,057.8 square meters) by the inferred depth of the blue silt (4.5–5.0 meters), the total volume of hydrated Maya Blue is between 9,260.1 cubic meters and 10,289 cubic meters.

How much palygorskite was present in this hydrated Maya Blue? Maya Blue consists of about 97%–99% palygorskite, and it is possible to estimate the approximate weight of palygorskite present by using its liquid limit as a basis of calculation. The liquid limit is the "moisture content, expressed as a percentage by weight of the oven-dry soil, at which the soil will just begin to flow when jarred slightly."[55] Palygorskite has a range of liquid limits, but the median of this range is 196%.[56] That is, it becomes liquid when approximately 196% of its weight in water is added. The blue silt layer thus consists of Maya Blue and includes the weight of the palygorskite, a small percentage of indigo, and water (196% of the weight of the palygorskite). So Maya Blue and its major constituent, palygorskite, make up approximately one-third of the weight of the blue silt.

Beyond this crude estimate, it is impossible to calculate the actual amount of Maya Blue or the amount of palygorskite in the silt without knowing its density because the calculation using the liquid limit of palygorskite is based on weight whereas the calculation of the amount of the blue silt in the cenote is based on volume. The weight of the hydrated Maya Blue/palygorskite per unit of volume is the missing variable.

Consequently, although some of the objects with Maya Blue recovered from the cenote may represent a termination event, the massive amount of Maya Blue in the blue silt is simply too great to be only the result of a single event. The blue silt thus probably represents centuries of the casting of many ritual objects and human sacrifices covered with Maya Blue into its depths.

HOW WAS MAYA BLUE MADE?

All of these data indicate that one way in which the Maya created their unique pigment was to ritually burn copal incense with palygorskite and the leaves or an aqueous leachate of the indigo plant (see chapter 10). Indeed, some of the copal in the vessels from the Sacred Cenote revealed distinct leaf impressions on their underside; many other objects of copal (both on copal from bowls and on modeled objects of it) have less clear vegetal impressions, indicating that they were worked on leaves. Other copal objects incorporated bark and leaves in their interior. Coggins and Ladd explained this phenomenon by saying that the copal was worked until malleable and then rolled, incorporating other substances into the interior of the copal. They thought that perhaps that the bark and leaves concentrated in the center of the ball may have come from the copal tree.[57]

It is quite possible, however, that at least some of the bark, leaves, and vegetal impressions were not from the trees that produced copal but rather from parts of the indigo plant that were incorporated into the copal or imprinted on it when it was softened with heat during the preparation of the offering. Because soot and blue paint were often present on the surfaces of the copal before it was rolled,[58] it is possible that the creation of Maya Blue began by rolling palygorskite and parts of the indigo plant together before the offering was melted and shaped prior to being thrown into the Sacred Cenote. Coggins and Ladd, however, make no note of any white substance that would indicate the presence of palygorskite on or in any of the offerings like that which I discovered in the bowl in the Field Museum collection. Further examination of the underside of the copal in these vessels in the collection of the

Peabody Museum may reveal the presence of palygorskite and leaf imprints from *Indigofera* plants.

Although there is much evidence supporting the method of making Maya Blue described in this chapter, it is only one method used by the ancient Maya. Additional evidence indicates that its creation is far more complicated and complex and will be described in the next chapter.

10

Did the Maya Use Other Methods to Create Maya Blue?

From the last chapter, it appears that we now know how Maya Blue was made and that the mystery of its preparation has been solved. The data supporting this conclusion were published in an article in the British archaeological journal *Antiquity* by me and my colleagues in 2008 and was summarized in the previous chapter.[1] At the end of that year *Archaeology* magazine placed this discovery first on its list "Top 10 Discoveries of 2008."[2]

Prior to the appearance of the story in *Archaeology*, one of the editors called me and said that he had talked to other scientists who were working on Maya Blue and asked them about our discovery. They responded that the "presence of copal and Maya Blue together does not indicate that one was burned to create the other, or that producing the pigment had any ritual significance."[3] The editor then asked me to respond. In a moment of disciplinary arrogance, I replied: "They are not anthropologists and perhaps they don't understand how ritual works." That statement was, of course, true, but then the editor asked me if we had done experimental work to verify our conclusion. I said no, we had not. It *was* true, however, that my research with my colleagues revealed that the underside of the offering in the bowl showed evidence of palygorskite, indigo, and Maya Blue that were mixed with the copal (see chapter 9), which indicated that the Maya had applied enough heat to melt the copal so that it took the shape of the bowl. Previous research indicated that heat was required to create the pigment (chapter 2).

https://doi.org/10.5876/9781646426683.c010

The use of ritual burning of copal to create Maya Blue, however, was not a new idea and was originally suggested by Cabrera Garrido in his 1969 monograph, *El Azul Maya*, based upon the residue in an Aztec incense burner (see chapter 9).[4] Furthermore, our interpretation was supported by other archaeological and ethnographic evidence of burning copal for offerings among the ancient and modern Maya. More important, the vessel and its contents were only one of the fifty other such copal offerings with blue on them that E. H. Thompson recovered from the Sacred Cenote at Chichén Itzá. These offerings are still in their original bowls and are stored in Harvard's Peabody Museum.[5]

The ancient Maya created Maya Blue with other kinds of copal offerings as well. In their description of the copal offerings (N = 160) from the Sacred Cenote in the Peabody Museum's collection, Coggins and Ladd said that after pottery sherds, copal offerings were the most numerous categories of objects recovered from the cenote. Most were intact (117 of 160), and blue occurred on "most, if not all the offerings."[6] Although they believed that the blue was painted on the copal, it was clear that the heat from the burning copal had softened it and that, for those offerings in vessels, the copal took the shape of the vessel. This observation is consistent with our analyses of the bowl in the Field Museum collection and indicates that the heat from burning incense with palygorskite and indigo was one method that the ancient Maya used to create the pigment (figure 9.2).[7] It is now evident, however, that the ancient Maya used other methods to prepare it as well.

ASSUMPTIONS IN INTERPRETING THE PAST

The assumptions used to learn about the past come from the culture of the interpreter in the present and can be both explicit and implicit. One such implicit assumption expressed by the critics of our *Antiquity* article reflects the belief that technology in ancient cultures is separate from religion. This separation, however, is not shared by cultures that did not experience the consequences of the Enlightenment in Western Europe. Rather, in preindustrial societies technology often has a significant religious component.

One does not have to be a scientist, however, to have post-Enlightenment assumptions about technology in non-Western preindustrial cultures. Many years ago one of my students interned with a development organization in West Africa. The organization was trying to motivate women to use a motorized mill that they had installed to dehull and grind grain. The local women were reluctant to use it, and the development organization could not understand why the women did not want to be more efficient and save time by

using the mill as opposed the time-intensive traditional method of grinding the grain with a large mortar and pestle. My student, however, discovered that the traditional method was associated with deep social and religious meanings that, if abrogated, would result in adverse consequences if the women used the more efficient motorized facility. This African culture, like many cultures of the world, does not value time and efficiency as highly as Western cultures.

This work has already described the religious meanings of Maya Blue, its constituents, and its uses. Besides throwing offerings of burning copal with indigo and palygorskite into the sacred space of the Sacred Cenote at Chichén Itzá, this work has already discussed the religious dimensions of the sources of palygorskite in Sacalum and Yo' Sah Kab near Ticul. Further, palygorskite, indigo, and copal all had healing and religious significance, and their ritual combination into Maya Blue communicated deep meanings of healing besides bringing forth the symbol of the rain god, Chaak, if not his actual presence.

PREPARING MAYA BLUE USING A COPAL OFFERING: LIMITATIONS

Although the ritual of burning/melting of the copal with palygorskite and indigo is consistent with observations about the bowl and its contents described in the last chapter, this technique has great limitations for creating Maya Blue for other uses. First, and most obvious, throwing a burning offering into the cenote meant that the pigment could not be retrieved and repurposed for painting pottery, murals, and sculpture. Second, if, as I have already argued, indigo, palygorskite, and copal were used for healing and the act of combining them in a ritual was geared to restoring the productivity of a parched land, then removing Maya Blue from the offering could be seen as a sacrilege. It could jeopardize, if not invalidate, its intended consequences of petitioning Chaak. So if the aroma from the burning copal and the emergence of Maya Blue were the end products of the offering to Chaak, and if the Maya viewed the creation of the pigment as his incarnation, then it is unlikely that the Maya prepared the pigment in this way for other purposes. Furthermore, because balls of copal with Maya Blue are sometimes recovered in burial contexts such as Temple I at Tikal,[8] and as offerings in the Sacred Cenote of Chichén Itzá,[9] the Maya preferred such offerings to remain intact and did not dissect them to remove the Maya Blue (see chapter 9).

If, on the other hand, the Maya *did* use this technique to create the Maya Blue for sculpture, murals, and pottery, how did they separate it from the

copal? Allowing the burning copal to turn to ash might leave Maya Blue behind, but too much heat from the burning copal might destroy the pigment.[10] Further, some palygorskite was left behind on the bottom of the copal offering like that described above in the Field Museum's collection (figure 9.2). So how would the Maya separate the palygorskite and the copal from their sacred pigment so that they could use it for other purposes?

Finally, examining the copal offering in the bowl in the Field Museum collection indicates that heating copal with palygorskite and indigo produces so little pigment that it would be insufficient for any other use. Indeed, this particular bowl is only 11 centimeters in diameter and 6 centimeters high, and it contained only a small portion of Maya Blue (figure 9.2).[11] Creating Maya Blue in this way initiated its sacred status and verified and enhanced its divine significance, but it is not likely that ancient Maya used this technique to create the pigment for pottery, murals, and sculpture. The ancient Maya must have employed other methods to make it for these media and restricted the copal-burning method to ritual offerings that symbolized, if not incarnated, the appearance of Chaak in their appeal for rain.

UNDERSTANDING THE PREPARATION OF MAYA BLUE

To dig more deeply into how Maya Blue was created, it is first necessary to understand how indigo combines with the palygorskite. One may think that because indigo is a blue dye, it simply "dyes" the palygorskite a blue color. In the sense that indigo colors cloth, it does indeed "dye" the palygorskite, but indigo does not really dye the clay in the same way as it dyes cloth because it combines with the palygorskite in different ways to create a paint that is unlike the properties of either indigo or palygorskite, but with some of the qualities of each. Cloth dyed with indigo still retains the characteristics of the cloth with simply added color. Indigo-dyed cloth thus is still cloth, but Maya Blue does not simply consist of palygorskite that is dyed blue. Rather, Maya Blue is an organic-inorganic chemical hybrid with stability in sunlight, does not fade over time, and is not destroyed by acids or alkalines.[12] Indigo, on the other hand, and the fabrics dyed with it fade over time with exposure to sunlight. Furthermore, acids and alkalines destroy it.[13] Maya Blue is only destroyed by high heat ($>300°C$).[14] Sepiolite, another fibrous clay mineral like palygorskite, is found in some samples of Maya Blue, but although heating a sepiolite/indigo mixture produces a Maya Blue–like pigment, it is not as resistant to dilute acids, alkaline reagents, and heat compared with the pigment prepared with indigo and palygorskite.[15]

Since Maya Blue contains indigo, one of the earliest attempts to replicate the pigment involved grinding palygorskite, mixing it with indigo powder, and then heating it to 150°C.[16] Creating it with this technique used artificial indigo. First synthesized in the late nineteenth century, artificial indigo is available commercially and is easily accessible in the stockrooms of university chemistry departments. Natural indigo, however, contains more varieties of indigo-related molecules than synthetic indigo. Synthetic indigo (indigotin), on the other hand, is formulated from only one of the compounds (indoxyl) found in natural, plant-based indigo.

Indigo, however, is not a powder in nature; it comes from plants in the genus *Indigofera*. It is the product of a chemical process that begins with soaking crushed leaves and stems of the plant in water (see chapter 7).

Although indigo is responsible for the coloring in Maya Blue, the ancient Maya did not use powdered indigo to make Maya Blue and certainly did not utilize its synthetic form. Rather, as Littmann first proposed in 1982,[17] they may not have used indigo at all but rather an aqueous extract from one of the *Indigofera* species to mix with the palygorskite. This extract consists of the chemical precursors of indigo that altered to indigo during the preparation process after they bound chemically to the palygorskite.

These chemical precursors and other indigo-like compounds are called indigoids, and a variety of them occur naturally in the *Indigofera* species, but their relative quantities vary with the species used and the season when the plants are harvested.[18] These compounds consist of indigotin, indirubin (indigo, brown), and a related compound, isoindigotin. Indigotin is the main coloring constituent of indigo dye and makes up 85%–98% of the extracts from the plants of the *Indigofera* species.[19] But other precursor compounds may also occur in these extracts, such as indican and isatan as well as directly related compounds such as isatin, indoxyl, and 2-idolinone, which can also accompany the indigotin, indirubin, and isoindigotin in the palygorskite structure.[20]

Besides indigo proper (indigotin), some of these indigo-like compounds, such as indirubin, occur in Maya Blue up until the Late Classic period when indirubin-free pigments began to occur. The different ratios of indigotin to indirubin in the pigments from these sites appear to be sensitive to the source of the indigo and to its methods of preparation, indicating that the Maya may have used varied species of the *Indigofera* genus and/or different recipes to create Maya Blue that changed over time.[21]

THE NATURE OF THE PALYGORSKITE-INDIGO BOND

Some of the inferences about how the ancient Maya created Maya Blue rest upon the way in which indigo and its precursors bind to the palygorskite. This bonding is a consequence of the structure of palygorskite, which consists of long fibers with interior channels filled with water molecules that are loosely bound to the structure of the clay.[22] Heat drives off these water molecules and loosens the clay's hydroxyl bonds so that they can bind to the indigoid compounds and create the organic-inorganic hybrid that is Maya Blue.[23] Removal of the water in these channels thus is critical for the insertion of the indigoid compounds that bind to the palygorskite. This bonding gives the pigment its blue-green color and its great stability, which, unlike indigo, resists fading and attacks by acids and alkaline solutions.[24] This bonding results from grinding the palygorskite/indigoid mixture together and then heating it, slowly and gradually, or for an extended period to produce the different color variations of Maya Blue. These distinct color variations indicate that the Maya employed several different techniques to produce the pigment that evolved over time.[25]

Although the bonding of indigo to the interior of the palygorskite channels is fundamental for the creation of Maya Blue,[26] it is only one of the options possible. Chemists and other physical scientists have discovered that indigo, its isomers,[27] and its precursors bind to the palygorskite in several locations, depending on how the mixture is prepared.[28] Some believe that indigo enters the channels to bind with the palygorskite during the heating process,[29] whereas others believe that indigo binds only to the open ends of the channels. Others, however, dispute these models, arguing that the indigo mainly binds to the grooves resulting from the broken channels on the external surface of the palygorskite fibers.[30] Still others argue that the indigo binds both to the ends of the channels *and* to the grooves on the surface of the fibers.[31] Another set of chemists proposes that the oxygen in the carbonyl group in the indigo molecule binds directly to aluminum (Al^{3+}) and/or magnesium (Mg^{2+}) cations in the silicon-oxygen lattice of the palygorskite.[32] Because of these varying binding locations, Antonio Doménech Carbó and his team at the University of Valencia in Spain have suggested that Maya Blue should best be viewed as a "polyfunctional organic-inorganic hybrid" in which indigoids can bind to any or all of these sites.[33]

Considerable insight into the bonding of indigoid compounds to palygorskite resulted from an experiment comparing a mixture of synthetic indigo and palygorskite with that of palygorskite mixed with the leachate derived from soaking the leaves of one of the *Indigofera* species (*Indigofera suffruticosa*). In this experiment analysts prepared Maya Blue by three methods. Although

only two were relevant to the ancient Maya, all the methods helped resolve the different explanations about where the indigo bonded to the palygorskite structure. One method involved placing 5 grams of fresh washed leaves of the indigo plant and 1.5 grams of palygorskite in 100 milliliters of water and letting it stand for eighteen hours at room temperature. Then the leaves were removed, and the suspension was stirred vigorously for twenty minutes, filtered, and dried at 180°C overnight. A second preparation used the well-known technique of grinding synthetic indigo powder with palygorskite and heating it to 180°C. Then all the samples were treated in a mechanical device that simulated aging:

> The temperature was maintained at 45°C–50°C for sixteen hours under UV exposure and a relative humidity of 20%–30%, followed by eight hours at 45°C–50°C under 80%–100% relative humidity without UV exposure. This cycle was repeated for 200 days, which is equivalent to ten years in real time.[34] Finally, each sample was tested for acid resistance and then analyzed using nuclear magnetic resonance to be sure that it met the characteristics of the stability of Maya Blue.[35]

The results revealed that indigo bonded to a variety of locations in the palygorskite. First, only the sample prepared with synthetic indigo was consistent with the hypothesis that indigo bonded to the external grooves of the broken channels. Second, only the sample prepared with an aqueous solution from the leaves of the plant revealed indigo inside of the channels of the palygorskite. This solution also included a water-soluble precursor of indigo, indoxyl, which leached out of the leaves of the *Indigofera* plant. Being smaller than the indigo molecule, it bonded both to the grooves on the surface of the clay structure and then moved into the channels, where, over time, it was oxidized to become indigo.[36] This experiment indicated that the ancient Maya did not have to start with indigo to create Maya Blue but rather could use a solution of the crushed leaves of an *Indigofera* species, which provided a precursor (such as indoxyl) that later became indigo.

These different bonding scenarios, however, are not mutually exclusive; they reveal that indigo-like molecules can bind to different locations in the palygorskite structure depending on the method of preparation. Some then oxidize within the structure to become indigo. Consequently, Maya Blue is not necessarily the product of mixing palygorskite and indigo but can result from the binding of indigoid precursors extracted from the *Indigofera* leaves to the palygorskite, after which the precursors alter to become indigo.[37]

The varieties of indigo-like precursors (indigoids) that bind to the palygorskite in Maya Blue vary in space and time,[38] indicating that the Maya

employed different techniques to create it.[39] Antonio Doménech Carbó and his team at the University of Valencia have proposed that these techniques have evolved over time. The first technique began in the Late Preclassic at the site of Calakmul in the southern Maya lowlands where the Maya created the pigment by crushing palygorskite and indigo with no (or slow and gradual) thermal treatment. The Maya continued using this technique up into the Postclassic period at Mayapán. During the Classic period at the sites of El Tabasqueño and Mulchic, however, the Maya employed a second technique that involved slow, gradual thermal treatment, frequently with the postheating addition of ochre-type minerals. A third technique required a thermal treatment between 160°C and 200°C and occurred at D'zula and Ek' Balam during the Late Classic. A fourth technique involved strong thermal treatments with temperatures exceeding 200°C but with local variants. These variants resulted from using different temperatures and adding ochre or other unknown materials prior to thermal treatments. The Maya used one of these variants at Chichén Itzá during the Terminal Classic and employed two others at Mayapán during the Postclassic.[40]

I doubt whether adding red ochre to Maya Blue is the only explanation for its presence in the pigment. Rather, it is highly likely that hematite (red ochre) and perhaps limonite (yellow ochre) were naturally present in at least some of the ancient palygorskite used to make Maya Blue. Indeed, besides white (*sak*), the Maya potters in Ticul recognize two color varieties of *sak lu'um* (palygorskite): red (*chak*) and yellow (*k'an*), which contain enough iron minerals to affect their color. As I have indicated previously (chapter 3), some of the palygorskite samples from the mine in Sacalum contain visible oxides of iron (hematite and limonite) that color them yellow with red specks. Trace element analyses (using LA-ICP-MS) of palygorskite samples collected in Sacalum and Yo' Sah Kab in 2008 confirm the presence of iron ions. Those samples from the Sacalum mine have a higher concentration of iron ions,[41] which would make the color of Maya Blue greener. By way of contrast, *sak lu'um* from the thin layer of above the mine in Sacalum and those from Yo' Sah Kab near Ticul are much whiter and have a smaller concentration of iron ions, which do not affect the color of the clay and presumably do not affect the color of Maya Blue made with it.[42]

As mentioned earlier, the color of Maya Blue may vary from shades of blue to green, as it does in the murals at Mayapán.[43] Besides the presence of iron minerals naturally present in the palygorskite and the differences in the preparation techniques used to create them, the wear from grinding and mixing Maya Blue in a bowl with a red slip introduces hematite (red ochre) into Maya

Blue and perhaps also accounts for the change in color. This scenario will be discussed later in this chapter.

Several investigators have found that dehydroindigo, an oxidized form of indigo, accompanies regular indigo in the palygorskite structure during preparation of Maya Blue.[44]

At first, the heat drives off the physically held water in the palygorskite channels, and then, as the temperature increases, the indigo oxidizes to dehydroindigo, attaches to the palygorskite structure (either in the grooves and/or at the ends of the channels), and then penetrates more deeply into the channels. Because dehydroindigo is yellow, it can alter the color of the pigment to be greener so that as the ratio of dehydroindigo to indigo changes, the hue of the pigment changes from blue to turquoise. This same pattern also occurs with the Maya Blue made with sepiolite.[45]

Other chemists have shown that the color of the indigo-palygorskite mixture changes from deep blue to greenish blue with the length of heating. This change results, they believe, from the interaction of the indigo with the palygorskite and a structural change of the indigo, consistent with the hypothesis that indigo is transformed to dehydroindigo with heat.[46] Since dehydroindigo is yellow, this transformation results in a greener pigment.

Another compound, isatin, which is naturally present in *Indigofera* species, also forms a stable Maya Blue–like pigment with palygorskite. It resisted degradation after being boiled for five hours with hydrogen peroxide. Because its molecule is smaller than that of indigo (indigotin), it penetrated more deeply into the channels of the palygorskite than indigo and blocked their entrances so that indigo could not penetrate as deeply.[47]

MAYA YELLOW

Maya indigoid-palygorskite hybrids are not restricted to pigments that end up as blue, blue-green, or green; they can also be yellow. Maya Yellow consists of palygorskite and indigoids such as dehydroindigo and perhaps isatin and is found on wall paintings from the Early Classic period (ca. AD 450) to the Postclassic in the Maya sites of Acanceh (Early Classic), Chacmultún (Late Classic), D'zula (Late Classic), Chichén Itzá (Terminal Classic), and Mayapán (Postclassic) (figures 2.1, 5.11).[48]

As for the creation of Maya Yellow, Doménech Carbó and his team have proposed that the creation of Maya Yellow was an intermediate step in the preparation of Maya Blue based on experimental data. First, the leaves and twigs of the *Indigofera* plants are soaked overnight in a suspension of slaked

lime in water. Then the coarse material is filtered out, and a portion of the yellow suspension is separated and combined with palygorskite to create Maya Yellow. The remaining portion of the suspension is aerated by stirring until it becomes greenish and finally blue. The suspension is filtered and dried to separate the indigo for dyeing and/or is used to make Maya Blue by crushing palygorskite with it.[49]

DID THE KNOWLEDGE OF CREATING MAYA BLUE SURVIVE INTO THE PRESENT?

Sometimes failed hypotheses can reveal important insights into a research problem. One such hypothesis proposed that the knowledge of creating Maya Blue survived into the present. So ethnographic research provided another approach for discovering how the ancients made the pigment. Did contemporary Maya potters know anything about creating Maya Blue?

When, in early 1965, I discovered the importance of palygorskite (*sak lu'um*) among Maya potters and then, in late 1965, learned that it was a critical component of Maya Blue, I wanted to test the hypothesis that potters recognized the unique characteristics of palygorskite. Since it was such a key component of Maya Blue, I wanted to verify whether modern Maya potters were still mining and using the same mineral that their ancestors had used to make the pigment. They were, and this research was summarized in chapters 4 and 5.

Since Ticul potters were aware of and still used *sak lu'um*, I wondered whether the knowledge of how to make Maya Blue had also survived. Three years previously (1962), Anna O. Shepard had suggested that the other component of Maya Blue might be indigo, but in 1965 no one had demonstrated its presence in the pigment except for its existence in a paint called Azul de Tekax (see below), brought from Yucatán in the 1920s.[50]

In January of 1966 I received a small grant to return to Ticul to collect data to test the relationship of potters' knowledge of *sak lu'um* for my master's thesis (see chapter 4). Before I left for Yucatán, however, I reread the articles by Gettens, Shepard, and Shepard and Gottlieb, the only articles written about Maya Blue at the time. Besides their discussion of Maya Blue, they reported the existence of Azul de Tekax, which A. Everett Austin had collected in Yucatán in the 1920s under the auspices of Harvard's Fogg Museum. Austin wanted to study the wall paintings in the Temple of the Warriors and in other buildings at Chichén Itzá. He brought back five vials of paint, one of which was labeled "Azul de Tekax." When this vial was discovered in 1957, only one half of a gram of the pigment remained. Analyses of it revealed that

it contained palygorskite (attapulgite) and indigo and showed all the characteristics of Maya Blue.[51]

A collaborator with Gettens, H. E. D. Pollock, noted that Tekax was a city in southern Yucatán and thought that Azul de Tekax might be linked to that city. Hoping to find modern evidence about the preparation of Maya Blue in Tekax, Anna O. Shepard, a colleague of Gettens and Pollock, went there to inquire about the pigment but found no evidence of it.[52]

Having learned some Yucatec Maya during my fieldwork in Yucatán in 1965, I realized that Austin's Azul de Tekax probably had no relationship with the city of Tekax at all but had another meaning. In Yucatec Maya the name "Tekax" can be separated into two morphemes, *te-* and *kax*. The morpheme *te-* is a locative adverb indicating a place or toward a place. Maya speakers pronounce *kax* with an initial glottalized velar stop (*k'*) and a final sibilant "sh" (*x*). This morpheme, *k'ash*, means "forest" (*monte* in Spanish),[53] and thus Azul de Tekax could be translated as "blue of the forest."[54] As a consequence, it was not likely that inhabitants of the city of Tekax possessed any unique or specialized knowledge of the pigment called Azul de Tekax that Austin collected, now known as Maya Blue.

Because of the translation of Azul de Tekax as "blue of the forest," however, I wanted to see if I could turn up some evidence of this pigment among Ticul potters that hopefully might be Maya Blue. After I arrived in Ticul in January of 1966, I consulted my informants from the previous year. One of them, an elderly potter named Augustin Tzum (1902–1988),[55] said that he knew of a blue paint, and, at my prompting, he and his son Alfredo tried to replicate it. I harbored an unexpressed hope that I could learn something about Maya Blue from their attempt.

To create the pigment, my informants said that they needed several different ingredients. One was *sak lu'um*, which Augustin said was added to create a shiny luster; Alfredo said that it made the color fire resistant. Their unsolicited mention of *sak lu'um* for making the pigment supported my unexpressed hope that the result of their creation would be Maya Blue.

My informants also said that they needed white clay (*sak k'at*), blue soap (*azul habón*), water, and a blue color that they had to purchase to make the pigment.[56] Augustin also added ashes (*senisa*), saying that the mixture had to soak for a while so that the hard *sak lu'um* could soften to mix well with the other ingredients.

When my informants had finished preparing the pigment, they painted a flowerpot (*masetero*) and a small water-carrying pot (*cantaro*) with it. They also cut a geometric floral pattern from folded paper and affixed it to a vessel

to create a resist design that would contrast with the color of the paste and that of the painted surface. Then they said that it was time to see what would happen to the pigment after it was fired. Augustin's son-in-law, Francisco Keh, was planning to fire his pottery the next day. So we took the painted vessels there to put in his kiln.

After the kiln had cooled two days later, we returned. The blue color had almost completely disappeared, and only a cream color with a few vague blue spots remained. The vessels with the resist design were also a cream color and, as expected, contrasted with the color of the unslipped surface under it.

By this time, it was clear that the pigment they created was *not* Maya Blue. Although they had used palygorskite (*sak lu'um*), their pigment did not have the texture of Maya Blue because the white clay and soap provided a binder for it. Further, Maya Blue is a post-firing pigment and is destroyed by the heat of firing.

My informants said that another way to obtain the blue color was to pick the fruits of the *ch'oh* "tree"—*ch'oh* being the Maya name for *Indigofera suffruticosa*—when they were dry, grind them, and then add water.[57] After soaking, they said, the water would have a blue color. Unfortunately, they could not find any *ch'oh* "trees" growing in their house lot to obtain the seeds.

Although this inquiry was attempted more than fifty-five years ago, these potters possessed no significant knowledge of creating Maya Blue acquired from their ancestors, if, indeed, the makers of that ancient pigment were potters. Nevertheless, this failed attempt revealed that the potters knew of a blue paint, that it was made with *sak lu'um*, and that one source of the blue color was *ch'oh*, the plant from which the ancient Maya derived the colorant for Maya Blue. Later that year (1966), I discovered Van Olphen's article in *Science* in which he described his synthesis of a Maya Blue–like pigment using palygorskite and indigo; this confirmed that my informants knew something about the components of Maya Blue, even though their attempt at preparation was not very illuminating. Nevertheless, the translation of Azul de Tekax as "blue of the forest" was consonant with the widespread occurrence of the different species of the indigo plant (including *Indigofera suffruticosa*) that grow wild in several parts of the Americas.[58]

A MODERN REPLICATION OF MAYA BLUE

Although it appeared that the knowledge of how to create Maya Blue is no longer part of Maya cultural heritage, a massive amount of information exists about how to make it based upon the analytical and experimental research of

chemists and physical scientists as well as from historical and ethnographic descriptions. Although artists' interest in Maya Blue existed for many years, the motivation to apply that information to replicate the pigment from traditional raw materials has recently emerged among the Maya of Yucatán.

In September of 2021 I was invited to participate in an international online symposium about Maya Blue sponsored by the British Museum. Participants included a small group of artists, chemists, anthropologists, art historians, and those interested in preserving Maya Indigenous knowledge. During this meeting I learned about the work of Luis May Ku, an artist/teacher from the Mexican state of Quintana Roo, who has replicated Maya Blue for his own use and to sell to other artists.[59]

Luis apprenticed himself to potters in Ticul and learned how to recognize *sak lu'um*, one of the critical components of Maya Blue. Knowing that the plant called *ch'oh* (*Indigofera suffruticosa*) was the source of the indigo used to make Maya Blue, he learned how to recognize it from local agriculturalists (*milperos*). He gathered its seeds and then grew it. When the plants matured, he cut them, crushed the stems and leaves, soaked them in water until the water turned blue, and then added *sak lu'um* to heated water, The resulting pigment was then dried, crushed into a powder, placed in small glass bottles, and sold it under the name "Ch'oj: Azul Maya."[60] *Ch'oj* is the modern Maya word for "blue" (see chapter 2).[61]

This method of making Maya Blue mimics the process described by Torres and Reyes-Valerio, gleaned from colonial and modern documents about producing indigo dye with the subsequent addition of palygorskite.[62] Although a productive and useful way to make Maya Blue, it was not necessarily the method that the ancient Maya used to make the pigment.

VESSELS USED FOR PREPARING MAYA BLUE

As I have already described, some approaches to discover how the ancient Maya made Maya Blue were experimental and based upon the process of extracting indigo dye from *Indigofera suffruticosa* and then adding palygorskite at the end of the process,[63] or by mixing palygorskite with indigo, indigo precursors, or extracts derived from the leaves of *I. suffruticosa* under different chemical conditions.[64] A third approach was ethnographic and tried to discover if knowledge of how to make the pigment survived among contemporary Maya potters.

A fourth approach involves the search for museum pieces used to create the pigment. One outcome of this approach was described in chapter 9 and

employed convergent thinking by combining ethnographic and archaeological information. A subsequent outcome emerged from combining reflection about my ethnographic experience and reading the chemical literature about the pigment.

As I mentioned previously, seemingly serendipitous experiences may come together to provide new insight for making a discovery or solving a mystery. This convergent thinking can be illustrated again by exploring different strands that uncovered another way in which the ancient Maya created their unique pigment.

One of these convergent strands consisted of the preparation of *sak lu'um* to make Maya Blue. The modern Maya define *sak lu'um* as white, hard, and rocklike, but which becomes plastic with water. So to create the pigment, the rocklike *sak lu'um* must be ground up because it is simply easier to make the pigment from a powdered material than from a rocklike substance.

As I discovered from reading the chemical literature about Maya Blue, however, grinding *sak lu'um* is not just a physical process that makes the palygorskite easier to use; it is also a key procedure for preparing any stable palygorskite-organic hybrid such as Maya Blue. Grinding increases the surface area of the clay so that the indigoid molecules can bind to the clay more completely. Using methylene blue, for example, Zhang and colleagues showed that increasing the amount of time used to grind the palygorskite improved the dispersion of its crystal bundles, facilitated the release of the water molecules from its channels, and intensified the interaction between palygorskite and the methylene blue dye. Increased grinding time thus greatly enhanced the formation of a stable organic-inorganic hybrid material. Another experiment revealed that grinding *wet* palygorskite preserved its structure and improved the stability of the resulting hybrid more than grinding the dry clay.[65]

The necessity of grinding the palygorskite before preparing Maya Blue raises the question about how the Maya did it and the tools they used for the task. After thinking about these questions, I realized that I had initially ignored the importance of grinding the palygorskite because it was so obvious. It was not until I read the chemical literature about the necessity of grinding it to disperse its fibers, and especially the importance of grinding it wet, that I began to think about how the ancient Maya did it. They obviously employed tools to grind it, but what kinds of tools? Did they employ a stone *mano* and *metate*, for example, to grind palygorskite like those used to grind maize?

As I thought about these questions, I remembered a grater bowl in the Field Museum's collection that I had discovered during my survey of the objects there with Maya Blue (figure 10.1). Another adjunct curator at the Field

FIGURE 10.1. *Interior of a tripod grater bowl covered with Maya Blue and with incisions in its base; excavated from El Osario, Grave 6, at Chichén Itzá by Edward H. Thompson in 1896. (Photograph by the author courtesy of the Field Museum, cat. no. 48158.)*

Museum, Linda Nicholas, had photographed that bowl, which was recovered from E. H. Thompson's excavations of the Osario (Grave of the High Priest) in 1896.[66] Thompson recovered another bowl just like it from the Sacred Cenote in 1904.[67]

In making this vessel, the potter scored thick incisions in the bottom of the bowl (figure 10.1), but why? How did the ancient Maya use this bowl? It was obviously used to grind something; hence, the descriptive term "grater bowl" is appropriate. It appeared, however, that they did not use it to grind the

lime-soaked maize kernels to make the dough (*masa*) for tortillas and tamales because its small size (diameter 16 cm; depth 6.7 cm) limited the amount of maize that could be ground. Further, grinding lime-soaked maize probably would break the bowl. On the other hand, the Maya might have used such bowls to grind chile peppers, although in my experience the contemporary Maya often ate them whole.

One clue about the bowl's use comes from examining the incisions in the base of its interior. Some of the clay excised remained after each incision was made. This residual clay revealed little use-wear, indicating that the Maya used the bowl only for a brief period and that the material ground was not very hard (figure 10.1). Most of the red slip around the incisions is gone, but Maya Blue is visible in and around the incisions.

A second clue about the bowl's use comes from the presence of Maya Blue elsewhere on the vessel (figure 10.1). The pigment is not a slip but rather covers most of the red slip and is sloppily applied. Why did the Maya smear the pigment around the inside and on the outside of the vessel on top of the slip—and do so carelessly? Because Maya Blue is a fugitive pigment and does not adhere well to an object, its apparent sloppy application may simply result from being washed off after the bowl was removed from the excavation.

A third clue comes from a white residue visible in and along some of the incisions and as specks and splotches elsewhere in and on the vessel (figure 10.1). This white residue might be the remains of palygorskite ground in preparation for making Maya Blue. Because *sak lu'um* is very hard and difficult to grind dry, it appears that palygorskite was ground when it was wet. When the process was completed, some of the wet palygorskite and the newly created Maya Blue stuck to the inside of the vessel and remained in and around the incisions.

If, on the other hand, the ancient Maya ground the raw rocklike *sak lu'um* dry, the bowls would break easily. Chunks of newly mined *sak lu'um* are so hard that temper miners at Yo' Sah Kab discard them in spoil piles in favor of smaller pieces of *sak lu'um* to crush for preparing temper. With future rains, these discarded chunks fall apart, and miners can break them up more easily (figure 4.2; see also chapter 4).[68]

The perception of the hardness of *sak lu'um* is also illustrated by one temper miner, Elio Uc, who mined *sak lu'um* to sell to those potters who had bought inferior temper. He mined large chunks of it (figure 3.1), soaked them in water, broke up the large pieces, and then spread out the smaller pieces to dry in the sun before he sold it to potters by the sack, eliminating the need for potters to crush the large chunks of *sak lu'um* to add to their substandard temper.[69]

Consequently, for producing Maya Blue, it is more likely that the ancient Maya ground wet palygorskite with the leaves of the indigo plant (or a leachate from them). The ancient Maya thus appear to have prepared Maya Blue using a wet process in this bowl rather than a dry process.

Heating is critical to create Maya Blue and ensure the stability of its color over time. Since the vessel is a tripod bowl, the ancient Maya could have placed it over a small fire to heat the mixture of the crushed palygorskite and the extract from the crushed indigo leaves. Then after the pigment cooled, it was scraped out, leaving some around the interior along with the remnants of palygorskite. The Maya potter thus probably did not decorate this vessel with Maya Blue; rather, its presence in the interior of the bowl, with evidence of horizontal wiping or scraping, indicates that the pigment likely resulted from creating Maya Blue.

Testing the Hypothesis

There are several ways to test the hypothesis that the ancient Maya used this bowl to create Maya Blue. One way would be to analyze the white residue in the bowl by X-ray diffraction to see if it was palygorskite. Another way would be to compare the bowl with the other tripod bowls from El Osario to determine whether they had similar patterns of residue and use-wear (table 10.1). Such common use-wear patterns increase the likelihood that the bowls were used for making Maya Blue even before trace element and mineralogical analyses would test the hypothesis that the white residue was palygorskite.

Examination of the Field Museum's collection of the pottery from El Osario revealed a total of sixteen tripod bowls. Two of them, J. Eric Thompson believed, were not actually from the monument.[70] Another was a greatly fragmented globular vessel with Maya Blue on its exterior, with no interior slip and no use-wear in its interior.[71] A third had a design painted on its interior base.[72] Thus, these four bowls did not appear to be relevant as vessels used to create Maya Blue. The remaining twelve bowls, however, were red-slipped tripod bowls, like the ones recovered from the Sacred Cenote (chapter 9), and were associated with five of the seven graves.

To evaluate whether these bowls were used to create Maya Blue, they were compared visually to the emptied bowl with copal and Maya Blue that came from the Sacred Cenote (chapter 9; figure 10.2). The trace element analysis of the Maya Blue from the copal of this bowl using LA-ICP-MS indicated that the pigment was made with palygorskite that came from Sacalum.[73]

FIGURE 10.2. *Interior of the bowl recovered from the Sacred Cenote at Chichén Itzá; without its copal offering, white residue can be seen. A triangular portion of the bowl (center right) was restored by the conservation department of the Field Museum. (Photograph by author; courtesy of the Field Museum, cat. no. 189262.)*

When the copal was removed from this bowl, its interior revealed a white substance in its interior base that was likely the palygorskite used to make the pigment (figure 10.2). It looked like the white residue remaining on the underside of the copal offering in it (figure 9.2) and that found in the interior in many of the twelve red-slipped bowls from El Osario.

For the visual comparison of the contents and use-wear of the bowls, the twelve red-slipped bowls from El Osario were grouped into two categories.

TABLE 10.1. Contents of El Osario at Chichén Itzá

Type of Artifact	Grave or Depositional Unit and Its Contents						
	1	A2	2	A3	3	A4	4
Skeleton	1		1		Mixed bones, presumably several individuals		
Tripod vessel	2		2		1 whole and several broken (shapes unspecified)		3
Beads			Jade (s)		Jade (s), red shell (s)		Jade (s), crystal (s), red shell (s)
Copper bells			2				22
Other jade							Many pendants, figurine
Figurine/ image		Pottery mask with blue, red, yellow, and black paint		Figurine head painted blue; pottery mask			
Chipped stone							
Other		*Incensario* portion with blue paint		Globular bowl painted blue	Pottery mask; potsherds	Inscribed limestone block, potsherds	Sherds

Note: Details based on J. Eric Thompson's summary ("Notes") of the artifacts recovered from E. H. Thompson's report ("Pyramid with Burial Well") of his excavation of El Osario. "Graves" are numbered sequentially from the top of the shaft (1) to the bottom (7); "A" refers to the dirt above the grave. Numbers in parentheses indicate the actual number of objects found. Where a number is not given, "s" indicates "several"; "x" indicates more than one. Five-digit numbers refer to Field Museum catalogue numbers.

A5	5	A6	6	7	Passage from shaft	Cavern below
	I		"Skeleton turned to dust"		"Charred human bones"	"Half-charred human bones"
I	I		2 with incised bottoms (48158, 48159)			
Jade (x), crystal (4), red shell (x)	Jade (s), red shell (s)	Jade (x), crystal (3), red shell (x)		Crystal (1), jade (s)	Crystal (x), jade (x), shell (s)	Jade (s), shell (s)
3		s		3	x	
"Small jades" (s)				4	Pendants (2)	Ball, amulet, pendants (x)
					Blackened image	Limestone with blue band
				Obsidian (2)		Obsidian point, eccentric flint, flint point
Copal, sherds		Broken vessels	Sherds with incised bottoms	Copal, charcoal, stucco fragments painted blue, tall vessel; sherds with incised bottoms	Image, head of image; sherds of "striated ware" but not of *incensarios* or sacred vessels.	Hammerstones (s), marble vase, mother-of-pearl plaques, jaguar canine, shell imitation of jaguar canines (3), stucco fragment painted blue; pearls (2), inscribed stone block, trunk of idol, vessel fragments, "many interesting vessels in fragments"

FIGURE 10.3. *Tripod grater bowl with incisions in its base and remnants of Maya Blue on its interior. It came from El Osario, Grave 6. (Photograph by author; courtesy of the Field Museum, cat. no. 48159.)*

One group (N = 3) consisted of those with incisions on the bottom interior ("grater bowls"; e.g., figures 10.1 and 10.3), and the other group (N = 9) had no incisions in their interior (e.g., figures 10.4 and 10.5). Of the group without incisions, a subgroup (N = 2) showed curvilinear impressions of low relief on their base and walls that did not appear to be polishing marks but rather impressions made by stirring (figure 10.5).

After my initial examination of these twelve bowls, I used three criteria to assess whether they were used to make Maya Blue: (1) the presence of Maya

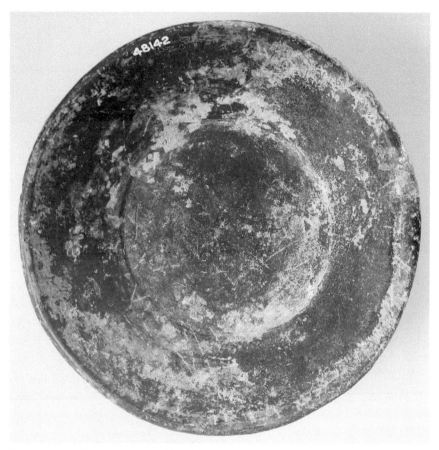

Figure 10.4. *Interior of a tripod bowl from El Osario; it was probably used to create Maya Blue. Notice the amount of white residue in the bowl, probably residual palygorskite. (Photograph by author, courtesy of the Field Museum, cat. no. 48142.)*

Blue on them, where it occurred, and, if possible, how it was placed there; (2) the presence of a white residue in and on the bowls; and (3) the discoloration and wear on the red slip on the interior base that indicated that some of the slip was removed by grinding and mixing and/or resulted from heating the bowl from below. I also examined the interior and exterior walls of the bowls microscopically using a Leica M80 microscope with a camera, model IC90E.

First, the presence of Maya Blue on the bowls varied from nonexistent to being smeared on the inside and outside (table 10.2). Most (N = 7) had some

TABLE 10.2. Location of Maya Blue on the bowl from the Sacred Cenote and the bowls from El Osario

Field Museum Cat. No.	Figure No.	Grater Bottom	Location of Maya Blue
COPAL OFFERING BOWL FROM SACRED CENOTE			
189292	10.2	No	Specks in tiny pits in interior base, on walls, and inside tiny chips on rim
RED-SLIPPED TRIPOD BOWLS FROM EL OSARIO			
48158	10.1	Yes	Extensive inside and outside
48159	10.3	Yes	Smudges inside and in incisions
48160	—	Yes	Small splotches on base/walls, mostly on upper part of interior, covering most of the exterior over the red slip
48142	10.4	No; stirring/grinding marks	Extensive on the upper part of interior wall, exterior wall (largely above flat base), and on tripods
48164	10.5	No; stirring/grinding marks	No evidence
48143	—	No	No evidence
48144	—	No	Many specks in interior with splotches on outside indicating horizontal wiping; inside of chip on rim
48145	—	No	Band on upper interior wall indicating horizontal wiping, splotches on exterior and base
48146	—	No	No evidence
48161	—	No	No evidence
48162	—	No	Splotches on interior wall, horizontally wiped around exterior wall, and some on exterior base
48163	—	No	No evidence

evidence of Maya Blue (e.g., figures 10.1, 10.3, 10.4). On the inside of three of the bowls, the pigment looked like it had been wiped around the walls of the vessel horizontally, leaving some of it behind (figures 10.1, 10.3, 10.4).

Second, an examination of the white residue on the bowls indicated that it occurred to a greater or lesser extent on all of them (table 10.3). On some (N = 8), it appeared as splotches that were sometimes exceedingly small. On others (N = 4), its extent indicated wiping or scraping in a horizontal motion (table 10.2, figures 10.1, 10.3, 10.4).

TABLE 10.3. Location of white residue on the bowl from the Sacred Cenote and the bowls from El Osario

Field Museum Catalogue Number	Figure No.	Grater Bottom	Location of White Residue (Probably Palygorskite)
COPAL OFFERING BOWL FROM SACRED CENOTE			
189292	10.2	No	Many white splotches on the interior with some evidence of horizontal wiping
RED-SLIPPED TRIPOD BOWLS FROM EL OSARIO			
48158	10.1	Yes	Thin covering of inside walls. Splotches inside, on base and in incisions. Splotches also found on outside walls and tripods
48159	10.3	Yes	Large splotches outside, inside, and in incisions
48160	—	Yes	In incisions and a bit above them; on exterior walls
48142	10.4	No; stirring/grinding marks	Splotches on interior base, exterior wall, and over Maya Blue; tiny microscopic chunks on exterior base
48164	10.5	No; stirring/grinding marks	Small splotches inside, many on outside
48143	—	No	Splotches on interior and exterior, indicating horizontal wiping on both sides
48144	—	No	Splotches inside and outside
48145	—	No	Small splotches inside and outside
48146	—	No	A few white splotches inside and outside
48161	—	No	A few white splotches inside, tiny ones outside
48162	—	No	On portion of interior and some on exterior wall, indicating horizontal wiping on the inside wall
48163	—	No	Many splotches on inside and outside base and walls; evidence of horizontal wiping on inside wall

Third, the wear and discoloring of the red slip on the interior base of all the bowls revealed evidence of grinding, mixing, and heating (table 10.4, e.g., figures 10.1, 10.3, 10.5). This explanation was inferred from comparing the interior walls of each vessel with its interior base by looking for contrasts of color

TABLE 10.4. Use-wear on the interior base of the bowl from the Sacred Cenote and the bowls from El Osario

Field Museum Catalogue Number	Figure No.	Grater Bottom	Condition of Red Slip in Interior Base Indicating Grinding, Mixing, and Heating
COPAL OFFERING BOWL FROM SACRED CENOTE			
189262	10.2	No	Slip lighter in color in places on base
RED-SLIPPED TRIPOD BOWLS FROM EL OSARIO			
48158	10.1	Yes	Slip largely worn off around incisions on base
48159	10.3	Yes	Almost all of the slip is worn off, pitted
48160	—	Yes	Slip largely gone around incisions on base
48142	10.4	No; stirring/ grinding marks	Slip somewhat worn and lighter in color around stirring/grinding marks and on base
48164	10.5	No; stirring/ grinding marks	Slip worn and lighter in color around stirring/grinding marks
48143	—	No	Slip worn, lighter in color with tiny pits
48144	—	No	Slip worn, lighter in color
48145	—	No	Slip worn, lighter in color, pitted
48146	—	No	Slip worn, lighter in color with carbonized strands, large blackened area on base
48161	—	No	Slip lighter in color with very thin stirring marks
48162	—	No	Slip lighter in color with scratches
48163	—	No	Little evidence of wear or change in color of slip

and the relative amount of the red slip remaining from probable use-wear. On the three bowls with incisions in their base, the slip was largely gone with some indication of wear around the grooves (figures 10.1, 10.3). This absence indicates some grinding or stirring occurred in the vessels. Two other vessels had long curvilinear marks of very low relief on the interior slip. These did not result from polishing because they occurred in long strokes, were somewhat worn and lighter in color, and were very narrow—about 2 millimeters wide (figure 10.5). They are too distant from one another to be the result of polishing by a smooth stone. Rather, these marks probably resulted from stirring or mixing the contents of the bowl with a pointed stick using little or no pressure.

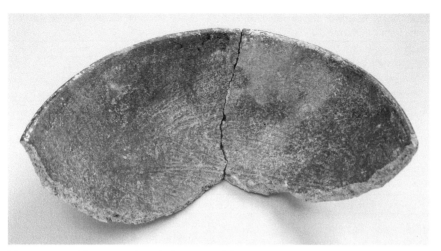

FIGURE 10.5. *Fragment of a red-slipped bowl from El Osario with stirring marks. Note that the stirring marks occur only on the bottom and lower portion in the areas that show wear on the red slip and thus are not likely the result of polishing. White residue appears on its rim and a bit on its wall. (Photograph by the author, courtesy of the Field Museum, cat. no. 48164.)*

The vessels without incisions on their interior base also showed wear on the internal base (N = 9). In all of these, the slip on the interior base was lighter in color showing some wear (N = 8), was pitted in some cases (N = 2) or showed evidence of scratches or stirring marks (N = 2; figure 10.5). In one bowl, the interior base showed many carbonized strands, even without the use of the microscope.

Finally, microscopic examination of the twelve bowls revealed carbonized plant materials both on the interior and exterior bases of ten of them (table 10.5). There were the remains of tiny, carbonized stems of plant materials on the interior bases of seven bowls and on the exterior bases on five bowls. The area around the incisions of one bowl showed heavy grinding (figure 10.3). A pitted surface with black carbonized material (specks/masses) in the pits appeared on four bowls.

All these observations indicate that the ancient Maya probably created Maya Blue in these twelve bowls. The palygorskite was ground wet with the leaves of the indigo plant because the plant materials in many of the bowls were microscopic and threadlike and not visible to the naked eye. They were probably veins from the leaves of the indigo plant. Further, judging by the lighter color of the interior base, grinding wet palygorskite and/or heating had

TABLE 10.5. Results of microscopic examination of the bowl from the Sacred Cenote and the bowls from El Osario

Field Museum Catalogue Number	Figure No.	Grater Bottom	Evidence of Plant Remains and Mixing/ Grinding/Heating Activity
COPAL OFFERING BOWL FROM SACRED CENOTE			
189292	10.2	No	Interior: Stirring marks crossways; crystalline material present, occasional carbonized strand; two yellow splotches (copal, sulfur?). Exterior: Heavily pitted with cracks on base; fused crystalline material present.
RED-SLIPPED TRIPOD BOWLS FROM EL OSARIO			
48158	10.1	Yes	Interior: Much white material in grooves; strands under Maya Blue and white material reveal red slip or earlier Maya Blue, indicating multiple uses. Exterior: Occasional carbonized strands under white material and Maya Blue.
48159	10.3	Yes	Interior: Black carbonized strands deep in the incisions; shiny black material with fibers along the axis of the incisions. Non-carbonized plant stems also occur in the incisions. Wear on the incisions on the base shows signs of heavy grinding.
48160	—	Yes	Interior: A few tiny, carbonized strands on base.
48142	10.4	No; stirring/ grinding marks	Exterior: Black carbonized fragments on base. One looks like carbonized plant material. Tiny uncarbonized plant stem fragments present.
48164	10.5	No; stirring/ grinding marks	Plant material carbonized on exterior and interior. Pitted surface filled with material with black carbonized specks.
48143	—	No	Interior: Many tiny irregularly shaped pits; white material has a slightly different shade than other bowls. Exterior: Tiny carbonized strands on base; sides pitted with tiny light-colored strands in red slip.
48144	—	No	Interior: Horizontal wiping of Maya Blue. Tiny pits inside, some with Maya Blue and/or a white substance in them. Exterior: Many small pits. A black material is embedded in the paste and in the lower vessel wall.

continued on next page

TABLE 10.5. (*continued*)

Field Museum Catalogue Number	Figure No.	Grater Bottom	Evidence of Plant Remains and Mixing/ Grinding/Heating Activity
48145	—	No	Interior: Pitted with carbonized black material (and strands) in tiny pits, iridescent strands, tiny blackened areas, tiny white splotches, tiny irregular scratches through red slip (stirring evidence?) on base. Exterior: Greatly pitted, white, no carbon.
48146	—	No	Interior: Tiny pits and scratches on wall and base; most filled with white material. Exterior: Pits and some scratches; pits usually filled with white material; wall partially blackened.
48161	—	No	Interior: Pitted on walls and base with tiny cracks and carbonized plant strands. Some tiny splotches of Maya Blue. Black around half of the wall. Exterior: Many pits on base.
48162	—	No	Interior: Tiny carbonized strands; scratches through slip and irregularly shaped pits. Exterior: Tiny localized carbon splotches; scratches in clay, pitted. Fire cloud on one tripod.
48163	—	No	Interior: A few carbonized strands on base, presence of strings and other areas of high reflectivity. Exterior: A few carbonized strands, blackened masses; some melted material in many tiny pits.

removed some of the red slip on the base. Heating was created by a smokeless fuel such as charcoal or copal because little or no evidence of carbon black existed on the exterior base. Heat was sustained over time because if carbon was deposited on the underside of the vessels, it had burned off. Nevertheless, heating left carbonized fragments behind on the exterior base of some of the vessels. Some of these carbonized materials were plant remains, indicating that the fuel used might have been copal. Copal was found in Grave 7 and above Grave 5 (table 10.1); one of these examples of copal remains consisted of a large mass with abundant tiny stems, many microscopic, like those seen in inside and outside of some of the bowls.[74]

Who Used the Bowls to Create Maya Blue?

Originally I had thought that because the bowls were associated with the skeletal material in what E. H. Thompson called the Grave of the High Priest, they were linked to the status and performative roles of the presumed elite religious practitioners whose bones were interred there. If accurate, this link would underscore the sacred nature of the pigment and the status of those who created it as elite religious specialists. As is often the case, initial hypotheses can be wrong, based upon faulty initial assumptions.

The archaeological context of the vessels, their provenience within the monument, their chronological placement, and the monument's placement and dating reveal a much more complicated picture. Now called El Osario, the Grave of the High Priest is a much smaller version of the Castillo or Temple of Kukulkan, the great pyramid at Chichén Itzá, and the contemporary main temple-pyramid at Mayapán. It was built during the Terminal Classic period over an underground cavern with a shaft connecting the top of the monument to the opening of the cavern below it.[75] Placed over an earlier structure, a shaft in the monument connected the surface to the shaft of the earlier structure that led into a passage and then into the cavern below. At some point, the opening to the passage at the base of the shaft was sealed with a stone.[76] The shaft was subsequently filled with earth, rocks, and caches of human skeletal material associated with a variety of elite and religious artifacts that Thompson called "graves." These "graves" were separated by intergrave fill that also included elite/religious artifacts as well as earth and rocks that in some places appeared to be deliberately thrown into the shaft (table 10.1).[77]

My first errant assumption posited that the bowls were deliberately buried accoutrements of deceased religious elites. Now, however, it is unlikely that these "graves" are technically graves or burials at all. Members of the Proyecto Gran Acuífero Maya recently investigated El Osario and challenged Thompson's interpretation that the "graves" in the shaft were the resting places of elite religious specialists. Rather, they argued that the "graves" were not like the burial chambers for elites in other parts of the Maya area but rather were deposits of human bones and artifacts in cysts that were much smaller and contained offerings, not burial furnishings. They are probably better categorized as caches of human bones with offerings.[78]

My second errant assumption involved the dating of the "graves." I assumed that they dated to the construction of El Osario during the Terminal Classic period.[79] Maya ceramic analyst Joe Ball, however, identified ten of the twelve red-slipped bowls described here as belonging in the Late Postclassic period.[80] Although each of the twelve bowls was associated with six of the seven caches

("graves") in the shaft and, in one case, the fill above a cache (Grave 5; table 10.1), each individual bowl was not documented to be from a particular cache except for two (Grave 6).[81] These two bowls are grater bowls that, according to Ball, are classified as the Papacal Incised type of Mayapán Red Ware characteristic of the Late Postclassic Period.[82] Because of their presence in Grave 6,[83] they lie almost at the bottom of the shaft (table 10.1), and all of the caches ("graves") with the other ten bowls lie above them, having been deposited later. Only one grave (Grave 7) lies below Grave 6. Below it, a passage with steps leads down into the cavern whose entrance was sealed by a large rock.[84] So these bowls and the accompanying bones and artifacts were placed in the monument long after the Terminal Classic and long after Chichén Itzá was abandoned.

All of the twelve bowls from El Osario are contemporaneous with the bowls with copal and Maya Blue dredged from the Sacred Cenote by E. H. Thompson.[85] However, none of the bowls from El Osario had copal in them, although masses of copal were found in each of two of the caches in the shaft (table 10.1).

The twelve bowls in the shaft of El Osario, like the identical vessels thrown into the Sacred Cenote during the Postclassic period, were probably placed there by pilgrims from Mayapán after Chichén Itzá was abandoned.[86] So although the bowls were found in the burial caches in the shaft, there is no reason to assume that the bones of the individuals associated with them were elite religious specialists whose grave goods reflected their status in life. Nevertheless, that assessment remains a possibility, but at this point without evidence.

So what is going on here? Earlier in this work I argued that the association of Maya Blue with appeals to Chaak, the rain god, was linked to its use during repeated droughts. Like changes in settlement pattern, economic activity, and political fortunes or lack of them during the Terminal Classic and Postclassic periods, appeals to the rain god were another kind of adaptation to drought conditions that was religious, throwing bowls of copal with freshly made Maya Blue and human sacrifices into the Sacred Cenote.

Appeals to the deity for the relief of drought did not just occur at the Sacred Cenote but also in activities found in caves that were in the underworld.[87] Maya Blue occurred in Balamkú and Balankanche caves near Chichén Itzá (chapter 9), and perhaps the deposits of human remains, pottery, and generally elite and religious objects in El Osario were offerings of the Mayapán pilgrims to the god of the underworld.

Other parallels exist between El Osario and the Sacred Cenote. Whereas the bowls for creating Maya Blue for the offerings placed in El Osario were

empty, those thrown into the Sacred Cenote were often filled with copal with Maya Blue on them, indicating that the process of burning the copal and creating the pigment was interrupted. Further, human sacrifice in El Osario also parallels that in the Sacred Cenote. The multiple skeletons in one of the caches in El Osario (Grave 3) were children; when Guillermo Anda and James Brady examined these skeletons in the Field Museum collection, they found evidence of head trauma, indicating that at least two were sacrificed before being placed in the cache.[88] This evidence parallels the sacrifice of adults and children as offerings in the Sacred Cenote.[89]

Consequently, throwing pottery with copal offerings and Maya Blue into the Sacred Cenote and then depositing the empty, used, and perhaps broken bowls just like them in the Osario shaft share a common link as offerings. To simply discard bowls used to make such a sacred pigment may have been a sacrilege, and perhaps it was more appropriate to place them with other sacred and elite objects and deceased individuals in another sacred space that was believed to be a passage into the underworld. Nevertheless, other tripod bowls of Mayapán Unslipped Ware with Maya Blue were found on the surface at Chichén Itzá; they did not have incisions, but Maya Blue occurred both on their interior and exterior.[90] Pilgrims also could have used them to make Maya Blue for offerings thrown into the Sacred Cenote.

FUTURE RESEARCH

The research on these bowls continues. As the next step, my colleagues will analyze the white material on the inside of the bowls and then hopefully discover the plant of origin of the microscopic charred and uncharred stems in the bowls. In addition, I want to verify that the white residue is indeed palygorskite and whether it comes from Sacalum, as did the palygorskite in the Maya Blue from other objects from El Osario that were analyzed previously (chapter 8).[91]

CONCLUSION

Even though the ancient Maya heated a mixture of palygorskite and indigo with copal incense as one way to create Maya Blue (chapter 9), this method probably was not used universally because, among other reasons, it produced an insufficient amount of the pigment for painting pottery, murals, sculpture, and human bodies and their altars for sacrifice. Furthermore, the question remains about how the Maya separated the blue pigment from the copal and

palygorskite to use for these other purposes. The ancient Maya must have used another method of preparation, but what was it?

Most of the literature about the creation of Maya Blue proposes methods based upon experimental chemistry or upon ethnographic and colonial methods used to extract indigo dye from the plant *Indigofera suffruticosa*, to which palygorskite was added. More recent research, however, indicates that the process was different. Palygorskite probably was wetted with leachate from the leaves of the indigo plant and then ground and mixed in a tripod bowl and then heated with charcoal or copal.

This inference is partly based of the work of chemists that revealed that several indigo-like compounds from *Indigofera suffruticosa* were chemical precursors of indigo that entered the palygorskite structure with more facility than the indigo molecule itself. This observation indicates that the ancient Maya did not necessarily create Maya Blue from palygorskite and indigo but rather from those indigo-like precursors (indigoids) in the leaves of the *Indigofera* plant that entered into the channels of the palygorskite, bound to it with heat, and then subsequently altered to indigo. From the earlier research on Maya Blue, very little indigo (0.5%–3.0%) is necessary to produce the pigment. Furthermore, experimental work and the detailed analyses of ancient Maya Blue by chemists and material scientists indicate that the Maya employed several recipes to create it.

The recovery of bowls in the burials and caches from El Osario at Chichén Itzá provides a new perspective on the creation of Maya Blue. The examination of these bowls reveals various combinations of Maya Blue, probable palygorskite, and both carbonized and uncarbonized plant parts in the bowls that indicate that the ancient Maya made the pigment by mixing wet palygorskite with the leaves (or leachate of them) of *Indigofera suffruticosa* and then heating the mixture over a low fire of burning copal or charcoal. Because both bowls and copal were associated with burial caches, it is likely that the bowls were offerings by religious specialists that created Maya Blue and used copal to prepare it, much like those who threw tripod bowls with the offerings of copal and newly formed Maya Blue into the Sacred Cenote to appeal to Chaak, the rain god. Conclusive evidence for identifying the creators of Maya Blue, however, requires more research.

11

How Did Maya
Blue Diffuse through
Mesoamerica?

Maya Blue was used in the southern part of Mesoamerica
for approximately 1,700 years. It first occurred at the
Maya site of Calakmul in the Petén during the Late
Preclassic period (300 BC–AD 300), continuing in the
southern Maya lowlands into the Classic period and
then into the Late Classic period, when its use greatly
expanded—at Bonampak, Yaxchilán, Palenque, and
Tikal, among others (figure 2.1). It had reached the
neighboring highlands of Guatemala by at least the
Late Classic period and moved into the northern low-
lands at El Tabasqueño, D'zula, Dzbilnocac, Kulubá,
Chacmultún, Mulchic, and Acanceh, among others. By
the Terminal Classic, it occurred at Ek' Balam, Kulubá,
and was widely used at Chichén Itzá. It is found in
El Salvador in the Early Postclassic and was employed
extensively at Mayapán in a wide variety of contexts
throughout the Postclassic (figure 5.11).[1]

The diffusion of Maya Blue into central Mexico,
however, did not follow the same pattern as it did in
the Maya area and was slower.[2] During the Classic
period, when central Mexico and adjacent areas were
dominated by the influence of Teotihuacán (figure 3.2),
artisans did not employ Maya Blue but rather painted
their polychrome stucco vessels with blue and green
mineral pigments that were natural, and not artificial
like Maya Blue.[3] This same pattern was described by
Leonardo López Luján and Michelle de Anda Rogel
in an article detailing the additive and subtractive

https://doi.org/10.5876/9781646426683.c011

material vestiges from Teotihuacán in the sacred precinct of Aztec capital of Tenochtitlán:

> . . . the rich Teotihuacán palette . . . consists of . . . three greens (a bright tone from malachite, an olive shade from malachite and lepidocrocite, and a dark variety combining malachite, azurite, hematite and, pyrolusite) and three blues (a greenish tone from malachite and chalcanthite, an ultramarine variety combining pyrolusite with calcium carbonate and sulfate, and a lighter shade combining ultramarine blue and white pigment) . . .[4]

Maya Blue did not arrive in central Mexico until the Epiclassic/Terminal Classic period, when it appeared at Cacaxtla (Tlaxcala, ca. tenth to thirteenth century), Taumín (Huastec culture, ca. eleventh and twelfth centuries), and El Tajín (Totonac culture, ca. eleventh and twelfth centuries). Besides these sites, the pigment also appeared on the low-relief slabs of the *talud-tablero* architecture in the palace of Tula, the Toltec center north of the Valley of Mexico.[5]

By the Postclassic period, the Aztecs used Maya Blue extensively, but within a dramatically reduced range of only five pigments compared to the color palate employed centuries earlier at Teotihuacán. It was used extensively on the twin pyramids (The Templo Mayor) in the center of the Aztec capital (Tenochtitlán); one was dedicated to Aztec rain god, Huitzilopochtli (Tlaloc), and the other to Quetzalcoatl, the warrior god. On the Tlaloc pyramid, Maya Blue appears on the four braziers that flank the serpent heads, on the figures of Tlaloc, on the altars at the entrance to the platform, and on the serpents that flank its stairways. Excavations at the side of the pyramid recovered jars adorned with masks of Tlaloc covered with the pigment. Maya Blue also adorns the ear and facial ornaments of the Tlaltecuhtli stone, the Venus glyphs, the eyebrows of the skulls, the telluric faces on the temple platform, and the low-relief sculpture there.[6]

The Aztecs used Maya Blue elsewhere in their capital as well. During the 1960s Mexico City became increasingly choked with traffic, and work started on a subway system that would provide a fast, underground rail network. During its construction, archaeologists discovered Aztec remains with Maya Blue in several locations, such as the market of Tlatelolco.[7]

Why did the Aztecs replace natural mineral pigments such as azurite (blue) and malachite (green), used during the Classic period, with Maya Blue in the Epiclassic and Postclassic periods? It is hard to say exactly, but it is likely that the replacement occurred for the same reason that Egyptian Blue replaced lapis lazuli in the Middle East. Azurite and malachite were probably less available

and came from very restricted sources, whereas Maya Blue could be created from more abundant materials: palygorskite and plants in the genus *Indigofera*. Species of *Indigofera* were widespread, and the two sources of palygorskite in Yucatán provided an abundant supply of the mineral (chapter 6). It is hard to imagine any source of azurite and malachite that would provide the equivalent of the estimated 589 cubic meters of palygorskite removed from the Sacalum mine, even though some of it was used for medicinal purposes.

The Aztecs valued Maya Blue so highly that the sources of the clay used to make it expanded during the Postclassic period. The palygorskite in at least some of the Aztec Maya Blue did not come from Yucatán but from else-where—perhaps northern Mexico.[8] Furthermore, the Aztecs supplemented palygorskite-based Maya Blue with the clay mineral sepiolite, or substituted it entirely for the palygorskite.[9] With these new clay resources, the Aztecs' production of Maya Blue was probably more extensive and widespread than the sources of azurite and malachite used during the Classic period in Teotihuacán.

By the late pre-Hispanic and early colonial periods, the use of Maya Blue had expanded greatly. Employed on codices during this time, it also appears in murals in sixteenth-century convents in central Mexico, and there is some evidence that its use continued into the nineteenth century.[10]

Since the use of Maya Blue expanded throughout southern Mesoamerica from a single origin, how did it move? Did the pigment or its constituent, palygorskite (and/or sepiolite), move? Or did the knowledge of how to make it move? Or did Maya Blue *and* the knowledge of how to make it diffuse? Another way to engage these questions is to ask: Why did it take more than a millennium for the pigment to expand throughout the Maya lowlands, into the Maya highlands, and finally into central Mexico?

TWO EXPLANATIONS

The explanations concerning the diffusion of Maya Blue can be grouped into two basic categories: the commodity movement hypothesis and the technology transfer hypothesis.[11] As will become evident, explanations of the spread of Maya Blue cannot be reduced to alternate hypotheses, but they do provide a convenient way to organize the evidence.

The Commodity Movement Hypothesis

There are many ways in which objects can move across space as well as many explanations for that movement, such as trade, exchange, and gifting. With

respect to this hypothesis, the concern is less about the particular mechanisms for movement of Maya Blue itself than the evidence that the pigment moved rather than the technology used to make it.

Anna O. Shepard and Hans Gottlieb first promulgated this hypothesis in 1962. They argued that Maya Blue was widely traded from a source on the Yucatán Peninsula because its copious use on pottery intended for household ritual at Mayapán indicated a local source: "It would not be surprising if it [Maya Blue] was obtained from distant sources for temple frescoes, particularly if the color had ceremonial significance. When it occurs frequently on pottery intended for household ritual, as at Mayapán, a local source is more probable."[12]

Five years later (1967), I proposed that Sacalum was the source of palygorskite for the Maya Blue in Mayapán because Sacalum is only 20 kilometers south of the site. Another source of palygorskite near Ticul (Yo' Sah Kab) is only slightly farther away (25 kilometers) and may also have been a source of the palygorskite used to make the pigment in Mayapán. At Yo' Sah Kab, a Terminal Classic occupation lies on top of the palygorskite deposit, and with the evidence of the Terminal Classic pottery found in the Sacalum cenote, both locations could also be sources for the palygorskite used for the Maya Blue found at sites further afield such as Chichén Itzá, just as Shepard and Gottlieb proposed (chapter 5). By 2012, my colleagues and I had successfully tested this link between Sacalum and Yo' Sah Kab and distant archaeological sites by demonstrating that the palygorskite in samples of Maya Blue from Chichén Itzá did indeed come from those sources (chapter 8).[13] In light of the archaeological context of these samples (chapters 9 and 10), however, this result does not exclude technology transfer as an explanation for the movement of the pigment to Chichén Itzá.

THE TECHNOLOGY TRANSFER (OR LOCAL PRODUCTION) HYPOTHESIS

An alternative to the commodity movement hypothesis was first put forward by Edwin R. Littmann in 1982. Although his first article in 1980 argued that Maya Blue was a blue montmorillonite (smectite), his second article built on a personal communication from geologist Wayne Isphording, who stated that palygorskite was widespread in the Maya area. In this article Littmann thus hypothesized that Maya Blue was made from local deposits of palygorskite and that the technical knowledge of how to make it moved rather than the pigment itself or its constituent, palygorskite.[14]

Superficially, each of these hypotheses is equally plausible for explaining the diffusion of Maya Blue, but each has quite different implications for understanding Maya prehistory.

EVALUATING THE COMMODITY MOVEMENT HYPOTHESIS

If one uses Occam's razor as a criterion to choose between alterative hypotheses, then the best explanation is the simplest. Applying this criterion to the diffusion of Maya Blue, the simplest explanation for its spread is the commodity movement hypothesis: palygorskite was mined at Sacalum and Yo' Sah Kab, made into Maya Blue at a site nearby (such as Mayapán), and then moved by various means elsewhere. In this scenario Maya Blue may have been exchanged along with other elite commodities, such as shells, obsidian, salt, and jade, or taken by Maya priests or shamans into new locations. During the Terminal Classic period, in particular, this trade expanded with seagoing canoes going around the Yucatán Peninsula and reaching the shores of central Mexico.[15] This network may be responsible for the presence of Maya Blue in the Tlaxcala, Huastec, and Totonac sites in central Mexico during the Epiclassic. But although this explanation is plausible, credible, and appears to be accurate, it is probably too simplistic.

The commodity movement hypothesis has much contextual evidence in its favor. First, it values, if not emphasizes, the role and importance of Maya Indigenous knowledge that is a part of Maya cultural heritage. Based upon their tradition, the Maya of Sacalum and Ticul selected and mined palygorskite based upon the recognizable physical properties of *sak lu'um*.

Recognizing the importance of the Maya perception of these properties has consequences for discovering the occurrence of palygorskite and its sources for making Maya Blue. From the Maya perspective, recognizing the properties and sources of *sak lu'um* is different from the mineralogical presence and geological occurrence of palygorskite, even though *sak lu'um* is palygorskite. All *sak lu'um* is palygorskite, but not all palygorskite is *sak lu'um*. No simple one-to-one correspondence exists between *sak lu'um* and the presence of palygorskite. Furthermore, how much palygorskite must be present in a material for the Maya to recognize it as having the physical properties of *sak lu'um*? Consequently, one must take the Maya perception of *sak lu'um*, its properties, and its sources into account to search for new sources of the mineral that the ancient Maya used to make Maya Blue.

The contemporary Maya recognize Sacalum and Yo' Sah Kab as the only consistent sources of *sak lu'um* they know. Each has a sense of place and a religious significance that reflects their unique position within Maya cultural heritage. Those unique sources continued into the twenty-first century.[16] Although other sources of palygorskite have been exposed in the contemporary landscape of Yucatán as a consequence of the construction of roads and railroads, the mining and distribution of *sak lu'um* in Yucatán persisted in the

traditional mining locations in Sacalum and near Ticul, and it was peddled widely from there, at least up through the end of the twentieth century.

The uniqueness of Sacalum and Yo' Sah Kab may be approached from another perspective. If palygorskite occurs in many locations in Yucatán, why are there no other locations like these that are a part of Maya Indigenous knowledge and Maya cultural heritage? If *sak lu'um* was so important for medicinal uses, why are there no other deposits of *sak lu'um* with evidence of exploitation that are a part of that heritage? As mentioned previously, the obvious answer to this question, of course, is that the sources of palygorskite outside of Yo' Sah Kab and Sacalum result from the modern alteration of the landscape by machines and explosives and were not part of the ancient landscape.

Second, the restriction of Maya Blue to ritual contexts of pottery, offerings, and on copal, murals, sculpture, and codices suggest that the pigment was valued by elites and that access to it was restricted either by a dearth of the raw materials (more likely *sak lu'um* than indigo plants) and/or by scant knowledge of how to create it. Elites may have restricted access to the sources of *sak lu'um* even though its medicinal use in modern Yucatán suggests that access to it was not restricted but may have been culturally and geologically scarce because massive amounts of it were found at only two sources (Sacalum and Yo' Sah Kab). If access to the sources of *sak lu'um* was not restricted, then the knowledge of how to make the pigment may have been restricted and known only by ritual specialists. The use of Maya Blue in ritual contexts, its creation in copal offerings, and in the bowls found in the graves in El Osario at Chichén Itzá supports this latter explanation (chapter 10).

Third, both the Sacalum cenote and Yo' Sak Kab have evidence of Terminal Classic pottery and occupation. This association supports the hypothesis that the ancient Maya were not just mining palygorskite to make pottery and treat illnesses but also using it to make Maya Blue. The Terminal Classic site that formerly existed on top of the palygorskite deposit at Yo' Sah Kab indicates that the palygorskite below it had immense value to the population that lived there because there is no other explanation for its placement.[17]

Although obviously used earlier, Maya Blue appeared with increasing frequency during the Terminal Classic period when several droughts plagued northern Yucatán. Some of the *puuc* sites were abandoned, and their populations moved north.[18] This shift also parallels the change in the representation of the rain god Chaak from the *puuc* sites to that in Chichén Itzá. At the *puuc* sites such as Uxmal, Kabah and Labná, Chaak was represented by stone mosaics (figure 3.2). At Chichén Itzá, however, the deity was symbolized by

painting portions of low-relief sculptures and murals with Maya Blue. Some Chaak images in the Puuc Mosaic style, however, occur at Chichén Itzá around the upper Temple of the Warriors and at the Nunnery, but Maya Blue was painted on the columns around the exterior and underneath the Temple of the Warriors (figures 1.2, 1.3), on the Venus Platform, on murals underneath the Temple of the Warriors, and in the upper and lower Temple of the Jaguar.[19] This change in the representation of Chaak from mosaic sculpture to blue paint represented a shift in the expression of the symbol of the deity, indicating a change from stone cutters and masons that sculpted and assembled the mosaics of Chaak in the *puuc* sites to painters that applied Maya Blue to the low-relief sculptures and murals at Chichén Itzá.

The use of Maya Blue reached its apex at the Postclassic site of Mayapán, where it was widely used on pottery, large three-dimensional modeled ceramic images of Chaak, murals (figure 8.5),[20] and on some temple floors (figure 3.1). This more intensive and extensive use of Maya Blue also increased the demand for *sak lu'um.*

EVIDENCE OF THE RAW PIGMENT

If Maya Blue itself moved across the Maya area and then into other parts of Mesoamerica, then one would expect to find examples of the raw pigment in archaeological contexts apart from its use on murals, pottery, copal, sculpture, and codices. Evidence of the raw pigment does come from the cave of Balamkú (Cave of the Jaguar God) approximately 3 kilometers northeast of Chichén Itzá where a small amount of loose Maya Blue is evident on and below the edge of a small grinding stone. A large pile of small, upturned grinding stones (*manos* and *metates*) lies near it. These stones are much smaller than those that the Maya use to grind lime-soaked maize kernels into a paste for tortillas, tamales, and pozole and are more portable. Given the difficulties of dragging full-sized *manos* and *metates* into the cave, these smaller grinding stones were used as offerings and were easier to bring into the cave than larger ones, but the ancient Maya also may have prepared the pigment there.[21]

The date of this offering corresponds to a period of several great droughts in the Maya area, and the Maya may have offered piles of these grinding stones to the god of the underworld. The presence of raw Maya Blue in this context suggests that some of it was also offered to Chaak to provide rain to sustain the Maya through this challenging time. At one point during this period, the nearby site of Chichén Itzá collapsed politically and was abandoned,

presumably because of the failure of its population to adapt to the droughts, and its inhabitants moved elsewhere.[22]

Other examples of unused Maya Blue pigments occur in archaeological contexts. One was a fragment of raw pigment on a lump of earth and charcoal from a hearth in Balankanche Cave near Chichén Itzá. Similarly, several examples of Maya Blue come from a ritual offering associated with late Aztec occupation under what is now modern Mexico City. All the Aztec samples were resistant to strong acids, and all contained indigo. Most included sepiolite, consistent with some of the other Maya Blue samples from the Aztec period, but one sample included palygorskite rather than sepiolite. Another sample of raw pigment with palygorskite and sepiolite was recovered from excavations behind the cathedral in Mexico City.[23] Finally, a chunk of raw Maya Blue was also found in an elite residence outside of the monuments in the ritual center of Mayapán.[24] Mayapán probably was a production center for Maya Blue in the Postclassic period, at least for the Maya area. So the discovery of a raw sample of the pigment there would be expected.

Even these examples, however, do not conclusively demonstrate that the pigment was moved. Rather, they may simply result from making the pigment on-site, a notion supported by the evidence that Maya Blue can be made by grinding palygorskite wetted with an aqueous solution from the leaves of the indigo plant and then heated, as well as its presence on a grinding stone in the Balamkú Cave.

A Corollary of the Commodity Movement Hypothesis

A corollary of the commodity movement hypothesis postulates that palygorskite was mined at Sacalum and Yo' Sah Kab, transported elsewhere, and then made locally into Maya Blue. The technology of creating Maya Blue, however, would still have to move by social means and thus would be subsumed under the technology transfer hypothesis. The plausibility of this corollary would be enhanced if examples of raw palygorskite occurred in archaeological contexts. Although the existence of "three small balls of white clay sediment resembling chalk" were found with Maya Blue in a Preclassic burial at the La Tronera site in the Valley of Acambaro in western Mexico, analysis of them was not reported, but they might be palygorskite.[25] As far as I know, however, no evidence of raw palygorskite has been found in archaeological contexts. It may exist, but it has not been recognized or reported by archaeologists. Discoveries of a white, chalklike substance may be palygorskite, but may not be mentioned by archaeologists, except in highly detailed site reports, because

without analysis, they may assume that it simply came from marl quarries and is mostly calcite and/or dolomite.

A Source of Palygorskite Outside of Yucatán?

A Source of Palygorskite Outside of Yucatán?

Recent analyses of several samples of Maya Blue from the Aztec capital and several other cultures in Mesoamerica indicate that the Aztecs used a different source of palygorskite than those in Yucatán. Using high-resolution X-ray diffraction and electron microscopy with element-point analyses, analysts found that the structure of the palygorskite in samples of Aztec Maya Blue (N = 6) was similar to but different from that found in the non-Aztec Maya Blue samples from other locations of Mesoamerica that ranged over a millenium (Maya, Totonac, Huastec, and colonial). The structure of the palygorskite in the non-Aztec samples, however, was similar but, more importantly, was like the structure of palygorskite from Yucatán. These comparisons of the analyses of the pigment indicate that the Aztecs used sources of palygorskite and sepiolite outside of Yucatán. Based upon geological descriptions, the analysts who discovered this dissimilarity suggested that this source was possibly northern Mexico.[26]

This suggestion fits with the discovery of Maya Blue in the Chupicuaro culture in a burial at a site along the Lerma River in western Mexico, which is much closer to central Mexico than Yucatán. Its occurrence is believed to predate the first appearance of Maya Blue in the Maya area at Calakmul by several hundred years and raises new questions. It might have another origin in western Mexico during the Middle Preclassic.[27]

THE TECHNOLOGY TRANSFER MODEL

The Problem of Technology Transfer

Besides accounting for the data, any hypothesis involves implicit assumptions, and when it concerns another culture, these assumptions can deeply affect the validity of the hypothesis. These assumptions often involve deep-seated implicit cultural and academic values. Consequently, considering the cultural and academic context in which one formulates a hypothesis is just as significant as testing it in the culture to which it is applied—in this case, the ancient Maya. As originally proposed by Littmann,[28] the technology transfer hypothesis assumed that palygorskite was widespread in the Maya area (especially the northern Yucatán Peninsula) so that when the knowledge to make Maya Blue became available, its creators used local sources of the clay to make the pigment.

The first problem with this assumption is that modern scientific views of landscape, geology, and mineralogy drive this hypothesis rather than Maya Indigenous knowledge and its heritage. As I have said before, one should not uncritically infer the availability of palygorskite for the ancient Maya using the analogy with the modern landscape, as if it were identical with the ancient one. It is true that palygorskite is widespread in Yucatán (chapter 5), but its geological occurrence does not necessarily mean that it was accessible to the ancient Maya. Compared with the thick deposits at Sacalum and Yo' Sah Kab, most of the other palygorskite deposits reported are small and do not exist in sufficient quantities for pottery temper, treating illness, and creating Maya Blue. Unlike those at Sacalum and Yo' Sah Kab, the other deposits of palygorskite became accessible as a result of modern alteration of the landscape where roadcuts, railroad cuts, and quarries have exposed the subsurface geology. Finding palygorskite in this modern, culturally modified landscape does not necessarily mean that the ancient Maya could access these deposits.

Rather, the ancient sources of palygorskite need to be understood in relationship to Maya Indigenous knowledge and the ancient Maya landscape rather than a landscape altered by modern technology and interpreted through cultural and academic biases of geology and mineralogy. Even with the massive alteration of the Maya landscape since the colonial period, however, *sak lu'um* is still being mined at Sacalum and Yo' Sah Kab, and up until the beginning of the twenty-first century, at least, it was still distributed widely from those traditional sources. The Indigenous knowledge of the ancient Maya (like that of the modern Maya) included knowledge of the physical properties of *sak lu'um*, where it was found, and, as it does today, the details and structure of the culturally categorized landscape.[29]

The occurrence of palygorskite thus needs to be viewed through the eyes of the Maya and their technological choices (e.g., their ethnomineralogy).[30] The Maya who use *sak lu'um* do not perceive the presence of palygorskite mineralogically. Rather, they possess a practical knowledge of the physical properties of a material that they know as *sak lu'um*. Modern geologists and clay mineralogists, however, know *sak lu'um* as a "clay" mineral, but to the Maya potter, *sak lu'um* is not a clay but rather "earth" (*lu'um*) and, in this case, is different from clay (*k'at*), such as "white clay" (*sak k'at*), and rock (*tunich*), such as *sakel bach tunich* or *tok' tunich* ("hard flint-like rock"). Nevertheless, *sak lu'um* is a rocklike material that potters sometimes call "*sak lu'um tunich*," or "white earth rock," and corresponds to what geologists would call "white palygorskite mudstone." The ancient Maya thus probably selected raw materials with those properties to create Maya Blue. So just because palygorskite occurs widely in Yucatán does

not mean that the Maya perceived its presence. Rather, the Maya perceive the presence of physical properties of certain deposits of palygorskite as *sak lu'um*.

This practical knowledge of palygorskite, however, is not necessarily easily transferable to other geological contexts (see chapters 3, 4, and 5). Rather, as I elaborated in *Maya Potters' Indigenous Knowledge: Cognition, Engagement, and Practice*, the way in which the contemporary Maya see their environment and their raw materials differs from that of modern science, and these perceptions vary from community to community, as documented by Raymond Thompson in his study of Yucatec Maya pottery making in 1951.[31]

Nevertheless, once individuals know the properties of *sak lu'um*, they have been known to discover it elsewhere. The most notable example of this process is the discovery of *sak lu'um* closer to the village of Chapab in the 1980s by one of the men who hauled pottery temper from Yo' Sah Kab to Ticul. Since then, this new mining area has served as the predominant source of temper for Ticul potters, eclipsing the use of Yo' Sah Kab for this purpose.

Another example of learning the characteristics of *sak lu'um* and then discovering new sources is the work of modern Maya painter and artisan potter Luis May Ku. Wanting to replicate Maya Blue, Luis apprenticed himself to Ticul potters to learn how to make pottery and select raw materials. One of these raw materials was *sak lu'um*, which he eventually discovered in rural Dzan, located 6 kilometers from Ticul and about 3–4 kilometers southeast of the sources of *sak lu'um* at Yo' Sah Kab and about the same distance from those sources closer to Chapab.[32]

As for the relationship of the ancient Maya landscape to the other possible sources of palygorskite used in Maya Blue, marl quarries and cenotes could have served as ancient sources of *sak lu'um*, as they do at Sacalum and Yo' Sah Kab. Marl quarries, however, are not necessarily a consistent source of *sak lu'um* because further tunneling into the marl deposit can destroy any evidence of palygorskite deposits. At Yo' Sah Kab, however, the palygorskite deposits are thick (2 meters), consisting of a marl layer and a solid palygorskite layer below it. Further, the area of the subsurface deposits with solid palygorskite is so widespread there that its quarries supplied palygorskite for many centuries. The Chapab source exhibits these same characteristics, even though mining only began there in the mid-1980s.

Similarly, the stratigraphy exposed in cenotes, whether containing water or not, may also have provided a source of palygorskite like that in the Sacalum cenote. Even though palygorskite was found in the Maní cenote and in the cenote used by Mama potters to obtain their raw materials, these cenotes are doubtful ancient sources for the palygorskite used in Maya Blue. The amount

in the Maní cenote was small, and none was found there in a recent survey.[33] Further, the pottery-making materials found in the cenote used by Mama potters are not recognized as *sak lu'um*, nor are they distinctive enough or pure enough to be used as a source of the palygorskite for Maya Blue. Indeed, surveys of the interior of that cenote that B. F. Bohor and I made revealed that no *sak lu'um* occurred there like that found in Sacalum and at Yo' Sah Kab. So the Maya Indigenous knowledge of the sources of palygorskite usable for making Maya Blue was not as widespread in antiquity as one might think in a landscape unaltered by modern technology.

As suggested above, however, once one learns the properties of *sak lu'um* from those who engage those properties by working with it, that knowledge can be applied elsewhere. An individual who learns the technology of making Maya Blue and the properties of *sak lu'um* can search for other sources of the material and, if found, can create Maya Blue in this new area. So the diffusion of the pigment and/or its technology can simply result from learning the process from one individual, and not necessarily result from the movement of elites, religious specialists, or populations.

Evaluating the Technology Transfer Hypothesis

The process of making Maya Blue, like all technology, is socially embedded, and its invention, evolution, use, and transmission involve human agency. It does not exist apart from the people that develop and use it. It is not disembodied from society, and its transfer through time and space can also take place by acquiring the knowledge and skills of how to make it through the processes of social interaction that are already present in the society. Technological knowledge, techniques, and skills also have a cognitive dimension and are often tied to religion, especially among preindustrial peoples.

Given the importance of the processes of social contact and learning in technology transfer, the critical questions about making Maya Blue become these: Who were the creators of Maya Blue? From whom did they learn to make it? With whom did they have social contact to transfer that knowledge across space and through time?

There are two tentative answers to these questions. The first posits that the process of learning to make the pigment is transmitted from generation to generation within households. My study of Maya potters in Ticul, Yucatán, provides some insight into this process. In spite of massive social change and acculturation, household personnel remained the source of the knowledge of the craft, and its technology was socially reproduced between 1965 and 2008 through families that extended back into the mid-nineteenth century,

a pattern verified by using genealogies and municipal records of births, marriages, and deaths. Furthermore, a comparison of the sources, raw materials, and paste reveals a similarity with those of the Terminal Classic period (AD 800–1100) in the area. These similarities indicate that the Indigenous knowledge of the local landscape and the technology of making pottery extended back to the Terminal Classic and were transmitted from generation to generation by means of the processes of household reproduction.[34]

Using processes of household reproduction as a model for the transfer of the technology of Maya Blue is not without its problems, however. If the composition of Maya households was largely reproduced by procreation, patrilineal inheritance of house lots, and virilocal postnuptial residence, as it was in the late twentieth and early twenty-first century in Ticul,[35] then how would the ancient Maya population transfer the knowledge of making Maya Blue from center to center? What kind of sustained social contact transmitted that knowledge?

If the makers of Maya Blue were potters, and if they were women, as they are in many Maya communities,[36] the transfer of Maya Blue technology could take place through exogamous patrilocal (or virilocal) postnuptial residence patterns that could move a woman outside of her community. In modern pottery-making communities, however, the technological knowledge of making pottery in one community is not easily transferred to another because of the lack of infrastructure for the craft in the new household as well as the differences in the physical properties of the clays and tempers available locally from those in the source community. Even after adaptation of their clay recipes to make pottery, not every clay or paste recipe, however, can be used to make every vessel.[37] In any case, the technology transfer hypothesis is much more complicated than if Maya Blue or palygorskite were simply one of several elite goods that were moved. Moving Maya Blue across the landscape by means of a mechanism such as trade and exchange requires far less social interaction than the interaction required to learn the technology for creating it.

Another answer to the question concerning the identity of the creators of Maya Blue considers the nature of the pigment itself and how it was used. Maya Blue is a post-firing pigment destroyed by high heat. That is, it must be applied to a pottery vessel after firing because it is destroyed by temperatures over 300°C.[38] Furthermore, Maya Blue is not a slip because it does not cover the entire vessel. It is too fugitive and does not serve as a barrier to the porosity of the vessel walls, unlike slips.

These characteristics of Maya Blue indicate that the person who applied the pigment was probably not the potter but rather someone else who added it long after firing. Adding decoration to an object after firing by someone other

than the potter is not unusual. The production of modern copies of Classic Maya vessels in Ticul, for example, provides a useful analogy for understanding this process. These copies were generally made in workshops, not households, and those who fabricated them were different from those who painted them; the skills of making a pot and those for painting the designs on it were vastly different. As a consequence, those workshops that produced this pottery were staffed with two kinds of specialists: potters and painters.[39]

In other cases, workshop owners contracted with household potters for a specified number of blank, unpainted vessels of a particular size and shape so that the painters in their workshop could decorate them. Some household potters specialized in providing such blank unpainted vessels to these workshops for decoration (chapter 3).

Consequently, it is likely that those who painted Maya Blue on pottery and other objects were not potters but rather specialist painters or religious specialists who made and applied the pigment. Just as modern Yucatec Maya rituals utilize a shaman (*hmen*) to offer incense to the Maya deities of the forest, creating Maya Blue from ritual offerings was likely performed by shamans. As was proposed in chapter 9, creating Maya Blue by burning copal symbolically combines the healing qualities of the indigo plant, palygorskite, and copal as a ritual offering to Chaak. The resulting blue is symbolic of the deity, representing his incarnation in its creation and reinforcing the importance of religious specialists in this role.

The act of throwing the bowl of burning copal with palygorskite and indigo (and/or its indigoid precursors) into the Sacred Cenote at Chichén Itzá thus reinforces the association of these constituents as a propitiation for healing a parched land (chapter 9). It further implies that religious specialists were responsible for the creation of Maya Blue. Indeed, the use of the pigment on balls of copal at Tikal and on the fifty other incense burners with copal and Maya Blue dredged from the cenote at Chichén Itzá indicate that religious specialists created Maya Blue during the burning of incense. The discovery of Maya Blue with a carbonized substance in a polychrome brazier excavated at Tlatelolco in the Aztec capital indicates that the Aztecs also might have created the pigment in this way.[40] The burning of incense to "create" Maya Blue thus underscored its elite and religious value because of its ritual associations.

Furthermore, the presence of red-slipped bowls with Maya Blue with a white residue in the burial caches in El Osario at Chichén Itzá further reinforces the notion that elite religious specialists created the pigment. The Maya used some of these bowls to grind and mix wet palygorskite and portions of the *Indigofera* plant to create Maya Blue, after which the pigment was wiped

out and allocated for painting on pottery, sculpture, and murals and other purposes (chapter 10).

So if the production of Maya Blue rested in the hands of religious specialists, how was the knowledge of making it acquired and passed down from generation to generation? How was this knowledge transmitted across space from Maya center to Maya center? Did ritual specialists move from site to site? In any event, producing Maya Blue in households *or* by religious specialists could account for the slow diffusion of the knowledge of how to make Maya Blue and why it took so long to reach central Mexico after its first occurrence during the Late Preclassic (300 BC–AD 300) at Calakmul.

One answer to these questions comes from the occurrence of Maya Blue at Cacaxtla (Tlaxcala), Taumín, El Tajín, and Tula during the Epiclassic/Terminal Classic period.[41] This distribution corresponds to the spread and expansion of the religious cult associated with the ideology of Quetzalcoatl/Kukulkan along with its shared economic and political interactions in many parts of Mesoamerica during the Epiclassic/Terminal Classic period.[42] Because Maya Blue appears earlier in the Maya area and the palygorskite in the Maya Blue from these Epiclassic sites came from Yucatán, the pigment probably came from Chichén Itzá and accompanied the expansion of the Quetzalcoatl cult during the Epiclassic/Terminal Classic period. Consequently, the simplest explanation for the long delay in the diffusion of Maya Blue in Mesoamerica was that single individuals, whether religious specialists or painters, transmitted the knowledge of how to create it.

Evidence for Technology Transfer

Some of the strongest evidence for the transfer of the knowledge for making Maya Blue comes from the analyses of blue and green variations of Maya Blue from eight Maya sites that date from the Preclassic to the Terminal Classic period.[43] These pigments reveal considerable variation in their composition resulting from different proportions of the indigoid compounds (such as indirubin) from the *Indigofera* plants used and from different temperatures used in its preparation. Further, the Maya also achieved blue/green color variation by mixing Maya Blue with red ochre at these sites, by heating blends to different temperatures, or by heating them longer.[44] These different recipes indicate that although some Maya Blue likely was moved, some of the knowledge of how to make it was not available and thus challenged local specialists to experiment and innovate in order to create the desired colors themselves.

Alternatively, the occurrence of ochre in Maya Blue in these instances could also be the result of using palygorskite that contained naturally occurring

hematite or the result of grinding ingredients in a red-slipped bowl (the slip on the bottom of some of the bowls from El Osario had worn off and had become mixed into the pigment during its preparation). These alternatives could also be the result of diverse kinds of preparation and raw materials from the application of local knowledge rather than movement of the pigment itself.

Another source of support for the technology transfer hypothesis comes from the use of a sepiolite-based Maya Blue found in central Mexico during the Aztec and early colonial periods. Sepiolite has properties similar to palygorskite and when heated with indigo can also produce Maya Blue, but the resulting pigment is not as stable as a palygorskite-based Maya Blue. As with indigo and palygorskite, the linking of indigo and sepiolite begins with grinding, but the bonding is not quite like the Maya Blue made with palygorskite and indigo. With palygorskite, the indigo precursors and dehydroindigo penetrate more deeply into the palygorskite structure than sepiolite, and heat treatment (up to 130°C) enables this penetration. This greater degree of penetration provides the much higher resistance of the palygorskite-indigo pigment to acid attack than the sepiolite-indigo variation of the pigment.[45]

Besides the indigo-palygorskite and indigo-sepiolite varieties of Maya Blue, the Aztecs created another variety of Maya Blue: an indigo-palygorskite-sepiolite pigment. The existence of this variety and one made just with sepiolite indicates that, at least in some cases, the technology of making Maya Blue moved rather than the pigment itself or the palygorskite used to make it. Its Aztec creators knew that Maya Blue was made with white clay and with portions of plants of the *Indigofera* species, but they selected a clay that turned out to be sepiolite, and palygorskite with sepiolite, rather than just palygorskite.

Where did the sepiolite come from? Some evidence indicates that the sepiolite may have come from Yucatán. Isphording and Wilson reported that in the samples of palygorskite from near Ticul, "though usually present in small quantities, sepiolite was the dominant mineral in some of the samples examined."[46] A trace amount was found in one sample collected near the "base of the lens" in Sacalum.[47] Clay mineralogist B. F. Bohor and Hector Neff, however, did not find any sepiolite in their analyses of dozens of samples of *sak lu'um* that Bohor and I collected from Ticul, Sacalum, and surrounding areas over the period of the forty-three years of my research there. None of the other geologists whose analyses are summarized in this work have found sepiolite in Yucatán either.[48] Sepiolite, however, was the dominant mineral in several samples collected by Isphording and Wilson near the archaeological site of Edzná, 115 kilometers southwest of Ticul in the state of Campeche, Mexico, and a small percentage of sepiolite (7%) was identified in the Maya

Blue on figurines from the island of Jaina, off the coast of Campeche 70 kilometers north-northeast of Edzná.[49]

Campeche is still a long way from the Valley of Mexico, and a sepiolite-based Maya Blue could still be imported into the valley by various means during the Aztec and early colonial periods. Nevertheless, the mere existence of sepiolite in Maya Blue late in the prehistoric period suggests that some movement of the technology occurred rather than the movement of the pigment itself.

Another example that supports the knowledge-transfer hypothesis comes from the Petén region of Guatemala. Trace element analyses of Maya Blue from the Postclassic site of Ixlú indicated that the trace elements in the palygorskite did not match the composition of any of the sources further north in Yucatán but were like that of other clays from the area.[50] This similarity suggests that there may be another ancient source of palygorskite in the Maya area besides Sacalum and Yo' Sah Kab.

COMMODITY MOVEMENT AND TECHNOLOGY TRANSFER: A SYNTHESIS

Trace element analyses of the Maya Blue on a Postclassic incense burner dredged from the Sacred Cenote at Chichén Itzá (described in chapter 9) indicate that the palygorskite for the pigment came from nearby Sacalum.[51] It is unclear, however, how the palygorskite got to the site, but it was a pilgrimage site, and pilgrims came there to throw offerings into its cenote even during the colonial period.[52] These pilgrims presumably brought incense burners with them along with palygorskite from Sacalum, combined it with the leaves of an *Indigofera* plant and copal in the tripod vessel, and then heated the vessel and its contents at the edge of the cenote before casting it into the depths of the water below.[53] The creation of Maya Blue by ritual performance of burning copal at the place of offering thus could involve both imported palygorskite and the knowledge of how to make the pigment.

Other evidence that supports both the movement of palygorskite and the technology transfer model comes from the site of La Blanca in the Petén region of Guatemala, where archaeologists found greenish pellets of a "Maya Blue–like" material dating to the Terminal Classic period. These pellets consisted of the components of Maya Blue, palygorskite, and indigo along with the other indigoids of dehydroindigo, isatin, and indirubin. The greenish hue resulted from the yellow dehydroindigo tinting the indigo. These pellets, however, were not Maya Blue because the indigo and the other indigoids could

be extracted from the pellets, indicating that they had not combined chemically with the palygorskite. The source of the palygorskite in the pellets was not known, but it appears that although their creators knew something about the process of making Maya Blue, they did not know all of it. In this case, the palygorskite likely was acquired through trade, exchange, or gifting, but the creators did not know how to use it to make the pigment. All that was missing was heating the mixture to create a stable Maya Blue.[54]

Analysis of the composition of the blue pigments used on codices produced before and immediately after the Spanish Conquest also indicates that the diffusion of Maya Blue involved both transfer of the pigment and the transfer of the technology to create it. In an analysis of thirteen codices (eight pre-Hispanic and five colonial) using portable noninvasive techniques, the European Mobile Lab Facility (MOLAB) found four different indigo-based blue pigments: (1) an indigo/palygorskite–based Maya Blue, (2) an indigo/palygorskite–based Maya Blue possibly created with a low indigo content and/or high heating temperatures, (3) a sepiolite-based Maya Blue, and (4) indigo used as a dye or supported on layered clays.[55]

A palygorskite-based Maya Blue was the scribes' choice on ten of the thirteen codices analyzed (Madrid, Nuttall, Bodley, Laud, Fejérváry-Mayer, Borgia, Cospi, Selden Roll, Mendoza, and Tudela). Seven of these were pre-Hispanic (Madrid, Nuttall, Bodley, Laud, Fejérváry-Mayer, Borgia, Cospi). The green of the Cospi, Fejérváry-Mayer, Zouche-Nuttall, and Colombino codices were also created with Maya Blue and a yellow dye, in or on the pigment.[56]

Originally, the MOLAB analysts thought that Maya Blue was introduced into southwestern and central Mexico during the Epiclassic, and they believed that they would find it on Postclassic documents from these regions. Instead, they found a far more complex picture. Only restricted areas of central and southwestern Mexico had easy access to the palygorskite-based Maya Blue during the Epiclassic, but it is not clear whether the pigment or only the palygorskite was imported and then made locally into Maya Blue, as indicated by the analyses of the Cacaxtla paintings. However, the use of sepiolite—and to some degree, kaolinite—in some of the Maya Blue pigments on these documents indicates that artisans in these areas possessed knowledge of how to make the pigment and were experimenting with locally available materials, perhaps because of the difficulties in obtaining palygorskite to produce a color similar to palygorskite-based Maya Blue. The use of an alternative source of blue, *Commelina*, instead of indigo, further confirms that the local population experimented to create a Maya Blue–like pigment.[57] Clearly, this variability indicates the existence of the transfer of the Maya Blue technology that was incompletely executed.

In the colonial period Maya Blue made with palygorskite was more available and widespread than previously. Because it was detected on various manuscripts such as codices (Mendoza, Tudela, Borbonicus, Forentinus, Huamantla), the Selden Roll, the Beinecke Map, on some maps attached to the Relaciones Geográficas, and on colonial manuscripts from the Basin of Mexico and more peripheral areas, it appears that the changes in trading patterns brought on by the Spanish Conquest made the palygorskite-based Maya Blue more widely available. Indeed, a palygorskite-based Maya Blue appears in twenty-eight sixteenth-century wall paintings in convents in the Mexican states of Puebla, Mexico, Tlaxcala, Hidalgo, and Morelos, and the palygorskite on them matches the composition of the palygorskite from Yucatán (figure 3.2).[58] It is unclear, however, whether Maya Blue was imported into these areas or whether it was locally made with imported palygorskite using knowledge acquired from elsewhere.

Maya Blue also appeared in murals in four other sixteenth-century convents in Yucatán, Hidalgo, and Morelos.[59] The source of the palygorskite used in the Maya Blue on these murals, however, has not been determined, and it not clear whether the pigment was the product of its physical transfer or the transmission of the knowledge of how to make it.

SUMMARY

At the beginning of the chapter, I asked several questions about the movement of Maya Blue in southern Mesoamerica and laid out two different explanations to account for its diffusion. Did the pigment move through its physical transfer, or did the knowledge of how to make it move? I also asked why it took more than a millennium to expand throughout Mesoamerica. The answers to these questions turned out to be quite complicated and raised even more questions. As is often the case, the data provide a far more complex picture than a single hypothesis can explain. It now appears that palygorskite, Maya Blue, *and* the knowledge of how to make it moved. At this time, it is difficult if not impossible to untangle these explanations from the data presented here without more research, but it is likely that Maya Blue moved both through transfer of the pigment itself and the technology to make it.

The restriction of Maya Blue to ritual and elite contexts of pottery, offerings, balls of copal, sculpture, and murals indicates that it was an elite and highly valued pigment in Maya art, society, and religion. The medical use of palygorskite among the modern Maya and in the prehistoric period implies that the knowledge of how to make the pigment was also restricted and known only

by ritual and/or curing specialists. Access to it was constrained by a limited number of sources of palygorskite and/or by the knowledge of how to use it. Indeed, the spatially limited sources for the clay may have enhanced its value. If the knowledge of how to make Maya Blue was the domain of religious specialists, then its transmission was also limited, but how did those religious specialists transmit that knowledge from site to site? Was this diffusion a consequence of intercity-state alliances, a population movement, or the movement of religious elites propagating a new (or revitalized) religion such as the Quetzalcoatl cult in the Epiclassic/Terminal Classic period? In any event, the lengthy period of the diffusion of the pigment into new areas during the 1,700 years of its use in Mesoamerica indicates that the social contact of those who knew how to make it was limited.

Finally, many questions remain about the diffusion of Maya Blue. Its appearance in western Mexico during the Middle Preclassic period raises the possibility of another early source of the pigment and that of the palygorskite used to make it. Further, the non-Yucatecan source of palygorskite in Maya Blue in Aztec times raises more questions about its source in the Postclassic and that of sepiolite at that time. There is much fodder here for future research about the diffusion of Maya Blue.

12

Future Research After Maya Blue was discovered in 1931, its composition was unknown for more than thirty years. In the late 1960s, however, chemists discovered that it was a clay-organic complex of palygorskite and indigo. Since then, chemists and material scientists have unlocked many of the mysteries of this unusual pigment based upon experimentation and laboratory analyses. It now appears that Maya Blue was made by several methods, probably not by using indigo itself but by using a solution of the leaves of one of the species of the *Indigofera* genus (likely *Indigofera suffruticosa*) that contained the precursors of indigo; they were adsorbed into the structure of the palygorskite, chemically bonded to it, and then changed into indigo with heat to become Maya Blue.

The quest for solutions to many aspects of the Maya Blue mystery, however, is far from over, and many avenues of future research lie ahead. As with the ethnobotanical and ethnopharmacological searches for new medical cures and drugs, the contextual information about Maya Blue that comes from archaeology, ethnohistory, ethnography, and art history is critical to understanding past technological choices that the ancient Maya made in creating this unusual pigment.

For archaeologists, the greatest significance of Maya Blue lies in its relationship to the societies that made and used it. Because this work is written from the perspective of anthropology and archaeology, I will suggest lines of future research only with those disciplinary foci.

https://doi.org/10.5876/9781646426683.c012

THE ARCHAEOLOGY OF PALYGORSKITE MINING

My initial stimulus to study Maya Blue and write this work did not originate from the physical sciences, from the study of museum objects, or from an interest in Maya Blue itself, but rather from an ethnographic study of modern pottery making and the discovery of potters' Indigenous knowledge.[1] Archaeological and technological approaches have demonstrated the use, distribution, composition, and characteristics of Maya Blue, but ethnography has related it to Maya language and culture and to the pre-Hispanic sources of one of its constituents, palygorskite.

A source of palygorskite in the Maya area was unknown for years. Then my ethnographic research in the mid-1960s demonstrated that the contemporary Maya potters in Ticul recognized the unique physical properties of palygorskite and used it as an additive for pottery temper and for treating several types of illnesses. The ancient Maya, like the contemporary Maya potters of Ticul, however, did not possess detailed scientific knowledge of the chemistry and clay mineralogy of palygorskite, but they did hold impressive practical wisdom of *sak lu'um* based upon their awareness of and experience with its physical properties.[2] *Sak lu'um* was palygorskite, but not all palygorskite was *sak lu'um*.

Consequently, eliciting Maya Indigenous knowledge can provide an important approach for those who study ancient technologies; physical science techniques alone do not provide a sufficient understanding of those technologies and the Indigenous knowledge that sustained them. Whereas the technical analyses of Maya Blue are important and chemists and material scientists have unlocked many of the secrets of the composition of the pigment and its variations, archaeologists should not lose sight of the fact that Maya Blue, the sources of its constituent materials, and its production technology (like all technology) are socially embedded and must be understood within their social and cultural context.

Although palygorskite occurs in many places in the Maya area, most of these deposits were not accessible to the ancient Maya. Rather, Maya Indigenous knowledge has revealed two probable ancient mining sites for the mineral. The first of these was the cenote at Sacalum, and the other lies in the area called Yo' Sah Kab near Ticul where a Terminal Classic site lay atop a palygorskite deposit about 2 meters thick. Unfortunately, when mining temper for making pottery intensified and expanded after 1967, the site was destroyed.

These locations are not just sources of palygorskite exploited by the modern Maya; they are unique because they are the largest, most abundant, and most accessible deposits of palygorskite accessible to the ancient Maya. Furthermore,

Ticul potters and the inhabitants of Sacalum recognize *sak lu'um* as a distinct *cultural* category in these locations. Both sources are associated with unique linguistic, ethnographic, ethnohistoric, and archaeological contexts, giving them a special sense of place that is part of modern Maya Indigenous knowledge (chapter 5).

Comparisons of the trace element analyses of a small set of samples of Maya Blue from Chichén Itzá and Palenque with those of contemporary sources of palygorskite have revealed that most of this set of Maya Blue samples used palygorskite that came from Sacalum and Yo' Sah Kab (chapter 8).[3] So future research should explore the archaeological evidence for palygorskite mining at Sacalum and Yo' Sah Kab.

The large mine in the Sacalum cenote is the largest and most impressive ancient source of palygorskite known. Its size and extent need to be carefully mapped and measured in far more detail than Bohor and I did in 1968.

The area covered by the cave-in at the front of the mine entrance should also be mapped and measured. From the extent of the collapse, it is clear that the mined-out palygorskite deposit extended much further into the cenote interior; detailed mapping of the talus from that collapse might provide a more precise estimate of the amount of palygorskite removed from the mine.

Excavations into the collapsed area in front of the mine and around the interior walls of the cenote may reveal the antiquity of the mining there by the association of specific types of pottery with detritus that contains palygorskite. These excavations also might reveal the approximate date of the collapse.

These excavations may also uncover tools (and/or their fragments) left behind from ancient mining activity. During my visit to the Sacalum cenote in 1967, two machetes were found abandoned inside the mine. Given that palygorskite is very hard and is currently mined with metal tools, the ancient Maya may have mined *sak lu'um* with tools made of a hard wood, such as *ha'abin* ("iron wood").[4] They may have also used antlers from local deer, just as Neolithic miners used antlers modified into picks, hammers, and punches to extract flint in the mines of southern England. Chipped stone tools would not stand up well to digging the hard palygorskite, but if the ancient miners did use them, they would break easily, leaving their fragments behind. In the Neolithic flint mines in continental Europe, miners frequently used such tools for mining, although they also employed antlers for this purpose. In the flint mines at Rijckholt-St Geertruid in continental Europe, stone hammers, stone picks, and narrow flint picks occurred most frequently as mining tools, with stone picks accounting for 98% of the implements recovered. The presence of many hammerstones indicated that the mining tools of chipped stone

were sharpened and reused on-site as needed by reshaping and retouching them.[5] So an intensive survey and excavation of mining sites at Sacalum and Yo' Sah Kab may uncover the remains of ancient tools, their fragments, and the implements used to make and modify their tools. Like the machetes found in the mine in the Sacalum cenote, Terminal Classic clay miners also left tools behind in the ancient clay mine at Hacienda Yo' K'at near Ticul. During an exploration of that mine in 1968, Bohor and I discovered an ancient sherd from the Terminal Classic period over a large lump of clay sealed in a collapsed mine tunnel.[6]

Finally, a survey of archaeological sites around Sacalum may reveal data about the production and distribution of palygorskite and Maya Blue—a point I made in early 1967:

> . . . an archaeological survey of the Sacalum area may turn up evidence of archaeological sites, and excavations of these sites may reveal that attapulgite (palygorskite) was mined in this area and accumulated for trade with other areas. With the source of palygorskite so near, Sacalum might also have been a production center for Maya Blue which the Maya traded over a wide area.[7]

When I visited Sacalum later that same year, informants told me about three archaeological sites nearby. One, called To, was 2 kilometers from the village along the road to Ticul and about 1 kilometer north of it. The following year (1968), when Bohor and I went to Sacalum, we passed an archaeological site near the village and north of the road; it may have been the To site (figure 12.1). Several mounds were visible, and I climbed to the top of the highest to take a photograph of the *puuc* ridge to the southwest. By 2008, however, when we visited Sacalum again, the mounds had disappeared. Another site, called Shkele, was located 8 kilometers north of Sacalum on or near a hacienda. A third archaeological site identified by locals was called Sak Nik Te' and was 5 kilometers from Sacalum in the direction of Muna.

Besides the Sacalum source, the area around Yo' Sah Kab also should be intensively surveyed to search for prehistoric occupation and mining activity. Even though the mining area expanded over the forty-three years that I worked in Ticul and the most obvious vestiges of the archaeological site that I observed in 1967 have disappeared, traces of it might remain. An aerial survey using LIDAR may reveal traces of structures amid the trees and abandoned temper preparation areas.[8] Further, an intensive archaeological survey of the *ejido* land, the cement company land, and other private land nearby might turn up further evidence of ancient mining and occupation and could determine the extent of both ancient and modern mining areas.

FIGURE 12.1. *View from the top of a large mound at an archaeological site called To, November 1968. The site was about 2 kilometers from Sacalum along the road to Ticul, and the* puuc *ridge could be seen to the southwest. Surface features included mounds and piles of rock (*center left*). This site may have been involved in the distribution of palygorskite from Sacalum for curing medical ailments and for making Maya Blue. The henequen here was grown for its fibers to make rope and twine, but that industry has since collapsed in Yucatán. All of the visible features shown here had disappeared by May of 2008.*

DISCOVERING OTHER SOURCES OF PALYGORSKITE

Although the most obvious ancient sources of palygorskite used in the production of Maya Blue came from Sacalum and Yo' Sah Kab, geologists have reported it from several other locations on the Yucatán Peninsula (see chapter 7).[9] Some of these deposits are relatively small, and if used by the Maya, any palygorskite obtained from them over the centuries was likely insufficient for making Maya Blue, treating illnesses, and for pottery temper. Others are larger, but without modern extraction technology of metal tools, machinery, and explosives, these deposits were inaccessible to the ancient Maya. Consequently, any sources of palygorskite used to make Maya Blue probably were limited to more accessible deposits like those in Sacalum and Yo' Sah Kab.

Nevertheless, at least one other source of palygorskite used in Maya Blue remains to be found. The trace element analyses of two samples of Maya Blue

from the Petén were not similar to those of the palygorskite samples from any of the known sources in Yucatán; rather, they were clustered together, even though the sample size was too small for statistical characterization (chapter 8).[10] So the ancient Maya used palygorskite not from just Yucatán to make Maya Blue but probably from the Petén as well.[11]

If this unknown source was small and the ancient Maya exploited it only temporarily, it may never be found. Nevertheless, trace element analyses of Maya Blue from a wide variety of contexts might reveal other sources in the Maya area. Yet they also may remain elusive—particularly if they were small, used infrequently, and restricted to a brief period of exploitation. Like the source of a potter's clay in the Barrio of Mejorada in Ticul whose useful life lasted less than 100 years and then was covered by modern construction, other palygorskite sources used for Maya Blue may be lost forever.[12]

Another possible source of palygorskite in the Petén is referenced by a historical reference to the place-name "Sacalum" that is different from the town of Sacalum in Yucatán.[13] In his treatment of the Spanish engagement with the Maya in the colonial period, Don Dumond briefly describes a massacre of Spanish soldiers in a church in an advance camp called "*Sacalum* (or *Sacluum*)" located "somewhere north of Lake Petén."[14] Citing others, he suggests that it may be located in the southern part of the state of Quintana Roo near its boundary with Campeche and may be the town now known as Chichanhá.[15] Only a survey of the area around the community, however, could determine whether palygorskite is found there. Chichanhá lies 60 kilometers directly east of the ancient Maya site of Calakmul, where the earliest use of Maya Blue occurred in the Late Preclassic period, and 140 kilometers north-northeast of the site of Ixlú, where Cecil identified a Maya Blue with a composition that did not match any of the sources of palygorskite in Yucatán.[16]

Nevertheless, other sources of palygorskite may yet be found. Because volcanic ash fell widely across the Maya area at various times in the past, some of it must have landed in highly saline, magnesium-rich lagoons, altering into palygorskite in many locations (see chapter 6). Consequently, sources of palygorskite with similar composition may occur widely. To discover these sources, investigators should search not just for white clays, as I did, but for a material that bears all the similarities to the Maya definition of *sak lu'um*—a white palygorskite mudstone. The search for other sources of palygorskite should continue in order to build a trace element database to compare with the trace element analyses of Maya Blue.[17] Likewise, searching for the source (or sources) of sepiolite should supplement this task because some Aztec Maya Blue was made with sepiolite or a combination of palygorskite and sepiolite.

ANALYZING MAYA BLUE ON MUSEUM OBJECTS

Museums house many of the world's treasures, but these institutions are not just venues for educational displays of objects from the cultures of the world. Rather, their collections provide opportunities to study ancient technologies by applying new analytical tools and contextual information that did not exist when the objects were collected. For example, the discovery of one of the ways in which the Maya created Maya Blue came from the analysis of the contents of an offering bowl that was stored away and forgotten in a museum for almost a century (chapter 9). Searching for vessels with Maya Blue in museum collections may reveal more information about how it was created.

One question that the study of museum collections can answer is this: What kind of vessels did the Maya use to create Maya Blue? Earlier in this work I suggested that there were at least two methods by which the ancient Maya created their unique pigment (chapters 9 and 10). Both methods were discovered by describing and analyzing the contents of vessels in the Field Museum collections.

One way was burning or heating copal incense with palygorskite and a derivative of the indigo plant (such as a leachate or leaves) in a tripod bowl. This discovery indicates that a search for objects with copal incense and Maya Blue in museum collections may help us understand more about the relationship between burning incense and the creation of the pigment. A detailed examination of the fifty bowls of copal that Edward Thompson dredged from the Sacred Cenote at Chichén Itzá, for example, can still yield more information and may show how the indigo plant was used for the preparation of Maya Blue by heating or burning copal. Three of these copal offerings have clear leaf impressions on the bottom, and many more have less clear vegetal impressions.[18] Coggins and Ladd believe that these offerings and other copal offerings from the cenote were worked on leaves, and some of these impressions might be leaves of one of the species of *Indigofera*. Further, it might be possible to identify other plant materials found on and in these copal offerings that may assist in understanding more details about the creation of the pigment.

A second way of creating Maya Blue emerged from the study of red-slipped tripod bowls from El Osario excavations in the Field Museum collection. In chapter 10 I suggested that the ancient Maya used these bowls to grind palygorskite wetted with aqueous extracts from indigo plants and/or crushed its leaves together with wetted palygorskite to make Maya Blue. Then the Maya heated the mixture in these bowls to stabilize the color. Analyses of the remains of the material in or around incisions on the base of such bowls

could confirm the presence of palygorskite. Microscopic examination of these grooves revealed tiny remnants of plant remains that were carbonized in some cases. Could these plant remains be parts of the indigo plant used to make Maya Blue?

Searching for other vessels with Maya Blue and subjecting their contents to residue analysis may provide even more insight into the creation and context of the pigment. Are there tripod bowls or other objects that show residues of Maya Blue, palygorskite, and microscopic plant fragments in museum and site collections from other Maya sites? Using museum objects to solve some of the mysteries of Maya Blue has only begun.

MAYA BLUE AND ANCIENT MAYA RELIGION AND CULTURE

Whereas the technical analyses of Maya Blue are important in unlocking the secrets of its composition, such approaches do not really tell us much about its relationship to its cultural context and issues of interest to archaeologists. Both methods for creating Maya Blue elaborated and documented in this work from studying ancient vessels in the Field Museum were ritually embedded within the religion of the ancient Maya, and to understand the ancient technology of its production, one needs to understand more about ancient Maya religion as well as modern Maya culture. Blue was obviously an important religious symbol for the ancient Maya, but relating it and its components to their cultural context can provide a deeper meaning of its significance with new hypotheses for testing.

The medicinal uses of both ingredients of Maya blue (palygorskite and extracts from the indigo plant) indicate that the symbolism of the pigment went beyond sacrifice and propitiation and was related to the physical healing produced by these components. Their ritual combination into Maya Blue during the burning of incense linked their medicinal qualities into a powerful symbol of healing as well as sacrifice. In this case, the creation of Maya Blue in a ritual context was likely the domain of ritual specialists. Verification of the identity of the makers of Maya Blue thus will be a provocative question for future research.

THE DIFFUSION OF MAYA BLUE

The questions of whether palygorskite (and/or sepiolite) and/or Maya Blue moved across the landscape, or whether the knowledge of how to make it moved, are far from being answered. The great intensity of archaeological work

in the Maya area provides an opportunity to obtain samples of the pigment from a wide area. These samples should be analyzed using a combination of X-ray diffraction, trace element analysis, and other physical science techniques. These analyses should be compared to the composition of palygorskite already available from Sacalum and Yo' Sah Kab.[19] It then should be possible to determine whether the palygorskite used in these pigments came from these two sources or from others. In either case, it may be possible to trace changes in the sources of palygorskite used in Maya Blue through time and discover heretofore unknown religious and socioeconomic links between Maya centers.

Milbrath and Peraza Lope, for example, believe that the Aztec Maya Blue came from Mayapán and that the Aztecs sought to control the trade of the pigment from there.[20] This hypothesis is quite easy to test because Mayapán is only 20 kilometers from what is probably the principal ancient source of palygorskite in Yucatán—Sacalum. All that is necessary is to compare the distinguishing trace elements of the Sacalum and Yo' Sah Kab with samples (chapter 8) of Aztec Maya Blue.

Unfortunately, at least some of the Aztec Maya Blue was not made with palygorskite from Yucatán, and this fact complicates assumptions about its Mayapán origin. Nevertheless, this discovery reinforces the need to use trace element analysis of samples of the pigment to identify patterns of the movement of the pigment and/or the palygorskite used to make it. Some analysts have suggested that northern Mexico was a source of the palygorskite in Aztec Maya Blue, and this possibility adds an entirely new dimension to the analysis of the pigment and its diffusion. Obviously, more analyses of Aztec Maya Blue using high-resolution transmission electron microscopy and synchrotron X-ray diffraction can determine whether the palygorskite in other samples of Aztec Maya Blue came from sources outside of Yucatán.[21]

Ironically, the first use of Maya Blue in Mesoamerica may not have been "Maya" at all. Although its first use appears in the Maya area at Calakmul in the southern Maya lowlands during the Late Preclassic, its earlier presence in the Lerma Valley in western Mexico in a Middle Preclassic burial opens another avenue of research that requires a more intensive search of museum collections and more excavations of the Chupicuaro culture to discover if Maya Blue existed in other Preclassic sites of that area. The chalky substance in the burial associated with Maya Blue at the La Tronera site should also be analyzed because palygorskite can look like a chalky substance.[22] Was this use of Maya Blue a local innovation? Or did this pigment come from a heretofore unidentified source of the pigment in the Maya area?

Analyzing a larger sample of palygorskite and Maya Blue from widespread locations may reveal patterns of trade and exchange of either Maya Blue or of palygorskite itself. Such analyses may also reveal whether the clay or the pigment was traded as well as whether the technology of how to create it moved. Consequently, it may be possible to determine whether Maya Blue was made from local sources or not. If the movement of the technology was responsible for its spread, it may be possible to detail the general patterns of social interaction that led to the transmission of the knowledge of its creation. Discovering these technologies, however, will be dependent upon the work of chemists and material scientists to discover and verify the various methods of preparation. Delineating the use of Maya Blue through time and space, using trace element analyses, may reveal patterns of spatial interaction through time.

One example that illustrates the diffusion and elite use of Maya Blue comes from the work of Maya ceramic analyst Joe Ball and his colleagues, who have chronicled the use of the pigment at the site of Buenavista del Cayo in Belize during the span of the Late Classic and Early Terminal Classic periods. Its first use there occurred about AD 620 on stucco fragments from severely deteriorated palace and elite residential facades.[23] Between AD 680 and AD 790, the Naranjo and Holmul palace schools nearby made occasional and sparing but regular use of Maya Blue on the Cabrito variety of Cabrito Cream-Polychrome as enhancements to labial and basal bands. By AD 780–790, however, the pigment had come to the Buenavista palace, where a painter/artist used it lavishly to embellish basal and labial bands on vessels of the Guajiro variety, intended for palace ("in-house") service wares, and occasionally applied it to other locations on these vessels. Maya Blue continued to be used on this ceramic variety until AD 840–860 and was also applied to a small number of other contemporary ceramics at Buenavista del Cayo, primarily of the K'om ceramic group.[24]

Maya Blue–adorned vessels in these cases seems clearly to be used by elites, but it is unclear where the pigment was made and whether it was physically transported to the Buenavista site. Preliminary trace element analyses of the Maya Blue on the Buenavista vessels indicated that the palygorskite used to make them came from Sacalum, 375 kilometers north-northeast.[25] Nevertheless, in this case, as in many cases, the mechanism of movement is an open question, as is the question of whether the palygorskite, the Maya Blue, and/or the technology used to make the pigment moved. An equally important question is why its use was adopted by elites at Naranjo, Holmul, and Buenavista de Cayo at all. The answer may involve religious explanations, at least in part.

OTHER FUTURE DIRECTIONS

There are many other directions for Maya Blue research that go beyond those proposed here. Could the ancient Maya have used additional species of *Indigofera* besides *Indigofera suffruticosa* to make Maya Blue? Do all these species have the same set of indigoid compounds in them? How do their proportions vary seasonally and between the species? What is the distribution of *Indigofera* species in Mesoamerica? My own research on *Indigofera* in the 1960s revealed a wide variety of species in Mesoamerica, with the greatest variety in the state of Guerrero in western Mexico. This observation, however, needs to be verified by a review of the more recent botanical literature.

At the beginning of this work, I asked: Did the ancient Maya deliberately know how to manipulate color variations of Maya Blue to use on their murals? Answering this question has now become much more complicated. Did they use different recipes to manipulate the color? Or did they choose variations of Maya Blue that came from the natural variability of the color of the constituent palygorskite (white, red, or yellow)? We now know that Maya Blue is not just one color; indigoid/palygorskite hybrids include colors of blue, blue/green, green, and yellow, and these colors are not necessarily just the result of natural variability of the palygorskite. Rather, the ancient Maya also employed different techniques to create Maya Blue through time, including adding ochre to some of their recipes, using palygorskite with substantial iron ions, heating the pigment longer and hotter to alter its color, or preparing it in red-slipped vessels where some of the hematite in the slip became incorporated into the pigment during preparation. Further, Maya Yellow was the result of an intermediate step in processing the leaves and stems from the indigo plant before Maya Blue was created.

Even after more than ninety years since the discovery of the unique characteristics of Maya Blue, unraveling the mysteries about the pigment and its constituents requires much more research. Many more frontiers of knowledge still exist in the study of Maya Blue for solving the mysteries of its creation, use, and context. Even now, with thousands of pages of research about the pigment, there is still much to learn.

PREFACE

1. Arnold, *Sak Lu'um in Maya Culture*; Arnold and Bohor, "Ancient Mine Comes to Light"; Arnold and Bohor, "Ancient Attapulgite Mine in Yucatán."

2. Sánchez del Río et al., "Maya Blue Pigment"; Sánchez del Río, "Maya Blue Studies in History and Archaeology"; Doménech Carbó, Doménech-Carbó, and Edwards, "Interpretation of Raman Spectra of Maya Blue."

3. Arnold, "Maya Blue: A New Perspective."

4. Arnold, *Sak lu'um in Maya Culture.*

CHAPTER 1: INTRODUCTION

1. Vázquez de Ágredos Pascual et al., "Characterization of Maya Blue Pigment"; Cabrera Garrido, *Azul Maya*; Gettens, "Identification of Pigments on Mural Paintings"; Gettens, "Maya Blue"; Haude, "Identification of Colorants"; Straulino-Mainou et al., "Maya Blue in Wall Paintings"; Arroyo-Lemus, "Survival of Maya Blue in Mexican Colonial Mural Paintings."

2. Tagle et al., "Maya Blue."

3. Sousa et al., "Photochemical Study on Indigo"; Splitstoser et al., "Early Pre-Hispanic Use of Indigo."

4. Sánchez del Río et al., "Synthesis and Acid Resistance of Maya Blue"; Fois, Gamba, and Tilocca, "Unusual Stability of Maya Blue"; Giustetto et al., "Chemical Stability of a Sepiolite/Indigo Maya Pigment."

5. Gutiérrez and Brito, "Archaeological Research of Códice Maya de México," 54, 55.

6. Merwin, "Chemical Analysis of Pigments."

7. Coggins, "Murals in the Upper Temple of the Jaguar."

8. Pelto and Pelto, *Anthropological Research.*

9. Polanyi, *Personal Knowledge.*

CHAPTER 2: BACKGROUND

1. Coggins, "Dredging the Cenote," 26.

2. Merwin, "Chemical Analysis of Pigments."

3. Gettens and Stout, *Painting Materials*, 130–131.

4. Magaloni, "Technique, Color and Art at Bonampak," 252.

5. Tagle et al., "Maya Blue."

6. Sánchez del Río et al., "Microanalysis Study of Archaeological Mural Samples." This study is one of many examining the variability of the color Maya Blue (chapter 10).

7. These samples are currently in the anthropology collection of the Field Museum in Chicago, Illinois.

8. Iron ions were found in Maya Blue, in the palygorskite used to make it (Sánchez del Río et al., "Fe K-edge XANES of Maya Blue"), and in a sample of palygorskite from Sacalum (José-Yacamán et al., "Maya Blue Paint"). Larger amounts of iron ions occurred in the palygorskite samples from the Sacalum mine than in those collected near Ticul at Yo' Sah Kab and the Chapab source (Arnold et al., "First Direct Evidence of Pre-Columbian Sources of Palygorskite"). See also chapter 8.

9. Berlin and Kay, *Basic Color Terms*, 31.

10. Barrera Vásquez et al., *Diccionario Maya Cordemex.*

11. Arnold, *Maya Potters' Indigenous Knowledge*, 31–49.

12. As I remember it, the Tzeltal pronunciation is without the glottal stop (*yaash*) and is simply a long *a*, unlike the pronunciation of Yucatec Maya: *ya'ash.*

13. Basic color terms, according to Berlin and Kay (*Basic Color Terms*), are those color terms that take standard affixes in a language, such as "-ish" in English, and thus exclude foreign color terms, such as magenta, chartreuse, and mauve, that do not normally have those suffixes (e.g., "chartreuse-ish"). For the list of languages used, see Berlin and Kay, *Basic Color Terms*, 45–104.

14. Berlin and Kay, *Basic Color Terms*, 31.

15. Bricker, Po'ot, and Dzul, *Dictionary of the Maya Language*, 312.

16. Bricker, Po'ot, and Dzul, *Dictionary of the Maya Language*, 86.

17. Berlin and Kay, *Basic Color Terms.*

18. Shepard and Gottlieb, *Maya Blue*; Tozzer, *Landa's Relación*, 89, 117, 119, 155, 156, 159, 164; Vidal, Muñoz, and Horcajada, "Ofrendas y Rituales," 8, 10, 12.

19. Tozzer, *Landa's Relación*; Tozzer, *Chichén Itzá and Its Cenote of Sacrifice*, 195–196, 203; Vail and Hernandez, *Maya Hieroglyphic Codices*; Vidal, Muñoz, and Horcajada, "Ofrendas y Rituales," 12.

20. Tozzer, "Introduction," vii. In a new book about the document attributed to Landa, four historians, Restall, Solari, Chuchiak, and Arden, provide a new translation of it appended with seven essays that detail different types of analyses of the work. They conclude that the document "is a somewhat arbitrary collection of material on various topics—almost all related to the history and culture of Yucatan in the sixteenth century, before and after contact with Spaniards—created by multiple authors, compilers, and copyists at different times during Landa's lifetime and long after it. . . . Portions of the manuscript were almost certainly not written by Landa . . ." (Restall et al., *Friar and the Maya*, 342).

21. Coe, *Breaking the Maya Code*, 145–166.

22. Tozzer, *Landa's Relación*, 117–119.

23. Tozzer, *Landa's Relación*, 117; Tozzer, *Chichén Itzá and Its Cenote of Sacrifice*, 203.

24. Tozzer, *Landa's Relación*, 117–119; Tozzer, *Chichén Itzá and Its Cenote of Sacrifice*, 107, 203.

25. Landa, *Yucatan before and after the Conquest*, 48, 49. See also Restall et al., *Friar and the Maya*, 99.

26. After the Conquest the number of water sources were expanded by digging wells using explosives and metal tools.

27. Not all sinkholes in Yucatán, however, have water at their base, and not all have vertical sides like this one.

28. Pérez de Heredia Puente, *Chen K'u*.

29. Tozzer, *Chichén Itzá and Its Cenote of Sacrifice*, 195, 196, 203.

30. Tozzer, *Landa's Relación*, 180–181; Tozzer, *Chichén Itzá and Its Cenote of Sacrifice*, 191.

31. Tozzer, *Chichén Itzá and Its Cenote of Sacrifice*, 189.

32. Thompson, *High Priest's Grave*.

33. Coggins, "Dredging the Cenote"; Tozzer, *Chichén Itzá and Its Cenote of Sacrifice*.

34. Coggins, "Dredging the Cenote"; Tozzer, *Chichén Itzá and Its Cenote of Sacrifice*, 195.

35. Tozzer, *Chichén Itzá and Its Cenote of Sacrifice*.

36. Coggins and Shane, *Cenote of Sacrifice*.

37. Coggins, *Artifacts from the Cenote of Sacrifice*.

38. Hooton, "Skeletons from the Cenote of Sacrifice"; Anda Alanis, "Sacrifice and Ritual Body Mutilation"; Price, Tiesler, and Freiwald, "Origin of the Victims in the Sacred Cenote," 4.

39. Price, Tiesler, and Freiwald, "Origin of the Victims in the Sacred Cenote."

40. Coggins and Ladd, "Copal and Rubber Offerings," 353.

41. Coggins, "Dredging the Cenote," 14; Tozzer, *Chichén Itzá and Its Cenote of Sacrifice*, fig. 707.

42. Tozzer, *Chichén Itzá and Its Cenote of Sacrifice*, 192, fig. 707; Coggins, "Dredging the Cenote," 14. Tozzer provided no overall scale on the profile of the cenote. So the depth of the blue layer was inferred by creating a scale subdividing the distances on the profile.

43. Tozzer, *Chichén Itzá and Its Cenote of Sacrifice*, 192.

44. Tozzer, *Landa's Relación*, 117.

45. Indigo undergoes fading (photodegradation) in an aqueous solution (Sousa, "Photochemical Study on Indigo").

46. Vail, "Maya Codices"; Vail and Hernandez, *Maya Hieroglyphic Codices*; Reyes-Valerio, *De Bonampak*, 86.

47. For a list of tropical storms and hurricanes that passed within two degrees latitude and longitude of the city of Ticul, Yucatán, between 1965 and 2008, see Arnold, *Evolution of Ceramic Production Organization*, 255–256. This spatial range includes most of the archaeological sites in northwestern Yucatán, including the *puuc* sites and Chichén Itzá. The frequency of such storms, however, occurs in multiyear cycles and may have been different in the ancient past.

48. Evans et al., "Quantification of Drought during the Collapse," 498; Hoggarth et al., "Political Collapse of Chichén Itzá."

49. Simms et al., "Evidence from Escalera al Cielo."

50. Hoggarth et al., "Political Collapse of Chichén Itzá." The Andes of South America also suffered a drought during this same period and was one important factor related to the collapse of the pre-Inca Wari Empire (Thompson et al., "1500-Year Record of Tropical Precipitation").

51. Coe, *Breaking the Maya Code*.

52. Gettens and Stout, *Painting Materials*, 130–131.

53. Palygorskite is a synonym for attapulgite, but priority is given to the name "palygorskite" because it was the first name given to the mineral (see Bailey et al., "Clay Mineral Nomenclature," 131).

54. Gettens, "Maya Blue," 563; Shepard, "Maya Blue."

55. Gettens, "Maya Blue," 558.

56. Gettens, "Maya Blue," 561.

57. Shepard, "Maya Blue."

58. Shepard and Gottlieb, *Maya Blue*.

59. Van Olphen, "Maya Blue."

60. Kleber, Masschelein-Kleiner, and Thissen, "Etude et identification."

61. Cabrera Garrido, *Azul Maya*.

62. This statement is based upon conversations with Luis Torres and Alejandro Huerta in Mexico City in 1970 and subsequent conversations and correspondence.

63. Sánchez del Río et al., "Maya Blue Pigment"; Sánchez del Río et al., "Synthesis and Acid Resistance of Maya Blue"; Giustetto et al., "Chemical Stability of a Sepiolite/Indigo Maya Pigment"; Li et al., "Influence of Indigo-Hydroxyl Interactions."

64. Cabrera Garrido, *Azul Maya*.

65. Littmann, "Maya Blue: A New Perspective."

66. Littmann, "Ancient Mesoamerican Mortars: Composition"; Littmann, "Ancient Mesoamerican Mortars: Puuc Area."

67. Arnold, "Ethnomineralogy of Ticul Potters."

68. Arnold, "Maya Blue: A New Perspective"; Arnold, *Sak Lu'um in Maya Culture*.

69. Kleber, Masschelein-Kleiner, and Thissen, "Etude et identification"; Van Olphen, "Maya Blue"; Cabrera Garrido, *Azul Maya*.

70. Littmann, "Maya Blue: A New Perspective," 95. For more details of the critique of Littmann, see Arnold, "Maya Blue and Palygorskite."

71. Carroll, *Clay Minerals*, 26–27; Moore and Reynolds, *X-Ray Diffraction*, 241–244.

72. Littmann, "Maya Blue: A New Perspective," 99.

73. Carroll, *Clay Minerals*, 26–27; Moore and Reynolds, *X-Ray Diffraction*, 241–243.

74. Kleber, Masschelein-Kleiner, and Thissen, "Etude et identification"; Cabrera Garrido, *Azul Maya*; Van Olphen, "Maya Blue."

75. Arnold, "Maya Blue: A New Perspective"; Arnold, *Sak Lu'um in Maya Culture*.

76. Kleber, Masschelein-Kleiner, and Thissen, "Etude et identification"; Cabrera Garrido, *Azul Maya*.

77. Cabrera Garrido, *Azul Maya*.

78. Littmann, "Maya Blue: A New Perspective," 93.

79. Kleber, Masschelein-Kleiner, and Thissen, "Etude et identification"; Cabrera Garrido, *Azul Maya*.

80. Van Olphen, "Maya Blue."

81. Gettens, "Maya Blue," 559.

82. Arnold, "Design Structure and Community Organization."

83. Rice, *Pottery Analysis*, 1st ed., 337.

84. Littmann, "Maya Blue—Further Perspectives"; Torres, "Maya Blue"; Reyes-Valerio, *De Bonampak*; Doménech Carbó, Doménech-Carbó, and Vázquez de Ágredos Pascual, "Electrochemical Monitoring of Indigo Preparation"; Arnold et al., "Evidence for the Production of Maya Blue."

85. Krekeler et al., "Palygorskite-to-Smectite Transformation."

86. Fois, Gamba, and Tilocca, "Unusual Stability of Maya Blue"; Hubbard et al., "Structural Study of Maya Blue"; José Yacamán et al., "Maya Blue Paint"; Ortega et al., "Analysis of Prehispanic Pigments."

87. Sánchez del Río et al., "The Maya Blue Pigment"; Sánchez del Río et al., "Maya Blue in Relation to History and Archeology"; Doménech et al., "Interpretation of the Raman Spectra of Maya Blue"; Giustetto et al., "Chemical Stability of a Sepiolite/Indigo Maya Pigment."

88. Chiari et al., "Crystal Structure Refinements of Palygorskite and Maya Blue"; Fernández et al., "Studies of Palygorskite Clays."

89. Chiari et al., "Pre-Columbian Nanotechnology"; Doménech et al., "Interpretation of the Raman Spectra of Maya Blue"; Fois, Gamba, and Tilocca, "Unusual Stability of Maya Blue"; Giustetto et al., "Chemical Stability of a Sepiolite/Indigo Maya Pigment."

90. Chiari et al., "Pre-Columbian Nanotechnology"; Doménech et al., "Interpretation of the Raman Spectra of Maya Blue"; Fois, Gamba, and Tilocca, "Unusual Stability of Maya Blue"; Giustetto et al., "Chemical Stability of a Sepiolite/Indigo Maya Pigment"; Hubbard et al., "Structural Study of Maya Blue"; Sánchez del Río et al., "Acid Resistance of Maya Blue."

CHAPTER 3: WHY IS MAYA BLUE UNIQUE?

1. Arnold et al., "Evidence for Production of Maya Blue"; Mullen, "Solving Maya Blue's Mystery."

2. Cabrera Garrido, *Azul Maya*; Chianelli et al., "Catalysts and Azul Maya Pigments," 133; Fois, Gamba, and Tilocca, "Unusual Stability of Maya Blue"; Gettens, "Identification of Pigments on Mural Paintings"; Gettens, "Maya Blue," 563; Giustetto et al., "Maya Blue"; Hubbard et al., "Structural Study of Maya Blue"; José-Yacamán et al., "Maya Blue Paint,"; José-Yacamán and Serra Puche, "Electron Microscopy of Maya Blue"; Kleber, Masschelein-Kleiner, and Thissen, "Etude et identification"; Ortega et al., "Analysis of Prehispanic Pigments," 755–756.

3. Gettens, "Identification of Pigments on Mural Paintings"; Sánchez del Río et al., "Synthesis and Acid Resistance of Maya Blue"; Riddle, Hopkins, and Butler, "Micro-Raman Spectra of Maya Blue"; Shepard and Gottlieb, *Maya Blue*, 14.

4. Leona et al., "Identification of Maya Blue," 50.

5. Zhang, Zhang, and Wang, "Preparation of Palygorskite/Methyl Violet."

6. Chiari et al., "Pre-Columbian Nanotechnology."

7. See Arnold, "*Sak Lu'um in Maya Culture*"; Arnold, "Ethnomineralogy of Ticul Potters." See the X-ray diffraction spectra of some samples of palygorskite with smectite in the supplemental data in Arnold et al., "First Direct Evidence of Pre-Columbian Sources of Palygorskite."

8. Krekeler and Kearns, "New Locality of Palygorskite-Rich Clay"; Krekeler et al., "Palygorskite-to-Smectite Transformation."

9. José-Yacamán and Serra Puche, "Electron Microscopy of Maya Blue," 11.

10. See the characteristics, composition, and uses of different types of marl for construction purposes in Arnold, *Maya Potters' Indigenous Knowledge*, 90–94.

11. Shepard, "Maya Blue"; Shepard and Gottlieb, *Maya Blue*.

12. Shepard, *Ceramics for the Archaeologist*, 191; Rice, *Pottery Analysis*, 1st ed., 149–151.

13. Ball, Taschek, and Baraciel Almada, "Cabrito Cream-Polychrome Tradition."

14. Arnold, "Changes in Ceramics as Commodities."

15. For a review of pigments used in ancient Greece, see Brecoulaki, "Precious Colours."

16. José-Yacamán et al., "Maya Blue Paint"; Cabrera Garrido, *Azul Maya*; Chianelli et al., "Catalysts and Azul Maya Pigments," 133; Fois, Gamba, and Tilocca, "Unusual Stability of Maya Blue"; Gettens, "Identification of Pigments on Mural Paintings"; Gettens, "Maya Blue," 563; Giustetto et al., "Maya Blue"; Hubbard et al., "Structural Study of Maya Blue"; Kleber, Masschelein-Kleiner, and Thissen, "Etude et identification," 44–46; Ortega et al., "Analysis of Prehispanic Pigments," 755–756.

17. Kupferschmidt, "In Search of Blue." YInMn Blue is named from the concatenation of the symbols of the elements whose oxides were used to create the pigment.

18. Kupferschmidt, "In Search of Blue," provides a timeline for the discovery of each blue pigment that goes back to 6700 BCE.

19. "The Mineral Chrysocolla"; Fletcher, "Stuccoed Vessels from Teotihuacán," 144.

20. King, "Malachite."

21. Fletcher, "Stuccoed Vessels from Teotihuacán," 144; López Puértlas, Manzanilla Naim, and Vázquez de Ágredos Pascual, "Color Production in Xalla, Teotihuacán."

22. King, "Azurite"; Doménech, Doménech-Carbó, and Edwards, "Quantitation from Tafel Analysis"; Fletcher, "Stuccoed Vessels from Teotihuacán," 144.

23. King, "Lapis Lazuli"; Frison and Brun, "Lapis Lazuli, Lazurite, Ultramarine 'Blue.'"

24. Frison and Brun, "Lapis Lazuli, Lazurite, Ultramarine 'Blue,'" 42–43.

25. King, "Turquoise"; "Turquoise Mineral Data."

26. See, for example, the mosaics with turquoise in Olivier and López Luján, "Imágenes de Moctezuma II," 78–91.

27. King, "Turquoise"; "Turquoise Mineral Data."

28. King, "What Is Jade?"

29. Coggins, "Cenote of Sacrifice: Catalogue." See the index on p. 174 for a list of the items of jadeite in the catalogue that came from the cenote.

30. Ball and Ladd, "Ceramics," 204, 207, 208, 109; see also Coggins and Ladd, "Copal and Rubber Offerings," 347. Small bits and pieces of jade as well as few loose beads also came from the cenote (see Moholy-Nagy and Ladd, "Stone, Shell, and Bone," 112).

31. Robinson, Reibenspies, and Rowe, "Blue Rock Art Paint," 214.

32. Robinson, Reibenspies, and Rowe, "Blue Rock Art Paint," 214.

33. Beads made of green obsidian from central Mexico were also recovered from the sacred cenote at Chichén Itzá (Moholy-Nagy and Ladd, "Stone, Shell, and Bone," 112).

34. Berke, "Blue and Purple Pigments."

35. Doménech Carbó et al., "Egyptian Blue in Wall Paintings"; Pradell et al., "Production of Egyptian Blue"; Matson, "Egyptian Blue"; Chiari and Scott, "Pigment Analysis"; Ingo et al., "Egyptian Blue Cakes."

36. Pradell et al., "Production of Egyptian Blue"; Chiari and Scott, "Pigment Analysis," 230–231; Vandiver and Kingery, "Egyptian Faience," 20; Doménech Carbó et al., "Egyptian Blue in Wall Paintings."

37. Vandiver and Kingery, "Egyptian Faience," 22.

38. Matson, "Egyptian Blue"; Dadashzadeh, Gorji, and Vahidzadeh, "'Egyptian Blue' or 'Lapis Lazuli Paste'?"; Pozza et al., "Egyptian Blue, Han Blue, and Han Purple," 3; Doménech Carbó et al., "Egyptian Blue in Wall Paintings"; Ingo et al., "Egyptian Blue Cakes."

39. Brecoulaki, "Precious Colours," 22.

40. Pozza et al., "Egyptian Blue, Han Blue, and Han Purple."

41. Moser, "Seri Blue"; Peirce, "Seri Blue."

42. Peirce, "Seri Blue."

43. Chiari and Scott, "Pigment Analysis," 230.

44. Chiari and Scott, "Pigment Analysis," 230.

45. Rice, *Pottery Analysis*, 2nd ed., 117, 123–124.

CHAPTER 4: PALYGORSKITE AND MAYA INDIGENOUS KNOWLEDGE

1. Metzger and Lathrap, *Ollero Yucateco*.

2. Metzger was a pioneer of "ethnoscience" (Metzger and Williams, "Tenejapa Medicine"; Metzger and Williams, "Formal Ethnographic Analysis"; Metzger and Williams, "Some Procedures and Results"; Black and Metzger, "Ethnographic Description and Law"), but the term is no longer used and considered to be part of cognitive anthropology (Tyler, *Cognitive Anthropology*; D'Andrade, *Development of Cognitive Anthropology*).

3. This Indigenous knowledge was synthesized and published as Arnold, *Maya Potters' Indigenous Knowledge*.

4. Arnold, *Maya Potters' Indigenous Knowledge*, 103–108.

5. These data about the Indigenous knowledge of firing were eventually published in Arnold, *Maya Potters' Indigenous Knowledge*, 154–197.

6. Haden and Schwint, "Attapulgite"; Galán, "Properties of Palygorskite-Sepiolite Clays."

7. Krekeler and Kearns, "New Locality of Palygorskite-Rich Clay," 723.

8. Bailey et al., "Clay Mineral Nomenclature."

9. Grim, *Clay Mineralogy*, 44–45; "Palygorskite Mineral Data."

10. Gettens, "Maya Blue"; Shepard, "Maya Blue"; Shepard and Gottlieb, *Maya Blue*.

11. "Palygorskite"; "Palygorskite Mineral Data."

12. Pelto and Pelto, *Anthropological Research*.

13. See Arnold, *Maya Potters' Indigenous Knowledge*, 79–120, for elaboration.

14. Arnold, *Social Change and Evolution of Ceramic Production*, 220; Arnold, *Maya Potters' Indigenous Knowledge*, 101–107.

15. For the details of temper preparation, see Arnold, *Maya Potters' Indigenous Knowledge*, 94–108.

16. Arnold, "Ethnomineralogy of Ticul Potters"; Arnold, *Maya Potters' Indigenous Knowledge*, 89–108.

17. Shepard, "Maya Blue"; Shepard and Gottlieb, *Maya Blue*.

18. Thompson, *Modern Yucatecan Maya Pottery Making*.

19. Anna O. Shepard to Dean E. Arnold, January 18, 1966. See excerpt in Arnold, "Beyond Cautionary Tales," 322; cf. Arnold, *Maya Potters' Indigenous Knowledge*, 89–108. Copy of original letter available in Dean E. Arnold Papers, 1965–2003, Wheaton College Archives and Special Collections, and in Anna O. Shepard Papers, Library of the University of Colorado.

20. See Arnold, *Maya Potters' Indigenous Knowledge*, 79–129.

21. Shepard did not publish the analyses of these samples until 1971 (Shepard and Pollock, *Maya Blue*).

22. Arnold, "Maya Blue: New Perspective."

23. Arnold, "Native Pottery Making in Peru"; Arnold, "Mineralogical Analyses of Ceramic Materials"; Arnold, "Ceramic Ecology in Ayacucho"; Arnold, "Design Structure and Community Organization"; Arnold, *Ecology of Ceramic Production*; Arnold, *Retracing Inca Steps*.

24. Arnold, *Sak Lu'um in Maya Culture*.

25. Anna O. Shepard to Bruce F. Bohor, March 27, 1967. See excerpt in Arnold, "Cautionary Tales," 329. Copy of original letter available in Dean E. Arnold Papers, 1965–2003, Wheaton College Archives and Special Collections, and in Anna O. Shepard Papers, Library of the University of Colorado. When, in 1965, I learned that attapulgite (palygorskite) was so important in Ticul pottery, I thought that it might be possible to identify it in fired pottery in both the present and the past and thus identify Ticul as its production location. At that time, however, I was looking at high-temperature phases of the palygorskite that could be uniquely identified using X-ray

diffraction in the fired pottery. This approach for discovering a distinct community of potters (or community of practice) was superseded by the seminal paper of Perlman and Asaro ("Pottery Analysis by Neutron Activation") indicating that neutron activation analyses might be used identify ancient clay sources, long before my colleagues and I were able to identify unique trace element signatures of communities of potters in Guatemala and Yucatán (Arnold et al., "Compositional Analysis and 'Sources' of Pottery"; Arnold et al., "Testing Interpretive Assumptions"). I eventually gave up on trying to identify the high-temperature minerals from palygorskite in ancient pottery and in 1970 switched to collecting ethnographic pottery, clay, and temper in Guatemala to test the assumptions of the meaning of trace element variation in ancient pottery (see Arnold et al., "Compositional Analysis and 'Sources' of Pottery"). More recently, Sánchez Fortoul ("Ceramic Composition Diversity"), however, successfully used X-ray diffraction to identify palygorskite in the ancient pottery from Mayapán, the ancient Postclassic capital of Yucatán. This technique plus trace element analysis of the modern pottery from Mama and Ticul should distinguish the pottery from these communities. Then comparing these results with ancient pottery should enable archaeologists to identify these communities of practice in the past (see Arnold et al., "Testing Interpretive Assumptions"; Arnold, *Maya Potters' Indigenous Knowledge*, 207–212).

26. Arnold, *Maya Potters' Indigenous Knowledge*, 91; cf. Shepard and Pollock, *Maya Blue*, 9. Other insoluble components identified later were quartz, zircon, sanidine, and apatite (Arnold et al., "First Direct Evidence of Pre-Columbian Sources of Palygorskite").

27. Arnold, "Ethnomineralogy of Ticul Potters"; Arnold, "Maya Blue and Palygorskite"; Arnold, *Social Change and Evolution of Ceramic Production*, 204–205; Arnold, *Maya Potters' Indigenous Knowledge*, 21, 90, 104, 125, 127.

28. Sillar and Tite, "Technological Choices."

29. Anna O. Shepard to Bruce F. Bohor, March 27, 1967. See excerpt in Arnold, "Beyond Cautionary Tales," 322.

30. See Arnold, "Ethnomineralogy of Ticul Potters"; Arnold, *Maya Potters' Indigenous Knowledge*, 199–214; Thompson, *Modern Yucatecan Maya Pottery Making*, 65–73; Shepard and Pollock, *Maya Blue*. Although I visited some of the same communities as Thompson (*Yucatecan Pottery Making*), I did not visit all of them. I also discovered potters in two communities (Akil and Peto) that Thompson did not mention in his study. Bohor and I did not publish the mineralogical analyses of samples of pottery-making materials from other communities besides Ticul, but this statement reflects a summary of those analyses except for the clay minerals in them. Many of these samples are now in the collection of the Field Museum.

31. These unique categories of pottery raw materials in different communities are also echoed in the distinct types of stone recognized and used within the different sections of the archaeological site of Sayil, 25 kilometers east-southeast of Ticul. See Carmean, McAnany, and Sabloff, "People Who Lived in Stone Houses."

32. Michelaki, Braun, and Hancock, "Local Clay Sources"; Michelaki, Hancock, and Braun, "Using Provenance Data"; see Ingold, *Making*, 195.

33. Arnold, *Sak lu'um in Maya Culture*, 35.

34. Eating dirt (or earth), called geophagy, occurs in many cultures in the world and has varied benefits and risks, particularly among children and pregnant women (Callahan, "Eating Dirt"). Browman and Gundersen ("Altiplano Comestible Earths") describe the practice in Peru and Bolivia. In West Africa more than 500 tons of a kaolinitic clay are shipped annually from the Nigerian village of Uzalla as a treatment for diarrhea—a practice parallel to the commercial use of the over-the-counter remedy Kaopectate for the same purpose (Vermeer and Ferrell, "Nigerian Geophagical Clay"). The intensity of mining this amount of clay suggests that most of the mining of palygorskite in the cenote of Sacalum may be a consequence of its use for geophagy and medicinal uses, not just for making Maya Blue (see next chapter).

35. In the 1960s, 1970s, and 1980s henequen was still a product of the haciendas of Yucatán, and many individuals in Ticul used the fibers to make hammocks and decorative objects such as coasters, place mats, and harnesses for hanging planters. The first step for creating these objects was to roll the fibers together into multiple strands. This rolling was sometimes done on the thigh using ground "white earth" (*sak lu'um*) as a lubricant.

36. Arnold, *Sak lu'um in Maya Culture*, 35–38.

37. In antidiarrheal medicines palygorskite is listed as attapulgite.

38. Another study using an antidiarrheal medicine showed that Imodium was more effective than palygorskite (Diasorb) in controlling diarrhea during the first twelve hours following the beginning of therapy by reducing stool frequency and significantly shortening the mean time from onset to the last unformed stool (Reza bin Zaid, Hasan, and Azad Khan, "Attapulgite in the Treatment of Acute Diarrhoea"). Subjective evaluations of the severity of symptoms and the overall relief following treatment of both Imodium and palygorskite, however, were the same, and both medications were well tolerated by patients (DuPont et al., "Comparison of Loperamide and Attapulgite in Treatment of Diarrhea").

39. Grim, *Clay Mineralogy*, 44–45.

40. Haden and Schwint, "Attapulgite," 61.

41. Drucker et al. ("Attapulgite and Enterotoxicity") verify that attapulgite and charcoal adsorb toxins in the intestines of rabbits.

42. DuPont et al., "Comparison of Loperamide and Attapulgite in Treatment of Diarrhea." Attapulgite was formerly (2004) listed in the US National Library of Medicine, Medline Plus, but no longer (https://medlineplus.gov/, accessed April 10, 2024). On the other hand, see "Attapulgite," Drugs.com, Drugsite Trust, accessed April 10, 2024, https://www.drugs.com/search.php?searchterm=attapulgite&a=1.

43. White, "Atterberg Plastic Limits," 510; Pablo-Galán, "Las Arcillas"; see also Arnold, *Maya Potters' Indigenous Knowledge*, 101–107.

44. White, "Atterberg Plastic Limits," 508–509. The plastic limit for attapulgite is higher than that of other clay minerals.

45. Arnold, *Maya Potters' Indigenous Knowledge*, 106–108.

46. Arnold, *Maya Potters' Indigenous Knowledge*, 90–108; Arnold, *Social Change and Evolution of Ceramic Production*, 193–228.

47. Arnold, *Social Change and Evolution of Ceramic Production*, 193–220, 214–215; Arnold, *Maya Potters' Indigenous Knowledge*, 126.

48. Paris, Meanwell, and Peraza Lope, "Azul Maya de Mayapán," 1083–1093.

49. Peter Day (personal communication, May 26, 2018) visited Ticul in conjunction with the 42nd International Symposium on Archaeometry in Mérida, Mexico, May 20–26, 2018.

CHAPTER 5: SOURCES OF PALYGORSKITE: MAYA CULTURAL HERITAGE

1. Ingold, *Perception of the Environment*.

2. Arnold, *Maya Potters' Indigenous Knowledge*, 115–117, 207–211.

3. Arnold, "Maya Blue: A New Perspective"; Arnold, *Sak lu'um in Maya Culture*; Arnold, "Ethnomineralogy of Ticul Potters"; Arnold, *Social Change and Evolution of Ceramic Production*, 191–220; Arnold and Bohor, "Ancient Mine Comes to Light"; Arnold and Bohor, "Ancient Attapulgite Mine in Yucatán."

4. Folan, "Analysis of a Source of *Sascab*"; Folan, "Mining and Quarrying Techniques"; Arnold, *Maya Potters' Indigenous Knowledge*, 73–75, 90–94.

5. Arnold, *Maya Potters' Indigenous Knowledge*, 88–91, 94–108.

6. Barrera Vázquez, "Cerámica Maya," 164; Rendón, "Alfarería Indígena de Yucatán"; Thompson, *Modern Yucatecan Maya Pottery Making*, 69; Arnold, *Sak lu'um in Maya Culture*; Arnold, "Ethnomineralogy of Ticul Potters"; Arnold, *Social Change and Evolution of Ceramic Production*, 191–220; Arnold et al., "First Direct Evidence of Pre-Columbian Sources of Palygorskite"; Arnold, "Maya Blue and Palygorskite"; Arnold, *Evolution of Ceramic Production Organization*; Arnold, *Maya Potters' Indigenous Knowledge*, 95–113.

7. The depths mentioned here and earlier in this chapter are broadly consonant with the depths of the mines elsewhere at Yo' Sah Kab and those at the mining area

nearer Chapab. During the reconnaissance of Yo' Sah Kab by Bohor and me in 1968, informants showed us three square test pits approximately 2 m × 2 m sunk down into the marl and solid palygorskite layers (Bohor, "Attapulgite in Yucatán"). Made by the Maya Cement Company (which owned the land) in the early 1960s, these pits presumably were dug to assess the potential of the subsurface materials for making cement. Pits 1 (Pozo 1) and 3 (Pozo 3) clarified the subsurface stratigraphy at Yo' Sah Kab, but this stratigraphy was variable, as was evident by comparing the profiles of Pit 1 with that of Pit 3 (Bohor, "Attapulgite in Yucatán," 114, 117). The cement company also cut a 100 m long swath into the surface nearby with a bulldozer to uncover the subsurface material below to assess the future potential of the area for raw material for making cement. Thereafter, that cut was used by the potters to mine temper along its edges, but to my knowledge the company never used the property to obtain any raw materials. It is unclear why the cement company officials thought that the materials from their property could be used in making cement, but they might have thought that some of the material was gypsum.

8. These values were the depths of the deposit in Elio Uc's mine in 2008, but the depths vary throughout the temper mining area, as they did in the profiles drawn of the three cement company pits that Bohor drew in 1968. Potters and miners, however, do not measure depths; they look for the presence of *sak lu'um* in the subsurface materials.

9. Arnold, *Social Change and Evolution of Ceramic Production*, 204–206; Arnold, *Maya Potters' Indigenous Knowledge*, 100–102.

10. Arnold, *Social Change and Evolution of Ceramic Production*, 193–197.

11. Arnold, "Maya Blue and Palygorskite."

12. *Posole* is a drink made from a mixture of water and the dough (*masa*) used to make tortillas. The Maya create the dough by grinding maize (corn) that has been soaked in water mixed with slaked lime.

13. Smith, *Pottery of Mayapán*, 1:28, 148–153; Arnold, "Maya Blue and Palygorskite"; Brainerd, *Archaeological Ceramics of Yucatán*, 174–175, 196–199.

14. Arnold, *Maya Potters' Indigenous Knowledge*, 108–113.

15. Puuc Unslipped Ware of the Ceh Pech complex. See Arnold, "Maya Blue and Palygorskite," for details; for the definitions of this ware and complex, see Smith, *Pottery of Mayapán*, 1:144–169.

16. Andrews, *Throne of the Tiger Priest*, 15, 61.

17. Arnold, "Maya Blue and Palygorskite."

18. It is interesting to note that one of the types of Puuc Unslipped Ware in the Terminal Classic period was tempered with potsherds, and this household may have been one of the suppliers of this type of that pottery identified by archaeologists (Smith, *Pottery of Mayapán*, 1:144–148, 2:4–7).

19. My informants said that there were formerly two such *pilas* in the site, but we could only locate one of them.

20. Stephens said: "In all directions, too, were seen the oblong stone hollowed out like troughs which at Uxmal were called *pilas*, or fountains, but here the Indians called them *hólcas* or *piedras de molir*, stones for grinding which they said were used by the ancients to mash corn upon; and the proprietor showed us a round stone like a bread roller, which they called *kabtum*, *brazo de piedra*, or arm of stone, used as they said, for mashing the corn." Stephens, *Incidents of Travel in Yucatán*, 168.

21. Arnold, *Social Change and Evolution of Ceramic Production*, 193–198.

22. See Arnold, "Does Standardization Really Mean Specialization?," 349–351; Arnold, *Social Change and Evolution of Ceramic Production*, 15–16; Arnold, *Maya Potters' Indigenous Knowledge*, 80–88.

23. Arnold and Bohor, "Ancient Clay Mine"; Arnold, *Maya Potters' Indigenous Knowledge*, 80–85, 86, fig. 4.3, 87, fig. 4.4.

24. These data are summarized in Arnold, *Maya Potters' Indigenous Knowledge*, 73, 112–113.

25. The importance of Yo' Sah Kab as part of potters' cultural heritage is also illustrated by their corporate attempt to block use of its resources in improving the road between Ticul and Chapab in 1967 (see Arnold, *Maya Potters' Indigenous Knowledge*, 113–115).

26. Pablo-Galán, "Palygorskite," 97.

27. The surface entrance of the sinkhole is approximately 30 m (EW) by 40 m (NS) as measured on Google Earth, and its center is located at N 20°27'49.76", W 89°20'44.19".

28. Based on the measurements of clay mineralogist B. F. Bohor, the palygorskite layer has a dip of 3 degrees and a strike of true north using the bottom of the dolomite layer on the roof of the mine as a reference.

29. This initial observation of the location of the mine was somewhat erroneous. Rather, the mine and its entrance are located on the north side of the cenote interior, as was verified by the 1968 and 2008 visits by Bohor and me.

30. Another of the informants said that the *sak lu'um* continued for 3 km and that there was another mine tunnel off to the right (east) inside the entrance, but that it did not contain *sak lu'um*. We were unable to verify these statements.

31. Arnold and Bohor, "Ancient Mine Comes to Light"; Arnold and Bohor, "Ancient Attapulgite Mine in Yucatán."

32. In the early 1970s Isphording and Wilson ("Relationship of 'Volcanic Ash,'" 485) claimed that *sak lu'um* from the mine in the Sacalum cenote "continues to be mined as a source of pottery clay," but there is no evidence that *sak lu'um* was ever used for pottery clay in either Sacalum or Ticul over the more than forty years of my experience working in Ticul. *Sak lu'um* was used for pottery temper in Ticul, but the *sak lu'um* from the Sacalum cenote was used for medicinal purposes.

33. Arnold and Bohor, "Ancient Mine Comes to Light"; Arnold and Bohor, "Ancient Attapulgite Mine in Yucatán."

34. Arnold, *Social Change and Evolution of Ceramic Production*, 15–16, 155–178.

35. Data on the deaths and injuries of miners can be found in Arnold, *Social Change and Evolution of Ceramic Production*, 178; Arnold, *Maya Potters' Indigenous Knowledge*, 11, 157.

36. Folan, "Pre-Hispanic Source of Attapulgite."

37. Folan, "Pre-Hispanic Source of Attapulgite."

38. Folan, "Pre-Hispanic Source of Attapulgite"; Arnold et al., "First Direct Evidence of Pre-Columbian Sources of Palygorskite."

39. Gates, "Yucatan in 1549 and 1579," 154.

40. Gates, "Xiu Family Papers," 133.

41. Roys, *Book of Chilam Balam of Chumayel*, 70–73; Folan, "Pre-Hispanic Source of Attapulgite," 183.

42. Folan, "Pre-Hispanic Source of Attapulgite," 183; Arnold, "Maya Blue: A New Perspective"; Arnold, *Sak lu'um in Maya Culture*. A study in rural Guinea in Africa found that eating dirt (geophagia) was an important risk factor for orally acquired nematodes and any soil-transmitted parasite infections such as hookworm (see Glickman et al., "Nematode Intestinal Parasites"). Substituting palygorskite from subterranean sources for surface soil would be one way to prevent, if not subvert, infection from surface soils.

43. Roys, *Book of Chilam Balam of Chumayel*.

44. Edmonson, *Heaven Born Merida*, 269.

45. Edmonson, *Heaven Born Merida*, 90.

46. The Maya text represents Dzan as *tz'aan*, and Edmonson writes it as *Tz'am* (Edmonson, *Heaven Born Merida*, 90). In the modern Yucatec Maya spoken in Ticul, final nasals sometimes exhibit free variation. Maya speakers, for example, sometimes pronounce my name, "Din," as "Dim." Yucatec Maya may have exhibited this same characteristic in the sixteenth century. Dzan is 5 km southeast of Yo' Sah Kab.

47. The archaeological site of San Francisco de Ticul lies in a straight line midway between the Terminal Classic clay source at Hacienda Yo' K'at (northwest of Ticul) and the Terminal Classic temper site at Yo' Sah Kab northeast of Ticul (see Arnold, *Maya Potters' Indigenous Knowledge*, 207–211).

48. Dunning, "Puuc Settlement Patterns," 20. In his travels around Yucatán in 1841 and 1842, John L. Stephens (*Incidents of Travel in Yucatán*, 158) described some of the ruins at the Hacienda San Francisco to the north of the city and his brief excavation there. He said that the local priest had told him that from the top of the highest mound on the site "in the dry season, when the trees were bare of foliage" the priest "had counted thirty-six mounds, every one of which had once held aloft a building or temple and not one now remained entire" (Stephens, *Incidents of Travel in Yucatán*, 161).

49. Stephens (*Incidents of Travel in Yucatán*, 158) believed that the convent and church in Ticul were built with stones from the San Francisco de Ticul site.

50. See Arnold, "Maya Blue and Palygorskite."

51. Maya archaeologist George Brainerd did some survey and excavation in the town of Dzan and indicated that the pottery found there came from the Terminal Classic period—what he called the "Florescent" stage (Brainerd, *Archaeological Ceramics of Yucatán*, 23–24, figs. 15, 37, 58–59, 61). Brainerd also put a trench into a *chultun* (a subterranean cistern or storage chamber) in a small site called Chanpuuc, located 3 km south of the Ticul church. Like the date of so much of the pottery mentioned here, the ceramics from this excavation were mainly from the same period (Brainerd, *Archaeological Ceramics of Yucatán*, 23, 138–139).

52. Folan, "Pre-Hispanic Source of Attapulgite," 183.

53. Arnold, "Maya Blue: A New Perspective"; Arnold, *Sak lu'um in Maya Culture*, 37–38; Shepard, "Maya Blue"; Shepard and Gottlieb, *Maya Blue*; Arnold, *Ceramic Theory and Cultural Process*, 50.

54. Arnold et al., "First Direct Evidence of Pre-Columbian Sources of Palygorskite."

55. Isphording and Wilson, "Relationship of 'Volcanic Ash,'" 495; Isphording, "Clays of Yucatán," 68; Cisneros de Leon et al., "Zircon in *Sak Lu'um*"; Littmann, "Maya Blue: A New Perspective," 92; Polette-Niewold et al., "Organic/Inorganic Complex Pigments," 1961; José-Yacamán et al., "Maya Blue Paint," 225; Folan, "Pre-Hispanic Source of Attapulgite."

56. Sánchez del Río, Suárez, and García-Romero, "Occurrence of Palygorskite," 215; Reyes-Valerio, *De Bonampak*, 123, 126, 127.

57. Arnold, *Maya Potters' Indigenous Knowledge*, xix, xx, xxvii.

CHAPTER 6: OTHER SOURCES OF PALYGORSKITE

1. For a narrative and summary of this ethnoarchaeological research, see Arnold, *Retracing Inca Steps*.

2. Arnold, "Ethnomineralogy of Ticul Potters"; Arnold, *Maya Potters' Indigenous Knowledge*, 73–76, 89–94.

3. Thompson, *Modern Yucatecan Maya Pottery Making*, 66.

4. Shepard and Pollock, *Maya Blue*, 8–9.

5. Thompson reported that potters said that the Mama sinkhole was 2 km from the village along the trail to Chumayel (Thompson, *Modern Yucatecan Maya Pottery Making*, 66). Bohor and I walked there in 1968, but we did not calculate the distance. By the time of my visit in 1994, however, there was a road to Chumayel, and the odometer distance was 2.75 km from the southeast corner of the Mama church to the point where a path from the road leads down into the cenote. That path was approximately 30 m

from the highway intersection of the road from Tekit to Chumayel. The outline of the sinkhole could be seen on images of Google Earth, usually near the end of the annual dry season: May 9, 2002; April 23, 2010 (most distinct); March 21, 2014; and March 25, 2015. From these images, the center of the sinkhole was located at N 20°27'49.93", W 89°20'44.35", and 210 m SSE of the highway intersection.

6. Arnold, *Evolution of Ceramic Production Organization*, 232–237.

7. Bohor, "Attapulgite in Yucatán." This cut is located approximately N 20°34'35.71", W 89°59'27.20", along the railroad line southeast of Maxcanú, according to Google Earth.

8. Sánchez del Río, Suárez, and García-Romero, "Occurrence of Palygorskite."

9. Arnold et al., "First Direct Evidence of Pre-Columbian Sources of Palygorskite," 2255, fig. 2.

10. Arnold et al., "Sourcing Palygorskite, 48."

11. Arnold, "Ethnography of Pottery Making in the Valley of Guatemala"; Arnold, "Ceramic Variability, Environment and Culture History."

12. Arnold, "Ethnography of Pottery Making in the Valley of Guatemala," 367–386.

13. Arnold et al., "Sourcing Palygorskite."

14. Isphording, "Clays of Yucatán," 67–68; Isphording and Wilson, "Relationship of 'Volcanic Ash,'" 484–485, in a letter cited in Littmann, "Maya Blue—Further Perspectives," 404. The stratigraphy of palygorskite and palygorskite-containing marl at Yo' Sah Kab and Chapab are much more complicated than Isphording describes (see chaps. 4 and 5). It would be difficult to follow the extent of a single deposit of palygorskite at these locations because the solid layer of palygorskite only occurs below the marl and is seldom exposed except in the marl mines and the pits excavated by the Maya Cement Company and described in the profiles by Bohor ("Attapulgite in Yucatan"). To determine the extent and shape of any palygorskite deposit would require massive excavation and removal of at least 2–3 m of overburden. The stratigraphy in the cement company pits, however, is variable, and not all conform precisely to the stratigraphy described here.

15. For a description and history of Yo' Sah Kab and the mining nearer Chapab, see Arnold, *Social Change and Evolution of Ceramic Production*, 93–198.

16. Pablo-Galán describes this deposit as an outcrop 12 m high and 10 m wide. It fits well with the palygorskite deposit exposed in the railroad cut through the west end of the Sierra de Ticul and detailed by Bohor ("Attapulgite in Yucatán"). Pablo-Galán, however, refers to this location as "south of the Sierra and 3 km north of Maxcanú" (Pablo-Galán, "Palygorskite," 97). Maxcanú, however, lies at the west end of the Sierra de Ticul, and a deposit that is 3 km north of Maxcanú would not be south of the Sierra.

17. Isphording, personal communication, quoted in Littmann, "Maya Blue—Further Perspectives," 404.

18. Krekeler and Kearns, "New Locality of Palygorskite-Rich Clay," 715. This deposit was located at 18°49' 18.54" N, 88°37' 51.66" W, but the location with these coordinates is not between the villages of El Paraíso and San Román in Quintana Roo as Krekeler and Kearns indicate. Sánchez del Río, Suárez, and García-Romero, "Occurrence of Palygorskite."

19. Bohor, "Attapulgite in Yucatán."

20. Palygorskite confers several advantages for forming the pottery and reduces shrinkage (see Arnold, *Social Change and Evolution of Ceramic Production*, 103–108).

21. Arnold, "Does Standardization Really Mean Specialization?"

22. Arnold, *Maya Potters' Indigenous Knowledge*, 79–121.

23. Folan, "Pre-Hispanic Source of Attapulgite," 183.

24. Cisneros de León et al., "Zircon in *Sak Lu'um.*"

25. Arnold, *Social Change and Evolution of Ceramic Production*, 193–220.

26. The mines occur in several places, and their locations vary greatly. They are anywhere from 2 km to 4 km beyond Yo' Sah Kab. Like the mines at Yo' Sah Kab, their locations change through time.

27. Arnold, *Social Change and Evolution of Ceramic Production*, 191–198; Arnold, *Maya Potters' Indigenous Knowledge*, 193–204.

28. Arnold et al., "First Direct Evidence of Pre-Columbian Sources of Palygorskite," 2255, fig. 2.

29. Bohor, "Attapulgite in Yucatán."

30. Sánchez del Río, Suárez, and García-Romero, "Occurrence of Palygorskite."

31. N 20°23.336', W 89°46.172'. Sánchez del Río, Suárez, and García-Romero, "Occurrence of Palygorskite."

32. N 20°31.510', W 90°03.015'. Sánchez del Río, Suárez, and García-Romero, "Occurrence of Palygorskite."

CHAPTER 7: MAYA BLUE AND INDIGO

1. Shepard, "Maya Blue"; Gettens, "Maya Blue," 560; Van Olphen, "Maya Blue."

2. Van Olphen, "Maya Blue."

3. Haden and Schwint, "Attapulgite," 60; Pablo-Galán, "Palygorskite," 447; Manciu et al., "Raman and Infrared Studies of Maya Pigments."

4. Hubbard et al., "Structural Study of Maya Blue"; Sánchez del Río et al., "Synthesis and Acid Resistance of Maya Blue"; Van Olphen, "Maya Blue."

5. Torres, "Maya Blue"; Van Olphen, "Maya Blue."

6. Arnold, "Evidence for Pre-Columbian Indigo," 66–68, 71–72.

7. Towle, *Ethnobotany of Pre-Columbian Peru*.

8. Arnold, "Evidence for Pre-Columbian Indigo," 59.

9. Arnold, "Evidence for Pre-Columbian Indigo."

10. Splitstoser et al., "Early Pre-Hispanic Use of Indigo."

11. Arnold, "Evidence for Pre-Columbian Indigo," 67.

12. Reyes-Valerio, *De Bonampak*, 59–66.

13. Contreras Sánchez, *Colorantes en La Nueva España*, 42–44.

14. Arnold, "Evidence for Pre-Columbian Indigo," 58.

15. Arnold, "Evidence for Pre-Columbian Indigo," 58–62.

16. Missouri Botanical Garden, "Indigofera."

17. Missouri Botanical Garden, "Indigofera."

18. "Indigofera."

19. Osborne, "Indumentaria Indígena de Guatemala."

20. Contreras Sánchez, *Colorantes en La Nueva España*, 41.

21. Among other ways to slow fading, several internet sites recommend that they not be hung in the sun to dry after washing (Hunt, "7 Simple Secrets").

22. Reyes-Valerio, *De Bonampak*, 45–47, 51–67, esp. 58–59.

23. Arnold, "Evidence for Pre-Columbian Indigo," 68–69; Reyes-Valerio, *De Bonampak*, 45–49, 58–59.

24. Arnold, "Evidence for Pre-Columbian Indigo," 68–69, 73–77.

25. Redfield and Redfield, *Disease and Treatment in Dzitás*, 71.

26. Summarized in Arnold, "Evidence for Pre-Columbian Indigo," 70; Roys, *Ethnobotany of the Maya*, 80; Redfield and Redfield, *Disease and Treatment in Dzitás*, 71; Arnold, "Evidence for Pre-Columbian Indigo," 68–69; Reyes-Valerio, *De Bonampak*, 45–49, 58–59.

27. Leite et al., "Antimicrobial Activity of *Indigofera suffruticosa*." This article also corroborates research on the aqueous extracts of two other species of *Indigofera* (*I. oblongifoliai* and *I. dendroides*) that show similar antimicrobial activity.

28. Campos et al., "*Indigofera suffruticosa*."

29. Campos et al., "*Indigofera suffruticosa*."

30. Contreras Sánchez, *Colorantes en La Nueva España*, 47. Yucatecan artist Luis May Ku (personal communication, September 18, 2021), who experimentally created Maya Blue on a large scale, also confirmed this season was the best for cutting the plants of *Indigofera suffruticosa* for his replication of Maya Blue.

31. Torres, "Maya Blue"; Reyes-Valerio, *De Bonampak*, 53–55, 127–153.

32. Torres, "Maya Blue"; Reyes-Valerio, *De Bonampak*, 52–58.

33. This option is also replicated experimentally by using honey, corn syrup, or another reducing agent.

34. Doménech Carbó, Doménech-Carbó, and Vázquez de Ágredos Pascual, "Electrochemical Monitoring of Indigo Preparation"; Doménech Carbó, Doménech-Carbó, and Vázquez de Ágredos Pascual, "Correlation between Properties of Maya Blue."

CHAPTER 8: IDENTIFYING ANCIENT SOURCES OF PALYGORSKITE USED IN MAYA BLUE

1. Arnold, Neff, and Bishop, "Compositional Analysis and 'Sources' of Pottery"; Arnold, Neff, and Glascock, "Testing Assumptions."

2. Arnold, Neff, and Bishop, "Compositional Analysis and 'Sources' of Pottery"; Arnold et al., "Testing Interpretative Assumptions"; Arnold, Neff, and Glascock, "Testing Assumptions"; Neff, Bishop, and Arnold, "Reconstructing Ceramic Production"; Speakman and Neff, "Application of Laser Ablation ICP-MS"; Stoner, "Analytical Nexus of Ceramic Paste."

3. Perlman and Asaro, "Pottery Analysis by Neutron Activation."

4. Cogswell, Neff, and Glascock, "Effect of Firing Temperature"; Arnold, Neff, and Glascock, "Testing Assumptions"; Arnold, "Does Standardization Really Mean Specialization?"; Arnold, *Maya Potters' Indigenous Knowledge*, 116; Arnold, "Mineralogical Analyses of Ceramic Materials."

5. Arnold, "Mineralogical Analyses of Ceramic Materials."

6. Perlman and Asaro, "Pottery Analysis by Neutron Activation."

7. Arnold, "Ethnography of Pottery Making in the Valley of Guatemala"; Arnold, "Ceramic Variability, Environment and Culture History"; Arnold et al., "Neutron Activation Analysis of Pottery and Pottery Materials."

8. Arnold, Neff, and Bishop, "Compositional Analysis and 'Sources' of Pottery."

9. Arnold, Neff, and Bishop, "Compositional Analysis and 'Sources' of Pottery."

10. Perlman and Asaro, "Pottery Analysis by Neutron Activation."

11. Arnold et al., "Testing Interpretive Assumptions," 69.

12. Arnold et al., "Testing Interpretive Assumptions," 71, 74.

13. Arnold, Neff, and Bishop, "Compositional Analysis and 'Sources' of Pottery."

14. Arnold, Neff, and Glascock, "Testing Assumptions."

15. The relationship between fired pottery and its constituent raw materials is more nuanced and complex than this and is covered more in detail elsewhere (Arnold, "Does Standardization Really Mean Specialization?").

16. Arnold et al., "Testing Interpretive Assumptions," 71, 74–75.

17. Actually, the ultimate result of this grant was the production of three books: Arnold, *Social Change and Evolution of Ceramic Production*; Arnold, *Evolution of Ceramic Production Organization*; Arnold, *Maya Potters' Indigenous Knowledge*.

18. Another study came to the same conclusion for the compositional analysis of prehistoric pottery (Kennett et al., "Compositional Characterization of Prehistoric Ceramics").

19. See Arnold, "Maya Blue and Palygorskite"; Arnold, "Ethnomineralogy of Ticul Potters"; Arnold, *Maya Potters' Indigenous Knowledge*, 79–120.

20. Arnold et al., "Sourcing Palygorskite," 48. In the list of samples analyzed in this publication (table 8.1), there is an error in the location of one of the samples. The last sample (MB28) was marked as being from Maní but was collected in Mama in 1968.

21. The issues of comparison between LA-ICP-MS and INAA are far more complicated than described in this summary, but the results did show that either technique could be used effectively for the trace element analysis of palygorskite and hence Maya Blue (Arnold et al., "Sourcing Palygorskite," 50).

22. Arnold et al., "Sourcing Palygorskite."

23. Arnold, *Sak lu'um in Maya Culture*; Arnold, "Ethnomineralogy of Ticul Potters"; Arnold, *Maya Potters' Indigenous Knowledge*, 191–220.

24. Arnold and Bohor, "An Ancient Mine Comes to Light"; Arnold and Bohor, "Ancient Attapulgite Mine in Yucatán"; Arnold, "Maya Blue and Palygorskite." When asked about the source of their temper, potters referred to the mining area closer to Chapab as simply "Chapab" rather than Yo' Sah Kab because it is separated from Yo' Sah Kab by a *rancho* and citrus orchard with no mining activity and is closer to the village of Chapab than it is to Ticul.

25. Arnold, *Maya Potters' Indigenous Knowledge*, 191–220.

26. For the details of temper preparation at Yo' Sah Kab, see Arnold, *Maya Potters' Indigenous Knowledge*, 94–109.

27. After the research visit of Bohor and me in Yucatán in 1968, Bohor produced a guidebook about some of the palygorskite deposits. It detailed the geological stratigraphy in the three cement company pits at Yo' Sah Kab (Bohor, "Attapulgite in Yucatán").

28. Arnold, *Evolution of Ceramic Production Organization*, 98–103; Arnold, *Maya Potters' Indigenous Knowledge*, 89.

29. Pablo-Galán, "Palygorskite."

30. In at least one case (the deposit at the turnoff to Oxkintok from the Muna-Maxcanu road), palygorskite was a very minor component within a layer of smectite.

31. Arnold et al., "First Direct Evidence of Pre-Columbian Sources of Palygorskite"; Arnold, "Ethnomineralogy of Ticul Potters"; Arnold, *Maya Potters' Indigenous Knowledge*, 116.

32. Arnold et al., "Sourcing Palygorskite"; X-ray fluorescence data confirmed the distinctiveness of this group from both the main Sacalum group and the Chapab and Yo' Sah Kab groups.

33. Cabrera Garrido, *Azul Maya*, 29; Leona et al., "Identification of Maya Blue," 40; Van Olphen, "Maya Blue"; Hubbard et al., "Structural Study of Maya Blue."

34. Grim, *Clay Mineralogy*; Arnold et al., "Sourcing Palygorskite."

35. Arnold et al., "Evidence for Production of Maya Blue."

36. Arnold et al., "First Direct Evidence of Pre-Columbian Sources of Palygorskite."

37. Arnold et al., "First Direct Evidence of Pre-Columbian Sources of Palygorskite."

CHAPTER 9: HOW WAS MAYA BLUE MADE?

1. See Carlson and Eachus, "Kekchi Spirit World." Although the Carlson and Eachus chapter provides data from the Kekchi language and culture that exist to the north of the Kiche language spoken in Chichicastenango, the features outlined there occur broadly across the other Maya languages and cultures of highland Guatemala.

2. Tozzer, *Chichén Itzá and Its Cenote of Sacrifice*, 209. The *Tropicos* database lists *Protium copal* as a member of the Burseraceae family with widespread distribution in Mexico and Central America. Missouri Botanical Garden, "*Protium copal* (Schltdl. & Cham.) Engl."

3. Arnold, *Maya Potters' Indigenous Knowledge*, 206–207.

4. Case et al., "Chemistry and Ethnobotany of Incense Copals."

5. Coggins and Ladd, "Copal and Rubber Offerings," 353.

6. Another ball of copal with Maya Blue came from Tikal and was in the collection of the University of Pennsylvania Museum (Shepard and Gottlieb, *Maya Blue*, 15).

7. Arnold, "Maya Blue and Palygorskite."

8. Arnold et al., "Sourcing Palygorskite."

9. Van Olphen, "Maya Blue"; Cabrera Garrido, *Azul Maya*.

10. Arnold et al., "Evidence for Production of Maya Blue," 155.

11. Arnold et al., "First Direct Evidence of Pre-Columbian Sources of Palygorskite."

12. Arnold et al., "Evidence for Production of Maya Blue."

13. Coggins, "Dredging the Cenote," 9–10.

14. Coggins, "Dredging the Cenote."

15. Coggins, "Dredging the Cenote"; Tozzer, *Chichén Itzá and Its Cenote of Sacrifice*.

16. Coggins and Shane, *Cenote of Sacrifice*; Thompson, *High Priest's Grave*, 7; see also McVicker, "Tale of Two Thompsons."

17. Thompson, *High Priest's Grave*, 7.

18. Nash and Feinman, *Curators*, 259; Donald Scott, Director, Peabody Museum of Archaeology and Ethnology, Harvard University, to Dr. S. C. Simms, Director, Field Museum of Natural History, March 7, 1932, Field Museum of Natural History, Department of Anthropology Archives.

19. Field Museum cat. no. 189262. See chap. 10.

20. Coggins and Ladd, "Copal and Rubber Offerings," 345–346.

21. Coggins and Ladd, "Copal and Rubber Offerings," 353; Tozzer, *Chichén Itzá and Its Cenote of Sacrifice*, 198; Tozzer, *Landa's Relación*, 117–118; Arnold et al., "Evidence for Production of Maya Blue."

22. Coggins, "Dredging the Cenote," 16.

23. Tozzer, *Chichén Itzá and Its Cenote of Sacrifice*, 197.

24. Tozzer, *Chichén Itzá and Its Cenote of Sacrifice*, 209.

25. Tozzer, *Chichén Itzá and Its Cenote of Sacrifice*, 197.

26. Tozzer, *Chichén Itzá and Its Cenote of Sacrifice*, 192.

27. Pérez de Heredia Puente, *Chen K'u*, 30–31.

28. Milbrath and Peraza Lope, "Revisiting Mayapán."

29. This attribution was based upon the ceramic types found that were analyzed by Ball and Ladd, "Ceramics," 192.

30. Pérez de Heredia Puente, *Chen K'u*, 9.

31. Pérez de Heredia Puente, *Chen K'u*, 15, 22; Ball and Ladd, "Ceramics," 192.

32. The only mention of blue in the INAH report was the blue on the ceramics recovered from the excavation of the peninsula on the west side of the cenote when the water was lowered (Pérez de Heredia Puente, *Chen K'u*, 15).

33. Smith, *Pottery of Mayapán*, 2:44, fig. 29aa; Smith, *Pottery of Mayapán*, 1:44.

34. Ball and Ladd, "Ceramics," 192, 202.

35. Smith (*Pottery of Mayapán*, 1:206) called this phase the "Tases Phase."

36. Tozzer, *Landa's Relación*, 54, 109; Tozzer, *Chichén Itzá and Its Cenote of Sacrifice*, 199.

37. Smith, *Pottery of Mayapán*, 1:44; Shepard and Gottlieb, *Maya Blue*, 8.

38. Paris, Meanwell, and Peraza Lope, "Azul Maya de Mayapán."

39. Vázquez de Ágredos Pascual et al., "Characterization of Maya Blue Pigment"; Ebert et al., "Regional Response to Drought."

40. *Hoja Mérida F16-10* (Yucatán, Campeche, Quintana Roo), Carta Topográfica, 1:250,000, Instituto Nacional de Estadística, Geográfica, e Informática, Aguascalientes, Mexico, 1982; Gilli et al., "Archaeological Implications of Strontium Isotope Analysis," 723, fig. 1A. Some of these cenotes are large enough to be seen on Google Earth.

41. Arnold, *Evolution of Ceramic Production Organization*, 250–256.

42. According to Evans et al. ("Quantification of Drought during the Collapse," 498), the Terminal Classic period was the among the driest periods of the Holocene in northern Yucatán, extending back more than "several thousand years." Simms et al., "Evidence from Escalera al Cielo."

43. Even today, men from Ticul who cultivate fields of maize using shifting slash and burn agriculture recognize that the soil in the *ya'ash k'ash* zone south of the *puuc* ridge is higher in quality than the soil north of the *puuc* around Ticul (Arnold, *Social Change and Evolution of Ceramic Production*, 37; Arnold, *Maya Potters' Indigenous Knowledge*, 63).

44. McAnany, "Water Storage in the Puuc Region"; Thompson, *Chultunes of Labná*; Zapata Peraza, *Los Chultunes*. In some places, such as the town of Santa Elena, the underground water table is 65–70 m below the surface (Arnold, *Social Change and Evolution of Ceramic Production*, 100). Digging wells south of the *puuc* ridge was only possible with metal tools and explosives after the Conquest.

45. See Milbrath and Peraza Lope, "Revisiting Mayapán."

46. Kennett et al., "Development and Disintegration of Maya Political Systems," 789.

47. Restall et al., *Friar and the Maya*.

48. Case et al., "Chemistry and Ethnobotany of Incense Copals."

49. Arnold, "Maya Blue and Palygorskite," 55, 60; Arnold et al., "Evidence for the Production of Maya Blue."

50. Arnold et al., "Evidence for Production of Maya Blue."

51. Arnold et al., "Evidence for Production of Maya Blue."

52. Ball and Ladd, "Ceramics," 193; Pérez de Heredia Puente, *Chen K'u*, 30.

53. Price, Tiesler, and Freiwald, "Origin of Victims in the Sacred Cenote"; Hooton, "Skeletons from the Cenote of Sacrifice"; Anda Alanis, "Sacrifice and Ritual Body Mutilation."

54. Coggins, "Dredging the Cenote," 14. In this calculation, Thompson's measurement of the N-S distance across the cenote (168 feet) was used as the diameter of the cenote.

55. White, "Atterberg Plastic Limits," 508.

56. This value was the median (196%) of the range of the liquid limit (161%–232%) of palygorskite documented by Pablo-Galán, "Las Arcillas." The value (177.8%) calculated by White ("Atterberg Plastic Limits," 510) is less.

57. Arnold et al., "Evidence for Production of Maya Blue"; Coggins and Ladd, "Copal and Rubber Offerings," 346.

58. Coggins and Ladd, "Copal and Rubber Offerings," 346.

CHAPTER 10: DID THE MAYA USE OTHER METHODS TO CREATE MAYA BLUE?

1. Arnold et al., "Evidence for Production of Maya Blue."

2. Patel et al., "Top 10 Discoveries of 2008."

3. Patel et al., "Top 10 Discoveries of 2008."

4. Cabrera Garrido, *Azul Maya*.

5. Coggins and Ladd, "Copal and Rubber Offerings," 345–346. The Field Museum bowl was traded to the Field Museum by the Peabody Museum in the 1930s, long before Coggins and Ladd's analysis and description. Another copal offering from the Sacred Cenote has blue on it and is part of the Field Museum's collection but without the vessel holding it. It was traded to the Field Museum by the Peabody Museum in 1932 (FM cat. no. 189263) along with several other objects from the Sacred Cenote.

6. Coggins and Ladd, "Copal and Rubber Offerings," 345.

7. Arnold et al., "Evidence for Production of Maya Blue."

8. In addition to the balls of copal with Maya Blue observed in the museum in Tikal in 1970, Shepard and Gottlieb (*Maya Blue*, 15) list another ball of copal with Maya Blue from Tikal obtained from the collection of the University of Pennsylvania Museum.

9. Pérez de Heredia Puente, *Chen K'u*, 9.

10. Heating Maya Blue above 300°C destroys it; see Shepard and Gottlieb, *Maya Blue*, 14.

11. The measurements in Arnold et al. ("Evidence for Production of Maya Blue," 154) are erroneous; the measurements used here come from the Field Museum catalogue (cat. no. 189262).

12. Sánchez del Río et al., "Acid Resistance of Maya Blue."

13. Gettens and Stout, *Painting Materials*.

14. Shepard and Gottlieb, *Maya Blue*, 14.

15. Sánchez del Río et al., "Synthesis and Acid Resistance of Maya Blue"; Giustetto et al., "Chemical Behavior of a Sepiolite/Indigo Maya Pigment."

16. Van Olphen, "Maya Blue," 645.

17. Littmann, "Maya Blue—Further Perspectives," 405.

18. Doménech Carbó, Doménech-Carbó, and Vázquez de Ágredos Pascual, "Electrochemical Monitoring of Indigo Preparation," 1340.

19. Sanz et al., "Analysis of Indigo from Maya Blue."

20. Doménech Carbó, Doménech-Carbó, and Vázquez de Ágredos Pascual, "Electrochemical Monitoring of Indigo Preparation."

21. Doménech Carbó, Doménech-Carbó, and Vázquez de Ágredos Pascual, "Electrochemical Monitoring of Indigo Preparation," 1345; Doménech Carbó, Doménech-Carbó, and Vázquez de Ágredos Pascual, "Chemometric Study of Maya Blue from the Voltammetry Approach."

22. This physically held water is called zeolitic water.

23. Manciu et al., "Raman and Infrared Studies of Maya Pigments"; Dejoie et al., "Diffusion of Indigo Molecule inside the Palygorskite Channels"; Chiari, Levy, and Giustetto, "NPD Studies on 'Maya Blue' Pigment." The capture of the indigo molecule is complicated and depends upon the crystalline variety of the palygorskite used, according to these authors.

24. Zhuang et al., "Influences of Micropores and Water Molecules in Palygorskite"; Fois, Gamba, and Tilocca, "Unusual Stability of Maya Blue"; Giustetto et al., "Chemical Behavior of a Sepiolite/Indigo Maya Pigment"; Sánchez del Río et al., "Acid Resistance of Maya Blue"; Zhang, Zhang, and Wang also found this to be true with methyl violet ("Preparation of Palygorskite/Methyl Violet").

25. "Slow gradual heating" is my interpretation of what Doménech Carbó et al. called "smooth thermal treatment" for creating a variety of Maya Blue (Doménech Carbó et al., "Chemometric Study of Maya Blue from the Voltammetry Approach," 2820; Doménech Carbó, Doménech-Carbó, and Vázquez de Ágredos Pascual, "Correlation between Properties of Maya Blue").

26. Sánchez del Río et al., "Combined Synchrotron Powder Diffraction and Vibrational Study."

27. Isomers are each of two or more compounds with the same chemical formula but with a different arrangement of atoms and different physical and chemical properties (Jones, "Isomerism"). Indirubin, for example, is an isomer of indigotin.

28. Doménech et al., "Evidence of Topological Indigo/Dehydroindigo Isomers"; Doménech Carbó, Doménech-Carbó, and Edwards, "Interpretation of Raman Spectra of Maya Blue"; Lima et al., "Aged Natural and Synthetic Maya Blue."

29. Dejoie et al., "Diffusion of Indigo Molecule inside the Palygorskite Channels"; Sánchez del Río et al., "Combined Synchrotron Powder Diffraction and Vibrational Study."

30. Van Olphen, "Maya Blue"; Chiari et al., "Pre-Columbian Nanotechnology."

31. Doménech Carbó, Doménech-Carbó, and Edwards, "Interpretation of Raman Spectra of Maya Blue"; Sánchez del Río et al., "Maya Blue Pigment"; Doménech et al., "Evidence of Topological Indigo/Dehydroindigo Isomers."

32. Polette-Niewold et al., "Organic/Inorganic Complex Pigments."

33. Doménech et al., "Maya Blue as Nanostructured Polyfunctional Hybrid."

34. Lima et al., "Aged Natural and Synthetic Maya Blue," 4558.

35. Lima et al., "Aged Natural and Synthetic Maya Blue." A third preparation technique used the same ratio of synthetic indigo and palygorskite, but with the indigo dye dissolved in dimethyl sulphoxide (DMSO). This portion of the experiment, however, is not relevant here because the ancient Maya did not have this chemical. The quote describes the treatment of the samples using the QUV Accelerated Weathering Tester from the Q Panel Company, which simulates weathering.

36. Lima et al., "Aged Natural and Synthetic Maya Blue."

37. Doménech et al., "Maya Blue as Nanostructured Polyfunctional Hybrid."

38. Doménech Carbó, Doménech-Carbó, and Vázquez de Ágredos Pascual, "Correlation between Properties of Maya Blue"; Doménech Carbó, Doménech-Carbó, and Vázquez de Ágredos Pascual, "Electrochemical Monitoring of Indigo Preparation"; Doménech Carbó, Doménech-Carbó, and Edwards, "Interpretation of Raman Spectra of Maya Blue."

39. Polette-Niewold et al. ("Organic/Inorganic Complex Pigments"), and Doménech Carbó, Doménech-Carbó, and Vázquez de Ágredos Pascual ("Chemometric Study of Maya Blue from the Voltammetry Approach") have suggested several ways of creating Maya Blue based upon the chemistry of its composition and experimental syntheses. See also Cabrera Garrido, *Azul Maya*; Littmann, "Maya Blue—Further Perspectives"; Reyes-Valerio, *De Bonampak*; Torres, "Maya Blue"; Doménech Carbó, Doménech-Carbó, and Vázquez de Ágredos Pascual, "Correlation between Properties

of Maya Blue"; Doménech Carbó, Doménech-Carbó, and Edwards, "Interpretation of Raman Spectra of Maya Blue."

40. Doménech Carbó, Doménech-Carbó, and Vázquez de Ágredos Pascual, "Chemometric Study of Maya Blue from the Voltammetry Approach," 2820.

41. Arnold et al., "First Direct Evidence of Pre-Columbian Sources of Palygorskite."

42. See the supplemental tables in Arnold et al., "First Direct Evidence of Pre-Columbian Sources of Palygorskite."

43. Polette-Niewold et al., "Organic/Inorganic Complex Pigments"; Meanwell, Paris, and Peraza Lope, "La Paleta Sagrada."

44. For example, Doménech Carbó, Doménech-Carbó, and Edwards, "Interpretation of Raman Spectra of Maya Blue"; Doménech Carbó et al., "Composition and Color of Maya Blue"; Doménech Carbó, Doménech-Carbó, and Vázquez de Ágredos Pascual, "Indigo/Dehydroindigo/Palygorskite Complex in Maya Blue."

45. Doménech Carbó, Doménech-Carbó, and Edwards, "Interpretation of Raman Spectra of Maya Blue"; Doménech Carbó et al., "Composition and Color of Maya Blue"; Doménech Carbó, Doménech-Carbó, Vázquez de Ágredos Pascual, "Different Indigo-Clay Maya Blue–like Systems."

46. Manciu et al., "Raman and Infrared Studies of Maya Pigments."

47. Zhou et al., "Insertion of Isatin Molecules into Palygorskite."

48. Doménech Carbó, Doménech-Carbó, and Vázquez de Ágredos Pascual, "From Maya Blue to Maya Yellow."

49. Doménech Carbó, Doménech-Carbó, and Vázquez de Ágredos Pascual, "From Maya Blue to Maya Yellow," 5862.

50. Gettens, "Maya Blue."

51. Gettens, "Maya Blue."

52. Gettens, "Maya Blue."

53. Barrera Vásquez et al., *Diccionario Maya Cordemex*, 387 (*k'ax*), 782 (*te*).

54. Arnold, "Maya Blue: A New Perspective"; Arnold, *Sak lu'um in Maya Culture*.

55. Arnold, *Evolution of Ceramic Production Organization*, 93, 116.

56. During a Maya Blue symposium sponsored by the British Museum in September of 2021, I learned that the Maya in Yucatán formerly used indigo derived from the *ch'oh* bush as bluing to whiten clothing during washing. So even though my informants' recipe and memory of the paint in 1966 did not match Maya Blue, the use of bluing for washing clothes revealed a former use of indigo in Yucatán. The use of *azul habón* (a substance that presumably included indigo) in my informants' recipe for making a blue paint thus did not depart far from the mark as a source of blue for creating a blue pigment. Besides its use for Maya Blue, the ancient Maya also may have used indigo to whiten their clothing during washing since traditional Maya clothing in Yucatán is white for both males and females.

57. The ancient Maya, however, more likely used the leaves, not the seeds, as the source of the pigment.

58. Van Olphen, "Maya Blue"; Arnold, "Evidence for Pre-Columbian Indigo."

59. May Ku, "Experimentaciones con Azul Maya"; Luis May Ku, personal communication, September 20, 2021. An extensive description of Luis's artistic work in a larger context is provided by Jessica Christie (Christie, "Contemporary Yucatec Maya Artist Luis May Ku").

60. This spelling reflects the Spanish orthography, which uses *j* to represent the more phonetic *h* in Yucatec Maya. *Ch'oh* is also the Yucatec Maya word for the most well-known plant in Mesoamerica that yields indigo, *Indigofera suffruticosa*.

61. Bricker et al., *Dictionary of the Maya Language*, 86.

62. Torres, "Maya Blue"; Reyes-Valerio, *De Bonampak*, 53–55, 123–143; Contreras Sánchez (*Colorantes en La Nueva España*, 46–53) describes the separate ways that indigo was extracted from the indigo plants in New Spain (Mexico) and Guatemala during the colonial period.

63. Littmann, "Maya Blue—Further Perspectives"; Torres, "Maya Blue"; Reyes-Valerio, *De Bonampak*, 53–55.

64. This experimental approach began with Van Olphen ("Maya Blue") and Littmann ("Maya Blue—Further Perspectives") and continued with many, many other investigators, some of which are described and cited earlier in this chapter.

65. Zhang et al., "Effect of Grinding Time"; Zhang et al., "Reply."

66. In his published notes of E. H. Thompson's excavations of the Grave of the High Priest, J. E. Thompson says: "The name of the High Priest's Grave was given to this structure by Edward Thompson, and, although there is little or no justification for this designation, it is now so firmly established that it has been retained in this publication" (Thompson, "Notes," 53). The name "Grave of the High Priest," J. E. Thompson says, was inappropriate because the monument contained seven graves (table 10.1) and thus should be called El Osario. E. H. Thompson's excavation and J. E. Thompson's listing of the contents of each of the provenience units in the shaft indicate that four of the seven graves (1, 2, 3, and 5) contained skeletal material, along with another that had turned to dust (Grave 6). Human bones also occurred in the passage below the shaft and in the cavern below it. One grave contained more than one individual (Grave 3). Most recently, archaeologists prefer "El Osario" as the name of the monument, and it will subsequently be referred to as such for the remainder of this work.

67. This bowl is illustrated in Ball and Ladd, "Ceramics," 208, fig. 7.8.

68. This process is described in more detail in Arnold, "Ethnomineralogy of Ticul Potters"; Arnold, *Social Change and Evolution of Ceramic Production*, 204–212; Arnold, *Maya Potters' Indigenous Knowledge*, 96–103.

69. Arnold, *Evolution of Ceramic Production Organization*, 102–103.

70. Thompson, "Notes," 35, vessels k and l (probably Field Museum cat. no. 48157).

71. Field Museum cat. no. 48593.

72. Field Museum cat. no. 48156.

73. Arnold et al., "Evidence for Production of Maya Blue"; Arnold et al., "First Direct Evidence of Pre-Columbian Sources of Palygorskite."

74. Field Museum cat. no. 48166. The association of this mass with a particular grave is unknown and is erroneously listed as potters' clay on the Field Museum's original catalogue card, but it is copal and is consistent with Thompson's original report of finding copal in the burials. There is no mention of potters' clay in Thompson's (*High Priest's Grave*) report.

75. Thompson, "Introduction," 9, 12; Cobb et al., "Desmitificación de la Tumba del Gran Sacerdote."

76. Thompson, *High Priest's Grave*, 26.

77. Thompson, *High Priest's Grave*, 18.

78. See Becker, "Maya Burials." This article discusses this issue in the context of the Classic period of the lowland Maya, but the discussion may also apply to the column of fill with "graves" in El Osario in the Late Postclassic period; Cobb et al., "Desmitificación de la Tumba del Gran Sacerdote."

79. Cobb et al., "Desmitificación de la Tumba del Gran Sacerdote"; Wagner, "Dates of the High Priest Grave."

80. According to Joe Ball, ten of these were Mayapán Red Ware, specifically the Mama Red type and Papacal Incised type. Two others (nos. 48162 and 48163) were Chichén Red Ware, specifically the Dzibiac Red. These latter two vessels dated to the Terminal Classic period and occurred in caches above the Papacal Incised types (48158 and 48159) in Grave 6 and thus were deposited in the Postclassic period, well after the Terminal Classic. They were likely were curated Terminal Classic heirlooms that were especially valued as offerings (Joe Ball, personal communication, September 20, 2023).

81. Thompson, *High Priest's Grave*, 24. These vessels probably were Field Museum cat. nos. 48158 or 48159, according to Thompson ("Notes," 49).

82. See Ball and Ladd, "Ceramics," 195–196, 202.

83. Thompson, "Notes," 49.

84. Thompson, *High Priest's Grave*, 27; Cobb et al., "Desmitificación de la Tumba del Gran Sacerdote."

85. Ball and Ladd, "Ceramics," 195–196, 202.

86. Tozzer, *Landa's Relación*, 54, 109–110; Tozzer, *Chichén Itzá and Its Cenote of Sacrifice*, 199.

87. Moyes et al., "Ancient Maya Drought Cult."

88. Cobb et al., "Desmitificación de la Tumba del Gran Sacerdote."

89. Hooton, "Skeletons from the Cenote of Sacrifice"; Anda Alanis, "Sacrifice and Ritual Body Mutilation"; Price, Tiesler, and Freiwald, "Origin of the Victims in the Sacred Cenote," 4.

90. These were illustrated in Smith's *Pottery of Mayapán*, 2:44–45, items y–bb.

91. See Arnold et al., "First Direct Evidence of Pre-Columbian Sources of Palygorskite."

CHAPTER 11: HOW DID MAYA BLUE DIFFUSE THROUGH MESOAMERICA?

1. Vázquez de Ágredos Pascual et al., "Characterization of Maya Blue Pigment"; Reyes-Valerio, *De Bonampak*, 83; Ramírez and Matsui, "Azul Maya en Xipe Totec, El Salvador"; Vandenabeele et al., "Raman Spectroscopic Analysis of Wall Paintings"; Doménech Carbó, Doménech-Carbó, and Vázquez de Ágredos Pascual, "Chemometric Study of Maya Blue from a Voltammetry Approach"; Doménech Carbó, Doménech-Carbó, and Vázquez de Ágredos Pascual, "Correlation between Properties of Maya Blue"; Doménech Carbó, Doménech-Carbó, and Vázquez de Ágredos Pascual, "Electrochemical Monitoring of Indigo Preparation." Guatemala attribution is based upon University of Pennsylvania Museum objects (nos. 37-12-43A, 37-12-43B, and 37-12-44B) from the Department of Alta Verapaz, Chimuxan, Saite, Cahabón River Drainage.

2. See also Reyes Valerio, *Azul Maya en Mesoamérica*, 94.

3. Fletcher, "Stuccoed Vessels from Teotihuacán," 145.

4. López Luján and Anda Rogel, "Teotihuacán in Mexico-Tenochtitlán," 6–7.

5. Sánchez del Río et al., "Crystal-Chemical and Diffraction Analyses"; Jiménez et al., "Compositional Variability of Pigments from Tula."

6. Lopez Luján and Anda Rogel, "Teotihuacán in Mexico-Tenochtitlán"; Reyes-Valerio, *De Bonampak*, 88; López Luján and Chiari, "Color in Monumental Mexica Sculpture"; Olivier and López Luján, "Imágenes de Moctezuma II"; Ortega et al., "Analysis of Prehispanic Pigments."

7. Cabrera Garrido, *Azul Maya*.

8. Sánchez del Río et al., "Crystal-Chemical and Diffraction Analyses."

9. Lopez Luján and Anda Rogel, "Teotihuacán in Mexico-Tenochtitlán," 6–7.

10. Grazia et al., "Shades of Blue"; Domenici et al., "Chemical Analyses of Pre-Hispanic Mesoamerican Codices"; Haude, "Identification of Colorants"; Arroyo-Lemus, "Survival of Maya Blue in Mexican Colonial Mural Paintings"; Straulino-Mainou et al., "Maya Blue in Wall Paintings"; Tagle et al., "Maya Blue."

11. Arnold, "Maya Blue and Palygorskite."

12. Shepard and Gottlieb, *Maya Blue*, 8–9. This hypothesis was formerly referred to as the Shepard/Gottlieb/Arnold/Bohor Hypothesis (Arnold, "Maya Blue and Palygorskite"), a clumsy designation attempting to attribute it to its originators.

13. Arnold, "Maya Blue: A New Perspective"; Arnold, *Sak lu'um in Maya Culture*, 37–38; Arnold, "Maya Blue and Palygorskite"; Arnold and Bohor, "Ancient Mine Comes to Light"; Arnold and Bohor, "Ancient Attapulgite Mine in Yucatán"; Folan, "Pre-Hispanic Source of Attapulgite"; Shepard and Gottlieb, *Maya Blue*; Arnold et al., "First Direct Evidence of Pre-Columbian Sources of Palygorskite."

14. Littmann, "Maya Blue: A New Perspective"; Littmann, "Maya Blue—Further Perspectives," 404.

15. Glover et al., "Interregional Interaction in Terminal Classic Yucatan."

16. Arnold, "Maya Blue and Palygorskite."

17. Arnold, "Maya Blue and Palygorskite"; Folan, "Pre-Hispanic Source of Attapulgite."

18. Hoggarth et al., "Political Collapse of Chichén Itzá."

19. The Upper Temple of the Jaguar is now closed, but a color rendering of the murals can be seen in Coggins, "Murals in the Upper Temple of the Jaguar," 161–165.

20. Paris, Meanwell, and Peraza Lope, "Azul Maya de Mayapán"; see also Meanwell, Paris, and Peraza Lope, "La Paleta Sagrada."

21. Steffens, "Maya Ritual Cave." Small examples of *manos* and *metates* like those in the cave of Balamkú were also sold in markets in Ticul in late October and early November of 1984 for preparing food for Day of the Dead ceremonies.

22. Hoggarth et al., "Political Collapse of Chichén Itzá."

23. Shepard and Gottlieb, *Maya Blue*, 15.

24. Paris, Meanwell, and Peraza Lope, "Azul Maya de Mayapán."

25. Vázquez de Ágredos Pascual et al., "Multianalytical Characterization of Pigments from Funerary Artefacts," 3.

26. Sánchez del Río et al., "Crystal-Chemical and Diffraction Analyses." These authors used crystal-chemical-point analysis in combination with electron microscopy and high-resolution X-ray diffraction to obtain the structural formula of each sample. The six Aztec samples analyzed came from the Templo Mayor and the Pyramid of Santa Cecilia Acatitlán.

27. Vázquez de Ágredos Pascual et al., "Multianalytical Characterization of Pigments from Funerary Artefacts."

28. Littmann, "Maya Blue—Further Perspectives."

29. Arnold, *Maya Potters' Indigenous Knowledge*, 50–78.

30. Arnold, *Maya Potters' Indigenous Knowledge*, 79–121.

31. Thompson, *Modern Yucatecan Maya Pottery Making*.

32. May Ku, "Experimentaciones con Azul Maya."

33. Sánchez del Río, Suárez, and García-Romero, "Occurrence of Palygorskite," 217.

34. Arnold, *Social Change and Evolution of Ceramic Production*, 31–91; Arnold, *Evolution of Ceramic Production Organization*, 57–241; Arnold, *Maya Potters' Indigenous Knowledge*, 199–215. The last year of my research among potters in Ticul was 2008.

35. Arnold, *Social Change and Evolution of Ceramic Production*, 31–91; Arnold, *Evolution of Ceramic Production Organization*, 57–241. This a general pattern, but the details are very nuanced. The composition of households always includes the nuclear family and others related by descent (consanguineal relatives) but may also include individuals related by marriage to someone in the household (affinal relatives). These affinal relatives may sometimes be the source of learning the craft of making pottery. Because the kind of affinal relatives in a household in Ticul, for example, can vary greatly, it is more appropriate to view the unit of learning and transmission of the craft as the household rather than a kin model.

36. See Arnold, "Ethnography of Pottery Making in the Valley of Guatemala"; Thompson, *Modern Yucatecan Maya Pottery Making*, 15–22; Reina and Hill, *Traditional Pottery of Guatemala*. In 1968 potters in Akil and Peto, Yucatán, were also women, but the Peto potters ceased making pottery in 1962.

37. Arnold ("Does Standardization Really Mean Specialization?") shows how potters adapt their paste recipes in Ticul and Mama because of changing raw materials. In the history of changing clay resources in Ticul, not every clay/recipe is suitable to make every vessel shape (see Arnold, *Social Change and Evolution of Ceramic Production*, 221–279).

38. Shepard and Gottlieb, *Maya Blue*, 14.

39. Arnold, "Changes in Ceramics as Commodities," 193–214; Arnold, *Evolution of Ceramic Production Organization*, provided a detailed history of the evolution of production units in Ticul.

40. Shepard and Gottlieb, *Maya Blue*, 16; Coggins and Ladd, "Copal and Rubber Offerings," 345–346; Cabrera Garrido, *Azul Maya*.

41. Sánchez del Río et al., "Crystal-Chemical and Diffraction Analyses."

42. Folan, Bolles, and Ek, "Tracing Mythic Interaction Routes in the Maya Lowlands."

43. Balamkú, Calakmul, Becán, Chicanná, Xpuhil, Hormiguero, Muñeca, and Chactún.

44. Doménech Carbó, Doménech-Carbó, and Vázquez de Ágredos Pascual, "Chemometric Study of Maya Blue from the Voltammetry Approach," 2820.

45. Straulino-Mainou et al., "Maya Blue in Wall Paintings"; Giustetto et al., "Chemical Behavior of a Sepiolite/Indigo Maya Pigment"; Sánchez del Río et al., "Maya Blue Pigment"; Sánchez del Río et al., "Synthesis and Acid Resistance of Maya Blue";

Li et al., "Influence of Indigo-Hydroxyl Interactions"; Grazia et al., "Shades of Blue," 2; Doménech Carbó, Doménech-Carbó, and Vázquez de Ágredos Pascual, "Comparative Study of Indigo-Clay Maya Blue–like Systems."

46. Isphording and Wilson, "Relationship of 'Volcanic Ash,'" 485.

47. Isphording, "Clays of Yucatán," 69. The deposit of palygorskite mined in the Sacalum cenote is about 1 m thick and shows no evidence of being a lens.

48. See, for example, Cisneros de León et al., "Zircon in *Sak Lu'um*."

49. Isphording and Wilson, "Relationship of 'Volcanic Ash,'" 485; Isphording, "Clays of Yucatán," 69; José-Yacamán and Serra Puche, "Electron Microscopy of Maya Blue," 11.

50. Cecil, "Central Petén Blue Pigment."

51. Arnold et al., "Evidence for Production of Maya Blue."

52. Tozzer, *Landa's Relación*, 54, 109; Tozzer, *Chichén Itzá and Its Cenote of Sacrifice*, 199. See also Restall et al., *Friar and the Maya*, 60n123, 179, 239.

53. See Arnold et al., "Evidence for Production of Maya Blue"; Arnold et al., "First Direct Evidence of Pre-Columbian Sources of Palygorskite."

54. Doménech Carbó et al., "Insights into the Maya Blue Technology"; Doménech Carbó et al., "Discovery of Indigoid-Containing Clay Pellets from La Blanca." The authors of these articles argued that this use of Maya Blue was likely for plaster and revealed an ordinary, non-ritual creation of the pigment. To be used as a plaster, however, the Maya Blue needs to be mixed with marl and slaked lime as a binder to have it cohere and then adhere to a surface. Because these pellets were found in fill in a plaza apparently near a presumably painted façade, it is equally possible that they were likely discards from an experimental process of a pigment creation.

55. Grazia et al., "Shades of Blue," 13.

56. Grazia et al., "Shades of Blue," 11–13; Domenici et al., "Chemical Analyses of Pre-Hispanic Mesoamerican Codices," 134, 138.

57. Grazia et al., "Shades of Blue," 17.

58. Straulino-Mainou et al., "Maya Blue in Wall Paintings." The use of Maya Blue in colonial convents in Mexico is independently reported by Sánchez del Río et al. ("Microanalysis Study of Archaeological Mural Samples," 1620), who found it at a Franciscan convent in Puebla (Cuauhtinchan, 1540–1570?). Another blue pigment was found in the Juitepec convent (Morelos, Mexico), but it was not Maya Blue.

59. These convents are in Dzidzantún in Yucatán (Santa Clara de Assisi, Franciscan), Actopan in Hildago (Augustinian), Ixmiquilpan in Hidalgo (Augustinian), and Tlayacapan in Morelos (Augustinian). See also Arroyo-Lemus, "Survival of Maya Blue in Mexican Colonial Mural Paintings."

CHAPTER 12: FUTURE RESEARCH

1. Arnold, *Sak lu'um in Maya Culture*; Arnold, "Ethnomineralogy of Ticul Potters"; Arnold, *Maya Potters' Indigenous Knowledge*.

2. Arnold, "Maya Blue: A New Perspective"; Arnold, "Ethnomineralogy of Ticul Potters"; Arnold, *Maya Potters' Indigenous Knowledge*, 79–113.

3. Arnold et al., "First Direct Evidence of Pre-Columbian Sources of Palygorskite."

4. *Piscidia communis* (Blake) Harms, from Arnold, *Maya Potters' Indigenous Knowledge*, 66.

5. Baczkowski, "Flint Mines of Southern England," 141, 143–146.

6. Arnold and Bohor, "Ancient Clay Mine at Yo' K'at"; Arnold, *Maya Potters' Indigenous Knowledge*, 85–87.

7. Arnold, *Sak lu'um in Maya Culture*, 37–38.

8. LIDAR has been used to discover Classic period sites in southern Belize, and this technique might also be useful to find ancient occupation at Yo' Sah Kab near Ticul and around Sacalum. Thompson, "Detecting Maya Settlements with Lidar."

9. Arnold et al., "Sourcing Palygorskite"; Isphording, "Clays of Yucatán, Mexico"; Krekeler and Kearns, "New Locality of Palygorskite-Rich Clay"; Kysar Mattietti et al., "Geochemical Investigation of Palygorskite-Rich Units"; Pablo-Galán, "Palygorskite"; Sánchez del Río et al., "Occurrence of Palygorskite."

10. Arnold et al., "Sourcing Palygorskite." Cecil provided the Maya Blue samples from the Petén (see Cecil, "Central Petén Blue Pigment").

11. Cecil, "Central Petén Blue Pigment."

12. Arnold, *Maya Potters' Indigenous Knowledge*, 165–167.

13. The town of Sacalum in the state of Yucatán also was a location mentioned in historical documents during this same period (also called the "War of the Castes") as the limit of the advance of the rebel troops when they attempted to march on Mérida in 1848. It is tempting to suggest that some of these rebel troops used knowledge of the *sak lu'um* that they learned in Sacalum, Yucatán, to identify and label a location where a similar material existed in the Petén and called it by the same name.

14. Dumond, *Machete and the Cross*, 15, 16.

15. Chichanhá (literally, "little water") lies in the state of Campeche at N 18°06'47", W 89°14'30", 135 km NNW of Lake Petén Itzá, using measurements in Google Earth.

16. Cecil, "Central Petén Blue Pigment."

17. These data have been published and are available in the supplementary materials in Arnold et al., "First Direct Evidence of Pre-Columbian Sources of Palygorskite." The data used for Arnold et al., "Sourcing Palygorskite," are available in the supplemental data in Cecil, "Central Petén Blue Pigment."

18. Coggins and Ladd, "Copal and Rubber Offerings," 346.

19. Arnold et al., "Sourcing Palygorskite"; Arnold et al., "First Direct Evidence of Pre-Columbian Sources of Palygorskite."

20. Milbrath and Peraza Lope, "Revisiting Mayapán."

21. Sánchez del Río et al., "Crystal-Chemical and Diffraction Analyses."

22. Vázquez de Ágredos Pascual et al., "Multianalytical Characterization of Pigments from Funerary Artefacts."

23. Ball, Taschek, and Baraciel Almada, "Cabrito Cream-Polychrome Tradition."

24. Ball, Taschek, and Baraciel Almada, "Cabrito Cream-Polychrome Tradition."

25. Laure Dussubieux, personal communication, December 19, 2023. This was a preliminary report based upon the LA-ICP-MS analysis in the Field Museum that compared the trace elements from the Buenavista Maya Blue samples with the palygorskite database described in chapter 8.

References Cited

Anda Alanís, Guillermo de. "Sacrifice and Ritual Body
Mutilation in Postclassical Maya Society: Taphonomy
of the Human Remains from Chichén Itzá's Cenote
Sagrado." In *New Perspectives on Human Sacrifice and
Ritual Body Treatments in Ancient Maya Society*, edited
by Vera Tiesler and Andrea Cucina, 190–208. New York:
Springer, 2007.

Andrews, E. Wyllys, IV. *Balankanche, Throne of the Tiger
Priest*. Middle American Research Institute Publication
32. New Orleans: Tulane University, 1970.

Arnold, Dean E. "Ceramic Ecology in the Ayacucho Basin,
Peru: Implications for Prehistory." *Current Anthropology*
16 (1975): 185–203.

Arnold, Dean E. *Ceramic Theory and Cultural Process*. Cam-
bridge: Cambridge University Press, 1985.

Arnold, Dean E. "Ceramic Variability, Environment and
Culture History among the Pokom in the Valley of Gua-
temala." In *Spatial Organization of Culture*, edited by Ian
Hodder, 39–59. London: Gerald Duckworth, 1978.

Arnold, Dean E. "Changes in Ceramics as Commodities
in Ticul, Yucatán, Mexico (1965–2008), and What They
Tell Us about Ancient Maya Ceramic Production." In
*The Value of Things: Prehistoric to Contemporary Commodi-
ties in the Maya Region*, edited by Jennifer P. Mathews
and Thomas H. Guderjan, 193–214. Tucson: University of
Arizona Press, 2017.

Arnold, Dean E. "Design Structure and Community Orga-
nization in Quinua, Peru." In *Structure and Cognition in*

https://doi.org/10.5876/9781646426683.c013

Art, edited by Dorothy Washburn, 56–73. Cambridge: Cambridge University Press, 1983.

Arnold, Dean E. "Does the Standardization of Ceramic Pastes Really Mean Specialization?" *Journal of Archaeological Method and Theory* 7 (2000): 333–375.

Arnold, Dean E. *Ecology of Ceramic Production in an Andean Community*. Cambridge: Cambridge University Press, 1993.

Arnold, Dean E. "Ethnoarchaeology and Investigations of Ceramic Production and Exchange: Can We Go beyond Cautionary Tales?" In *The Legacy of Anna O. Shepard*, edited by R. L. Bishop and F. W. Lange, 321–345. Boulder: University Press of Colorado, 1991.

Arnold, Dean E. "The Ethnography of Pottery Making in the Valley of Guatemala." In *The Ceramics of Kaminaljuyu*, edited by Ronald K. Wetherington, 327–400. University Park: Pennsylvania State University Press, 1978.

Arnold, Dean E. "Ethnomineralogy of Ticul, Yucatán, Potters: Etics and Emics." *American Antiquity* 36 (1971): 20–40.

Arnold, Dean E. "The Evidence for Pre-Columbian Indigo in the New World." *Antropología y Técnica* 2 (1987): 53–84. Mexico City: Universidad Nacional Autónoma de México.

Arnold, Dean E. *The Evolution of Ceramic Production Organization in a Maya Community*. Boulder: University Press of Colorado, 2015.

Arnold, Dean E. "Maya Blue." In *Encyclopaedia of the History of Science, Technology, and Medicine in Non-Western Cultures*, edited by Helaine Selin, 2866–2870. Dordrecht: Springer, 2015.

Arnold, Dean E. "Maya Blue: A New Perspective." Master's Thesis, Department of Anthropology, University of Illinois, Urbana, 1967.

Arnold, Dean E. "Maya Blue and Palygorskite: A Second Possible Pre-Columbian Source." *Ancient Mesoamerica* 16 (2005): 51–62.

Arnold, Dean E. *Maya Potters' Indigenous Knowledge: Cognition, Engagement, and Practice*. Boulder: University Press of Colorado, 2018.

Arnold, Dean E. "Mineralogical Analyses of Ceramic Materials from Quinua, Department of Ayacucho, Peru." *Archaeometry* 14 (1972): 93–101.

Arnold, Dean E. "Native Pottery Making in Quinua, Peru." *Anthropos* 67 (1972): 858–872.

Arnold, Dean E. *Retracing Inca Steps: Adventures in Andean Ethnoarchaeology*. Salt Lake City: University of Utah Press, 2021.

Arnold, Dean E. *Sak lu'um in Maya Culture and Its Possible Relationship to Maya Blue*. Department of Anthropology Research Reports 2. Urbana: University of Illinois, 1967.

Arnold, Dean E. *Social Change and the Evolution of Ceramic Production and Distribution in a Maya Community*. Boulder: University Press of Colorado, 2008.

Arnold, Dean E., and Bruce F. Bohor. "An Ancient Attapulgite Mine in Yucatán." *Katunob* 8, no. 4 (1976): 25–34.

Arnold, Dean E., and Bruce F. Bohor. "The Ancient Clay Mine at Yo' K'at, Yucatán." *American Antiquity* 42 (1977): 575–582.

Arnold, Dean E., and Bruce F. Bohor. "Attapulgite and Maya Blue: An Ancient Mine Comes to Light." *Archaeology* 28 (January 1975): 23–29.

Arnold, Dean E., Bruce F. Bohor, Hector Neff, G. M. Feinman, P. R. Williams, L. Dussubieux, and R. Bishop. "The First Direct Evidence of Pre-Columbian Sources of Palygorskite for Maya Blue." *Journal of Archaeological Science* 39 (July 2012): 2252–2260.

Arnold, Dean E., Jason R. Branden, Patrick Ryan Williams, Gary M. Feinman, and J. P. Brown. "The First Direct Evidence for the Production of Maya Blue: Rediscovery of a Technology." *Antiquity* 82 (2008): 152–164.

Arnold, Dean E., Hector Neff, and Ronald L. Bishop. "Compositional Analysis and 'Sources' of Pottery: An Ethnoarchaeological Approach." *American Anthropologist* 93 (1991): 70–90.

Arnold, Dean E., Hector Neff, Ronald L. Bishop, and Michael D. Glascock. "Testing Interpretive Assumptions of Neutron Activation Analysis: Contemporary Pottery in Yucatán, 1964–1994." In *Material Meanings: Critical Approaches to the Analysis of Style*, edited by Elizabeth Chilton, 61–84. Salt Lake City: University of Utah Press, 1999.

Arnold, Dean E., Hector Neff, and Michael D. Glascock. "Testing Assumptions of Neutron Activation Analysis: Communities, Workshops, and Paste Preparation in Yucatan, Mexico." *Archaeometry* 42, no. 2 (2000): 301–316.

Arnold, Dean E., Hector Neff, Michael D. Glascock, and Robert J. Speakman. 2007. "Sourcing the Palygorskite Used in Maya Blue: A Pilot Study Comparing the Results of INAA and LA-ICP-MS." *Latin American Antiquity* 18, no. 1 (2007): 44–58.

Arnold, Dean E., Prudence M. Rice, William A. Jester, Warren N. Deutsch, Bong K. Lee, and Richard I. Kirsch. "Neutron Activation Analysis of Pottery and Pottery Materials from the Valley of Guatemala." In *The Ceramics of Kaminaljuyu*, edited by Ronald K. Wetherington, 543–586. University Park, Pennsylvania State University Press, 1978.

Arroyo-Lemus, Elsa M. "The Survival of Maya Blue in Sixteenth-Century Mexican Colonial Mural Paintings." *Studies in Conservation* 67, no. 7 (2021): 445–458. https://doi.org/10.1080/00393630.2021.1913825.

Baczkowski, Jon. "Learning by Experience: The Flint Mines of Southern England and Their Continental Origins." *Oxford Journal of Archaeology* 33, no. 2 (2014): 135–153. https://doi.org/10.1111/ojoa.12031.

Bailey, S. W., G. W. Brindley, W. D. Johns, R. T. Martin, and M. Ross. "Summary of National and International Recommendations on Clay Mineral Nomenclature: 1969–70 CMS Nomenclature Committee." *Clays and Clay Minerals* 19 (1971): 129–132.

Ball, Joseph, and John Ladd. "Ceramics." In *Artifacts from the Cenote of Sacrifice, Chichén Itzá, Yucatán*, edited by Clemency Coggins, 191–233. Memoirs of the Peabody Museum of Archaeology and Ethnology, vol. 10, no. 3. Cambridge, MA: Harvard University, 1992.

Ball, Joseph W., Jennifer Taschek, and Maria Baraciel Almada. "The Cabrito Cream-Polychrome Tradition at Buenavista Del Cayo, Belize: Definition, History, Distribution, and Sociocultural Significance." In *Process and Patterns: Narratives from the Smithsonian Neutron Activation Program in Archaeology*, edited by Erin L. Sears. Washington, DC: Smithsonian Institution Scholarly Press, forthcoming.

Barrera Vazquez, Alfredo. "Cerámica Maya." *Obre, Órgano de la Universidad Nacional del Sureste de México* 1, no. 3 (1937): 162–164.

Barrera Vásquez, A. O., J. Ramón Bastarrachea Manzano, W. Brito Sansores, Refugio Vermont Salas, D. Dzul Góngora, and Domingo Dzul Poot. *Diccionario Maya Cordemex: Maya-Español, Español Maya*. Mérida, Mexico: Ediciones Cordemex, 1980.

Becker, Marshall J. "Maya Burials as Caches; Caches as Burials: A New Interpretation of the Meaning of Ritual Deposits among the Classic Period Lowland Maya." In *New Theories on the Ancient Maya*, edited by Ellen C. Damien and Robert J. Sharer, 185–196. University Museum Monographs 77. Philadelphia: University Museum, University of Pennsylvania, 1992.

Berke, Heinz. "The Invention of Blue and Purple Pigments in Ancient Times." *Chemical Society Review* 36 (2007): 15–30.

Berlin, Brent, and Paul Kay. *Basic Color Terms: Their Universality and Evolution*. Berkeley: University of California Press, 1969.

Black, Mary, and Duane Metzger. "Ethnographic Description and the Study of Law." *American Anthropologist* 67, no. 6, pt. 2 (1965): 141–165.

Bohor, Bruce F. "Attapulgite in Yucatán: Guidebook to Field Trip No. 4." *Proceedings of the International Clay Conference, Mexico City, Mexico, July 16–23*, edited by Sturges W. Bailey, 114–125. Wilmette, IL: Applied Publishing, 1976.

Brainerd, George W. *The Archaeological Ceramics of Yucatán*. Anthropological Records 19. Berkeley: University of California Press, 1958.

Brecoulaki, Harikleia. "'Precious Colours' in Ancient Greek Polychromy and Painting: Material Aspects and Symbolic Values." *Revue Archéologique* 1, no. 57 (2014): 3–35.

Bricker, Victoria, Eleuterio Po'ot Yah, and Ofelia Dzul de Po'ot. *A Dictionary of the Maya Language: As Spoken in Hocabá Yucatán.* Salt Lake City: University of Utah Press, 1998.

Browman, David L., and James Gundersen. "Altiplano Comestible Earths: Prehistoric and Historic Geophagy of Highland Peru and Bolivia." *Geoarchaeology* 8, no. 5 (1993): 413–425.

Cabrera Garrido, José María. *El "Azul Maya."* Informes y Trabajos del Instituto de Conservación y Restauración de Obras de Arte, Arqueología y Etnología 8. Madrid: Ministerio de Educación y Ciencia, Dirección General de Bellas Artes, 1969.

Callahan, Gerald N. "Eating Dirt." *Emerging Infectious Diseases* 9, no. 8 (2003): 1016–1021.

Campos, Janaina K. L., Tiago F. da S. Araújo, Thaíse G. da S. Brito, Ana P. S. da Silva, Rebeca X. da Cunha, Mônica B. Martins, Nicácio H. da Silva, Bianka S. dos Santos, César A. da Silva, and Vera L. de M. Lima. "*Indigofera suffruticosa* Mill. (Anil): Plant Profile, Phytochemistry, and Pharmacology Review." *Advances in Pharmacological Sciences* 2018, Article ID 8168526. https://doi.org/10.1155/2018/8168526.

Carlson, Ruth, and Francis Eachus. "The Kekchi Spirit World." In *Cognitive Studies of Southern Mesoamerica,* edited by Helen L. Neuenswander and Dean E. Arnold, 36–65. Publication 3. Dallas: SIL Museum of Anthropology, 1977.

Carmean, Kelli, Patricia A. McAnany, and Jeremy A. Sabloff. "People Who Lived in Stone Houses: Local Knowledge and Social Difference in the Classic Maya Puuc Region of Yucatán, Mexico." *Latin American Antiquity* 22, no. 2 (2011): 143–158.

Carroll, Dorothy. *Clay Minerals: A Guide to Their X-ray Identification.* Geological Society of America Special Paper 126. Boulder, CO: Geological Society of America, 1970.

Case, Ryan J., Arthur O. Tucker, Michael J. Maciarello, and Kraig A. Wheeler. "Chemistry and Ethnobotany of Commercial Incense Copals, Copal Blanco, Copal Oro, and Copal Negro, of North America." *Economic Botany* 57, no. 2 (2003): 189–202.

Cecil, Leslie G. "Central Petén Blue Pigment: A Maya Blue Source Outside of Yucatán, Mexico." *Journal of Archaeological Science* 37, no. 5 (2010): 1006–1019.

Chianelli, Russell R., Myriam Perez de La Rosa, George Meitzner, Mohammed Siadati, Gelles Berhault, Apurva Mehta, Joh Pople, Sergio Fuentes, Gabriel

Alonzo-Nuñez, and Lori A. Polette. "Synchrotron and Simulations Techniques Applied to Problems in Materials Science: Catalysts and Azul Maya Pigments." *Journal of Synchrotron Radiation* 12 (2005): 129–134. https://doi.org/10.1107/S0909049504026172.

Chiari, Giacomo, Roberto Giustetto, J. Druzik, E. Doehne, and G. Ricchiardi. "Pre-Columbian Nanotechnology: Reconciling the Mysteries of the Maya Blue Pigment." *Applied Physics A: Materials Science and Processing* 90, no. 1 (2008): 3–7.

Chiari, Giacomo, Roberto Giustetto, and Gabriele Ricchiardi. "Crystal Structure Refinements of Palygorskite and Maya Blue from Molecular Modeling and Powder Synchrotron Diffraction." *European Journal of Mineralogy* 15 (2003): 21–33.

Chiari, Giacomo, Davide Levy, and Roberto Giustetto. "NPD Studies on 'Maya Blue' Pigment and Palygorskite Clay." ISIS Experimental Report, Rutherford Appleton Laboratory, RB no. 13593, July 20, 2004. https://www.researchgate.net/publication/281497358_NPD_Studies_on_Maya_Blue_pigment_and_Palygorskite_clay.

Chiari, Giacomo, and David Scott. "Pigment Analysis: Potentialities and Problems." *Periodico di Mineralogia* 73 (2004): 227–237.

Christie, Jessica J. "El Patrimonio Maya es la Tierra ('Maya Heritage is the Earth'): The Work of Contemporary Yucatec Maya Artist Luis May Ku." *World Art* 13, no. 3 (2023): 245–270. https://doi.org/10.1080/21500894.2022.2154830.

Cisneros de León, A., A. K. Schmitt, J. Roberge, L. Heiler, C. Ludwig, and F. H. Schmitt. "Zircon in *Sak Lu'um*: Evidence of Multiple Eocene Silicic Tephra Layers as Palygorskite Precursors in the Yucatán Peninsula, Mexico." *Journal of South American Earth Sciences* 93 (2019): 394–411. https://doi.org/10.1016/j.jsames.2019.05.005.

Cobb, Allan, James E. Brady, Marco Antonio Santos Ramirez, and Guillermo de Anda. "La Desmitificación de la Tumba del Gran Sacerdote: Investigaciones en la Cueva debajo del Osario." *Arqueología Mexicana*, no. 159 (2019): 43–48.

Coe, Michael D. *Breaking the Maya Code*. 3rd ed. New York: Thames & Hudson, 2012.

Coggins, Clemency Chase. "The Cenote of Sacrifice: Catalogue." In *Cenote of Sacrifice: Maya Treasures from the Sacred Well at Chichén Itzá*, edited by Clemency Chase Coggins and Orrin C. Shane III, 22–156. Austin: University of Texas Press, 1984.

Coggins, Clemency Chase. "Dredging the Cenote." In *Artifacts from the Cenote of Sacrifice, Chichén Itzá, Yucatán*, edited by Clemency Chase Coggins, 9–31. Memoirs of the Peabody Museum of Archaeology and Ethnology, vol. 10, no. 3. Cambridge, MA: Harvard University, 1992.

Coggins, Clemency Chase. "Murals in the Upper Temple of the Jaguar." In *Cenote of Sacrifice: Maya Treasures from the Sacred Well at Chichén Itzá*, edited by Clemency Chase Coggins and Orrin C. Shane III, 157–165. Austin: University of Texas Press, 1984.

Coggins, Clemency Chase, ed. *Artifacts from the Cenote of Sacrifice, Chichén Itzá, Yucatán*. Memoirs of the Peabody Museum of Archaeology and Ethnology, vol. 10, no. 3. Cambridge, MA: Harvard University, 1992.

Coggins, Clemency Chase, and John M. Ladd. "Copal and Rubber Offerings." In *Artifacts from the Cenote of Sacrifice, Chichén Itzá, Yucatán*, edited by Clemency Chase Coggins, 245–357. Memoirs of the Peabody Museum of Archaeology and Ethnology, vol 10, no. 3. Cambridge, MA: Harvard University, 1992.

Coggins, Clemency Chase, and Orrin C. Shane III, eds. *Cenote of Sacrifice: Maya Treasures from the Sacred Well at Chichén Itzá*. Austin: University of Texas Press, 1984.

Cogswell, J. W., Hector Neff, and Michael D. Glascock. "The Effect of Firing Temperature on the Elemental Characterization of Pottery." *Journal of Archaeological Science* 23 (1996): 283–287.

Contreras Sánchez, Alicia del Carmen. *Capital Comercial y Colorantes en La Nueva España: Segunda Mitad del Signo XVIII*. Zamora, Michoacán: El Colegio de Michoacán, 1996.

D'Andrade, Roy. *The Development of Cognitive Anthropology*. Cambridge: Cambridge University Press, 1995.

Dadashzadeh, Maral, Mahnaz Gorji, and Reza Vahidzadeh. "'Egyptian Blue' or 'Lapis Lazuli Paste'? Structural Study and Identification of the Collection of the Objects Nominate Lapis Lazuli Paste in the National Museum of Iran." *Journal of Research on Archaeometry* 2, no. 2 (2107): 35–48. https://jra-tabriziau.ir/article-1-47-en.html&sw'2017.

Dejoie, Catherine, Pauline Martinetto, Eric Dooryhée, Ross Brown, Sylvie Blanc, Patrice Bordat, Pierre Strobel, Philippe Odier, Florence Porcher, Manuel Sánchez del Río, Elsa Van Eslande, Philippe Walter, and Michel Anne. "Diffusion of Indigo Molecule inside the Palygorskite Clay Channels." MRS Online Proceeding Library 1319, Article 601 (2011). https://doi.org/10.1557/opl.2011.924.

Doménech, Antonio, María Teresa Doménech-Carbó, Manuel Sánchez del Río, Sara Goberna, and Enrique Lima. "Evidence of Topological Indigo/Dehydroindigo Isomers in Maya Blue–like Complexes Prepared from Palygorskite and Sepiolite." *Journal of Physical Chemistry* 113, no. 28 (2009): 12118–12131. https://doi.org/10.1021/jp900711k.

Doménech, Antonio, María Teresa Doménech-Carbó, Manuel Sánchez del Río, María Luisa Vázquez de Ágredos Pascual, and Enrique Lima. "Maya Blue as a Nanostructured Polyfunctional Hybrid Organic-Inorganic Material: The Need to Change Paradigms." *New Journal of Chemistry* 33 (2009): 2371–2379. https://doi.org/10.1039/B901942A.

Doménech Carbó, Antonio, María Teresa Doménech-Carbó, and Howell G. M. Edwards. "On the Interpretation of the Raman Spectra of Maya Blue: A Review on the Literature Data." *Journal of Raman Spectroscopy* 42 (2011): 86–96. https://doi .org/10.1002/jrs.2642.

Doménech, Antonio, María Teresa Doménech-Carbó, and Howell G. M. Edwards. "Quantitation from Tafel Analysis in Solid-State Voltammetry: Application to the Study of Cobalt and Copper Pigments on Severely Damaged Frescos." *Analytical Chemistry* 80 (2008): 2704–2716.

Doménech Carbó, Antonio, María Teresa Doménech-Carbó, Francisco López-López, Francisco Manuel Valle-Algarra, Laura Osete-Cortina, and Estrella Arcos-Von Haartman. "Electrochemical Characterization of Egyptian Blue Pigment in Wall Paintings Using the Voltammetry of Microparticles Methodology." *Electro-analysis* 25, no. 12 (2013): 2621–2630.

Doménech Carbó, Antonio, María Teresa Doménech-Carbó, and María L. Vázquez de Ágredos Pascual. "Chemometric Study of Maya Blue from the Voltammetry of Microparticles Approach." *Analytical Chemistry* 79 (2007): 2812–2821.

Doménech Carbó, Antonio, María Teresa Doménech-Carbó, and María L. Vázquez de Ágredos Pascual. "Comparative Study of Different Indigo-Clay Maya Blue–like Systems Using the Voltammetry of Microparticles Approach." *Journal of Solid State Electrochemistry* 13 (2009): 869–878. https://doi.org/10.1007/s10008-008-0616-1.

Doménech Carbó, Antonio, María Teresa Doménech-Carbó, and María L. Vázquez de Ágredos Pascual. "Correlation between Spectral, SEM/EDX, and Electro-chemical Properties of Maya Blue: A Chemometric Study." *Archaeometry* 51, no. 6 (2009): 1015–1034. https://doi.org/10.1111/j.1475-4754.2009.00453.x.

Doménech Carbó, Antonio, María Teresa Doménech-Carbó, and M. L. Vázquez de Ágredos Pascual. "Electrochemical Monitoring of Indigo Preparation using Maya's Ancient Procedures." *Journal of Solid State Electrochemistry* 11 (2007): 1335–1346. https://doi.org/10.1007/s10008-007-0296-2.

Doménech Carbó, Antonio, María Teresa Doménech-Carbó, and Maria Luisa Vázquez de Ágredos Pascual. "From Maya Blue to 'Maya Yellow': A Connection between Ancient Nanostructured Materials from the Voltammetry of Micropar-ticles." *Angewandte Chemie* 123, no. 25 (2011): 5859–5862. https://doi.org/10.1002 /ange.201100921.

Doménech Carbó, Antonio, María Teresa Doménech-Carbó, and María L. Vázquez de Ágredos Pascual. "Indigo/Dehydroindigo/Palygorskite Complex in Maya Blue: An Electrochemical Approach." *American Chemical Society* 111 (2007): 4585–4595.

Doménech Carbó, Antonio, María Teresa Doménech-Carbó, Cristina Vidal-Lorenzo, Mária Luisa Vázquez de Ágredos-Pascual, Laura Osete-Cortina, and

Francisco Manuel Valle-Algarra. "Discovery of Indigoid-Containing Clay Pellets from La Blanca: Significance with Regard to the Preparation of Maya Blue." *Journal of Archaeological Science* 41 (2014): 147–155. https://doi.org/10.1016/j.jas.2013.08.007.

Doménech Carbó, Antonio, María Teresa Doménech-Carbó, Cristina Vidal-Lorenzo, and Mária Luisa Vázquez de Ágredos-Pascual. "Insights into the Maya Blue Technology: Greenish Pellets from the Ancient City of La Blanca." *Angewandte Chemie: Communications* 51, no. 3 (2012): 700–703. https://doi.org/10.1002/anie.201106562.

Doménech Carbó, Antonio, Sigrid Holmwood, Francesca Di Turo, Noemi Montoya, Francisco Manuel Valle-Algarra, Howell G. M. Edwards, and María Teresa Doménech-Carbó. "Composition and Color of Maya Blue: Reexamination of Literature Data Based on the Dehydroindigo Model." *Journal of Physical Chemistry* 123 (2019): 770–782. https://doi.org/10.1021/acs.jpcc.8b08448.

Domenici, Davide, Costanza Miliani, David Buti, Brunetto Geovanni Brunetti, and Antonio Sgamellotti. "Coloring Materials, Technological Practices, and Painting Traditions: Cultural and Historical Implications of Nondestructive Chemical Analyses of Pre-Hispanic Mesoamerican Codices." In *Painting the Skin: Studies on the Pigments Applied on Bodies and Codices in Pre-Columbian Mesoamerica*, edited by Élodie Dupey García and María Luisa Vásquez de Ágredos Pascual, 129–143. Tucson: University of Arizona Press, 2019.

Drucker, M. M., J. Goldhar, P. L. Ogra, and E. Neter. "The Effect of Attapulgite and Charcoal on Enterotoxicity of *vibrio cholerae* and *Escherichia coli* Enterotoxins in Rabbits." *Infection* 5, no. 4 (1977): 211–213. https://doi.org/10.1007/BF01640782.

Dumond, Don E. *The Machete and the Cross: Compesino Rebellion in Yucatán*. Lincoln: University of Nebraska Press, 1997.

Dunning, Nicholas. 1994. "Puuc Ecology and Settlement Patterns." In *Hidden among the Hills: Maya Archaeology of the Northwest Yucatán Peninsula: First Maler Symposium, Bonn, 1989*, edited by Hands J. Prem, 1–43. Anlage, Mochmuhl, Germany: Verlag von Flemming, 1994.

DuPont, Herbert L., Charles D. Ericsson, Margaret W. DuPont, Alexandro Cruz Luna, and John J. Mathewson. "A Randomized, Open-Label Comparison of Nonprescription Loperamide and Attapulgite in the Symptomatic Treatment of Acute Diarrhea." *American Journal of Medicine* 88, suppl. 6A (1990): 20S–23S.

Ebert, Clare E., Nancy Peniche May, Brendan J. Culleton, Jaime J. Awe, and Douglas J. Kennett. "Regional Response to Drought during the Formation and Decline of Preclassic Maya Societies." *Quaternary Science Reviews* 173 (2017): 211–235. https://dx.doi.org/10.1016/j.quascirev.2017.08.020.

Edmonson, Munro S., trans. and ed. *Heaven Born Merida and Its Destiny: The Book of Chilam Balam of Chumayel.* Austin: University of Texas Press, 1986.

Evans, Nicolas P., Thomas K. Bauska, Fernando Gázquez-Sánchez, Mark Brenner, Jason H. Curtis, and David A. Hodell. "Quantification of Drought during the Collapse of the Classic Maya Civilization." *Science* 361, no. 6401 (2018): 498–501. https://doi.org/10.1126/science.aas9871.

Fernández, M. E., J. A. Ascencio, D. Mendoza-Anaya, V. Rodríguez Lugo, and M. José-Yacamán. "Experimental and Theoretical Studies of Palygorskite Clays." *Journal of Materials Science* 34 (1999): 5243–5255.

Fletcher, Jessica M. "Stuccoed Tripod Vessels from Teotihuacán: An Examination of Materials and Manufacture." *Journal of the American Institute for Conservation* 41 (2002): 139–154.

Fois, Ettore, Aldo Gamba, and Antonio Tilocca. "On the Unusual Stability of Maya Blue Paint: Molecular Dynamics Simulations." *Microporous and Mesoporous Materials* 57 (2003): 263–272.

Folan, William J. "Coba, Quintana Roo, Mexico: An Analysis of a Prehispanic and Contemporary Source of *Sascab.*" *American Antiquity* 43, no. 1 (1978): 79–85.

Folan, William J. "Mining and Quarrying Techniques of the Lowland Maya in Mining and Mining Techniques in Ancient Mesoamerica." *Anthropology Stony Brook* 1–2 (1982): 149–174.

Folan, William J. "Sacalum, Yucatán: A Pre-Hispanic and Contemporary Source of Attapulgite." *American Antiquity* 34 (1969): 182–183.

Folan, William J., David D. Bolles, and Jerald D. Ek. "On the Trail of Quetzalcoatl/ Kukulcan: Tracing Mythic Interaction Routes and Networks in the Maya Lowlands." *Ancient Mesoamerica* 27 (2016): 293–318.

Frison, Guido, and Giulia Brun. "Lapis Lazuli, Lazurite, Ultramarine 'Blue,' and the Colour Term 'Azure' up to the 13th Century." *Journal of the International Colour Association* 16 (2016): 41–55. https://aic-color.org/resources/Documents/jaic_v16_03_GdC2015.pdf.

Galán, E. "Properties and Applications of Palygorskite-Sepiolite Clays." *Clay Minerals* 31 (1996): 443–453.

Gates, William. "The Xiu Family Papers." In *Yucatan before and after the Conquest*, by Friar Diego de Landa, 120–135. 1937. Reprint, New York: Dover Publications, 1978.

Gates, William. "Yucatan in 1549 and 1579." In *Yucatan before and after the Conquest*, by Friar Diego de Landa, 138–157. 1937. Reprint, New York: Dover Publications, 1978.

Gettens, Rutherford J. "Identification of Pigments on Fragments of Mural Paintings from Bonampak, Chiapas, Mexico." In *Bonampak, Chiapas, Mexico*, edited by K.

Ruppert, J. E. S. Thompson, and T. Proskouriakoff, 67. Publication 602. Washington, DC: Carnegie Institution of Washington, 1955.

Gettens, Rutherford J. "Maya Blue: An Unsolved Problem in Ancient Pigments." *American Antiquity* 27, no. 4 (1962): 557–564.

Gettens, R. J., and G. L. Stout. *Painting Materials: A Short Encyclopaedia.* New York: Van Norstrand, 1942. Reprint, New York: Dover Publications, 1966.

Gilli, Adrian, David A. Hodell, George D. Kamenov, and Mark Brenner. "Geological and Archaeological Implications of Strontium Isotope Analysis of Exposed Bedrock in the Chicxulub Crater Basin, Northwestern Yucatán, Mexico." *Geology* 37, no. 8 (2009): 723–726. https://doi.org/10.1130/G30098A.1.

Giustetto, Roberto, Francesc X. Llabrés i Xamena, Gabriele Ricchiardi, Silvia Bordiga, Alessandro Damin, Roberto Gobetto, and Michele R. Chierotti. "Maya Blue: A Computational and Spectroscopic Study." *Journal of Physical Chemistry B* 190, no. 41 (2005):19360–19368.

Giustetto, Roberto, O. Wahyudi, I. Corazzari, and F. Turci. "Chemical Stability and Dehydration Behavior of a Sepiolite/Indigo Maya Pigment." *Applied Clay Science* 52 (2011): 41–50.

Glickman, L. T., A. O. Camara, N. W. Glickman, and G. P. McCabe. "Nematode Intestinal Parasites of Children in Rural Guinea, Africa: Prevalence and Relationship to Geophagia." *International Journal of Epidemiology* 28 (1999): 169–174.

Glover, Jeffrey B., Zachary X. Hruby, Dominique Rissolo, Joseph W. Ball, Michael D. Glascock, and M. Steven Shackley. "Interregional Interaction in Terminal Classic Yucatan: Recent Obsidian and Ceramic Data from Vista Alegre, Quintana Roo, Mexico." *Latin American Aniquity* 29, no. 3 (2018): 475–494.

Grazia, Chiara, David Buti, Anna Amat, Francesca Rosi, Aldo Romani, Davide Domenici, Antonio Sgamellotti, and Costanza Miliani. "Shades of Blue: Noninvasive Spectroscopic Investigations of Maya Blue Pigment. From Laboratory Mock-ups to Mesoamerican Codices." *Heritage Science* 8, no. 1 (2020): 1–20. https://doi.org/10.1186/s40494-019-0345-z.

Grim, Ralph E. *Clay Mineralogy.* New York: McGraw-Hill, 1968.

Gutiérrez, Gerardo, and Baltazar Brito Guadarrama. "The Archaeological Research of Códice Maya de México." In *Códice Maya de México: Understanding the Oldest Surviving Book of the Americas,* edited by Andrew D. Turner, 37–69. Los Angeles: J. Paul Getty Museum, Getty Research Institute, 2022.

Haden, W. Linwood, Jr., and Ira A. Schwint. "Attapulgite: Its Properties and Applications." *Industrial and Engineering Chemistry* 59, no. 9 (1967): 58–69.

Haude, Mary Elizabeth. "Identification of Colorants on Maps from the Early Colonial Period of New Spain (Mexico)." *Journal of the American Institute for Conservation* 37 (1998): 240–270.

Hoggarth, Julie A., Sebastian F. M. Breitenbach, Brendan J. Culleton, Clare E. Ebert, Marilyn A. Masson, and Douglas J. Kennett. "The Political Collapse of Chichén Itzá in Climatic and Cultural Context." *Global and Planetary Change* 138 (2016): 25–42. https://doi.org/10.1016/j.gloplacha.2015.12.007.

Hooton, Ernest A. "Skeletons from the Cenote of Sacrifice at Chichén Itzá." In *The Maya and Their Neighbors: Essays on Middle American Anthropology and Archaeology*, edited by C. L. Hay, R. Linton, S. K. Lothrop, H. Shapiro, and G. C. Vaillant, 272–280. New York: Appleton Century, 1940.

Hubbard, Basil, Wenxing Kuang, Arvin Moser, Glenn A. Facey, and Christian Detellier. "Structural Study of Maya Blue: Textural, Thermal, and Solid-State Multinuclear Magnetic Resonance Characterization of the Palygorskite-Indigo and Sepiolite-Indigo Adducts." *Clays and Clay Minerals* 51 (2003): 318–326.

Hunt, Mary. "7 Simple Secrets to Make Jeans Last Longer." *Everyday Cheapskate*, updated July 12, 2023, https://www.everydaycheapskate.com/7-simple-secrets-for-how-to-make-jeans-last-longer/, accessed July 25, 2023.

"Indigofera." *WFO: World Flora Online.* https://www.worldfloraonline.org/search?query=Indigofera&limit=24&start=0&sort=, accessed July 15, 2023.

Ingo, Gabriel M., Altan Çilingiroglu, Gabriella Di Carlos, Atilla Batmaz, Tilde De Caro, Christina Riccucci, Erica I. Parisi, and Federica Faraldi. "Egyptian Blue Cakes from the Ayanis Fortress (Eastern Anatolia, Turkey): Micro-chemical and -Structural Investigations for the Identification of Manufacturing Process and Provenance." *Journal of Archaeological Science* 40 (2013): 4283–4290.

Ingold, Tim. *Making: Anthropology Archaeology, Art and Architecture.* London: Routledge, Taylor and Francis, 2013.

Ingold, Tim. *Perception of the Environment: Essays on Livelihood, Dwelling and Skill.* London: Routledge, Taylor and Francis, 2000.

Isphording, Wayne C. "The Clays of Yucatán, Mexico: A Contrast in Genesis." In *Developments in Sedimentology: Palygorskite-Sepiolite, Occurrences, Genesis and Uses*, edited by A. Singer and E. Galán, 59–73. Amsterdam: Elsevier, 1984.

Isphording, Wayne C., and E. M. Wilson. "The Relationship of 'Volcanic Ash,' Sak Lu'um, and Palygorskite in Northern Yucatán Maya Ceramics." *American Antiquity* 39 (1974): 483–488.

Jiménez, Luis Abel, Nora A. Pérez, Armando Arciniega, Mariana Díaz de León, Yareli Jáidar, and Edgar Casanova-González Jimenez. "Compositional Variability of Pigments of Related Materials Used in Stone Relief from the Tula

Archaeological Zone, Mexico: Overcoming Challenges of a Highly Restored Site." *Journal of Cultural Heritage* 43 (May–June, 2020): 80–89. https://doi.org/10.1016/j .culher.2019.12.011.

Jones, Maitland. "Isomerism." *Britannica*, April 6, 2023, https://www.britannica.com /science/isomerism, accessed July 23, 2023.

José-Yacamán, M., Luis Rendón, J. Arenas, and Mari Carmen Serra Puche. "Maya Blue Paint: An Ancient Nanostructured Material." *Science* 273 (1996): 223–225.

José-Yacamán, M. and Mari Carmen Serra Puche. "High-Resolution Electron Microscopy of Maya Blue Paint." *Materials Research Society Symposium Proceedings* 352 (1995): 3–11.

Kennett, Douglas J., Sebastian F. M. Breitenbach, Valorie V. Aquino, Yemane Asmerom, Jaime Awe, James U. L. Baldini, Patrick Bartlein, Brendan J. Culleton, Claire Ebert, Christopher Jazwa, Martha J. Macri, Norbert Marwan, Victor Polyak, Keith M. Prufer, Harriet E. Ridley, Harald Sodemann, Bruce Winterhalder, and Gerald H. Haug. "Development and Disintegration of Maya Political Systems in Response to Climate Change." *Science* 338 (2012): 788–791.

Kennett, Douglas J., Sachiko Sakai, Hector Neff, Richard Gossett, and Daniel O. Larson. "Compositional Characterization of Prehistoric Ceramics: A New Approach." *Journal of Archaeological Science* 29, no. 5 (2002): 443–455.

King, Hobart M. "Azurite." Geology.com, Geoscience News and Information, https://geology.com/minerals/azurite.shtml, accessed July 24, 2023.

King, Hobart M. "Lapis Lazuli." Geology.com, Geoscience News and Information, https://geology.com/gemstones/lapis-lazuli/, accessed July 24, 2023.

King, Hobart M. "Malachite." Geology.com, Geoscience News and Information, https://geology.com/minerals/malachite.shtml, accessed July 25, 2023.

King, Hobart M. "Turquoise." Geology.com, Geoscience News and Information, https://geology.com/minerals/turquoise.shtml, accessed July 24, 2023.

King, Hobart M. "What Is Jade?" Geology.com, Geoscience News and Information, https://geology.com/gemstones/jade/, accessed July 25, 2023.

Kleber, R., L. Masschelein-Kleiner, and J. Thissen. "Etude et identification du 'Bleu Maya.'" *Studies in Conservation* 12 (1967): 41–56.

Krekeler, M. P. S., E. Hammerly, J. Kakovan, and S. Guggenheim. "Microscopy Studies of the Palygorskite-to-Smectite Transformation." *Clays and Clay Minerals* 53 (2005): 93–99.

Krekeler, Mark P. S., and Lance E. Kearns. "A New Locality of Palygorskite-Rich Clay from the Southeastern Yucatán: A Potential Material Source for Environmental Applications." *Environmental Geology* 58 (2009): 715–726. https://doi.org/10 .1007/s00254-008-1545-0.

Kupferschmidt, Kai. "In Search of Blue." *Science* 364, no. 6439 (2019): 424–429.

Kysar Mattietti, G., M. Krekeler, D. E. Arnold, H. Neff, M. D. Glascock, and R. J. Speakman. "Geochemical Investigation of Palygorskite-Rich Units—Central Yucatán." Paper presented at the joint meeting of the Geological Society of America, Soil Science Society of America, American Society of Agronomy, Crop Science Society of America, Gulf Coast Association of Geological Societies with the Gulf Coast Section of SEPM, Houston, TX, Paper No. 193-25, October 6, 2008.

Landa, Friar Diego de. *Yucatan before and after the Conquest.* Translated and edited by William Gates, 1937. Reprint, New York: Dover Publications, 1978. First published in 1566.

Leite, Sônia Pereira, J. R. Cardosa Vieira, P. Leys de Medeiros, R. M. Leite, V. L. de Menezes Lima, H. S. Xavier, and E. de Oliveira Lima. "Antimicrobial Activity of *Indigofera suffruticosa*." *Evidence-Based Complementary and Alternative Medicine* 3, no. 2 (2006): 261–265. https://doi.org/10.1093/ecam/nel010.

Leona, Marco, Francesca Casadio, Mauro Bacci, and Marcello Picollo. "Identification of the Pre-Columbian Pigment Maya Blue on Works of Art by Noninvasive UV-VIS and Raman Spectroscopic Techniques." *Journal of the American Institute for Conservation* 43 (2004): 50.

Li, Li, Guanzheng Zhuang, Mengyuan Li, Peng Yuan, Liangliang Deng, and Haozhe Guo. "Influence of Indigo-Hydroxyl Interactions on the Properties of Sepiolite-Based Maya Blue Pigment." *Dyes and Pigments* 200, no. 5 (2022): 110138. https://doi.org/10.1016/j.dyepig.2022.110138.

Lima, Enrique, Ariel Guzmán, Marco Vera, Jose Luis Rivera, and Jacques Fraissard. "Aged Natural and Synthetic Maya Blue–Like Pigments: What Difference Does It Make?" *Journal of Physical Chemistry* 116 (2012): 4556–4563. https://dx.doi.org/10.1021/jp207602m.

Littmann, Edwin R. "Ancient Mesoamerican Mortars, Plasters, and Stuccos: The Composition and Origin of *Sascab*." *American Antiquity* 24, no. 2 (1958): 172–176.

Littmann, Edwin R. "Ancient Mesoamerican Mortars, Plasters, and Stuccos: The Puuc Area." *American Antiquity* 25, no. 3 (1960): 407–412.

Littmann, Edwin R. "Maya Blue: A New Perspective." *American Antiquity* 45 (1980): 87–100.

Littmann, Edwin R. "Maya Blue—Further Perspectives and the Possible Use of Indigo as the Colorant." *American Antiquity* 47 (1982): 404–408.

López Luján, Leonardo, and Giacomo Chiari. "Color in Monumental Mexica Sculpture." *Res* 61–62 (2012): 331–342.

López Luján, Leonardo, and Michelle de Anda Rogel. "Teotihuacán in Mexico-Tenochtitlán: Recent Discoveries, New Insights." *The PARI Journal* 19, no. 3 (2019): 1–26.

López Puértolas, Carlos, L. R. Manzanilla Naim, and M. L. Vázquez de Ágredos Pascual. "Archaeometric Study of Color Production in Xalla, Teotihuacán." 42nd International Symposium on Archaeometry ISA, May 2018. Unpublished poster, PDF file. https://www.researchgate.net/publication/325502160.

Magaloni, Diana. "Technique, Color and Art at Bonampak." In *Courtly Art of the Ancient Maya*, edited by Mary Miller and Simon Martin, 250–252. London: Thames & Hudson, 2004.

Manciu, F. S., L. Reza, L. A. Polette, B. Torres, and R. R. Chianelli. "Raman and Infrared Studies of Synthetic Maya Pigments as a Function of Heating Time and Dye Concentration." *Journal of Raman Spectroscopy* 38 (2007): 1193–1198. https://doi.org/10.1002/jrs.1751.

Matson, Frederick R. "Egyptian Blue." In *Persepolis II: Contents of the Treasury and Other Discoveries*, edited by Erich F. Schmidt, 133–135. Oriental Institute Publication 64. Chicago: University of Chicago Press, 1957. https://oi.uchicago.edu/sites/oi.uchicago.edu/files/uploads/shared/docs/oip69.pdf.

May Ku, Luis. "Experimentaciones en Curso Con Azul Maya." PowerPoint presentation presented at the online Azul Maya Symposio, Santo Domingo Centre for Excellence for Latin American Research, Department of Africa, Oceania and the Americas, British Museum, September 16, 2021.

McAnany, P. A. "Water Storage in the Puuc Region of the Northern Maya Lowlands: A Key to Population Estimates and Architectural Variability." In *Precolumbian Population History in the Maya Lowlands*, edited by T. P. Culbert and D. S. Rice, 263–284. Albuquerque: University of New Mexico Press, 1990.

McVicker, Donald. "A Tale of Two Thompsons: The Contributions of Edward H. Thompson and J. Eric Thompson to Anthropology at the Field Museum." In *Curators, Collections, and Contexts: Anthropology at the Field Museum, 1893–2002*, edited by Stephen E. Nash and Gary M. Feinman, 139–152. Fieldiana Anthropology n.s. 36. Chicago: Field Museum of Natural History, 2003.

Meanwell, Jennifer, Elizabeth H. Paris, and Carlos Peraza Lope. "La Paleta Sagrada: La Mineralogía de los Pigmentos en el Arte Religioso en Mayapán, Yucatán, México." In *XXXI Simposio de Investigaciones Arqueológicas en Guatemala, 2017*, edited by B. Arroyo, L. Méndez Salinas, and G. Ajú Alvarez, 1095–1104. Guatemala City: Museo Nacional de Arqueología y Etnología, 2018.

Merwin, H. E. "Chemical Analysis of Pigments." In *The Temple of the Warriors at Chichén Itzá, Yucatán*, edited by E. H. Morris, J. Charlot, and A. A. Morris, 355–356.

Carnegie Institution of Washington Publication 406. Washington, DC: Carnegie Institution of Washington, 1931.

Metzger, Duane, and Donald W. Lathrap, consultants. *Ollero Yucateco*. Urbana, IL: Motion Picture Service, University of Illinois, 16 mm film, 22 min., 1965.

Metzger, Duane, and Gerald E. Williams. "Formal Ethnographic Analysis of Tenejapa Ladino Weddings." *American Anthropologist* 65 (1963): 1076–1101.

Metzger, Duane, and Gerald E. Williams. "Some Procedures and Results in the Study of Native Categories: Tzeltal Firewood." *American Anthropologist* 68 (1966): 389–407.

Metzger, Duane, and Gerald E. Williams. "Tenejapa Medicine 1: The Curer." *Southwestern Journal of Anthropology* 19 (1963): 216–236.

Michelaki, Kostalena, Gregory V. Braun, and Ronald G. V. Hancock. "Local Clay Sources as Histories of Human-Landscape Interactions: A Ceramic Taskscape." *Journal of Archaeological Method and Theory*, 22 (2015): 783–827. https://doi.org/10.1007/s10816-014-9204-0.

Michelaki, Kostalena, Ronald G. V. Hancock, and Gregory V. Braun. "Using Provenance Data to Assess Archaeological Landscapes: An Example from Calabria, Italy." *Journal of Archaeological Science* 39, no. 2 (2012): 234–246. https://doi.org/10.1016/j.jas.2011.08.034.

Milbrath, Susan, and Carlos Peraza Lope. "Revisiting Mayapán." *Ancient Mesoamerica* 14, no. 1 (2003): 1–46. https://doi.org/10.1017/S0956536103132178.

"The Mineral Chrysocolla." Minerals.net. https://www.minerals.net/mineral/chrysocolla.aspx, accessed July 25, 2023.

Missouri Botanical Garden. "Indigofera." *Tropicos*. https://tropicos.org/name/40030938, accessed July 15, 2023.

Missouri Botanical Garden. "*Protium copal* (Schltdl. & Cham.) Engl." *Tropicos*. https://tropicos.org/name/4700094, accessed April 14, 2024.

Moholy-Nagy, Hattula, and John M. Ladd. "Objects of Stone, Shell, and Bone." In *Artifacts from the Cenote of Sacrifice, Chichén Itzá, Yucatán*, edited by Clemency Chase Coggins, 99–152. Memoirs of the Peabody Museum of Archaeology and Ethnology, vol. 10, no. 3. Cambridge, MA: Harvard University, 1992.

Moore, Duane M., and Robert C. Reynolds Jr. *X-Ray Diffraction and the Identification and Analysis of Clay Minerals*. 2nd ed. Oxford: Oxford University Press, 1997.

Moser, Mary Beck. "Seri Blue." *The Kiva* 30, no. 2 (1964): 3–8.

Moyes, Holley, Jamie J. Awe, George A. Brook, and James W. Webster. "The Ancient Maya Drought Cult: Late Classic Dave Use in Belize." *Latin American Antiquity* 20, no. 1 (2009): 175–206.

Mullen, William. "Solving Maya Blue's Mystery." *Chicago Tribune*, February 27, 2008, sec. 1, 11.

Nash, Stephen E., and Gary M. Feinman, eds. *Curators, Collections, and Contexts: Anthropology at the Field Museum, 1893–2002*. Fieldiana Anthropology n.s. 36. Chicago: Field Museum of Natural History, 2003.

Neff, Hector, Ronald L. Bishop, and Dean E. Arnold. "Reconstructing Ceramic Production from Ceramic Compositional Data: An Example from Guatemala." *Journal of Field Archaeology* 15 (1988): 339–348.

Olivier, Guilhem, and Leonardo López Luján. "Las imágenes de Moctezuma II y sus símbolos de poder." In *Moctezuma II: Tiempo y Destino de un Gobernante*, edited by Leonard López Luján and Colin McEwan, 79–123. Mexico City: Instituto Nacional de Anthropología e Historia, 2010.

Ortega, M., J. A. Ascencio, C. M. San-Germán, M. E. Fernández, L. López, and M. José-Yacamán. "Analysis of Prehispanic Pigments from 'Templo Mayor' of Mexico City." *Journal of Materials Science* 36 (2001): 751–756. http://doi.org/10.1023/A:1004853311627.

Osborne, Lilly De Jongh. "Apuntes Sobre La Indumentaria Indígena de Guatemala." *Anthropología e Historia de Guatemala* 1, no. 2 (1949): 50–57.

Pablo-Galán, Liberto de. "Las Arcillas: 1. Clasificación, Identificación, Usos y Especificaciones Industriales." *Boletín de La Sociedad Geológica Mexicana* 28, no. 2 (1964): 49–91.

Pablo-Galán, Liberto de. "Palygorskite in Eocene-Oligocene Lagoonal Environment, Yucatán, Mexico." *Revista Mexicana de Ciencias Geológicas* 13 (1996): 94–103.

"Palygorskite." Minedat.org. https://www.mindat.org/min-3072.html, accessed September 5, 2023.

"Palygorskite Mineral Data." Webmineral.com. http://webmineral.com/data/Palygorskite.shtml#.Y39QWH3MJD8, accessed September 29, 2023.

Paris, Elizabeth H., Jennifer L. Meanwell, and Carlos Peraza Lope. "El 'Azul Maya' de Mayapán: Análisis de Materiales y Evidencia Etnoarqueológica para una Industria de Pigmentos del Periodo Postclásico." In *XXXI Simposio de Investigaciones Arqueológicas en Guatemala, 2017*, edited by B. Arroyo, L. Méndez Salinas, and G. Ajú Alvarez, 1083–93. Guatemala City: Museo Nacional de Arqueología y Etnología, 2018.

Patel, Samir S., Roger Atwood, Eti Bonn-Muller, Zach Zorich, Malin Grunberg Banyasz, Heather Pringle, Mark Rose, and Eric A. Powell. "Top 10 Discoveries of 2008," *Archaeology* 62, no. 1 (January/February 2009): 20–27.

Peirce, H. Wesley. "Seri Blue—An Explanation." *The Kiva* 30, no. 2 (1964): 33–39.

Pelto, Pertti, and Gretel H. Pelto. *Anthropological Research: The Structure of Inquiry*. 2nd ed. Cambridge: Cambridge University Press, 1978.

Peréz de Heredia Puente, Eduardo J. *Chen K'u: The Ceramics of the Sacred Cenote at Chichén Itzá: Study of the Ceramic Fragments of the Explorations Conducted in the 60s*. Foundation for the Advancement of Mesoamerican Studies, Inc. (FAMSI), 2008. http://www.famsi.org/reports/97061/, accessed April 14, 2024.

Perlman, I., and Frank Asaro. "Pottery Analysis by Neutron Activation." *Archaeometry* 11 (1969): 21–52.

Polanyi, M. *Personal Knowledge: Towards a Post-Critical Philosophy*. Rev. ed. London: Routledge, 1962.

Polette-Niewold, Lori Ann, Felicia S. Manciu, Brenda Torres, Manuel Alvarado Jr., and Russell R. Chianelli. "Organic/Inorganic Complex Pigments: Ancient Colors Maya Blue." *Journal of Inorganic Biochemistry* 101 (2007): 1958–1973. https://doi.org/10.1016/j.jinorgbio.2007.07.009.

Pozza, Giorgio, David Ajo, Giacomo Chiari, Franco de Zuane, and Marialuisa Favaro. "Photoluminescence of the Inorganic Pigments Egyptian Blue, Han Blue and Han Purple." *Journal of Cultural Heritage* 1, no. 4 (2000): 393–398. https://doi.org/10.1016/S1296-2074(00)01095-5.

Pradell, Trinitat, Nativitat Salvado, Gareth D. Hatton, and Michael S. Tite. "Physical Processes Involved in Production of the Ancient Pigment, Egyptian Blue." *Journal of the American Ceramic Society* 89, no. 4 (2006): 1426–1431. https://doi.org/10.1111/j.1551-2916.2005.00904.x.

Price, T. Douglas, Vera Tiesler, and Carolyn Freiwald. "Place of Origin of the Sacrificial Victims in the Sacred Cenote, Chichén Itzá, Mexico." *American Journal of Physical Anthropology* 79, no. 1 (2019): 98–1151. https://doi.org/10.1002/ajpa.23879.

Ramírez, Claudia A., and Toshiya Matsui. "Azul Maya y Pigmentos Naranja en Xipe Totec, Carranza, Aguilares, El Salvador: Un Estudio a través de Espectrografia de Fourrier, SEM y Difracción de Rayos X." Unpublished manuscript, 2019. PDF file. https://www.academia.edu/38284811/Azul_maya_y_pigmentos_naranja_en_Xipe_Totec_Carranza_Aguilares_El_Salvador_Un_estudio_a_trav%C3%A9s_de_espectrografia_de_Fourrier_SEM_y_Difracci%C3%B3n_de_Rayos_X.

Redfield, Robert, and Margaret Park Redfield. *Disease and Its Treatment in Dzitás, Yucatán*. Carnegie Institution of Washington Publication 523. Washington, DC: Carnegie Institution of Washington, 1940.

Reina, Ruben, and R. M. Hill. *The Traditional Pottery of Guatemala*. Austin: University of Texas Press, 1978.

Rendón, Silvia. "Notas sobre la Alfarería Indígena de la Peninsula de Yucatán." *Revista Mexicana de Estudios Antropológicos* 9 (1947): 107–123.

Restall, Matthew, Amara Solari, John F. Chuchiak IV, and Traci Ardren. *The Friar and the Maya: Diego de Landa and the Account of the Things of Yucatan*. Denver: University Press of Colorado, 2023.

Reyes-Valerio, C. *De Bonampak al Templo Mayor: El Azul Maya en Mesoamérica*. Mexico City: Siglo XXI, 1993.

Reza bin Zaid, Mohammad, Mahmud Hasan, and A. K. Azad Khan. "Attapulgite in the Treatment of Acute Diarrhoea: A Double-blind Placebo-controlled Study." *Journal of Diarrhoeal Disease Research* 13, no. 1 (1995): 44–46.

Rice, Prudence M. *Pottery Analysis: A Sourcebook*. Chicago: University of Chicago Press, 1987.

Rice, Prudence M. *Pottery Analysis: A Sourcebook*. 2nd ed. Chicago: University of Chicago Press, 2015.

Riddle, Jacqueline W., Emily J. Hopkins, and Ian S. Butler. "Variable-Temperature Micro-Raman Spectra of the Synthetic Artists' Pigments, Chrome Yellow and Maya Blue: An Undergraduate Research Project." *Spectroscopy Letters* 48 (2015): 556–560. https://doi.org/10.1080/00387010.2014.924529.

Robinson, Eugenia, Joseph Reibenspies, and Marvin W. Rowe. "Blue Rock Art Paint in Guatemala: Not 'Maya Blue.'" In *American Indian Rock Art*, edited by Mavis Greer, John Greer, and Peggy Whitehead, 37:209–216. Cupertino, CA: American Rock Art Research Association, 2011.

Roys, Ralph L. *The Book of Chilam Balam of Chumayel*. Carnegie Institution of Washington Publication 438. Washington, DC: Carnegie Institution of Washington, 1933.

Roys, Ralph L. *The Ethnobotany of the Maya*. Middle American Research Series Publication 2. New Orleans: Tulane University, 1931.

Sánchez del Río, Manuel. "Maya Blue Studies in Relation to History and Archeology." In *Fatto d'Archimia, Los Pigmentos Artificiales en las Técnicas Pictóricas*, edited by M. del Egido and S. Kroustallis, 259–272. Madrid: Ministerio de Educación, Cultura y Deporte, 2012.

Sánchez del Río, Manuel, Enrico Boccaleri, Marco Milanesio, Gianluca Croce, Wouter van Beek, Constantinos Tsiantos, Georgios D. Chyssikos, Vassilis Gionis, George H. Kacandes, Mercedes Suárez, and Emilia García-Romero. "A Combined Synchrotron Powder Diffraction and Vibrational Study of the Thermal Treatment of Palygorskite-Indigo to Produce Maya Blue." *Journal of Materials Science* 44 (2009): 5524–5536. https://dx.doi.org/10.1007/s10853-009-3772-5.

Sánchez del Río, Manuel, Antonio Doménech, M. T. Doménech-Carbó, M. L. Vásquez de Ágredos Pascual, M. Suárez, and E. Garcia-Romero. "The Maya Blue Pigment." In *Developments in Palygorskite-Sepiolite Research: New Outlook on these*

Nanomaterials, edited by Emilio Galán and Areih Singer, 453–481. Developments in Clay Science 3. Amsterdam: Elsevier B.V., 2011. https://www.researchgate.net /publication/248393332.

Sánchez del Río, Manuel, Javier García-Rivas, Mercedes Suárez, and Emilia García-Romero. "Crystal-Chemical and Diffraction Analyses of Maya Blue Suggesting a Different Provenance of the Palygorskite Found in Aztec Pigments." *Archaeometry* 63, no. 4 (2021): 738–252. https://doi.org/10.1111/arcm.12644.

Sánchez del Río, Manuel, P. Martinetto, C. Reyes-Valerio, E. Dooryhée, and M. Suárez. "Synthesis and Acid Resistance of Maya Blue Pigment." *Archaeometry* 48, no. 1 (2006): 115–130. https://doi.org/10.1111/j.1475-4754.2006.00246.x.

Sánchez del Río, Manuel, P. Martinetto, Andrea Somogyi, C. Reyes-Valerio, E. Dooryhée, N. Peltier, L. Alianelli, B. Moignard, L. Pichon, T. Calligaro, and J.-C. Dran. "Microanalysis Study of Archaeological Mural Samples Containing Maya Blue Pigment." *Spectrochimica Acta Part B* 59 (2004): 1619–1625. https://doi.org/10 .1016/j.sab.2004.07.027.

Sánchez del Río, Manuel, Armida Sodo, S. G. Eeckhout, T. Neisius, P. Martinetto, E. Dooryhée, and C. Reyes-Valerio. "Fe K-edge XANES of Maya Blue Pigment." *Nuclear Instruments and Methods in Physics Research, Section B: Beam Interactions with Materials and Atoms* 238 (2005): 50–54. https://doi.org/10.1016/j.nimb.2005.06.017.

Sánchez del Río, M., Mercedes Suárez, and E. García-Romero. "The Occurrence of Palygorskite in the Yucatán Peninsula: Ethno-historic and Archaeological Contexts." *Archaeometry* 51, no. 2 (2009): 214–230.

Sánchez Fortoul, Carmen G. "Ceramic Composition Diversity at Mayapán, the Last Maya Capital." *Open Journal of Archaeometry* 1 (1), e4 (2013): 16–19. https://doi.org /10.4081/arc.2013.e4.

Sanz, E., A. Arteaga, M. A. García, C. Cámara, and C. Dietz. "Chromatographic Analysis of Indigo from Maya Blue by LC-DAD-QTOF." *Journal of Archaeological Science* 39, no. 12 (2012): 3516–3523. https://dx.doi.org/10.1016/j.jas.2012.06.019.

Shepard, Anna O. *Ceramics for the Archaeologist*. Carnegie Institution of Washington Publication 609. Washington, DC: Carnegie Institution of Washington, 1956.

Shepard, Anna O. "Maya Blue: Alternative Hypotheses." *American Antiquity* 27, no. 4 (1962): 565–566.

Shepard, Anna O., and Hans B. Gottlieb. *Maya Blue: Alternative Hypotheses*. Notes from a Ceramic Laboratory 1. Washington, DC: Carnegie Institution of Washington, 1962.

Shepard, Anna O., and Harry E. D. Pollock. *Maya Blue: An Updated Record*. Notes from a Ceramic Laboratory 4. Washington, DC: Carnegie Institution of Washington, 1971.

Sillar, Bill, and Michael Tite. "The Challenge of 'Technological Choices' for Materials Science Approaches in Archaeology." *Archaeometry* 42, no. 1 (2000): 2–20.

Simms, Stephanie R., Evan Parker, George J. Bey III, and Tomás Gallarta Negrón. "Evidence from Escalera al Cielo: Abandonment of a Terminal Classic Puuc Maya Hill Complex in Yucatán, Mexico." *Journal of Field Archaeology* 37, no. 4 (2012): 270–288.

Smith, Robert E. *The Pottery of Mayapán.* 2 vols. Papers of the Peabody Museum of Archaeology and Ethnology 66 (pts. 1 and 2). Cambridge, MA: Harvard University, 1971.

Sousa, Micaela M., Catarina Miguel, Isa Rodrigues, A. Jorge Parola, Fernando Pina, J. Sérgio Seixas de Melo, and Maria J. Melo. "A Photochemical Study on the Blue Dye Indigo: from Solution to Ancient Andean Textiles." *Photochemical & Photobiological Sciences* 7 (2008): 1353–1359. https://doi.org/10.1039/b809578g.

Speakman, R. J., and H. Neff. "The Application of Laser Ablation ICP-MS to the Study of Archaeological Materials: An Introduction." In *Laser Ablation ICP-MS in Archaeological Research*, edited by R. J. Speakman and H. Neff, 1–15. Albuquerque: University of New Mexico Press, 2005.

Splitstoser, Jeffrey C., Tom D. Dillehay, Jan Wouters, and Ana Claro. "Early Pre-Hispanic Use of Indigo Blue in Peru." *Science Advances* 2, no. 9 (2016). https://doi.org/10.1126/sciadv.1501623.

Steffens, Gena. "Maya Ritual Cave 'Untouched' for 1,000 Years Stuns Archaeologists." *National Geographic*, March 4, 2019, https://www.nationalgeographic.com/culture/2019/03/maya-ritual-balamku-cave-stuns-archaeologists/?cmpid'org 'ngp::mc'crm-email::src'ngp::cmp'editorial::add'History_20190311::rid'41260281295, accessed July 2, 2023.

Stephens, John L. *Incidents of Travel in Yucatán.* Vol. 1. 1843. Reprint, New York: Dover Publications, 1963.

Stoner, Wesley D. "The Analytical Nexus of Ceramic Paste Composition Studies: A Comparison of NAA, LA-ICP-MS, and Petrography in the Prehispanic Basin of Mexico." *Journal of Archaeological Science* 76 (December 2016): 31–47. https://doi.org/10.1016/j.jas.2016.10.006.

Straulino-Mainou, L., T. Pi-Puig, B. Lailson-Tinoco, K. Castro-Chong, M. F. Urbina-Lemus, P. Escalante-Gonzalbo, S. Sedov, and A. Flores-Morún. "Maya Blue Used in Wall Paintings in Mexican Colonial Convents of the XVI Century." *Coatings* 11 (2021): 88. https://doi.org/10.3390/coatings11010088.

Tagle, Alberto A., Hubert Paschinger, Helmut Richard, and Guillermo Infante. "Maya Blue: Its Presence in Cuban Colonial Wall Paintings." *Studies in Conservation* 35 (1990): 156–159.

Thompson, Amy. "Detecting Classic Maya Settlements with Lidar-Derived Relief Visualizations." *Remote Sensing* 12, no. 17 (2020): 2838. https://doi.org/10.3390 /rs12172838.

Thompson, Edward H. *The Chultunes of Labná, Yucatán*. Memoirs of the Peabody Museum of American Archaeology and Ethnology, vol. 1, no. 3. Cambridge: Peabody Museum, Harvard University, 1895.

Thompson, Edward H. *The High Priest's Grave, Chichén Itzá, Yucatán, Mexico: A Manuscript by Edward H. Thompson*. Edited by J. Eric Thompson. Field Museum of Natural History Publication 412, Anthropology Series 27, no. 1. Chicago: Field Museum of Natural History, 1938.

Thompson, Edward H. "Pyramid with Burial Well and Cenote Chamber Beneath." In *The High Priest's Grave, Chichén Itzá, Yucatán, Mexico: A Manuscript by Edward H. Thompson*, edited by J. Eric Thompson, 13–38. Field Museum of Natural History Publication 412, Anthropology Series 27, no. 1. Chicago: Field Museum of Natural History, 1938.

Thompson, J. Eric. "Introduction." In *The High Priest's Grave, Chichén Itzá, Yucatán, Mexico: A Manuscript by Edward H. Thompson*, edited by J. Eric Thompson, 7–12. Field Museum of Natural History Publication 412, Anthropology Series 27, no. 1. Chicago: Field Museum of Natural History, 1938.

Thompson, J. Eric. "Notes on the Report." In *The High Priest's Grave, Chichén Itzá, Yucatán, Mexico: A Manuscript by Edward H. Thompson*, edited by J. Eric Thompson, 45–63. Field Museum of Natural History Publication 412, Anthropology Series 27, no. 1. Chicago: Field Museum of Natural History, 1938.

Thompson, L. G., E. Mosley-Thompson, J. F. Bolzan, and B. R. Koci. "A 1500-Year Record of Tropical Precipitation in Ice Cores from the Quelccaya Ice Cap, Peru." *Science* 229 (1985): 971–973.

Thompson, Raymond H. *Modern Yucatecan Maya Pottery Making*. Memoirs of the Society for American Archaeology 15. Salt Lake City: Society for American Archaeology, 1958.

Torres, Luís M. "Maya Blue: How the Mayas Could Have Made the Pigment." In *Materials Issues in Art and Archaeology, Proceedings of the Materials Research Society*, vol. 123, edited by Edward V. Sayre, Pamela Vandiver, James Druzik, and Christopher Stevenson, 123–128. Pittsburgh, PA: Materials Research Society, 1988.

Towle, Margaret A. *The Ethnobotany of Pre-Columbian Peru*. Viking Fund Publications in Anthropology 30. New York: Wenner-Gren Foundation for Anthropological Research, 1961.

Tozzer, Alfred M. *Chichén Itzá and Its Cenote of Sacrifice: A Comparative Study of the Contemporaneous Maya and Toltec*. Memoirs of the Peabody Museum of

Archaeology and Ethnology Harvard University 11 and 12. Cambridge, MA: Peabody Museum, Harvard University, 1957.

Tozzer, Alfred M. "Introduction." In *Landa's Relación de las Cosas de Yucatán, A Translation*, edited by Alfred M. Tozzer, vii–x. Papers of the Peabody Museum 18. Cambridge, MA: Peabody Museum, Harvard University, 1941.

Tozzer, Alfred M. ed. *Landa's Relación de las Cosas de Yucatán: A Translation*. Papers of the Peabody Museum 18. Cambridge, MA: Peabody Museum, Harvard University, 1941.

"Turquoise Mineral Data." Webmineral.com. http://webmineral.com/data/Turquoise .shtml#.Y4Hef33MJD8, accessed September 29, 2023.

Tyler, Steven A. *Cognitive Anthropology*. New York: Holt, Rinehart, Winston, 1969.

Vail, G. "The Maya Codices." *Annual Review of Anthropology* 35 (2006): 497–519.

Vail, Gabrielle, and Christine Hernández. *The Maya Hieroglyphic Codices*, ver. 5.0, 2018. http://www.mayacodices.org/, accessed April 14, 2024.

Van Olphen, H. "Maya Blue: A Clay-Organic Pigment?" *Science* 154 (1966): 645–646.

Vandenabeele, P., S. Bodé, A. Alonso, and L. Moens. "Raman Spectroscopic Analysis of the Maya Wall Paintings in Ek' Balam, Mexico." *Spectrochimica Acta Part A* 61, no. 10 (2005): 2349–2356.

Vandiver, P. B., and W. D. Kingery. "Egyptian Faience: The First High-Tech Ceramic." In *High-Technology Ceramics: Past, Present, and Future, The Nature of Innovation and Change in Ceramic Technology*, edited by W. D. Kingery, 19–34. Ceramics and Civilization 3. Westerville, OH: American Ceramic Society, Inc., 1986.

Vázquez de Ágredos Pascual, María Luisa, María Teresa Doménech Carbó, and Antonio Doménech Carbó. "Characterization of Maya Blue Pigment in Pre-Classic and Classic Monumental Architecture of the Ancient Pre-Columbian City of Calakmul (Campeche, Mexico)." *Journal of Cultural Heritage* 12, no. 2 (2011): 140–148. https://doi.org/10.1016/j.culher.2009.12.002.

Vázquez de Ágredos Pascual, María Luisa, Clodoaldo Roldán-García, Sonia Mucia-Mascarós, David Juanes Barber, María Gertrudis Jaén Sánchez, Brigitte Faugère, and Véronique Darras. "Multanalytical Characterization of Pigments from Funerary Artefacts Belongs to the Chupicuaro Culture (Western Mexico): Oldest Maya Blue and Cinnabar Identified in Pre-Columbian Mesoamerica." *Microchemical Journal* 150 (November 2019): 104101. https://doi.org/10.1016/j.microc.2019.104101.

Vermeer Jr., Donald E., and Ray E. Ferrell. "Nigerian Geophagical Clay: A Traditional Antidiarrheal Pharmaceutical." *Science* 227 (1985): 634–636.

Vidal Lorenzo, Cristina, Gaspar Muñoz Cosme, and Patricia Horcajada Campos. "Ofrendas y Rituales Postclásicos Dedicado a Chaahk en el Sito Maya de Chilonché (Petén, Guatemala)." *Latin American Antiquity* 32, no. 1 (2021): 1–18.

Wagner, Elisabeth. "The Dates of the High Priest Grave ('Osario') Inscription, Chichén Itzá, Yucatán." *Mexicon* 17, no. 1 (1995): 10–13.

White, W. Arthur. "Atterberg Plastic Limits of Clay Minerals." *American Mineralogist* 34, nos. 7–8 (1949): 508–512. Internet Archive Volume Report of Investigations 144. Illinois Geological Survey, Illinois State Government Document. http://archive.org/details/atterbergplastic144whit.

Zapata Peraza, Renée L. *Los Chultunes: Sistemas de Captación y Almacenamiento de Agua Pluvial. Colección Científica, Serie Arqueología.* Mexico City: Instituto Nacional de Antropología e Historia, 1989.

Zhang, Yuan, Wenbo Wang, Bin Mu, Qin Wang, and Aiqin Wang. "Effect of Grinding Time on Fabricating a Stable Methylene Blue/Palygorskite Hybrid Nanocomposite." *Powder Technology* 280 (August 2015): 173–179. https://doi.org/10.1016/j.powtec.2015.04.046.

Zhang, Yuan, Wenbo Wang, Bin Mu, Qin Wang, and Aiqin Wang. "Reply to 'Comment to the Paper: Effect of Grinding Time on Fabricating a Stable Methylene Blue/Palygorskite Hybrid Nanocomposite.'" *Powder Technology* 299 (2016): 261–262. https://doi.org/10.1016/j.powtec.2016.05.048.

Zhang, Yujie, Junping Zhang, and Aiqin Wang. "Facile Preparation of Stable Palygorskite/Methyl Violet@SiO$_2$ 'Maya Violet' Pigment." *Journal of Colloid and Interface Science* 457 (November 2015): 254–263. https://doi.org/10.1016/j.jcis.2015.07.030.

Zhou, Wei, Hong Liu, Tingting Xu, Yeling Jin, Shijie Ding, and Jing Chen. "Insertion of Isatin Molecules into the Nanostructure of Palygorskite." *RSC Advances* 5, no. 94 (2014): 51978–51983. https://doi.org/10.1039/C4RA06299J.

Zhuang, Guanzheng, Li Li, Mengyuan Li, and Peng Yuan. "Influences of Micropores and Water Molecules in the Palygorskite Structure on the Color and Stability of Maya Blue Pigment." *Microporous and Mesoporous Materials* 330 (January 2022): 111165. https://doi.org/10.1016/j.micromeso.2021.111615.

Index

blue silt, in Sacred Cenote, 19–20, 141–42
Bodley Codex, 193
Bohor, Bruce F., 26, 191; on clay sources, 27, 32, 57; on palygorskite sources, 61, 81, 89, 96, 115, 116; *sak lu'um* analysis, 48–49; trace element analyses, 119, 120–21
Bonampak, 176
Book of Chilam Balam of Chumayel, 83–84, 95
Borbonicus Codex, 194
Borgia Codex, 193
Bowditch, Charles P., 132
Brady, James, 174
Branden, Jason, 131
Brazil, indigo in, 107
Breazeale Nuclear Reactor, 111
Bronze Age, 35
Brown, J. P., 131
Buddhist rituals: blue used in, 38
Buenavista del Cayo (Belize), 35, 205
burials, 146, 160; at El Osario, 172–73, 174, 234n66. *See also* El Osario
burning, 140, 202; copal, 146–47, 189, 192; ritual, 126–27, 133–34, 142
burns, *sak lu'um* used for, 57

Cabrera-Garrido, Jose Maria, 23, 24, 27, 128–29, 145
Cabrito Cream-Polychrome pottery, 35; Cabrito Variety, 205
Cacaxtla, 177, 190, 193
caches, El Osario, 172–73, 175
Calakmul, 137, 151, 176, 184, 201, 204
calcium copper tetrasilicate, 41
Campeche, 113, 114, 192
Cancún, tourism in, 98
canícula, 138
Carnegie Institution of Washington, at Chichén Itzá, 11, 132–33
case-hardening properties, of smectite, 33–34
Caulk (Spain), Egyptian Blue in, 41
Cave of the Jaguar God. *See* Balamkú, Cave
cenotes: Chichén Itzá, 17–20; distribution of, 137, 139; palygorskite mines in, 61, 69–81, 90, 186–87, 217n34; pre-Hispanic use of, 82–86
ceramic taskscape, 56
ch'oh, 106, 140, 155, 233n56, 234n60
Chaac Mool throne seat (Chichén Itzá), 38

Chaak, 3, 21, 139, 140, 173; and blue, 11, 15, 16, 20, 137, 189; at Chichén Itzá, 181–82; offerings to, 10, 146, 175
Chacmultún, 152, 176
Chanchochoclá, 94, 99
Chapab, 61, 68, 94, 186, 218–19n7; mines near, 64, 93, 118, 120, 223n14; palygorskite from, 121, 227n24; *sak lu'um* from, 97, 116, 117
charcoal, 10, 128, 171, 175, 183
chemical analysis, 22–23, 114. *See also* trace element analyses
Chiapas, 46
Chichanhá, 201
Chichén Itzá, 11, 35, 67, 83, 127, 151, 176, 179; abandonment of, 182–83; Chaak at, 181–82; excavations at, 132–33; jadeite in, 38–39; Maya Blue in, 4–6, 6f, 10, 16–17, 86; Maya Yellow, 152; murals at, 153–54; offerings in, 189–90; pigment samples from, 124, 198; as pilgrimage site, 137–38, 192; rituals in, 16–17. *See also* El Osario; Sacred Cenote
Chichicastenango, 125
Chicxulub Crater, 137
chi'ich'hi', 91
children: sacrifices of, 19, 174; *sak lu'um* use, 57, 75, 83, 217n34
China, 37, 42
Chinautla, potters in, 92–93
chipped stone tools, for mining, 198
ch'oh, ch'ooh. See indigo
chromium, in palygorskite, 121
chrysocolla, 36
chultun, 21, 139
Chumayel, 90
Chupicuaro culture, 184, 204
churches, murals in, 3. *See also* convents
cisterns, 21, 139
Classical Period, Maya Yellow, 152
clay, 14, 52, 68, 98, 185; blue and green, 27–28; INAA sourcing, 110–15; sources of, 113–14. *See also by type*
clay-organic complex, 31, 196
climate, impacts of, 137–39
Códice Maya de México (Grolier Codex), 4
codices, 20, 193, 194
cognitive anthropology, 45
Colombino Codex, 193
color: Maya Blue variations, 151–52, 206; of *sak lu'um*, 75, 151

with palygorskite, 149–52; aqueous leachate of, 142, 148, 149–50, 175, 202, 225*n27*; as dye, 104, 105–6; in Maya Blue, 4, 10, 13, 23, 101–2, 131, 156; medicinal uses of, 106–7, 140; production of, 107–8; *I. suffruticosa*, 102, 104, 105, 107; *I. tinctoria*, 102, 105, 194
indigoids (indigo-like molecules), 152; bonds with, 149–51, 157
indigotin, 148, 152
indirubin (indigo brown), 148, 192
indoxyl, 148, 150
Indus Valley, 41
infection, *sak lu'um* use for, 57
infrared absorption spectrometry, 23
Ingold, Tim, 60
insecticide, indigo as, 107
Institute for Integrated Research in Materials, Environments, and Society (IIRMES), 123, 124
Instituto Nacional de Antropología y Historia (INAH), and Sacred Cenote, 134, 135
instrumental neutron activation analysis (INAA), 116; clay sourcing, 110–15
iron minerals, 15, 151. See also hematite; limonite
isatin, 152, 192
isoindigotin, 148
isomers, 149, 232*n27*
Isphording, Wayne, 179
Itzá Maya, migration, 83–84
Itzamná, 20
Ixlú, 192
Izabal, Lake, 93

jade, jadite, 38–39
Jaina, 32, 192
jaundice, indigo for, 107
jiquilite. See indigo

Kabah, 138, 139, 181
Kaminaljuyu, 111
kaollnite, In Tlcul, 52
Kaopectate, 57, 217*n34*
Kao-Tin Advance Formula, 58
k'at. See clay
Kay, Paul, 14
Keh, Francisco, 155
Kikil, Itzá Maya migration, 83

Kleber, compositional analysis, 26–27
knowledge: Indigenous, 9, 44–45, 54–55, 87, 88–89, 180; local, 58–59; practical vs. scientific, 55–56; transmission of, 187–88
K'om ceramic group, 205
Ku, Luis May, 156, 186
Kukulkan, 190
Kulubá, 176
Kupferschmidt, Kai, 36

La Blanca (Guatemala), greenish pellets, 192–93
Labná, 132, 138, 181
La Casa de las Golondrinas, paintings at, 39
Ladd, John, 141
lagoons, saline, 93, 118, 201
LA-ICP-MS. *See* laser ablation-inductively coupled plasma-mass spectroscopy
Landa, Diego de, 9, 141; descriptions by, 15–16, 22; about Sacred Cenote, 19, 136, 140, 141
landscape: Indigenous knowledge of, 60, 185, 186; palygorskite sources and, 94, 99
languite, 39
lanthanum, 123*f*
lapis lazuli, 35, 38, 41
laser ablation-inductively coupled plasma-mass spectroscopy (LA-ICP-MS), 110, 115, 116, 120–21; in trace element analysis, 122*f*, 123*f*, 128, 160
Late Classic period, 3, 82, 137, 151, 176, 205
Late Postclassic period, 139; El Osario, 172–73
Late Preclassic period, 11, 13, 137, 151, 176, 201
Lathrap, Donald W., 45, 48, 89, 103
La Tronera, 183, 204
Laud Codex, 193
lazurite, 38
leachate, of indigo leaves, 142, 149–50, 175, 202, 225*n27*
learning, and technology transfer, 187–88
Lees, Robert B., 45
Leguminosae. See Fabaceae
Lerma River, Chupicuaro culture, 184, 204
leucoindigo, reduction of indigo to, 108
lime, as binder, 33–34
limonite, 36, 151
Littmann, Edwin R., 179, 184; composition analysis, 24–25, 26, 27
Lo de Reyes (Guatemala), 93
log concentrations, 117*f*, 121*f*, 122*f*

Quai Branly Museum, Paris, 38
quarries (*sah kabo'ob*; *sascaberas*), 61
Quetzalcoatl, 177, 190; cult of, 195
Quetzaltenango, 125
quicklime, 33, 34, 108
quilitl. See indigo
Quintana Roo, 94, 156, 201
Quinua (Peru), 111

rain god. *See* Chaak
rain, symbolism of, 20
rainy season, 21, 138; in Ticul, 46–47
Relación de las Cosas de Yucatán (Landa), 15
Relaciones Geográficas, maps in, 194
reliability, 51–52
religious meaning, 203; technology, 145–46
religious specialists, and Maya Blue production, 189–90
research: context of, 8–9; history of, 22–24
Reyes-Valerio, 28
ritual, 35, 144, 179, 181; Chaak-related, 21, 182; at Chichén Itzá, 16–17, 192; copal used in, 126–27; Landa's description of, 15–17; in Maya Blue production, 10, 140–41, 194–95; at Pascual Abaj, 125–26, 126*f*; pigment creation in, 133–34; of Sacred Cenote offerings, 134–36
Rohn, Arthur H., 45
Roman Empire, Egyptian Blue in, 41
Roth, Nicole, 128
Roys, Ralph L, 83

Sacalum, 99, 124, 151, 191, 240*n13*; archaeological evidence in, 197, 198–99; cenote mine, 61, 69–79, 82–86, 89, 139, 220*n32*, 239*n47*; palygorskite from, 10, 87, 93, 94, 121, 131, 179, 180, 204, 208*n8*; *sak lu'um* from, 57, 96–97; trace element analysis, 79–80, 115, 116, 117
Sacojito (Guatemala), 93
Sacred Cenote (Chichén Itzá), 17, 18*f*, 229*n32*; blue silt in, 19–20, 141–42; jadeite at, 38–39; offerings in, 130*f*, 133–36, 145, 146, 174, 189, 192; sacrifices in, 21–22, 139–40; vessels from, 161*f*, 173, 175, 202, 229*n32*
sacredness, of Maya Blue, 10
sacred sites, rituals at, 125–26, 126*f*
sacrifices: color of, 3, 5–6; human, 16–17, 174; at Sacred Cenote, 19, 21–22, 139–40
sah kab, sascab, 53, 55

sakel bach tunich, 185
sak lu'um, 24, 87, 140, 151, 180–81, 197, 217*n35*, 220*n30*; cultural significance of, 51, 52–53, 54–56, 99–100; ethnohistoric and archaeological use of, 82–86; at Hacienda Uxmal, 91–92; identification of, 96–98; Indigenous knowledge of, 58–59, 88–89, 185–86; medicinal use of, 57–58; preparation of, 157, 159–60; from Sacalum mine, 69–81, 198–99; in temper, 47–48; trace element analyses, 115–21; X-ray diffraction of, 48–49; Yo' sah Kab mines, 61–69. *See also* palygorskite
Sak Nik Te, 199
Salisbury, Stephen S., 132
Sanders, William, 93
San Francisco de Ticul, 65–66, 67, 84, 221*n47*, 221*n48*, 222*n49*
San Juan de Mecat church, Valencia, 38
sascab, 55
sascaberas, 61
Sapper Fumarole (Santiaguito Dome, Guatemala), 39
Sauer, Carl, on diffusion of domesticated plants, 103
Sayil, 138, 139, 217*n31*
scanning electron microscopy, 131
sculpture, 4, 11, 15, 17, 181, 182
secondary electron and backscattered electron, 131
Selden Roll, 193, 194
sense of place, 61–62, 65, 68, 97, 115, 137, 180, 198
sepiolite, 4, 22, 178, 183, 201; in blue pigment, 23–24; in Maya Blue, 13, 100, 147; sources of, 191–92
Seri Blue, 35, 39–40, 42, 43
settlement patterns, Terminal Classic changes, 138–39
shamans, 125–26, 126*f*, 180, 189
Shepard, Anna O., 23, 50, 91, 153, 154, 179; on palygorskite, 53–55, 88, 90; on scientific knowledge, 55–56
sherds, as mining tools, 68
Shkele, 199
sinkholes, 209*n27*; near Mama, 90, 91, 95. *See also* cenotes
sky god. *See* Itzamná
slaked lime, 34, 239*n54*